PRACTICAL
ART SCHOOL

PRACTICAL ART SCHOOL

Twelve Lessons in Painting, Drawing & Sketching

CLB

4410 Practical Art School

This edition published in 1999 by
CLB, an imprint of
Quadrillion Publishing Ltd of
Godalming Business Centre, Woolsack Way
Godalming, Surrey, GU7 1XW, England

Distributed in the USA by Quadrillion Publishing, Inc.
230 Fifth Avenue, New York, NY 10001

ISBN 1-84100-218-6
Printed in Italy

Contents

Preface

The twelve lessons in *Painter's Progress* will teach you to draw, using a variety of drawing materials, and to paint in watercolour and oils. They are intended for anyone who is prepared to spend a little time, on a regular basis, on the various projects which illustrate and explain each section.

We have worked from the beginning on two basic assumptions: that anyone can be taught to draw and paint, and that teaching art should be firmly grounded on a representation of the world that we see around us.

The first assumption is clearly set out in our opening essay on the introduction to art, and on how we can learn to see.

The second assumption is practical rather than dogmatic. There is no single way to teach a complex and personal subject such as art. But, as practising and exhibiting artists, as well as teachers, we all believe that a sound background in direct observation and representational painting is necessary to achieve a reasonable standard of skill in one's chosen medium. The objects you have at home, the view from your window, the town- and landscapes all around you – these are the best subjects for beginners and a continuing education for more experienced students.

Once you have learnt to handle the objects and views that are part of your everyday experience, you will be able to experiment with different techniques, and to explore the world of imagination and intuition. We have deliberately given our own personal views on practical and technical matters so that you may gain from three teachers rather than one.

The whole course of twelve sections has been planned to occupy a year, with one lesson a month, based on five to ten hours' work a week. For those of you who may have more time than this to spend, there is ample scope in each lesson in the form of suggested projects, and ideas for increasing your experience by means of sketches and painting trips.

There are others who will find it difficult to keep to a schedule because of family or business commitments. However, the lessons have been specially constructed so that each project can be a goal in itself, with breaks between periods of working time. Of course, regular and continuing practice will give the best results, but the best is not always realistic. So don't be discouraged: the most important task is to begin.

For those who want to learn something of how art has evolved, there are brief historical introductions to each lesson. At the end of the book, selected biographical notes on well-known painters and a comprehensive guide to museums and galleries will encourage you to appreciate our artistic heritage. The glossary of the most common art terms (which are also the most commonly misused terms) will be useful if you go on to read the suggested, and more specialized, books in the bibliography, while the buyer's guide for various levels of skill and expertise will be a boon when you are faced with the enormous selection of materials found in the comprehensive list of suppliers. An index to names and special subjects completes the reference section, with acknowledgements to those who have been kind enough to supply us with pictures and photographs for our many examples. These illustrations are appropriately captioned in the text. Projects or examples painted by the authors, or specifically for the book itself, are not captioned.

Ian Simpson
Tom Robb
Fred Cuming

Part I
Introduction to Art

An artist must learn to see – to perceive – in the same way that an athlete learns to breathe and move properly so that his or her body can be used to its fullest extent, or a musician's ear is trained to hear clearly.

Perception, like the athlete's control of breathing and movement and the musician's finely tuned sense of hearing, is a development of a natural faculty – a child needs no training in order simply to see. Nevertheless, we are coming to know more and more about the processes of thinking and seeing as science develops some very unusual concepts about the brain and its mechanical abilities. There are numerous theories about hitherto unknown links between the eye and the brain, and a growing number of experiments are trying to pinpoint the areas involved in art and creative imagination.

These ideas are fascinating to the artist, and especially to the art teacher, because they seem to confirm the belief that the brain will take from the eye all it needs to give the hand the correct information. It is a matter of training the eye to look at shape, form, colour and dimension, and then training the brain to interpret this information clearly and simply enough for the hand to put it down on paper or canvas.

Seeing starts when light rays enter the eye through the lens, which focuses them into a

Folklore couple; Kossuth

sharp, inverted image on the retina – rather as a camera takes a photograph. These rays are then converted into nerve impulses which travel to the brain, where they are interpreted as pictures.

The eye, therefore, is responsible for the purely mechanical aspect of seeing. The brain organizes, stores and assesses this visual experience. It is amazingly adept at decoding the messages it receives, with the ability to use its vast, stored knowledge to create complex images from very little information.

However, because visual impulses are instantly interpreted to form the most acceptable pictures, the brain often makes assumptions that reach the wrong artistic conclusions.

These conclusions are used in two ways by the artist: as identification of what is seen, and then as information to be passed to the hand so that the object can be drawn or painted as accurately as possible. This, in turn, re-creates the picture for the viewer.

An experienced artist may, of course, deliberately misinterpret 'reality' in order to present a personal or particular image; the flat shapes of a Matisse flower have many levels of decorative and psychological meaning, but Matisse was also capable of creating the most precise and detailed naturalistic paintings. Change or distortion should be the result of knowledge not ignorance.

Two factors are involved in perception. The first is recognition. The brain does not need all the information about an object in order to identify it. It simply needs enough to stimulate the memories buried in the vast storehouse of its experience.

The second factor, selection, involves even more discrimination. Essential elements must be picked out from the more obvious characteristics, so that the lines and marks on the paper or canvas stimulate the viewer's brain to 'see' what the artist wants him to see.

Developing this skill is essential when you are studying art. In the months to come you will learn to use your eyes more carefully and more precisely than ever before.

It is also important to understand that the brain is not impersonal. Because it reaches back into the individual's experience, it almost always has many preconceived ideas – barriers to accurate seeing, or perception.

We have many hidden and conflicting reactions to the human body, and every art teacher knows that each student in a life class will see the model very differently. This is not simply because of their varied viewpoints, but because they are projecting their ideas of nudity onto the model, either in an ideal form or, often, in imitation of a well-known style or painter.

This is clear in drawings and paintings by children, who make the object that is most important to them the largest. Adults are more subtle, but distort reality in the same way, and for the same reasons. The conflict between brain and eye is a major problem for art students. The ability to see objectively is a basic skill that must be learnt, and the brain is often unable or unwilling to record exactly what the eye sees.

Personal and emotional responses can be deliberately used to create moods and reactions in the viewer, but their use must be intentional and controlled by the artist.

There are two practical problems in learning to re-create what you have taught your eye to see: dimension and texture.

The external world has three dimensions: height, width and depth. But the surfaces on which we paint – paper and canvas – have only two effective dimensions: height and width.

To translate what we see we must learn to use the illusion, not the reality, of depth and surface.

There are two ways of creating a third dimension. The first aid is formal perspective. This system, developed over the centuries to a mathematical formula, is based on planes, vanishing points, and so on. It seems complicated, but the rules are in fact quite simple. Above all, perspective is useful for the artist working from imagination, because it can create an entire city or a simple vase of flowers in the correct proportion, and with the correct illusion of depth and substance.

The second method is direct observation. As you learn to see angles, tones and relationships between subjects, you will be able to re-create these elements on paper simply by putting down accurately what you see in front of you.

Surfaces are depicted from direct observation. While perspective can give the correct outlines and forms, only direct observation can tell you about the infinite details which make up texture, and which must be re-created in order to increase the appearance of depth and dimension in your work.

Learning to See Colour

There is a terminology to explain the various aspects of colour. Not many things in this world are pure colour, but the property whereby something is called red or green, for example, is referred to as its 'hue'. To change the hue of a colour, another must be added to it.

The gradations of darkness and depth of a hue are called its 'shade', made by adding black. 'Tint', on the other hand, is the variety of colour created by adding white. This term may also be used to describe the inclination of one colour towards another, for example blue with a green tint. 'Tone' is a term used to describe the overall effect of light and dark in a picture; it may also be used to describe shade or tint.

Finally, all colours have a degree of brilliance. Colours of a different hue may have the same degree of tone, but still look vastly different. This difference is the degree of saturation of the colour and is described as 'chroma', or more commonly as 'intensity'.

The word colour itself is an umbrella term generally understood to mean a combination of hue, tone and intensity. Once you understand these properties you will be able to identify which aspect of a colour to emphasize for a certain effect or, indeed, to decide why a colour looks wrong in a composition.

One of the more important aspects of colour is that it can be used to convey the artist's emotion – how he feels about what he is painting. Look at works from Picasso's blue period or the violent colour of van Gogh's last paintings when he was losing his grip on reality and was torn by devastating emotions.

You will find a description of primary, secondary and tertiary colours, and how they are formed, on page 15, Steps 5, 6 and 7 of the colour wheel project.

Very briefly, colours that approach red are warm, vibrant, dominant, aggressive and capable of arousing the emotions. Warm colours tend to advance. Colours that tend towards blue are cool and soothing, often sombre and sometimes melancholic. Colours at this end of the spectrum appear to recede. The secondary colours of green and violet, containing as they do both warm and cool elements, are the most adaptable hues on the artist's palette. The way an artist uses these colours together, the degree of their intensity, and so on, all contribute to the artistic statement.

Any type of artistic endeavour will involve the use of colour, sometimes unmixed but more usually combined to make different hues. Beginners have little experience of the latter, and although there is a basic formula for colour-mixing, most artists achieve subtle variations by educated guesswork, their choice guided by an understanding of the composition of the pigments they are using and by their knowledge of the principles of colour.

Mixing Project

As a first attempt at mixing colours to match with a visual reference, tear a picture from a colour magazine, cut a strip from it about 1in. (2.5cm) wide and glue this strip down the side of a piece of size A2 cartridge paper.

Squeeze a little of each of the primary colours, plus black and white, onto the palette and try to mix hues and tones similar to those on the magazine strip.

You will probably be unable to mix colours that match exactly. The primary colours you are using will not be of the same hue as the printing inks, and it may well be impossible to match those in the pink and violet range. Nevertheless, try to get as near as you possibly can.

Colour Wheel

For this colour-mixing exercise you will need the following materials (which you will be able to use again later): a tube each of acrylic paint in cadmium red, cobalt blue and cadmium yellow; a hard and a soft pencil; two No.4 sable brushes; a few sheets of white cartridge paper, size A2; a piece of tracing-paper the size of this book; a drawing-board; a wide-necked jar filled with water; and an old white dinner plate or a palette. Acrylic paints are recommended for this first exercise as there is very little difference between their appearance when dry or wet. They dry quickly and can be easily painted over.

The project will take at least an hour; if it takes longer, this may reflect the care you have taken rather than any lack of ability!

Step 1. Use the hard pencil to trace the black and white circle below, and its various divisions.

Step 2. Using the soft pencil, completely cover the back of the tracing-paper with even scribbling.

Step 3. Place the tracing-paper on a sheet of cartridge paper, scribble-side down, and retrace the lines, thus transferring the drawing of the circle onto the cartridge paper.

Step 4. Squeeze a small amount of paint from each tube onto your palette, spacing the blobs quite far apart so that there is no danger of the colours running into one another.

Step 5. Using a small amount of water to thin the paint, fill in first the red triangle, then the yellow, and finally the blue. Leave the centre white. Take great care to rinse the brush thoroughly before

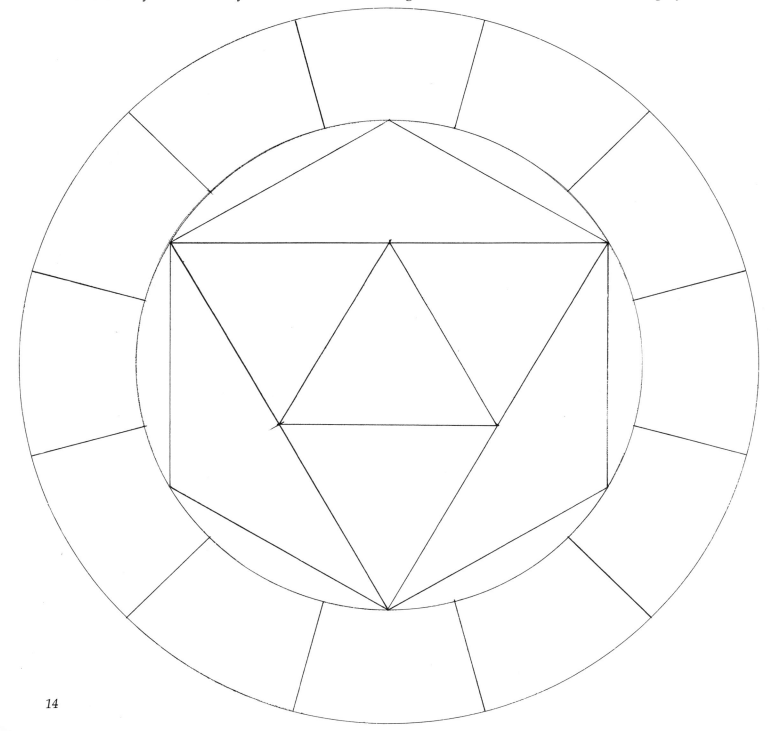

applying the next colour. Don't use too much water as the colour must be opaque on the page. These three basic colours, from which all others are mixed, are called primary colours. By mixing two of them together you make a secondary colour: orange, green and violet are secondary colours made by mixing respectively red and yellow, blue and yellow, and red and blue.

Step 6. Mix the secondary colours by gradually adding small amounts of one primary to another until you have achieved a hue that appears halfway between the two – so that, for instance, the orange is neither too red nor too yellow. Test the colour on a scrap of paper first.

Look at the colour wheel. You will see that each secondary colour appears again in the outer band. Mix enough paint to fill both triangles and the outer division, and to leave enough for the next step. Keep the colours on the palette separate.

Step 7. Now put the primary colours in the correct places on the outer band. Six divisions will be filled in and there will be six gaps left. These are to be filled with the tertiary colours: red-orange, yellow-orange, yellow-green, blue-green, blue-violet, red-violet. They are produced by mixing a primary with the secondary colour on either side.

Step 8. Mix the tertiaries carefully; again they must appear to be halfway between the primary and secondary colours from which they are made.

It is surprisingly difficult to achieve twelve distinct colours in equal progression around the circle. When you work on the third band you may find that the secondaries were not mixed accurately and lean too far towards one or other primary. This in turn will affect the hue of the tertiary colours, and it may be necessary to begin the whole exercise again.

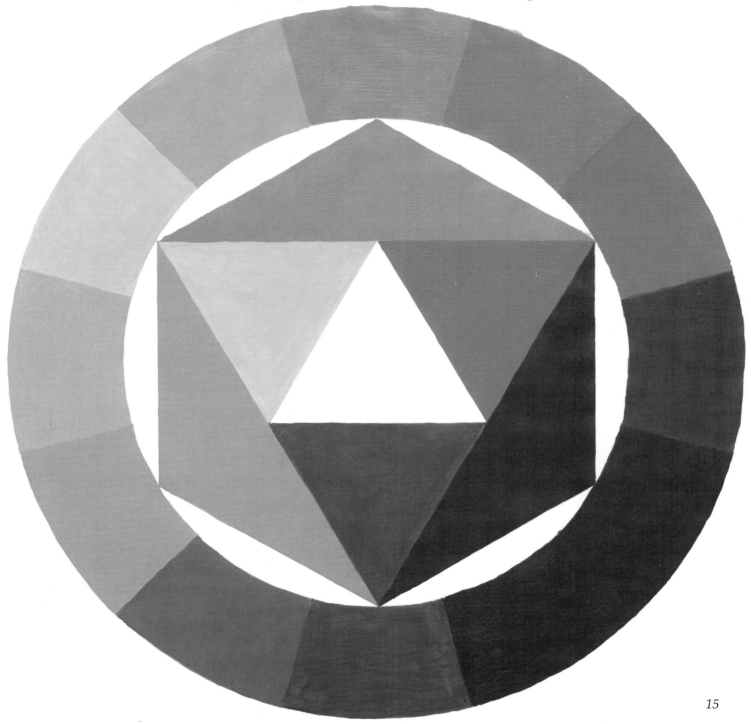

A First Experiment

Put a book on a table, near the edge. Draw it quickly in pen or pencil. Because your eye is not yet trained, you will probably find this simple study surprisingly difficult. The primary hurdle is getting the angles right.

To understand the difference between using perspective or tone to create depth, take a fresh look at the book. You drew an outline, but there are, of course, no lines around the book; the outline is an artificial device to show where one object stops and another starts. The drawing is not reality but the lines, based on perspective, stimulate the brain to see a book.

Now look again. The edge of the table is a horizontal line. Look at the edges of the book; they intersect the horizontal line at different angles. Learning to see those angles and to re-create them on paper is the first step towards an artist's perception.

A line that you know to be horizontal or vertical will be a great help in your first experiments. Later you will see how to use a table, a shelf, a windowsill and the vertical lines of corners and curtains as guides for many studies.

If you use colour to fill in the shapes made by the lines, covering up the pencil marks, the proportions will be correct and the picture will seem more 'real' – but it will still not look like the book.

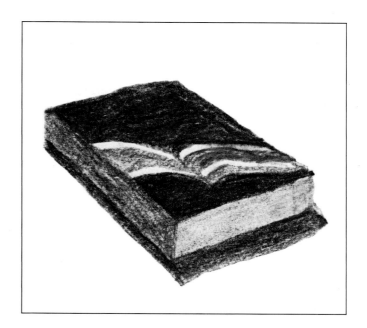

Now add the tiny changes of colour, the shadows and texture of the cover and the shiny surface of the jacket to give tone, and the picture will finally begin to look like the object on the table. It is still an illusion, but good enough to make the eye and brain think they see reality.

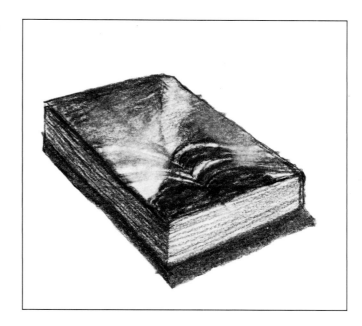

Transfer the same method – looking for angles and their relationships – to a more complicated subject. Look through a window and you will see all kinds of angles that you can learn to use: roof-top lines, fences, trees, paths, roads.

When you have trained your eye to perceive the relative distances and comparisons between these points you will have taken the first step towards working from direct observation. Eventually you will be able to create the illusion of three dimensions, even in a linear drawing without tone or shading.

Finally, to understand how important it is to ignore the old adage that seeing is believing, look in a mirror. You will, of course, think the face you see is an absolute reflection of your real face. Use chalk or lipstick to mark the top of your head and the bottom of your chin in the mirror. Now measure the distance. You will find the reflection is only half the real height of your face. Remember this experiment when you begin to use a mirror for a self-portrait.

If you want to check your perception of reality against a true image, take photographs of subjects you are going to paint, but don't look at the results until after the first sketch is finished. This exercise can be a good lesson in objectivity – real and imagined.

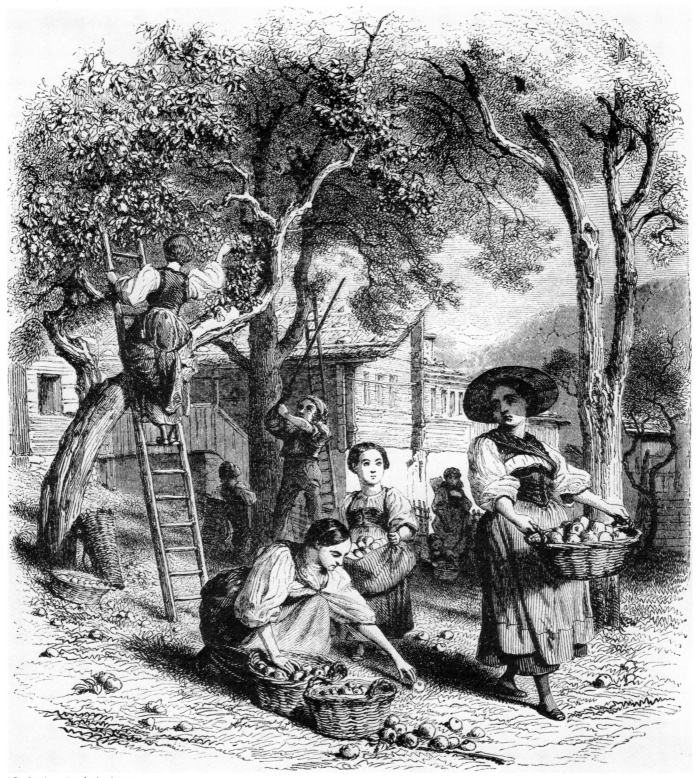

'Gathering Apples'; Anon

Lesson One Drawing

What is drawing, as opposed to painting, and how can they be separated – if at all? No sharp division is truly possible. Categories of art have been made more to satisfy our wish to organize than because the subject demands them.

The simplistic approach is to say that drawing is based on describing the outlines of shapes and that it is usually in black and white, while painting is concerned with the planes of shapes and is usually in colour. This definition can work reasonably well as long as it is understood that the division is arbitrary, and more a matter of convenience than fact. There is an infinite variety of steps between a pure outline drawing and a painting made only of broad bands of colour.

We do not know when man first began to draw. The definition of drawing in an artistic context is simply the pulling of some kind of writing instrument over a surface to make marks. However, the first cave drawings are complex enough to question the accuracy of this definition. In these prehistoric works we see subtle impressions of bison, deer and other animals being pursued by hunters across the uneven face of a rock wall, drawn in line and in what appears to be an early air-brush technique.

Over the millennia drawings were generally outlined in black ink or some form of charcoal. The latter was used under all kinds of painting to make the guidelines for the artist to follow, and medieval manuscripts are full of instructions on how to make kilns and burn the necessary wood. Pens were an early invention; while the Romans developed bronze pens with solid nibs, the ancient Egyptians used sharpened reeds to draw on clay, or used pen and ink made of powdered earth to draw on papyrus.

Prehistoric cave drawing of a mammoth

During the Dark Ages, drawing in manuscripts became increasingly common. Many medieval texts still survive, decorated with abstract letters embellished with gold and brilliantly coloured paints, as well as little pictures to illustrate points in the text or simply to please the patron who paid for a copy of the holy text to be made. Pictorial art also extended to stone and metal; buildings and jewellery were decorated with patterns which were often drawn first, rather than sculpted as three-dimensional forms.

Oriental painters used brush and ink as well as watercolour, but although their works were linear in expression, enough wash was used for most historians to describe them as paintings.

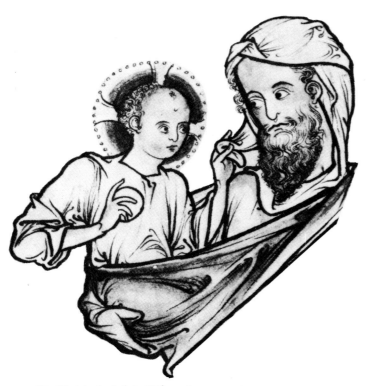

'St. Christopher'; late 12th century

Ink drawing from a Japanese scroll; 14th century

Renaissance artists made thousands of sketches using brown and white chalk as well as black charcoal, these were usually studies for large paintings – parts of the human anatomy, sections of landscape, botanical studies – and were used by the master's apprentices as a kind of textbook and to aid their work when completing a studio painting. (Many paintings from this period were 'team efforts', with the apprentices and students doing their work, while the master applied only the finishing touches.) Some of the best examples of this kind of drawing are to be seen in the notebooks of Leonardo da Vinci (1452–1519), and are worth serious study by any aspiring art student.

The graphite pencil was not developed until the eighteenth century. It brought great changes, giving a fine line and precision without the inconvenience of ink. By that century all the basic artistic tools had been developed, and drawings achieved the status of finished works of art. The pastel portraits of Jean Baptiste Perroneau (1715?–1783) and Jean Baptiste Siméon Chardin (1699–1779) are excellent examples of early pastel work.

During this time a number of other influences helped to make drawing popular. Travel became increasingly common, and part of a gentleman's or lady's education was the 'Grand Tour' of the sights and cities that were Classical Europe. Their sketchbooks were as important a piece of equipment to them as the camera is to the modern tourist. The austere effect created by the monochrome colour range of their drawing implements was perfectly suited to the classical repertoire of architecture and furnishing.

Fascination with new developments in printing – which relies almost entirely on line – encouraged admiration for artists' original working drawings as well. All these factors came together in the nineteenth century when drawings were collected and hung in galleries and homes to be viewed with appreciation and even reverence. At last, drawing had come of age and was regarded as a true art form. Using a wide variety of techniques – pencil, chalk, pastels – artists such as Edgar Degas (1834–1917) and Odilon Redon (1840–1916) drew with economy and masterly precision. At the same time, Japanese woodblock prints revolutionized the use of colour, and Oriental ink and brush techniques made their own contribution to the ways in which this medium was used. The combination of pen, ink and wash became a favourite of artists in Europe and America.

In the present century so many artists have turned to drawing that it is impossible to suggest more than a few for study: the endless variety of style, subject and technique in the immense output of Pablo Picasso (1881–1973); the remarkable use of pattern and texture in the work of Joan Mirò (*b.*1893) and Henri Matisse (1869–1954); and the impact of modern artists such as David Hockney (*b.*1937) and Frank Stella (*b.*1936).

There has been a great revival in traditional drawings of flowers and still lifes, as well as exploration of the use of line in very different ways. The drawing below of Ulysses is typical of many modern experiments in the use of line and almost primitive shapes.

With its extraordinary variety it is not surprising that, for most of the greatest artists in any era, drawing has been the very foundation of all art.

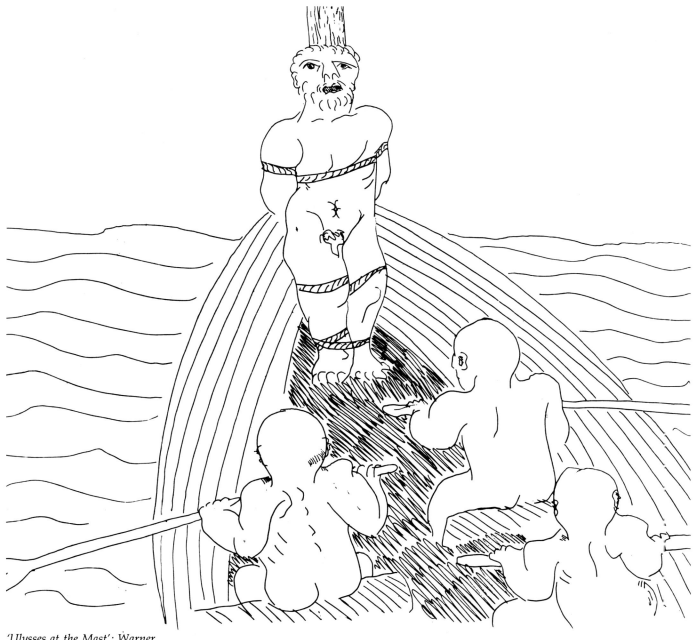

'Ulysses at the Mast'; Warner

Materials

A wide range of materials can be used for drawing on paper, and a number of pieces of equipment are desirable rather than essential. Basically a pencil, a piece of paper, and a firm support are sufficient to make a start.

Board

You will need a board large enough for A2 size (420×594mm) paper. If you want to obtain a piece of hardboard or blockboard for the purpose, it should be larger than A2 size. The surface must be smooth. Commercial drawing-boards are finished so that the edges do not chip easily, and they should not warp. Remember that you will eventually be working out of doors, and the board should not be too heavy to carry.

Clips

Clips or sticky tape are better than pins or tacks, and can be used to fix the paper to the board. Clips are probably the easiest to use. The type will depend on the board – those for heavier boards will not fit onto thin hardboard. Some clips adhere too firmly, and tend to remove the corners of the paper when it is pulled off the board.

Fixative

Drawings made with soft media, particularly pastels, charcoal and conté, must be fixed or they will smudge, or even rub off completely.

Fixative is available in aerosol cans or as a liquid that is applied to the drawing with a diffuser.

Pastels and Chalks

Pastels are powdered pigments mixed with gum or resin. They are mixed so as to form a rather dry paste (from which the word pastel is derived) which is then moulded into pastel sticks. Pastels can be used for drawing and can also produce effects that look like painting.

In making coloured chalks and crayons, the pigment is mixed with oil or wax before being formed into sticks.

Conté (called after its inventor) is a mixture of clay, graphite, water and paste which is produced in square sticks and in pencil form. Conté crayons are available in black (in three degrees of softness), sepia, red and white.

Rapidograph

Ball-tip pen

Felt-tip pen

Black ballpoint

Fine felt-tip pen

EE pencil

4B pencil

HB pencil

H pencil

Medium charcoal

Fine charcoal

Charcoal in holder

Conté crayon

Selection of pastels

Brush holder

Black watercolour

Indian ink

Sable brushes

Mapping pen

Selection of Chinese ink brushes

Block of Chinese ink

Liquid Chinese ink

Chinese ink grinding block

Oil Pastels

Oil pastels are somewhat different from pure pastels. An oil binding makes them useful for preparatory work for an oil painting, and a brush dipped in turpentine can be used to spread out the colour in washes. These pastels are not as brittle and fragile as pure pastels or chalks.

Pencils

Pencils are graded from very hard (6H) through to very soft (6B). You are unlikely to need anything harder than H (the harder pencils are for technical drawings). The soft range will be useful, but HB, B and 2B are best to start with. Keep a sharpener handy, or a very sharp penknife.

Types of Ink

A number of different kinds of ink are available: those intended for writing, and various drawing inks. Drawing inks are made in a variety of colours but for our purposes we will only require black ink, often called indian ink. However, you may wish to experiment with coloured varieties later.

All inks are suitable for drawing and basically fall into two kinds: waterproof and non-waterproof. The waterproof types can be used to make drawings which can have watercolour paint added later for colour and tone without the ink being removed or smudged. Non-waterproof inks can be diluted (they are generally best thinned with distilled water) and allow lines to be made paler or washes of ink to be used in the drawing.

Extras

You will need a pot of water (drawings using a brush and washes of ink or paint are included in the projects), and something on which to mix the washes. This could be a palette, although a white enamel plate is equally suitable.

Putty rubbers are worth buying in twos or threes – they get put down and lost all too easily.

Drawing materials are best kept in a box. Artists' shops sell these, but fishing-tackle versions are just as good. A variety of boxes can be converted, and a compartmentalized travelling kit can be made out of canvas for working outdoors.

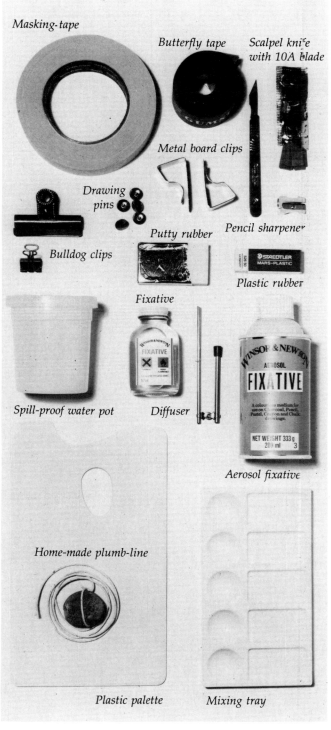

Masking-tape

Butterfly tape

Scalpel knife with 10A blade

Metal board clips

Drawing pins

Putty rubber

Pencil sharpener

Bulldog clips

Plastic rubber

Fixative

Spill-proof water pot

Diffuser

Aerosol fixative

Home-made plumb-line

Plastic palette

Mixing tray

The number of small items an artist can collect is enormous, but these are the essentials you will need no matter what your choice of medium

Supports

Donkeys and easels are not essential, but they are desirable – it is difficult to prop a board on your knee to draw. Even if this problem is overcome, it is necessary to have some means of keeping the board upright. Its position can have a significant bearing on the final drawing. Using a board that lies flat (or almost flat) on the knee gives a foreshortened view because the top of the board is further away from your eye than the bottom, and at an angle. A finished drawing that looks satisfactory while the board is flat may be distorted when it is hung in a vertical position.

The ideal is to have a vertical, or nearly vertical, board and to draw with your arm almost fully extended. A donkey is useful but takes up a good deal of space, and isn't easily portable; it only allows you to draw from a single sitting position.

A radial easel is rigid, takes up less space, and can be used with a chair or stool, but it too is not very portable. The best solution would be a radial easel for indoors, and a sketching easel for working outside. If you prefer to buy only one easel, look for a version that can be used inside and out.

Donkey and drawing-board with folding easel in the background

Radial easel and stool

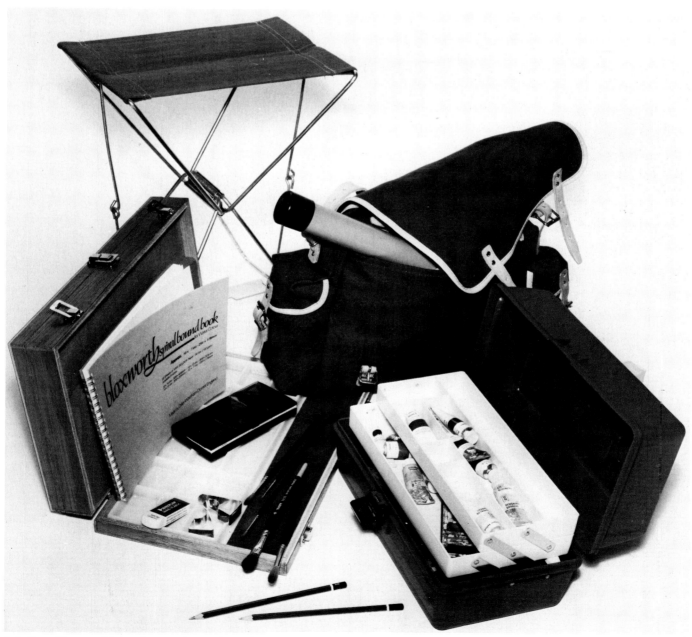

Selection of bags and boxes for carrying equipment

Paper and Pens

One of the best ways to see how different marks are made on various textures and colours is a personal sampler.

Buy a notebook of coloured drawing paper, or small sheets of assorted finishes and tones. Tear off a strip from each one, then paste the strips lightly onto a backing paper. Keep the rough papers on one side, the smooth papers on the other.

Make a small collection of drawing implements. You may use various colours, or concentrate on blacks; in either case, the result will be instructive and interesting. As you draw across the papers, there is a decided change in the quality of line. By lifting your implement in between each strip, you will isolate the marks

and help to make the contrast even more striking.

In the photograph below are papers which have a distinctive, rougher finish. On these the marks take on a crayon-like quality; even the thin lines made by the fine nib look like Japanese calligraphy, with light and dark tones as the pen is moved back and forth.

On the right the same pens and pencils used on smooth, light-coloured paper give a much harder line, charged with energy and bite. Every column is sharper and thinner – even the charcoal and conté sticks are elegant and with very little texture.

When you have finished both sets, compare the marks with each other on an individual basis; the

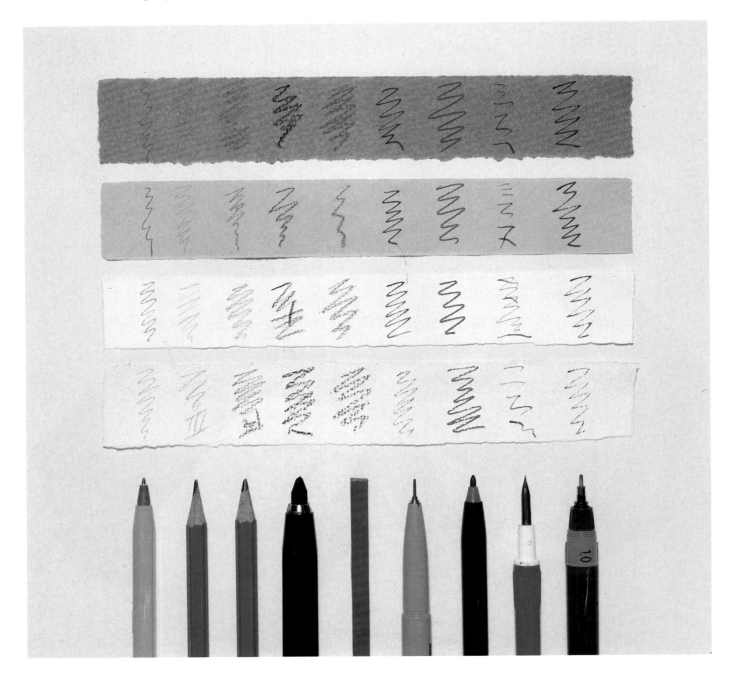

ballpoint sinks into the rough paper, but stays very fine and clear on the smooth. Both pencils are relatively light, but they are nearer to each other in texture on the smooth papers than on the rough. There the soft pencil looks almost like the charcoal next to it. The purple felt tip shows less change from one side to the other, whereas the fine nib line is so light that it almost disappears from the photograph on the right.

You can try the same exercise with different shades of the same colour on one paper, observing how the tones of purple or blue are affected by the surface. But don't get too involved with colours unless you are using pastels; at this stage you should be training your eye in the subtleties of monochrome, and bright colours will only be a distraction.

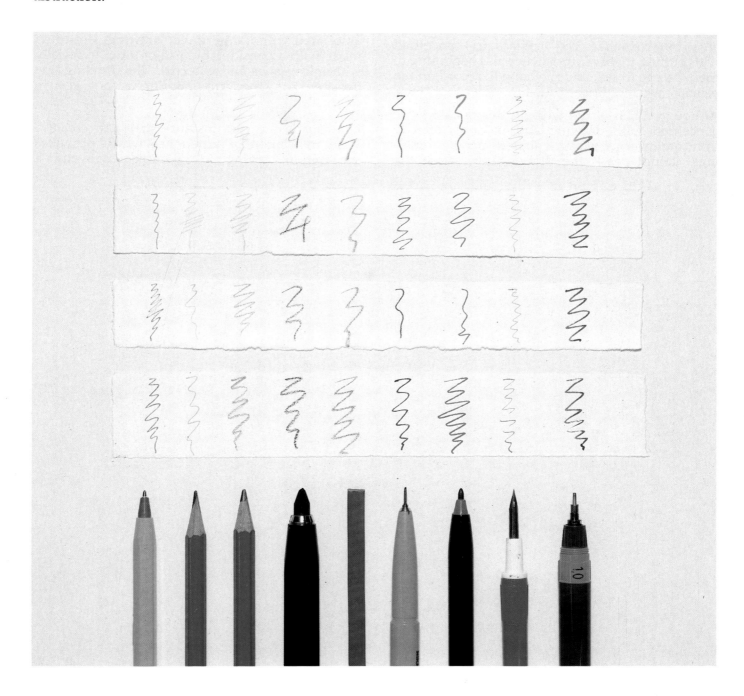

Starting to Work

The Basic Skill

If you can really *see* what you want to draw, you will be able to draw it. If the drawing is vague, it is because your observation is vague. A simplified statement, perhaps, but it is necessary to believe in that first, vital step; anyone can learn to draw, not by studying various techniques but by discovering how to see in a particular, clear way.

The drawing process itself can be summed up in two words: seeing and recording. For the first, you use your eyes intelligently; the recording process is simply a way of checking how effective your brain and eye co-ordination has been. Learning to draw is based on practising these two processes, the foundations for all forms of art.

The notes on perception have shown how the eye and brain work together to translate reality into an acceptable image. This first lesson is concerned with putting theory into practice and beginning to train the eye to see, and the hand to record, in the primary work of linear drawing.

Although much of the work in this book will be concerned with drawing and painting directly from the external world – objects, people, buildings, landscapes – the drawing process is the same if the subject comes from your imagination. You must learn to see your internal world clearly if you are going to be able to record it effectively. Yet looking back at the history of drawing an immediate contradiction seems to appear; even if you see clearly and are able to translate what you see into a drawing, the result will never be a complete copy of reality. This is because we live in a colour-saturated world and drawing is usually conceived as monochrome – objects are described by their shape and position in space rather than their colour. In the lessons that follow you will learn to use watercolour drawings and pastel drawings in many different hues, as well as chalks and conté crayons, to reflect the real world.

The use of tone is another concept that is usually associated with painting; yet drawings are often made with a considerable use of tone, especially with ink washes and charcoal. The dividing line between drawing and painting is not always clear.

Drawing is the true instant art; it can create a vivid translation of experience which provokes the brain into seeing life and movement even in a

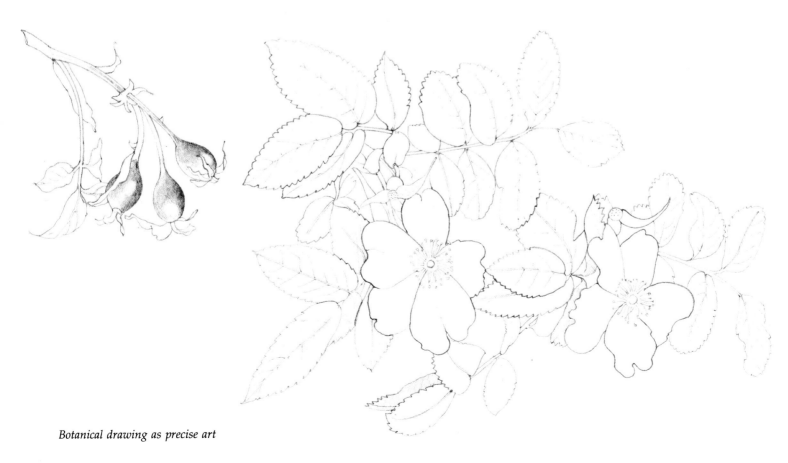

Botanical drawing as precise art

few black outlines on white paper, capturing the shape, the mood, the atmosphere all in just a moment. The other use of drawing is as a tool for the painter: notes made outdoors, sketches of heads or hands, the quick glimpse of a scene through a window, a detail of a dress or pattern to be used as a memo later in the studio.

It is this double virtue that gives drawing its primary place in art. For that reason, you should begin any serious art education with the study of learning to draw.

When students make their first drawings they often think that the major problems are caused by lack of technical skill and information. This is seldom the case! The various lines, textures and areas of tone or shading can all be demonstrated in a matter of minutes. You should master them in a matter of hours.

Pencils, pens and crayons all make marks on paper; what is important is how the marks are used. Practice and use will give familiarity and ease to the hand; the first attempts may feel clumsy, but this clumsiness will disappear once you concentrate on why you are making marks, not how to make them. Another encouraging point for beginners is to remember that drawings need not be neat and tidy, or follow a particular style. An artist like Joan Miró may describe an object with just a single fluently drawn line.

Such working drawings give an impression of intense observation, an intensity which reflects the ability to see in a remarkably vivid way. There are as many ways of drawing as there are artists. The language, the grammar, which this lesson

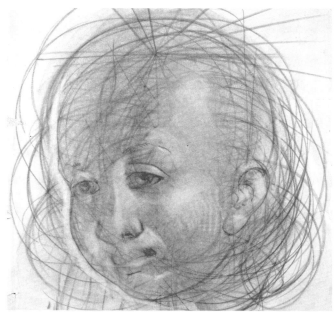

A working sketch of a child's head by Bauer that includes some detail and tone

introduces can and should be translated into an individual style.

The first examples and projects will be easy and straightforward. We will simplify all the possible variations, and concentrate on how to use the various drawing tools. This will also give you an understanding of other artists' works that cannot be gained in any other way. Your appreciation and understanding will be multiplied and heightened as you see how they have tackled the problems which will confront you. Eventually you will be able to use your new experience of the visual world to find exciting and stimulating ways to share your personal vision.

Ink sketch for working

Using Pastels

The use of pastels is a curious amalgam of painting and drawing. Although the sticks are held and worked like charcoal, chalks or conté, they are made in so many tints and colours, and can be used for such subtle shadings, that they have become painters' tools, a kind of powdered watercolour.

The sticks themselves are made of pure pigment, compressed and cut into manageable lengths. In some brands a small amount of gum or resin is mixed with the pigment to help keep the stick's shape. The texture is very soft, and colours can be mixed directly on the paper.

Many artists work with chalk and crayon as well as pastels to add strength and body to the picture. Toned papers are particularly attractive with pastels, but make sure they have a good, rough surface to hold the flakes.

If you make a mistake rub lightly on the paper – but be careful or you will also rub off the texture and leave a shiny bit of surface. For your first projects it will be better to let the lines stand as working marks.

Buy a small box of pastels at first, and experiment simply with making marks of various kinds.

Pastels are extremely delicate, and can be all too easily smudged or blown off the paper. If you enjoy the medium and want to explore it further, various ways of fixing pastels will help to give them durability: spray fixatives, simple pressure over a piece of tracing-paper, or even hot steam from a kettle will help the pigment sink into the tooth of the paper or canvas.

The colour will probably change under any of these processes, and the drawing will lose its fresh, clear appearance. For this reason, although there are pastel studies and projects throughout the book, don't try to produce finished drawings at this stage. Keep the studies for your own use, and use them to learn about space and form, and the texture of dry pigment.

Using a Grid

The best way to understand the properties of the various media is to try them out. The following sections give you an opportunity to do this, and also show how to begin to observe analytically.

Pencil

Most people are readily familiar with pencil, and although it can be very difficult to use, and should be set aside for long periods, its familiarity makes it a good medium with which to start.

The purpose of the following exercise is to show that the shape of even a complicated subject can be drawn if references are used.

You will need paper (a sheet of A3, or A2 folded down the middle of the long side) and a soft pencil (2B). Find a fairly complicated object – a jug or teapot, for example – and put it in front of a grid. For this, use any piece of white card that is bigger than the object.

The size of the squares will depend on the subject you have selected. The grid in the illustration is based on one-inch squares – a larger jug should be set against larger squares, a smaller one

against smaller squares, and so on. Rule the grid in pen and ink so that it will be usable for some time.

Count the squares that go across and down the finished grid.

Now draw another grid, on the drawing-paper. The squares can be smaller or larger than those on the background grid, but you must use the same number.

Draw the outline of the jug or teapot by looking at each square behind the object and copying the shape onto the matching square on your drawing-paper.

Do not rub out. Leave all your attempts to get the outline right. Invariably, rubbing out means you may only redraw the line in the same position.

Charcoal

Now, use charcoal to draw another simple shape. Charcoal smudges easily, so keep your hand off the paper. You will also need to keep turning the stick to find a 'corner' which will give a sharp line. (Some practice may be necessary before you can do this effectively, but sharpening is useless – the point vanishes virtually at first use.)

This time put the same object, or something similar, against a more usual background – a teapot against curtains or wallpaper, for example.

Instead of using a grid, refer to the background, and immediate vicinity, of your subject – curtains or wallpaper, window-frame, table-mat, etc. – in order to draw the shape accurately.

Again, do not rub out.

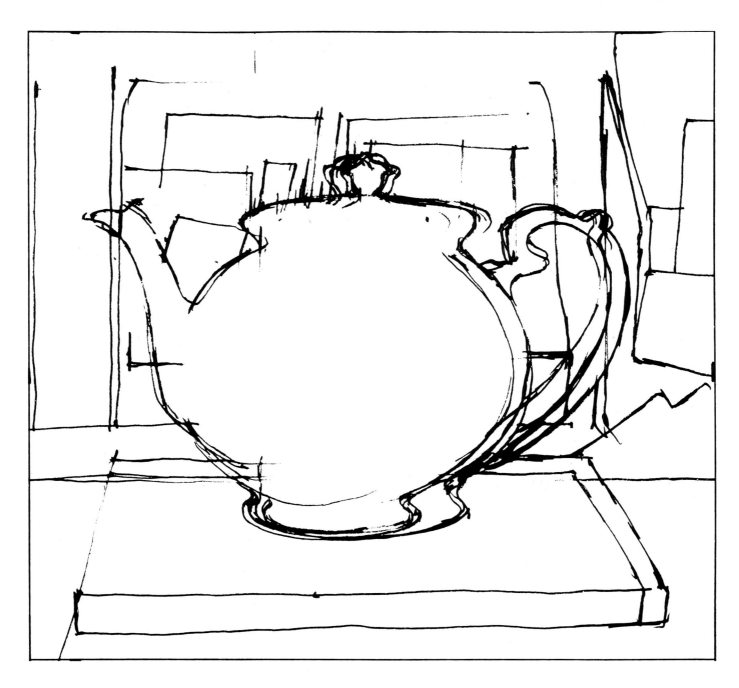

Ink

Inks used with a pen will produce fine or thick lines, depending on the nib. Remove ink from the nib with water, and dry the nib with a cloth when you finish drawing. For comparison with the charcoal drawings, try out a medium-sized nib, and make drawings using any ink you wish. Again, make lines only and draw the shapes of household objects using all available references. Use two objects this time, one behind the other. Do a number of drawings with different inks to see how each produces a different quality of line.

A Pastel Drawing

To make different colours, mix the pastels by rubbing them on top of each other on paper in varying proportions. Experiment by combining yellow, blue and red on grey paper, in the proportions indicated in the illustrations on the left: one layer of yellow with one of blue; one of yellow with two of blue; yellow with an equal amount of red, and so on.

Quite a lot of powder will be left on the paper when the colours have been mixed. This must be shaken off, and the pastel fixed.

When you have experimented with the colours, try making a drawing. This first pastel is concerned only with shapes.

Step 1.

Step 1. Arrange a group of household objects. You will need some bright colours, so choose appropriately.

Use table-mats, and curtains and/or wallpaper for reference for the straight planes.

Make the first drawing in line, using the edge of your pastel and working lightly.

Step 2. This is just a preliminary positioning of the objects so use a light-coloured pastel which will not be difficult to cover as the work progresses. Don't spend long on this stage before moving on to the next.

Step 2.

Step 3. Now fill in the background and foreground. Concentrate on the negative, rather than the positive, shapes. In other words, ignore the objects themselves but draw the outlines of the spaces between and around them and fill them in purely as abstract areas of colour. Decide on the main colour for each area, and mix the pastels to make shades that are simple, clear and flat. Ignore shadows, reflections and slight colour variations.

Step 4. Finally, fill in the objects, again as flat shapes, working carefully around the edges of each area. It may be necessary to fix the drawing at intermediate stages to avoid smudging, but in any case use a fixative at the end. You will need to do more than one drawing before you feel comfortable using pastels.

Step 3.

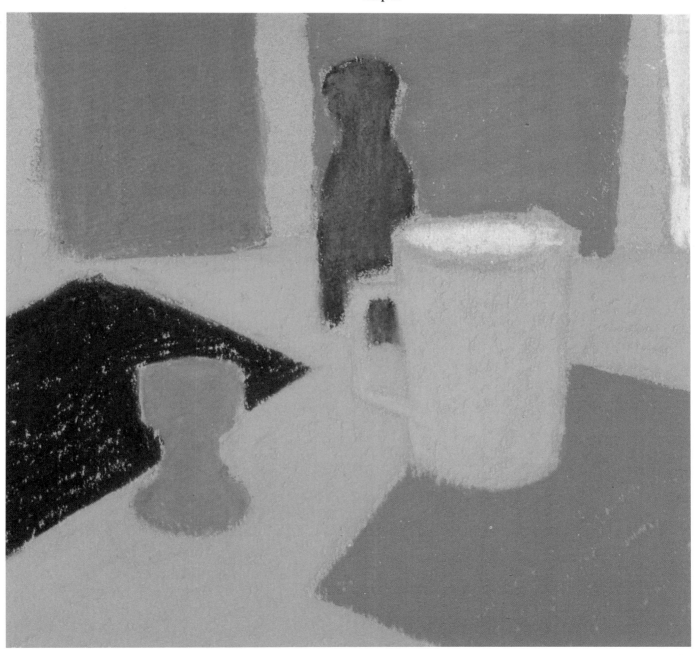

Step 4.

Perspective

Up to now, objects have been drawn only as shapes. However, a fundamental problem of drawing is that of creating an illusion of three dimensions. To a large extent this is done by seeing that objects (or parts of them) appear to get smaller as they get further away. This visual trick of the eye has been developed into a drawing system known as perspective.

Perspective is often regarded as the key to drawing with great accuracy and quality. It is, in fact, simply a device for establishing the scale of objects at different places in space. A mathematically based system, developed since the fifteenth century, it is usually attributed to the Italian architect Brunelleschi.

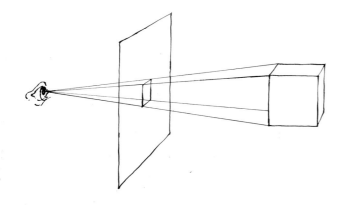

If you look out of a window and trace the outlines of a few outside objects on the glass you will have a good example of the problems of perspective. The illustration, based on a drawing from a Leonardo da Vinci sketchbook, shows how a box would appear between the eye and the subject if it was traced on a flat screen (da Vinci was one of several artists who worked on the development of perspective). Using the rules of perspective means that you can draw without the need for tracing: the picture plane – the flat surface of the paper or canvas – replaces the window.

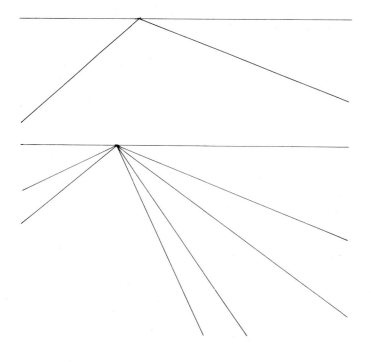

The system is based on two simple rules:

1. Lines which are in fact parallel appear, if extended, to meet at a point on the horizon, called the vanishing point.

2. All parallel lines appear to meet at the same point on the horizon.

To see how perspective works, make a series of drawings of rectangles using a combination of observation and perspective.

Place two rectangular sheets of paper on a table about 3ft or 4ft (about 1m to 1.2m) away so that each has two sides 'flat on' to you. Then sit down and make a pencil or pen line drawing of the shape of the rectangles.

If you want to make sure you can see how the horizon works, use a large sheet of paper on an easel to draw on, and small rectangles (postcards). Otherwise you will almost certainly find that one of the vanishing points will lie off your paper.

Try to assess the angles of the receding sides of the rectangles by eye. Be absolutely honest in your observations. When you have finished, draw an imaginary horizon at your eye-level, and extend the sides of the rectangles until they meet. Be sure to sit on the same chair, at the same level as when you drew from observation. The sides of the rectangles should meet at a single point – on the eye-level you have imagined.

Try drawing from different heights (that is, different eye-levels), again comparing the results of using observation with those using perspective.

The drawings of rectangles and rectilinear solid forms assumed them to be on level ground. This illustration shows what happens if a rectangle is tilted, or propped up at one end as if on a gradient; the effect from the point of view of perspective is to raise the eye-level of the tilted-up rectangle.

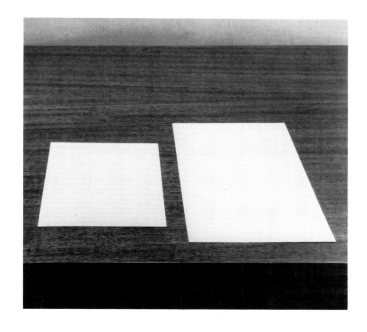

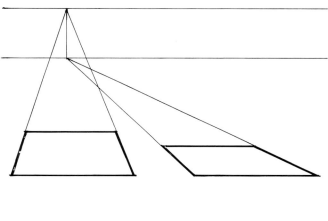

If a level rectangle is contrasted with one titled down, the reverse happens: in effect the eye-level of the former is lowered. Looking at rectangles may seem a cold, geometric approach to drawing, but rectangles form the basis of many subjects.

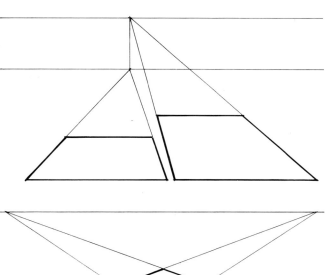

This simple use of a vanishing point is known as 'parallel perspective'. However, while rectangles are the basic components of many objects – buildings are an example – you will not always want to draw them flat on. To cope with corner-on viewpoints, there is a system known as 'angular perspective'.

The illustrations below show the effect of very different eye-levels; and also the extent to which architectural subjects rely on the ability to translate arrangements of rectangles into familiar scenes.

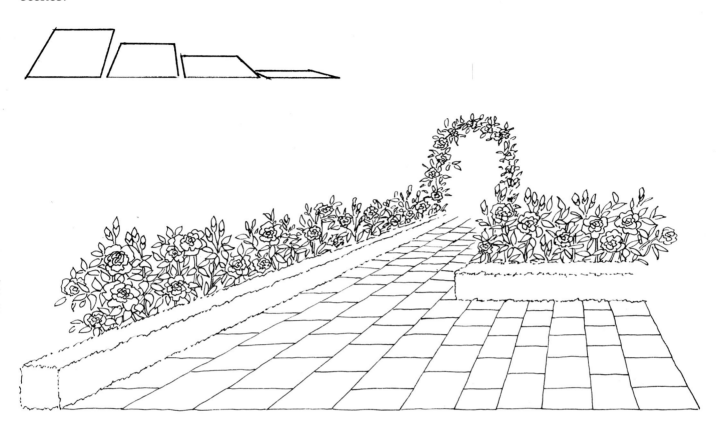

In practice, we often find flat-on and corner-on rectilinear objects in the same drawing.

Now, place the postcards in a corner-on position. Assess the angles and draw from observation. Then insert an eye-level and vanishing points, as before.

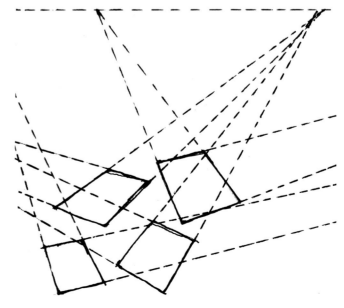

The system does, however, provide some useful checks and references when drawing. For example, if you draw two rectangular buildings side by side, and they seem awkwardly placed, check whether the sides, when extended, show that they were drawn from the same eye-level.

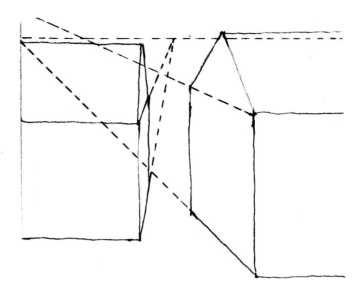

Direct Observation and Perspective

It is possible to draw objects, shadows and even reflections following the various rules of perspective. It is especially valuable if a drawing is made without external references (an architect's impression of what a proposed building will look like, for example); and it is also useful for added figures which could not be drawn from observation, as it will help you to decide on the correct scale.

However, formal perspective is not actuality.

First, the system assumes a spectator with a fixed viewpoint, something that never exists in reality. In practice, head and eyes move constantly, and an artist draws from a number of different points of view.

Second, although perspective can show how identical objects appear to shrink as they get further away, our interpretation of this, when drawing from direct observation, is affected by the size constancy factor. In other words, although perspective may geometrically reconstruct the correct size of a far-off tree, the brain enlarges the tree automatically because it knows it is large in reality.

Perspective therefore relates to what we see, but is not identical to it. It produces technically correct results which are similar to photographs in which distant objects invariably look too small. For these reasons formal perspective is not essential to the artist who works well from observation.

Simple Shapes

Curves and Cylinders

The lessons on rectangles and perspective were concerned with objects that are drawn solely in straight lines. However, many others are based on curved shapes. First, it will be useful to examine the simple, regular, predictable curves which form circles and cylinders.

The illustration compares a rectangle and a circle on a flat horizontal surface. The rectangle (seen flat on) shows its full width, but the depth is optically reduced. The circle also keeps its full width, and its depth is reduced so that it appears to be oval.

The object of this first exercise is to learn how to draw circles seen from different positions. Cut circles out of card (or use discs of any material) and position them so that some are flat and some raised.

Make drawings using a medium you have not tried previously (charcoal, pencil or conté). Draw only in line, and carefully assess how the oval shapes compare with the full circles. Because the cards are in fact circular, the ovals (ellipses) will be symmetrical. It is essential to assess precisely the depth of each ellipse – a step that is all too easily overlooked in the practical difficulty of drawing the curves.

To check that your drawing is symmetrical draw two lines, on tracing-paper, that intersect at right angles in the centre of the circle. Trace the shapes made by opposite segments, and compare them. The more similar they are, the more symmetrical your drawing will be.

Drawing curves demands a good deal of practice and control. A common fault is to make the ellipses too pointed. Remember, in reality the shape is a continuous curve.

When you feel reasonably confident, move on to the next exercise – drawing cylinders, the solid forms derived from circles. These form the basis of many kitchen utensils such as pans and jugs, and wheeled objects. Use cylindrical tin cans or, even better, glass containers. Make sure they are cylindrical, with straight sides and same-sized tops and bottoms. An odd ridge here and there is unimportant, but the sides should not be curved. Draw in line, and use a medium that you have not yet tried.

Now set up a group that includes a solid rectangle (a small box, or a book) that contrasts with the cylinders. Once again, draw in line, and experiment with one of the media that you have not used so far.

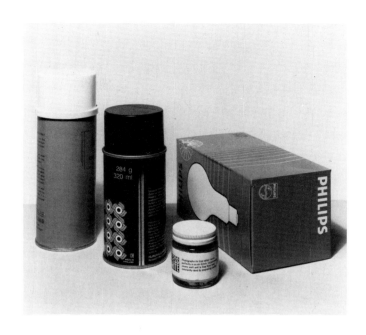

If your viewpoint is above the objects, the bases (of the solid rectangle as well as the cylinders) will seem larger – that is, have greater depth – than the tops. This is often given to students as a rule, rather than a fact of observation. It is most important that you *see* this phenomenon, and don't merely accept the theory. If all the cylindrical objects are cans, it will be best to draw them (and the solid rectangles) as if they were transparent so that the tops and bottoms can be clearly compared.

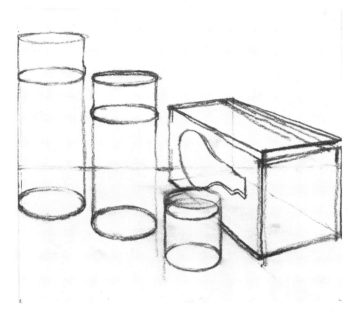

The real problems of drawing cylindrical objects are not presented until the cylinders are laid on their sides.

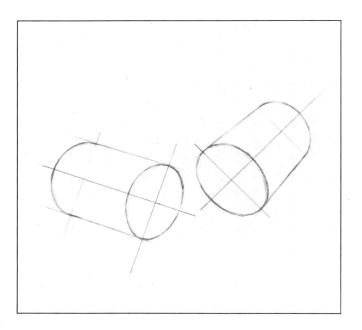

Set up a group using tins or glass objects as before, or cut up cardboard tubes as illustrated. Make a line drawing, preferably with a medium you have not yet tried. By now you will be able to predict that the sides of the cylinders will appear to move closer together as they recede, as happened with rectangles. Another phenomenon is that the circular ends seem to be tilted ellipses. Move one of the cylinders, and you will see that the extent of the tilt depends on the angle at which the cylinder is turned away from you.

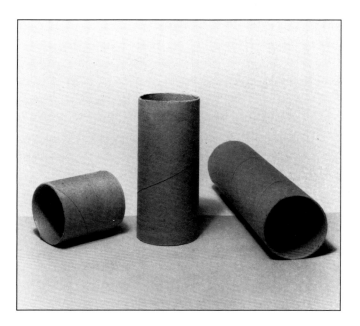

The next visual fact is more difficult to observe but is shown in this illustration: a line drawn through the centre of the cylinder, along its axis, is always at right angles to a line drawn through the centre of the ellipse.

You must see this for yourself. Don't accept it as a rule which will guarantee that your drawings will be correct.

Next, make a line drawing of a clear wine bottle with its cork lying beside it. The bottle is really two cylinders joined together, with a cone shape (also based on a circle) at its base.

Although the theory is simple, cylindrical objects are extremely difficult to draw. Make as many studies as possible of objects based on cylinders: cups, saucers and other household utensils are ideal subjects, and children's toys can offer a real test of observation and drawing control.

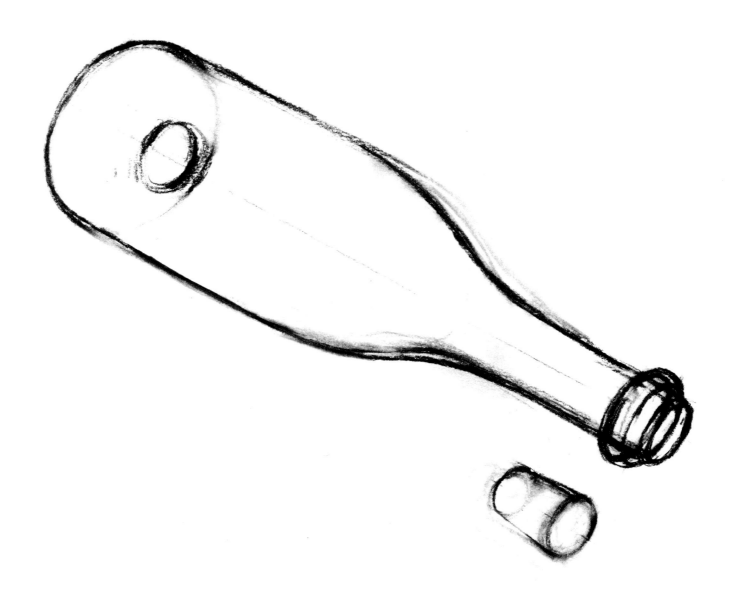

Drawing in Tone

Up to now, exercises have been based on objects that can be drawn with line only. Either they had edges (boxes) or, if surfaces were curved (the wine bottle), flat cross-sections at the top and bottom clearly revealed the shape of the three-dimensional form. Subjects that are without clearly defined edges, or ones that do not give many clues as to their 'cross-section', will set the most difficult drawing problems. A sphere is an obvious example.

A more accessible method which relies less on experience and dexterity is the use of tonal media which naturally create areas of shading. This is a very particular use of the word 'tone', and not to be confused with later examples which will teach you about tonal colour and recession.

For this first, primary use of tone it will be more comfortable and sensible to work with media that respond with one or two strokes; ink wash, charcoal sticks, conté crayons. Try different parts of the sticks with varying degrees of pressure (not too hard or you will break them or crumble the edges) and a few simple ink washes with a thick brush.

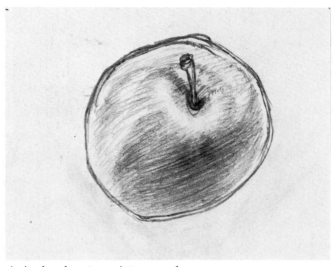

A simple sphere turns into an apple

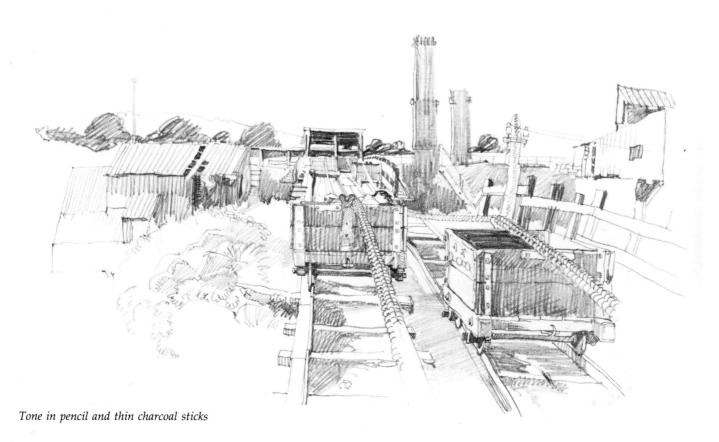

Tone in pencil and thin charcoal sticks

44

'Ship at Sea'; Tekla Torn. Tone in crayons and ink-simple geometrics with very effective results

Drawing in Line and Tone

To familiarize yourself with line and tone combinations, crumple a large piece of white paper so that there are some definite folds, and other areas that are simply crushed. Make drawings from the paper, using line and tone together from the start. Combine a medium you have already found useful for line drawings with either black watercolour paint, or an ink which can be diluted with water. Quite large areas of tone can be laid in quickly with a brush. Wash off some paint or ink to lighten the effect; add more to darken it. Any method of producing tone is perfectly acceptable provided it adequately reproduces those aspects of your observations that you have chosen to record.

Any combinations are possible, and you should experiment: try using a single medium for both line and tone, then all possible combinations. Often it is best to begin with the tonal areas and draw the line later, going on to more tone and more line drawing. There is no correct sequence of events and no correct combination of media. Everything depends on practice, experience and individual preference.

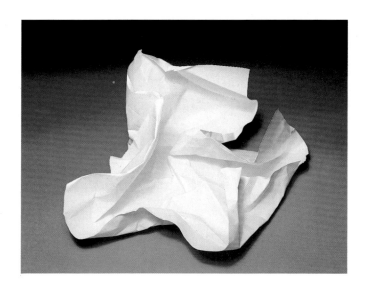

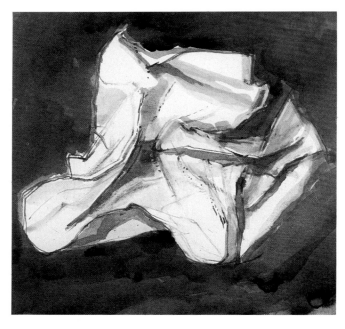

Now set up a group of eggs and table-tennis balls and draw these objects. Be sensitive to the weight of line and tone. Try to disregard everything except the actual three-dimensional form of the spheres. Trial and error are important at this stage. Repeat the exercise until you are reasonably satisfied with the results. As we move away from simple shapes (which can be clearly reproduced) to three-dimensional forms, your ability to be critical of your realization of a particular object becomes more and more important.

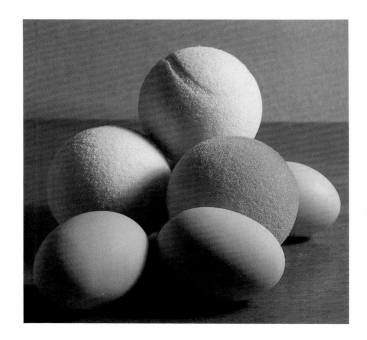

This time, use charcoal or conté for the tonal areas in at least some of the drawings. Make tone by scribbling naturally, which for a right-handed person means making strokes that tilt right from the vertical. Practice will enable you to merge the strokes together – it is not unusual for artists to assist the process by rubbing over the scribbled area with a finger. This must be done with discretion, however, or you may produce a very smooth effect completely without character.

The symmetrical rounded forms of the table-tennis balls and eggs should now be extended to freer shapes. Make a group using pebbles, larger stones, or other three-dimensional forms – oddly shaped balloons, for example, or rounded cottage loaves. Make a number of drawings using line (the choice of medium is up to you) and tone.

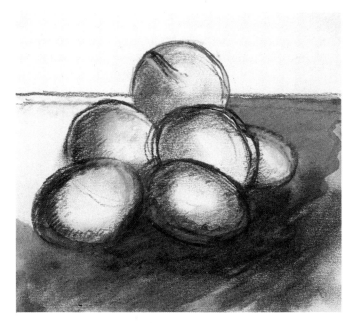

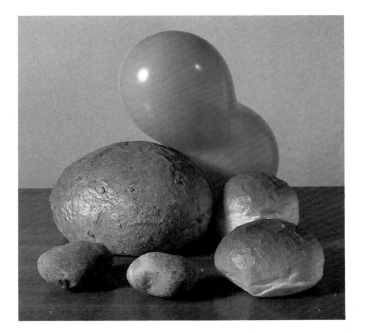

Finally, be on your guard against becoming mannered. It is all too easy to be seduced by the smudges that can be made with a finger; a conté crayon used on its side can produce a flat area of tone that looks almost as if it had been printed. Do not lose sight of the fact that drawing is primarily concerned with seeing and translating.

And don't get so involved in interesting effects that you cease to look at the subject. When you drew with line only, you ignored the colour of the objects and the way the light fell on them. Similarly, tone should be used only to describe what is helpful in translating what you see.

Drawing is a process of selection. What is left out is as important as what is included.

Use of Photography

Black-and-white photographs are useful for recording tone values, lighting effects, and the scale relationship between distant and nearby objects.

However, photography has its limitations. For example, a camera with automatic exposure takes a reading from, and exposes for, the most powerful source of light; taking a photograph of an outdoor scene from inside a room will result in an almost completely black interior. A more sophisticated camera can take a light reading from such an interior, but anything outside will be almost white. With experience you will be able to achieve a balance between these two extremes.

A number of photographs taken with a wide range of exposures will give a helpful series of tonal studies from which to work, and will demonstrate the variety of tonal interpretations available in a single situation.

Colour pictures can also be used, but once again care must be taken with exposure; take a number of photographs ranging from light to dark.

However, you should never work directly from photographs – the artist's eye is essential to a successful study.

A photographic study in perspective

A pattern made by leaves and their shiny surfaces

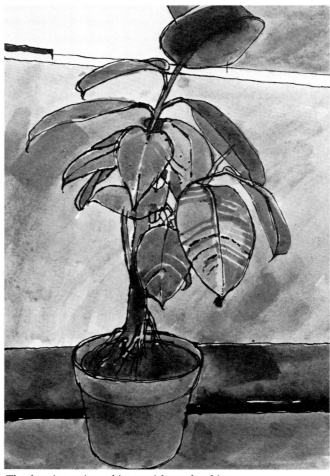

The drawing using white to pick up the shine

A photograph will help to rebuild a difficult or complex set-up

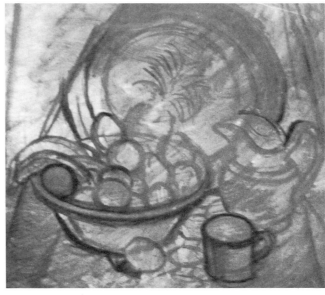

The first drawing from the set-up

Drawing Plants

This exercise – drawing plants in pots – poses the problem of drawing geometric and free forms when contained within one subject. As well as plants, a wide range of other subjects could also bring these elements together. For example, twigs, logs or branches could be combined with wooden blocks and bricks.

Use any medium, but try to explore one in which you have little experience.

It is important first to consider the overall shape of the plants and other objects, and the shapes of the negative areas. Spend a considerable time establishing the outlines of the main shapes before you begin to break them down into pots,

leaves and the other components of the group.

When using tone, contrast the gentle curves of the leaves with the hard edges of the geometric forms. As you reduce the larger areas to smaller details, some of the main shapes may turn out to be wrong after all. Move constantly from small shapes to large ones, checking all the time for accuracy. Don't be satisfied if your drawing is only approximately right: be prepared to change it until you feel it is the most accurate statement you can make at that stage.

Look back at previous exercises in this lesson and call upon earlier drawing experiences to help you relate each object to the others around it.

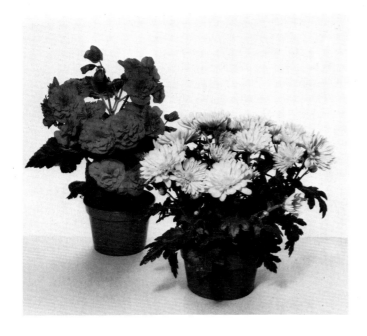

Step 1. Having chosen plants that provide a good contrast in flower shapes and tones, arrange them quite simply on the table. Then, using dark brown conté, draw in the main shapes of the plants and the horizontal line that is the back edge of the table. This line will serve as an important reference for assessing the correct shape and position of the objects. Remember to check the accuracy of the negative areas around the plants; this will help you draw them correctly.

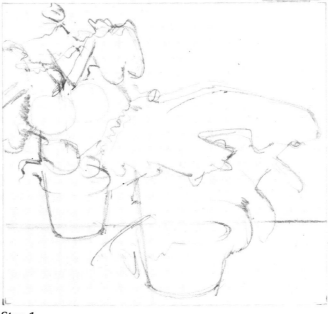

Step 1.

Step 2. Consider the shape of the drawing. If the composition is so simple as to be uninteresting, this can easily be rectified by moving in on the subject, in this case turning the picture area from a square into a rectangle, cutting off one of the plants so that it is merely introduced at the side. Begin to establish tone by indicating the darkness of the foliage and plant pots, using conté and diluted brown and blue ink. With your brush draw in the shapes of the foliage and the flowers in the foreground.

Step 3. Carry on developing the detail seen in the flowers, using white conté and pen and ink in addition to the other media. But take care not to put in so much detail that the simple shapes are lost and their three-dimensionality smothered in a sea of brush-strokes, pen lines and chalk marks.

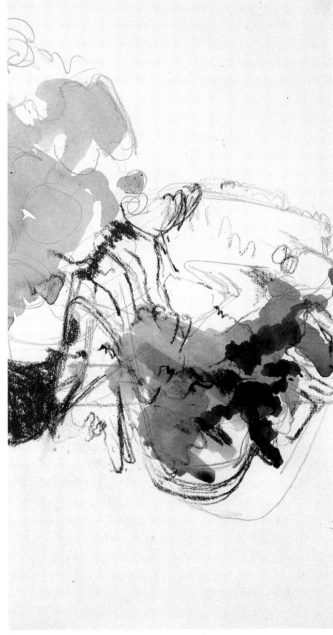

Step 2.

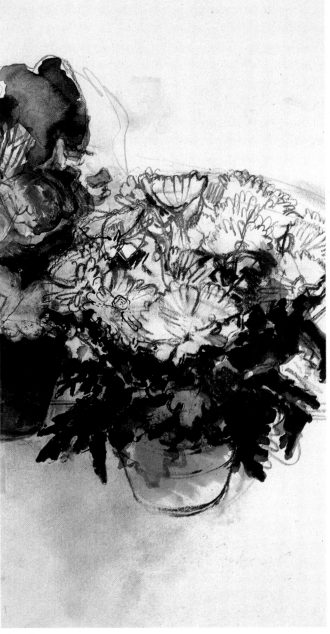

Step 3.

Looking at Drawings

To understand the three forms of art in this book – drawing, watercolour and oils – it is necessary to look for their different qualities, and different aspects of technique and observation. This will not only help you in your progress as a painter, it will also increase your pleasure in, and appreciation of, the work of great painters and draughtsmen.

Drawings are fundamental tools in almost all the fine arts; even sculptors usually work from them. But drawings as finished works in their own right are less popular than watercolours or oils, among new artists and casual museum-goers. Compared with a roomful of glowing Impressionist paintings, a display of black-and-white drawings seems to fade into insignificance. Nevertheless, if you take the trouble to learn how to look and what to look at, a drawing can have more freshness, substance and imagination than a painted rainbow.

The purpose of all art is to fill our eyes and minds; to make a statement from one creator to one viewer, a private conversation which must be respected, and encouraged. Go to a gallery or museum with an open mind. That first, fresh glimpse, without any preconceptions of what you are going to see, is unbelievably precious.

Find a quiet room (happily, most drawings are hung in small side galleries) where you know there are works by Dürer, Rembrandt or Degas – any of the great masters. Select one that you find attractive.

Look at the drawing without trying to see too much. Let its imagery sink in gently, and your mind wander around the subject – a flower may remind you of one in your garden, a portrait may look like someone you know. Stroll around the room and look at other works, but keep coming back to the first drawing. Then leave. If possible, leave the building and let the drawing remain in your mind until a second visit – all art is a matter of selection, and too much at one time will simply leave you overwhelmed and over-stimulated. If another visit is inconvenient, go to a totally different exhibition in another room, have a drink or a snack or look through the museum or gallery bookshop. Think of something else for half an hour and allow the drawing to make its point without effort. When you return for a second look at 'your' drawing, make a study of what you see.

We already know, of course, that art cannot be separated into 'line', 'colour' and 'composition'. They are all combined in the final work. But it is possible to determine how the work achieves its effect by relating all the components. Understanding that relationship is what is meant by perception – the art of observation.

Begin with the atmosphere. Perhaps you have chosen a quiet landscape, or a still figure. All the lines in the landscape will be soft and gently curving, the attitude of the figure will be calm, the hands and feet at rest. The overall pattern of the composition will follow naturally: long lines of field and hill in the landscape, without sharp cliffs, barely sketched-in clouds – a feeling, even in black and white, of quiet sunlight, dawn or dusk. The lines of the figure also suggest rest and serenity; the face is without much expression, the clothes or drapes loose, as relaxed as the figure itself. There is a sense of order. Now look at the tones. Seldom stark black and white, they are more probably soft charcoal or pencil on a grey or tinted paper; the shadows merge, tones are indistinct where they blend from light to dark.

Look closely at the details and see whether each line is short, or whether it curves around a large area. Observe how a fold of drapery, a tiny smile at the corner of the mouth, add to the effect.

Above all, look for the technique used to create the illusion of depth and three-dimensional solidity. Drawing has to depend on the quality of its basic tone and line for perspective – there are no blue colours to lead the eye to distant hills. Did

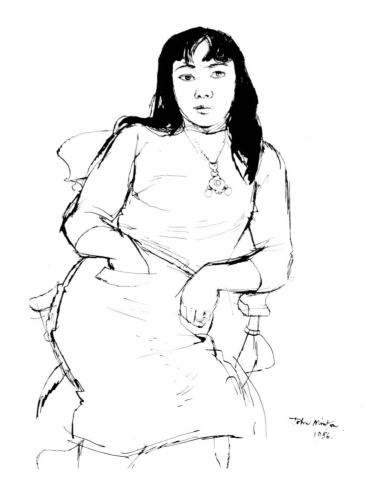

Portrait by Minton

the artist use a smudgy thick pencil or a faint thin line? Is there a change in scale – a nearby flower is ½in. (1.25cm) high, a distant church steeple the same measurement? Depth can sometimes be created with thick strokes in the foreground and thin ones in the background.

Look for a nearby contrasting drawing – one filled with spirit and motion. Compare every aspect of this picture with the first.

The movement in this second picture was probably created by a fast-moving hand. Strokes were applied quickly, almost as though the artist was impatient to get everything down at once. You can often see tiny drops where the ink spattered from the nib of the drawing-pen. Details are probably few, and not very distinct. A face is an outline, an eye a simple stroke.

Take in everything you can in a reasonable period. You will do better, and learn more, from three or four short visits than from a long, weary afternoon. Remember that art is a form of visual communication between the artist and the viewer; you need time to understand what you have seen. Some drawings will be forgotten before you reach the museum door. A drawing by a master will stay clear and distinct in your memory for years – perhaps even for a lifetime.

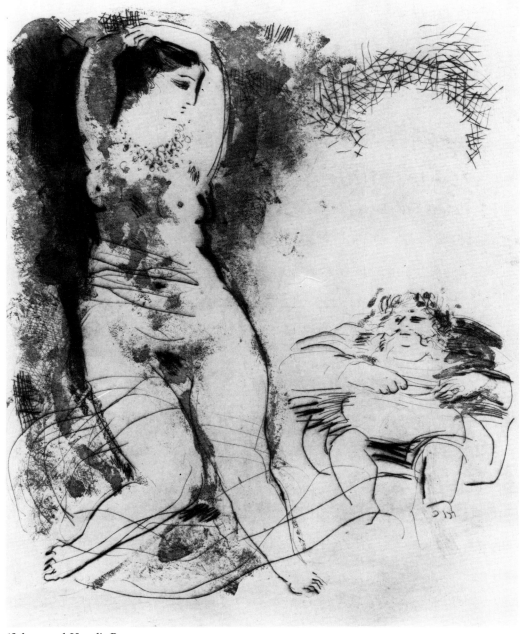

'Salome and Herod'; Bauer

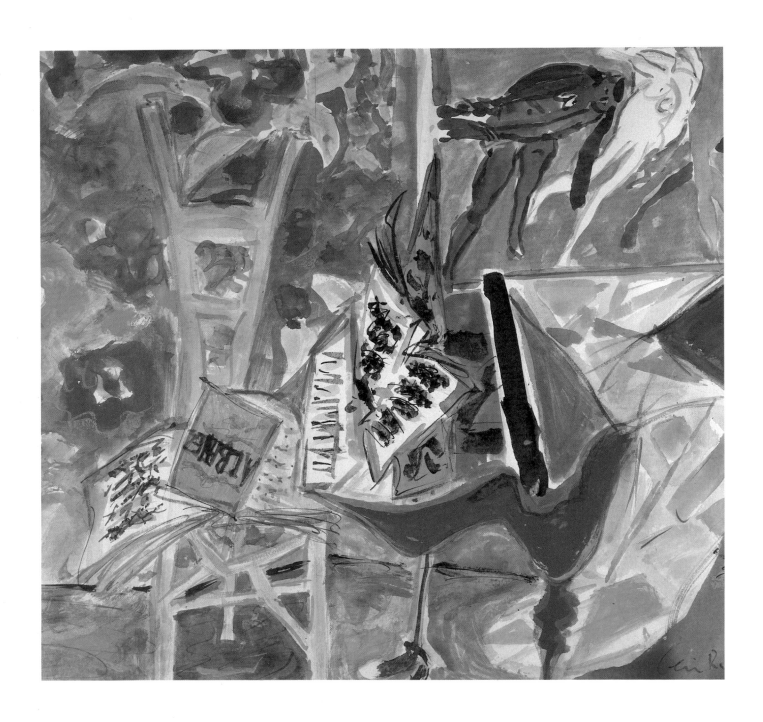

Watercolour from 'The Music Series'; Richards

54

Lesson Two
Watercolour

Watercolour has a curious history. Today it is sometimes regarded as a less important medium than oils, but mixtures of pigment, fixative and water have been used throughout the history of painting. There is always a debate about how the early cave paintings were made, but many historians believe that they were drawn with ground rocks and clays mixed with water.

Frescoes were a favourite form of painted decoration for many pre-Christian civilizations. Purified lime was used to fix the pigment on the damp plaster. Artists had to work quickly and with a sure hand; there was no way of correcting mistakes. Provided the wall, ceiling or other surface is kept in good condition, fresco paintings can look as fresh now as when they were first made. Their transparent effect and soft, pastel tones are typical of many water-based media. During the classical period, frescoes decorated temples and private and public buildings. Wall-painting continued for many centuries, and frescoes were still popular in the Renaissance, not only in churches but in homes and pleasure houses of all kinds.

Gouache is made from opaque pigments, ground in water and thickened with gum and occasionally honey. It was sometimes used with fresco paints for highlights.

Tempera was a similar development, blended with egg yolk or oil. Both gouache and tempera were commonly in use by the eleventh century, and pure watercolour could not match the depth and richness of their opaque colouring. This was particularly important when medieval illuminators started to use gold leaf, which will not blend with ordinary watercolour; many manuscripts are basically in watercolour with some gouache or tempera added with the gold.

Eastern painters were more conservative, and their finest work was, and is, reserved for watercolour on silk. Examples date from as early as the third century; because they were painted on scrolls and rolled up in protective containers, they have survived in perfect condition. The Chinese masters were concerned with symbolism and meditation; their brush-strokes were freely drawn, but they were meant to inspire philosophical reflection on other arts: poetry, imagery and earlier well-known paintings. The greatest artists attained an incredibly high degree of skill with the brush, and managed to describe the beauty of the physical world with a spiritual vocabulary. Watercolour is the perfect medium for such delicately balanced work. Simple washes can be used to build up a very complex surface, full of shifting shadows. The feeling of depth and perspective is the result of layers of paint, drifting quietly away to a subtle glimmer of colour for the background.

The supreme period of painting in China and Japan was from about the fourteenth to the eighteenth centuries, the very time when oil paints had arrived in the West to dominate Western art for centuries. Large studio paintings were becoming more and more fashionable, replacing frescoes and panels in churches as well as palaces and palazzos, and watercolour fell into disuse as a serious medium. Many of the painters we associate with huge masterpieces in oil actually used watercolour continually – but for themselves and their on-the-spot sketches and studies. Albrecht Dürer (1471–1528) painted nature studies in watercolour; there are also many small sketches by Sir Peter Paul Rubens (1577–1640) and Sir Anthony van Dyck (1599–1641) among others – proof enough of the enduring and appealing qualities of the medium.

Towards the end of the eighteenth century, what is widely known as the English School developed techniques using watercolour for the best expression of land- and seascapes. Of course other artists all over the world were working towards the same goal, but nowhere else were there so many supremely successful examples which can still be seen today.

Virtually every style and mood can be found: hot summer days, cold winter nights, storms at sea and calm spring dawns – all the seasons of the year are captured for us to enjoy and admire. Although some English painters such as Thomas Gainsborough (1727–88) and John Constable (1776–1837) used watercolour primarily for studies and quick sketches, others chose the medium to re-create their love of nature and the grandeur of the picturesque; Paul Sandby (1725–1809), John Crome (1768–1821), Thomas Girtin (1775–1802) and John Robert Cozens (1752–97) all

'Street'; Vuillard

'Bromley Garden'; Snow

experimented with individual styles and methods. Girtin's work is particularly interesting; he used a very limited palette of five colours, creating depth and tone with washes of thin paint which were allowed to dry before being overlaid with fresh washes, repeated until the picture was complete. This can be a useful exercise for new artists as it explores every facet of the material, and uses different surfaces to create textures and highlights.

Joseph Mallord William Turner (1775–1851), John Sell Cotman (1782–1842) and Richard Bonington (1801/2–28) are easily appreciated. Their more impressionistic techniques were considered revolutionary in their own lifetimes, and yet they are obviously fundamental to the classic modern school and, in Turner's case, are very much a part of the history of abstract art.

Paul Cézanne (1839–1906), also a master painter by any standards, and in many media, used watercolour in an astonishingly direct way. His water-drenched pots of geraniums, swaying trees and distant mountains seem to have been painted literally yesterday, but are in fact a version of Girtin's many-layered washes.

During the past few decades, contemporary watercolours have suddenly achieved considerable esteem. We have found new ways of admiring the freshness and lightness of flower studies, for designs and illustrations as well as paintings; it should be remembered that botanical and wildlife artists have almost always preferred to paint flowers, animals and birds in watercolour because of its ability to portray the subtlest changes in tone and texture. Sketches and finished watercolours are popular again, for all kinds of subjects.

Prosaic though it may seem, the size of modern homes has also affected our interest in art. While many famous paintings of the past are far too large, even as reproductions, to fit comfortably in a living-room, watercolours are usually small in scale – perfect for giving the greatest amount of pleasure in the smallest possible space.

Above all, watercolour has become deservedly popular with the growing number of leisure artists who prefer the spontaneity of light, fresh colours and the sense of movement they can achieve with a simple box of paints, a brush, and a glass of water.

From Drawing to Painting

Modern water paints are often lighter and more 'impressionistic' than oils and have frequently been neglected by those serious artists who concentrate on large pictures and portraits. In fact, they are a flexible and interesting medium for realizing ideas in colour and wash, with a special quality of spontaneous and airy brushwork.

The words 'drawing' and 'painting' are often used interchangeably for watercolour. In a strict sense, there is a difference. A drawing implies the use of a brush and paint to draw a line picture, while a painting has wash and tone, in much broader areas. Most artists combine both methods, mixing line and wash to produce a single image without the distinct outlines often seen in oil paintings.

As a beginner you may find it useful first to draw in the composition very gently with pencil, but don't come to rely on this too much, or you will miss the fundamental delight of the medium – allowing the colour itself to describe the subject-matter.

It is this very fresh sketchiness which has given watercolour its reputation for being a difficult medium. However, the technique is well within the capabilities of any student who takes a little time and effort to understand the materials, and the basic rules for using them well.

An essential binding agent is added to a mixture of pigments and water so that when the water evaporates, the dry paint is fixed to the surface instead of becoming powdery and flaking away. A variety of binders has been used in the past: gum arabic, various kinds of glue, casein starch, glycerine, egg white and even honey. Today, chemicals are used to produce new mixtures such as acrylics, but the exercises in this first lesson concentrate on the traditional transparent washes of watercolour.

The greatest problem with any kind of watercolour is its lack of opaque covering power. Once the paint is on the paper, it cannot be painted over or easily erased, and new students worry about making a dreadful mess, which seems to get worse and worse. Take a bold approach; after all, painting should be a pleasure as well as an art. Think about what you want to achieve, mix the colours that please you, and use the brush directly and simply, with confidence and a relaxed grip. It will be enjoyable, comfortable, and very successful.

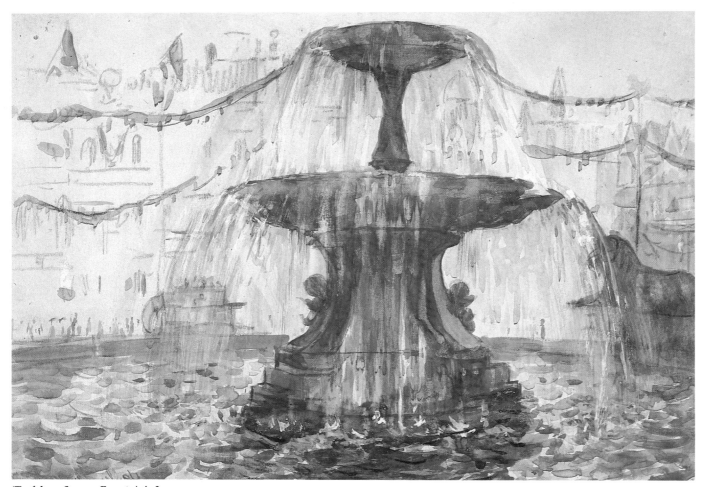

'Trafalgar Square Fountain'; Lever

The paintings on these pages illustrate the basic approaches to watercolour painting in the modern artist's vocabulary: studies for use in other paintings, and finished work for the gallery. The sketch opposite, by Haley Lever, the well-known marine artist, was painted in 1903 on a visit to London. Most of Lever's work features water and harbour scenes of New York and New England, and although this delightful sketch was made in the middle of a city his fascination with water made the fountain a focal point.

Appropriately for this lesson this is a study for a large oil painting, recording just the background buildings, which are barely visible. The texture of the falling water and the colours in the fountain pool itself are carefully developed.

The abstract painting on this page, in watercolour and acrylics, is in direct contrast, a very controlled and well-thought-out studio work by Michael Tilson. It was drawn first, then filled in along the geometric divisions used by the artist to explore different textures and colours. Every part of the painting is finished, and the qualities of opaque acrylics are deliberately set against the dry-brush watercolour technique in the central area.

If you compare the two paintings you can see how varied watercolour can be, even within the limita-tions set by the medium. The sketch is traditional in being light, 'open' in feeling, and fresh – even though it was painted over fifty years ago. The abstract was painted in the 1970s; today the geometric patterns might have been filled in with acrylics, but they would have lost the slightly transparent appearance that is obvious even in the 'solid' areas.

Most important of all, you must learn to disregard the suggestion that watercolour is a difficult medium or, conversely, that it is suitable only for genteel country ladies with sketchbooks. Never try to impose such restrictions on any of your tools; they will work for you in almost limitless variety as long as you treat them with respect and imagination.

'Abstract No. 3'; Tilson

Materials

The quality of the materials you use will determine the ultimate success – or failure – of a painting. Always work with the best possible paints, brushes and paper, in order to achieve the best possible results. This even applies to sketches and studies. Inferior paper, for example, blurs the effect of all your brush-strokes and muddies the surface of the paint.

Young pianists are often discouraged and disappointed if they start their lessons on a cheap, tinny instrument, and may decide there is no joy or pleasure in music. Artists can be discouraged in the same way.

Try this experiment. Buy a sheet of poor quality cartridge paper or a so-called 'artist's pad', a cheap camel-hair brush (the softer the better), and a tube of student's blue watercolour. Mix the colour with water, and cover the paper with a blue wash, following the guide on page 70.

Next, buy a sheet of heavyweight, handmade watercolour paper with a very rough surface, a small tube of artist's ultramarine watercolour, and a large, fine quality sable brush. Again, cover the paper with a blue wash. When both versions are dry, pin them on the wall; you will see the difference immediately.

Repeat this experiment with different papers, brushes and colours, remembering that quality is not synonymous with costliness; while cheap materials are seldom good to use, some expensive versions are sold at inflated prices.

There are many ways of making economies with the odds and ends of a painter's studio. Eventually you will find which materials suit you best, and which are most appropriate for a particular subject or style.

Buy the finest quality equipment you can afford, and take good care of it. The results will be worth both time and money.

There is simply no way that you can achieve the distinctive crispness or clarity of true watercolour without the right materials.

Brushes

The best brushes for watercolour painting are made from pure sable, normally with a round ferrule. Though expensive they are sensitive and manageable – colour can be persuaded to go exactly where you want it – and much longer lasting than cheaper versions. A sable will cover large areas, yet, because it comes to a clean, sharp point, even a large brush can be used to paint very fine detail. It can also be more sensitive and effective than a pencil, chalk or pen for making precise, accurate drawings.

A large selection of sizes is available. Start with No. 3, No. 5 and No. 7.

A sable, squirrel or camel mop is normally used for washes. Because these big, square-ended brushes retain a large amount of colour an extensive wash can be laid quickly and evenly. Although such brushes are expensive, this is one time you can economize wisely; a 1in. (2.5cm) decorating brush, available from hardware shops, is just as effective. It will give an even covering of colour, will improve with use, and should last for years.

To make painting easier, always use the largest suitable brush for any given application, as it will hold more colour than a smaller version.

Washes can be laid successfully with man-made fibre brushes, which have recently improved in quality. However, they do not come to a fine point and you will find them most useful for covering larger areas; details are more easily handled with the natural hair brushes.

A Few Special Brushes

Experiment with all kinds and types of brush to extend your experience and understanding. Eventually, as you develop your individual approach to watercolour, you will settle on a few brushes which are suited to the particular way you paint, and which you find comfortable to hold.

In the past, watercolour and oil brushes were much longer. Sable versions, called 'writers', 'liners', or 'one stroke', are still used by signwriting artists, and often come in genuine quills. Using one of these will give you the feel of a long

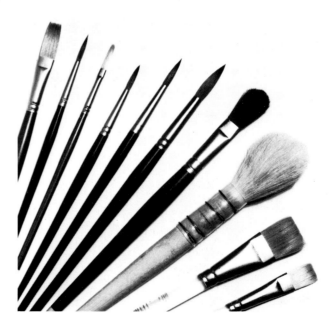

brush – and also increase your appreciation of historical examples of brushwork.

Long hog-hair brushes are useful for large watercolours, and some artists use them exclusively. They must not be confused with hog-hair brushes for oil painting.

Japanese and Chinese brushes, made of soft hair with cane handles, are also useful. Basically writing instruments, they are not designed for making large areas of wash, and should be used upright like a pen for drawing fine, sensitive lines.

Care

Keep brushes clean, dry and protected. After use they must be washed in clear water, shaken, and shaped to a fine point, then placed in a jar, hair uppermost, to dry at room temperature. They will be ruined if you leave them standing hair downwards in a jar, even if it contains water.

Some kind of protective case is essential when brushes are carried for outdoor use. If they are left loose in a box they will move about, damaging the hairs so that they are no longer capable of fine work. Specially designed brush boxes are available. Alternatively, make your own holder with two pieces of stiff card or thin wood about 2×10in. (5×25cm), larger if necessary. Fix the brushes to one piece with rubber bands (taking care not to touch the hairs); use the other as a cover, and hold them together with more rubber bands.

The illustration on the right clearly shows good and bad ways of storing brushes. The black sable leaning against the glass will be out of shape and distorted within a week or two, no matter how expensive it was. Aside from the waste of money, such poor treatment is bad for your painting; lines will be uneven and spattered around the edges, the hairs will stick out at odd angles and trail paint by the side of your intended brush-strokes, and all your work will look clumsy and amateurish.

By contrast the inexpensive squirrel brush, also illustrated, will last for years and years because it is stored neatly on a piece of backing to protect the hairs, and carried in a brush tube when you work outdoors.

An ample supply of water for cleaning brushes and washing out colour washes is always necessary. Clean your brushes as you work, always giving them a good shake in a pot of clean water every time you change paints, or the colour on the brush will mix with the one you want on the paper, and the paints in your pans will be contaminated with other colours.

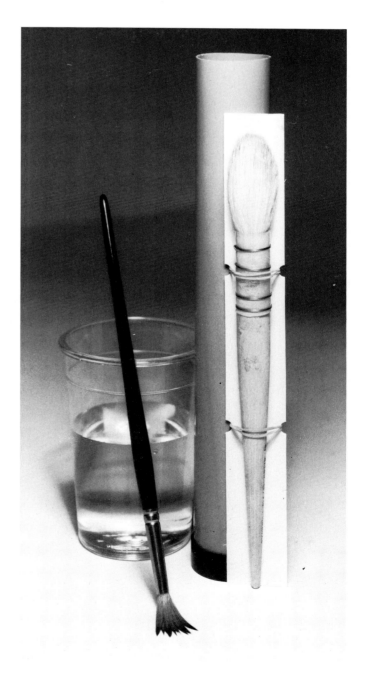

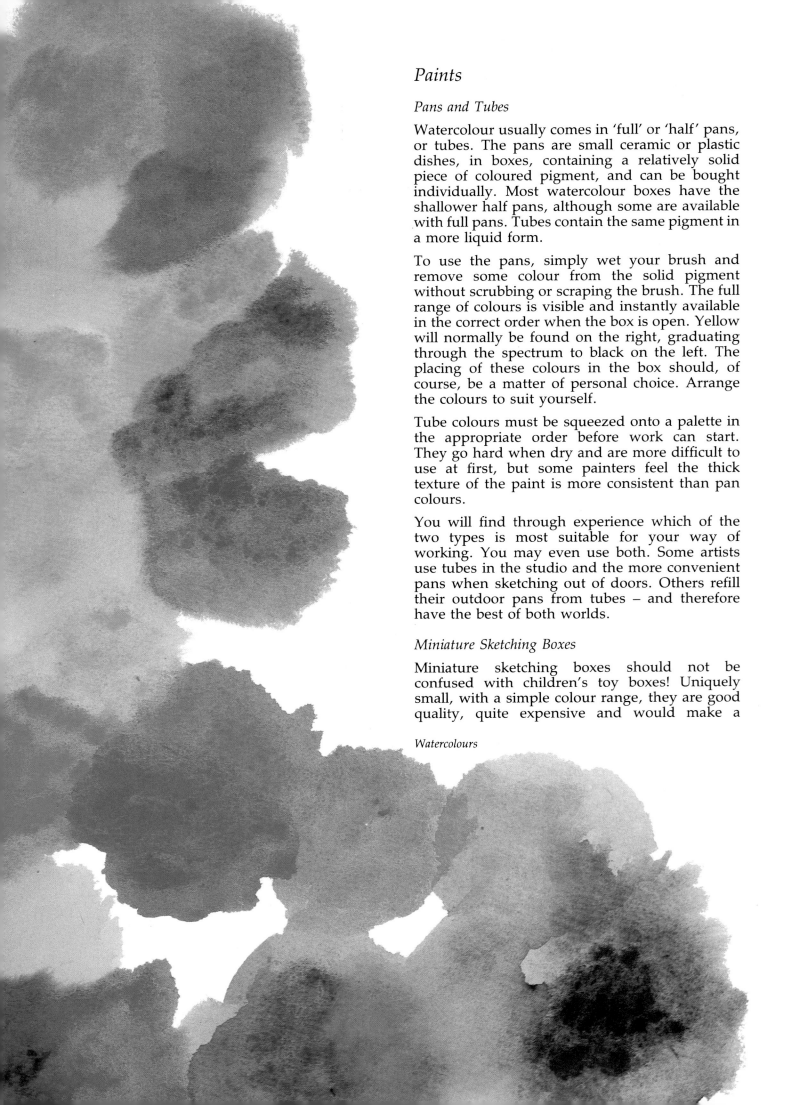

Paints

Pans and Tubes

Watercolour usually comes in 'full' or 'half' pans, or tubes. The pans are small ceramic or plastic dishes, in boxes, containing a relatively solid piece of coloured pigment, and can be bought individually. Most watercolour boxes have the shallower half pans, although some are available with full pans. Tubes contain the same pigment in a more liquid form.

To use the pans, simply wet your brush and remove some colour from the solid pigment without scrubbing or scraping the brush. The full range of colours is visible and instantly available in the correct order when the box is open. Yellow will normally be found on the right, graduating through the spectrum to black on the left. The placing of these colours in the box should, of course, be a matter of personal choice. Arrange the colours to suit yourself.

Tube colours must be squeezed onto a palette in the appropriate order before work can start. They go hard when dry and are more difficult to use at first, but some painters feel the thick texture of the paint is more consistent than pan colours.

You will find through experience which of the two types is most suitable for your way of working. You may even use both. Some artists use tubes in the studio and the more convenient pans when sketching out of doors. Others refill their outdoor pans from tubes – and therefore have the best of both worlds.

Miniature Sketching Boxes

Miniature sketching boxes should not be confused with children's toy boxes! Uniquely small, with a simple colour range, they are good quality, quite expensive and would make a

Watercolours

useful and exciting addition to your normal range of equipment if you intend travelling light. They usually contain a folding brush; some models even incorporate a water container and are especially useful for outdoor sketching, or when travelling abroad.

This little box and a small pad of good watercolour paper is the only equipment needed – and both will fit into a coat pocket.

Gouache and Acrylics

So far, this lesson has concentrated on watercolour in its pure form. However, other amalgams also use water to spread the coloured pigment. One of the most popular is gouache, which has a mixture of white opaque pigment and is sometimes called 'poster paint' or 'body colour'.

Gouache is an extremely useful medium for some purposes, and is often twinned with watercolour although the two methods of painting are very different. Much denser than watercolour (which produces a transparent effect), and with a high saturation of pigment, gouache can be used for thin washes but is better suited to covering an area with an opaque layer rather like oils. Its great advantage is that white can be added to another colour to achieve a desired tint or can be painted over other shades, which is impossible with pure watercolour. Many artists have used gouache to highlight parts of watercolour paintings instead of washing out, and it is quite useful for adding solid opaque white to the clouds in a landscape, perhaps over a light blue-grey wash. Dark opaque colour can be added to the foreground for sharp details.

True poster paint is even thicker and more opaque than gouache and can produce very even, solid colours. It has a curiously dull quality, and tones become lighter as the paint dries.

Acrylic pigments, mixed with polymer resins for binding, can be used with water. The binding material is a plastic and acrylics therefore become waterproof when dry.

They are generally used in the same way as gouache or oil paints, and produce similar results. An advantage is that it is possible to paint one colour over another without 'lifting' the previous dry layer – the binder that holds the pigment to the paper is more effective than in watercolour paints.

Always make sure your brushes are well cleaned immediately after use – once the paint dries it is not easily removed.

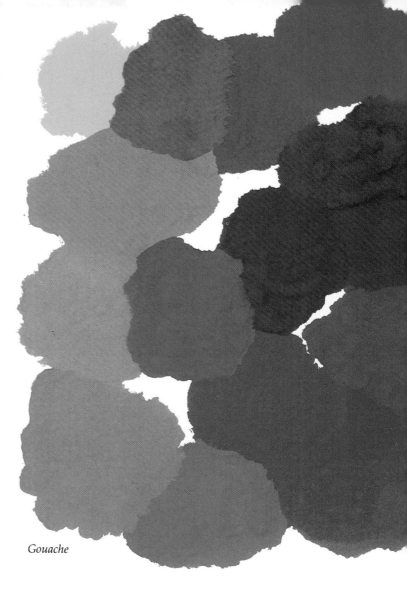

Gouache

Acrylics

Papers

Paper is naturally of prime importance. It is the basis of a painting, and quality and type should be appropriate to both technique and subject.

Paper is made by mixing a fibrous pulp with water, which drains away to leave a layer of fibres that interlock and form a sheet as they dry. A wide variety of material can be used: wood, straw, bamboo, jute, manila, hemp, cotton, etc.

The finished sheet should be strong and durable. Its characteristics and qualities will depend on the type of fibre, size, and whether ingredients such as china clay have been added.

'Handmade' or 'mould-made' cotton rag papers are expensive, but are by far the finest available. For the former, the papermaker agitates paper pulp liquid on a fine wire tray until an even layer of pulp is formed. This is then drained and pressed by hand. The same quality of pulp is often used for mould-made paper and the process is similar except that it is done by machine and not by hand, and the paper is therefore cheaper to manufacture. There is little loss in quality, but the finish and texture may be smoother.

Cotton rag paper is not easy to find – clothes made from pure cotton are not always available to use for rags, and papermakers have some difficulty in finding the quality and quantity that they need. Man-made fibres are extensively mixed with cotton these days and it is impossible to separate the fibres for the manufacture of paper.

There are three main grades of paper surface:

NOT press – Rough with a very uneven textured surface. Difficult to use at first, it repays persistence as it has enormous potential, especially for large pictures.

Cold press – A medium grade of texture, and the most popular for watercolour.

Hot press – Extremely smooth. The better quality papers are almost like sheets of glass.

Generally, a small picture is painted on smooth lightweight paper, and a large picture on rough heavyweight paper. However, some artists use rough paper for small studies, while others paint only on a relatively smooth paper, regardless of size. Try them all for yourself.

The very wide variation in texture between, at the top, NOT press and, at the bottom, Hot press

Toned Papers

'Toned' or lightly coloured papers are a useful addition to the normal white. Greys and blues especially were used to great effect in the past, with highlights such as white clouds in white gouache paint and chalk. Try all the various tones. You will see how the colours are muted by the shade of the paper.

Toned papers for watercolour come in sepia, grey and blue, as well as various shades of cream

Stretching Paper

Most individual sheets of paper have to be stretched before you use them, to prevent wrinkling as the paint dries. The procedure is not difficult and can be quickly learnt.

All paper has a front and a back, so first make sure that the front or working surface is uppermost. Hold the sheet up to the light. The watermark or writing, usually the maker's name or the name of the paper, will be visible if the front is towards you. If there is no watermark, look closely at both surfaces. The front has an even regular texture, while the back is often smoother, with slightly more shine, and shows a slight mechanical pattern. The distinction between the two is readily apparent in good quality paper, but can be seen in any sheet. Check this in a commercial sketchbook or block of drawing- or watercolour paper, where the front is always uppermost.

1. Dampen the paper evenly on both sides with a sponge, and allow a few minutes for the water to soak in.

Lay the paper on a drawing-board, a piece of plywood, or the smooth side of stiff hardboard.

2. Now fix it to the board. Run a strip of brown gummed paper about 2 in. (5 cm) wide, through a dish of water and stick it down with about one third over the edge of one side of the paper, the rest of the strip on the board. Do this on the other three edges of the sheet.

Allow the paper to dry at room temperature. Don't attempt to speed up the drying by putting it by a fire or radiator – the paper will probably split. Once dry, it is ready for use.

3. When you have finished your painting, leave it on the board until it is dry. Then remove the paper by cutting carefully round the edges of the brown strip with a sharp knife. The sheet should be completely flat.

Very heavy quality rag papers don't require stretching; watercolour boards (board covered in watercolour paper) will also stay reasonably flat.

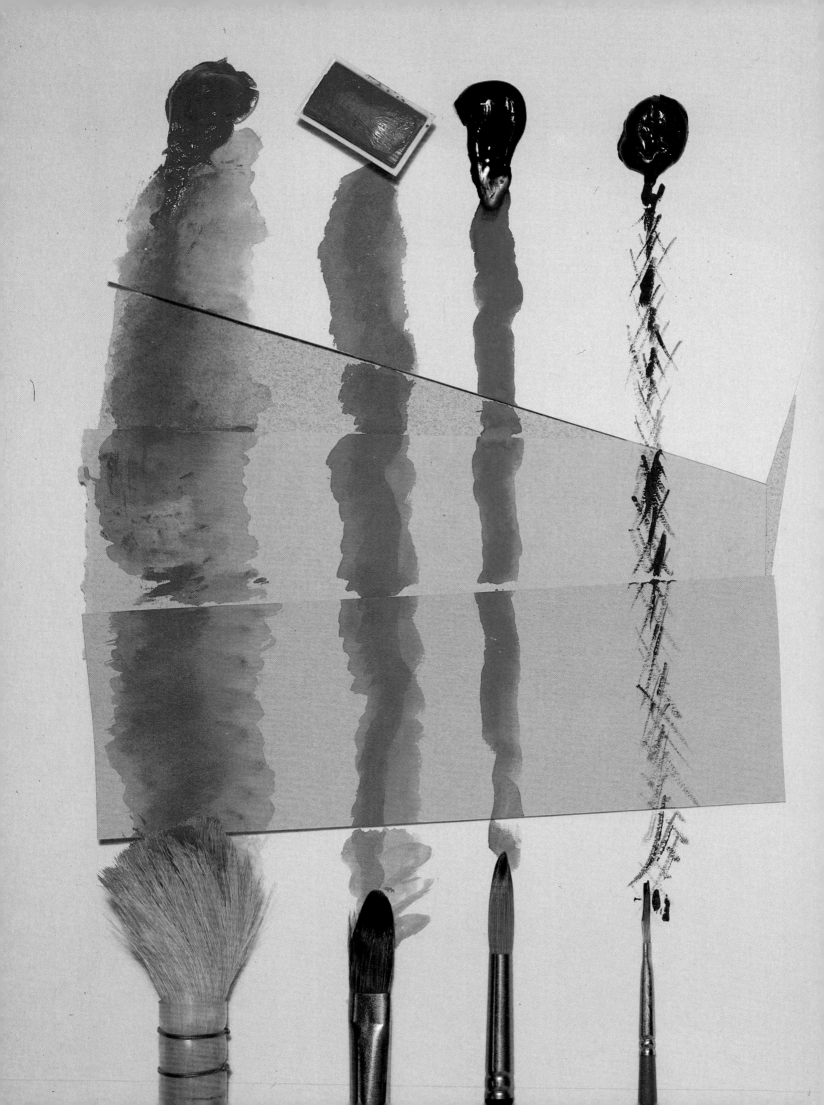

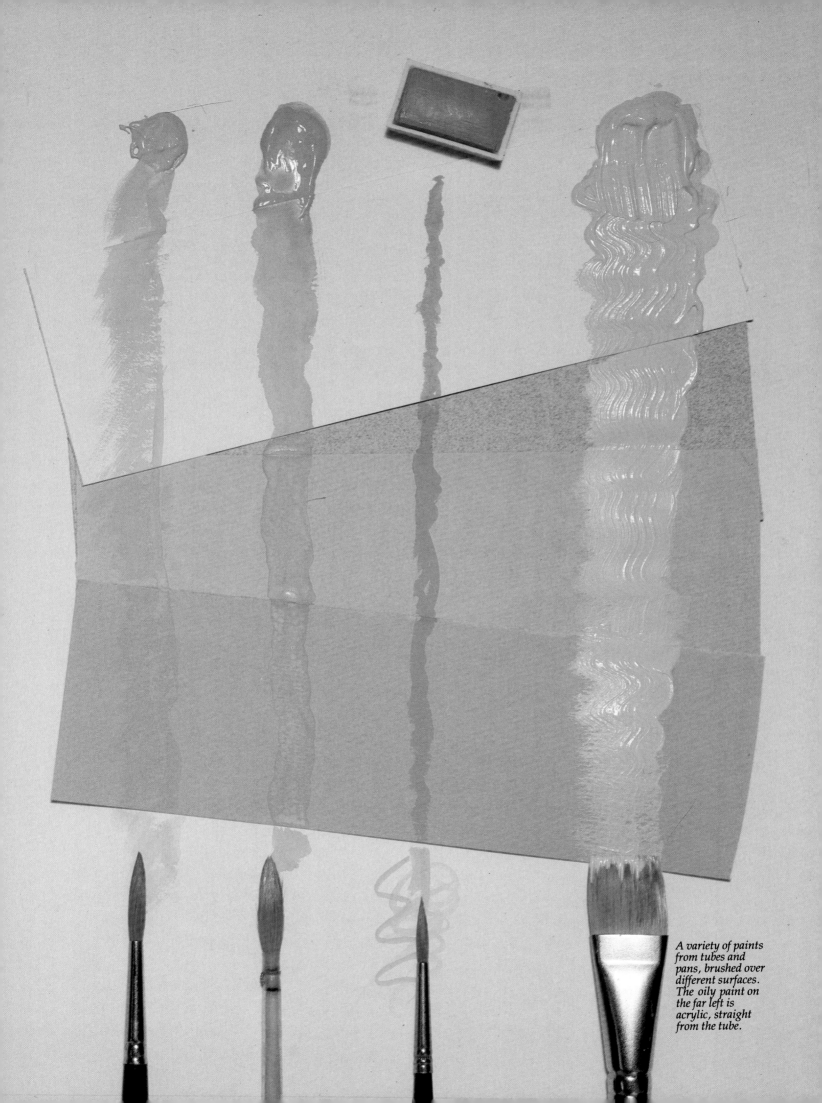

A variety of paints from tubes and pans, brushed over different surfaces. The oily paint on the far left is acrylic, straight from the tube.

Starting to Work

Before you start to work on more complicated subjects, practise using brushes and paints to make simple shapes.

Drawing with watercolour is very different from using pen and ink or charcoal. The brush may feel awkward at first, but don't clutch the handle too tightly. If you do, it will be impossible to make freely drawn strokes.

In these first exercises, concentrate on keeping your wrist loose, with just enough tension to hold the brush. Eventually the brush will feel like an extension of your hand, capable of light touches or wide sweeping arcs.

Use black paint or some other single colour, and a medium-sized brush like a No. 7. Wet the brush

reasonably generously and move it on the paint until it has picked up enough colour to slide comfortably over the paper.

Use a large-sized pad for these first strokes. Although you can work on a smaller piece of paper, it is better to give yourself enough space to move freely. Don't make the mistake of starting off on tiny sheets. The biggest fault of amateur painters is working too small – every stroke is hampered, every experiment cramped and crabbed.

It may seem wasteful, but learn to cover the paper from side to side; swing the brush across the sheet until your wrist, arm, elbow and shoulder are working in a comfortable rhythm.

A First Sketch

Sailing-boats with their white sails against the blue sky have always been a popular subject with artists, and particularly with watercolourists. The reasons are obvious: the strong colours of the sea and sky are exciting, and the effect of light and shade on the hulls and sails of the boats creates all kinds of interesting shapes to study.

The sculptor carves into a piece of wood or stone to find the shape he wants inside; a watercolour artist places tone on the paper to give shape to white spaces, which are given a meaning and significance they did not have before.

Using white paper in a positive way is one of the basic principles of true watercolour painting.

The following exercises show how the white triangles left on the paper become white sails on the sea.

1. Seascape with a beach in the foreground, and small boats in the centre.

2. As above with the sky added. The sails are left as bare paper, giving them tone against the sky.

3. To complete the picture, additional colours are added to give clouds at the top of the picture and additional texture of stone and rocks in the immediate foreground.

1.

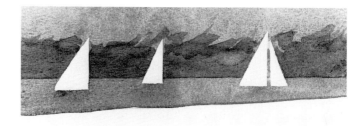

2.

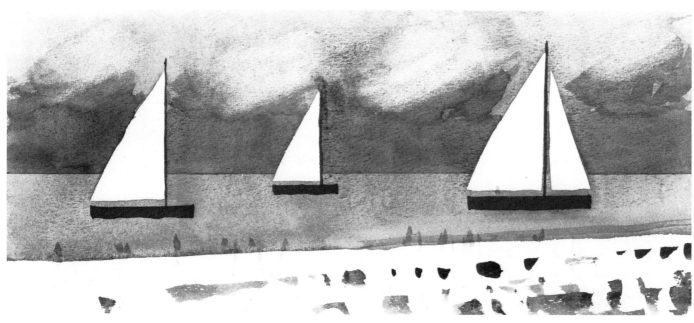

3.

Washes

Washes are essential to watercolour painting, and this section shows the basic techniques involved.

In addition to watercolour paints, water, and a mixing tray, you will also need a sheet of good quality cartridge paper, a board, and a ½in. (13mm) flat brush. Start with the board flat.

To produce an even wash, top left, mix an adequate quantity of paint and load it on your brush. Tilt the board to which the paper is attached towards you at a very slight angle that will allow the water to run down. Make a brush-stroke across the top, then, as the colour collects at the bottom of the stroke, lay successive overlapping strokes allowing the colour to run down the page.

When you have finished, remove the excess at the bottom by drying your brush on a cloth and mopping up the unwanted paint. This gives an even wash from top to bottom.

To make a graduated wash, top right, start with almost pure paint and add water until you finish with clean water on the bottom. Colour added to water will give a graduated wash from white to colour.

Other variations, below, are also based on these methods.

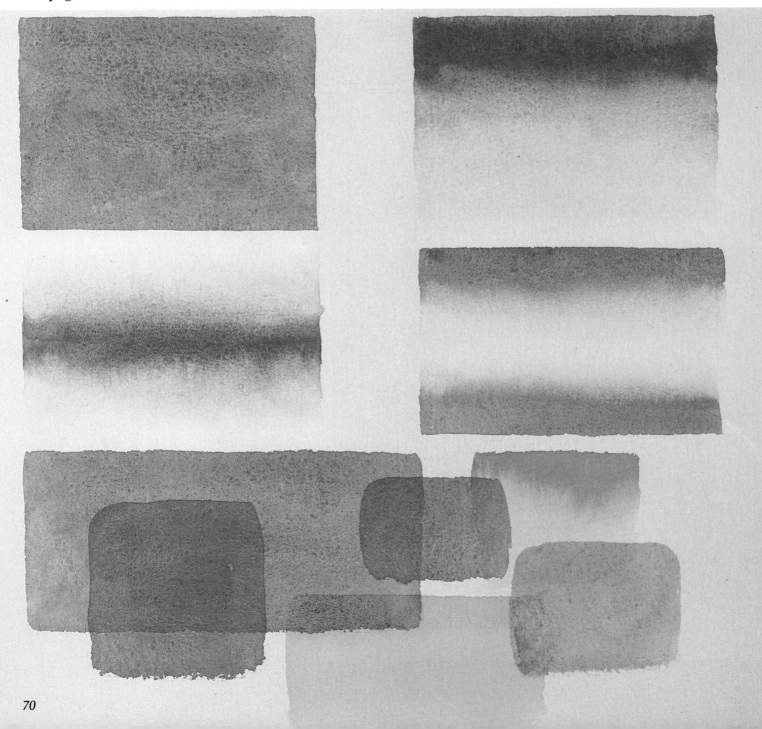

Washing Out

Washing out enables you to create highlights using the whiteness of the paper for contrast.

Make sure you use good quality paper. Soft cartridge will 'rough up' and you may make a hole in your picture.

First lay a wash for the sky of light blue/grey, and allow this to dry thoroughly. Then try to produce white clouds. Take a fine sable brush and, with clear water, soften the colour on the shapes you wish to remove. Carefully remove the paint with a damp sponge or cloth – even a white paper handkerchief.

For a soft effect, use a sponge to give a graduated or blurred edge, so that the colour merges gently into the white.

The techniques on these pages can be used in a variety of ways and combinations. The washes are sometimes large, sometimes small; they can be long and thin, almost like brush-strokes, or small, isolated patches.

Apply a second coat of clean water with the brush, and once again remove the excess water and colour. Repeat until the paper is as clean and white as you require. This method gives a clean, sharp edge. In the examples below the white sails have been washed out of the ground colour.

Composition

A successful composition is a visually acceptable balance of tone, colour, shape and texture. Although this may seem daunting, it is surprisingly easy to achieve a satisfactory 'mix'.

Composing a picture consists of arranging things, which we all do in everyday life. We arrange our time by deciding what to do; we arrange objects in a room, articles on shelves, clothes to wear. This same selective mechanism is used in composing a picture.

Decide what you would like to include and where to put each object. All that is necessary is to develop a heightened awareness of what you see: the colours and shapes.

In theory, an interesting subject and good painting should automatically result in a balanced picture – and the part intuition plays in achieving this will certainly increase with experience. However, although there is no great mystery to understanding, appreciating – or creating – a successfully composed picture, some basic understanding of composition is useful, and will be of great help when the time comes to select appropriate and interesting arrangements to paint.

We are already conditioned to expect to see certain arrangements in the visual world, and the brain rejects anything that does not conform to such expectations – an upside-down landscape, for example, with the sky at the base of the picture, seems silly. In the same way a predominant tree or house at the extreme left or right often seems wrong – we normally position our heads so that an important object is more or less at the centre of our vision. However, a focal point in the absolute centre of a picture may 'feel' just as wrong, and look better slightly to the left or right.

Basic Composition Sketches

1. This first attempt has put the tree almost in the middle of the picture. Not usually the most satisfactory position, but if the tree is interesting enough in shape and detail, then it could work very well.

2. Here I have moved a few feet and turned so that the tree is seen on the left, giving a more open feel to the entire composition. The additional lines of the furrows and hedges add to the spacious feeling of a wide sky and distant fields.

3. A more complicated composition, involving a grove of trees – rather overpowering – and a distant farmhouse. In fact, the proportions are like the second sketch, the great bulk on the right with the horizontal stretch of ground focused on the house. Look at the bank of trees behind the house: with just a simple wash the entire composition is closed in, the house seems lonely and rather desolate, the sky a slightly menacing grey.

Two views of agricultural furrows, leading the eye in different directions

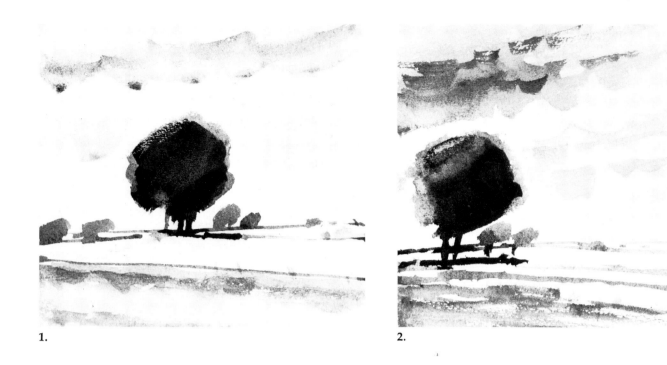

1.

2.

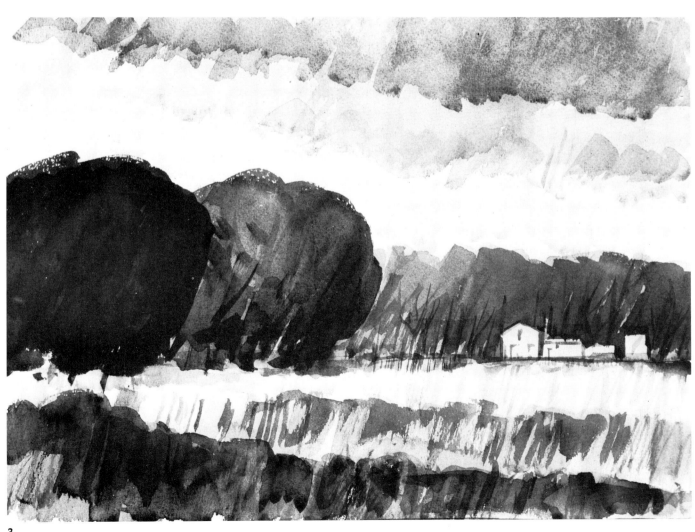

3.

Making a Frame

This simple exercise will help you to understand the underlying rules of composition.

Find a picture – one of your own, or a print – or photograph. A landscape would be a suitable subject. Now, cut a rectangle from the centre of a card about 12×18in. (30×46cm). Place this frame over the picture, and move it around. Position the horizon in the middle of the cut-out rectangle, then towards the top and then the bottom. Move the card to the left and right. Decide which position best suits the picture – in other words, which is the best composition?

Make your own diagrammatic picture and repeat the framing trials.

Remember that this kind of artificial frame is not the same as the 'frame' described as being part of the actual painting. Look through this book and you will see many strong vertical or horizontal lines that give emphasis to landscapes. Here the card is used to provide the same kind of emphasis by blocking out the surroundings and pulling the picture together.

The illustration below shows three frames, of different sizes, in various positions. Most artists would probably choose the middle-size picture as having the best proportions, with the house nicely tucked up in the top right corner, and the wide road narrowing dramatically as it curves away. The smallest frame gives a lighter feeling because of the much greater sky area, though the rest of the view is not too different. The large frame on the left has less of a focal point; such a view will demand more subtle painting, and a careful balance of the grass in the foreground with the distant line of dark hedges.

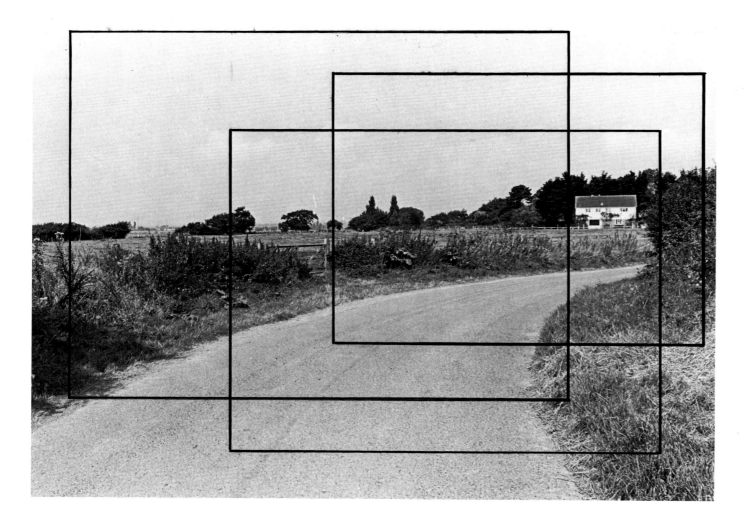

Practical Examples

The illustrations on this page are all based on a simple riverscape. Look at each and try to decide on its merits as a composition. Which is the most successful? Paint your own similar composition – and remember these exercises when you select your own subjects.

Discuss your work with other students. Look at famous paintings and analyse how they are composed, and how the successful balance between the four basic elements – tone, colour, shape and texture – is achieved. This will sharpen your critical awareness, and develop your appreciation and understanding of composition.

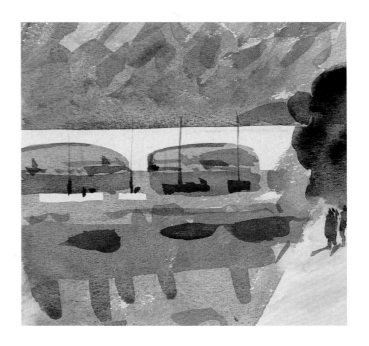

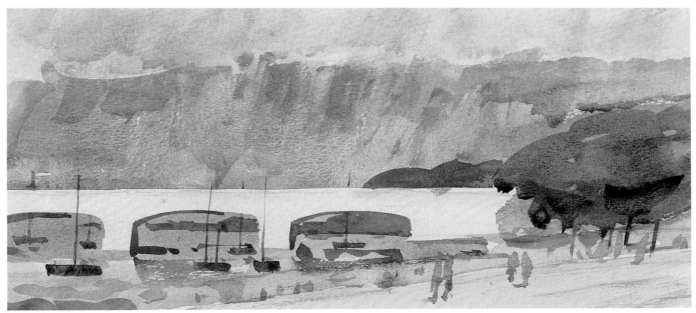

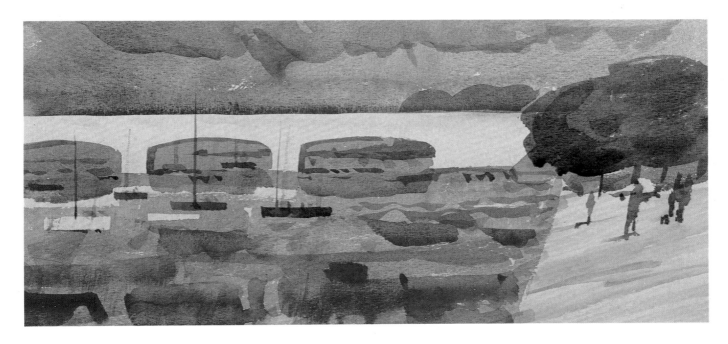

Using Tone

Tone refers to the monochrome value of a picture or subject – the degree of darkness or light, irrespective of colour. When painting, it is necessary to see the subject in tone. This may sound difficult – even impossible – but it is comparatively simple and there are some ways of making it even easier.

One method is to use the Claude mirror, named after the seventeenth-century painter Claude Lorraine. Take a 6in. (15.2cm) square piece of black glass, clear glass painted black on one side, or polished black plastic sheet. Hold this up and you will see that the dark surface reduces the reflection of the subject almost to a tonal image, minimizing the effect of colour.

In landscape painting particularly, artists use tonal recession – a succession of tones from light to dark – to create an illusion of space. This convention is based on the observation that nearby objects are strong in both tone and colour, with clear, well-defined shapes, while those that are far away are weaker in colour and tone and are less sharp.

Remember that watercolour tones depend on the amount of pigment you use. Light tones have a great deal of water, dark tones just enough to let you paint easily. Don't try to darken or lighten the tones by mixing colours.

The techniques in this lesson can be used in a variety of ways and combinations. The washes are sometimes large, sometimes small; they can be long and thin, almost like brush-strokes, or small, isolated patches.

The illustration below was painted in colour, and seems to be a complicated exercise in greys and greens and browns. But when it is printed in black and white, as it is here, you can see that the colours are used to provide the basic three tones – light, medium and dark – with a minimum of pen-work to point up the details.

Use black-and-white film in your camera for the same reason, and you will soon see how even the most complex paintings can usually be simplified into related tones. The Claude mirror serves the same purpose; learn to use it until your eye can see the tones without its aid.

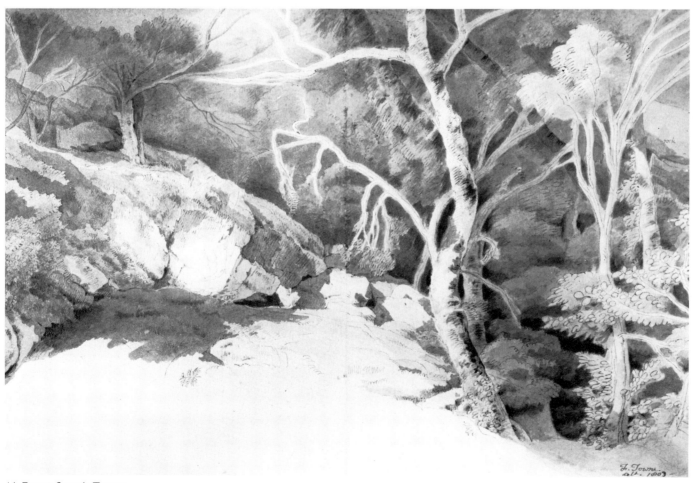

'A Forest Scene'; Torone

Perspective in Tone

You can use tone to increase the sense of perspective even in very simple watercolours. Here the receding wall has been emphasized by the row of stanchions that march into the distance.

When you start to sketch views that have considerable depth, try to use the brush carefully, because thicker strokes will seem nearer the eye and thinner strokes further away, though both may be on the same plane.

Preparing Colour-washed Backgrounds

As you begin to work more and more with colours, you will need to practise making a wash over good-sized sheets of paper. Although some changes in tone across the page are acceptable and even desirable, there will be many occasions when a background should be laid as neatly and evenly as possible.

When painting out of doors, prepared sheets are extremely useful: a band of darker tone for the ground, and a blue or blue-grey wash for the sky.

All these prepared sheets can be made at one session, and will give you working material for some time ahead. Even more important, they will be thoroughly dry so that second and third washes will take much less time than if you have to start from a white sheet.

Work from a board that is flat, or almost flat, to make sure there are no dripping lines. Use a large squirrel mop or decorating brush, well dampened, with a minimum of colour.

Such washes are also a very good way of judging the quality of your paper, and of seeing the variation in texture that different paper surfaces will achieve. In this way you will learn to use the paper to work *with* you, not *against* you. Try putting thin washes of the same colour on three or four different samples; see how the paint is absorbed into the various surfaces, and what sort of finish they give after they are dry.

Experiment, too, with different brushes and types of paint. See if you can notice the change when you use artists' and students' colours. Look at the rhythm of your brush-strokes – do they give an even effect, or were they applied in all directions as you tried to cover the areas that you missed the first time?

Pin up the finished samples in different lights; this will teach you more about colour and refraction.

Observation is the key to all art; from this one simple exercise you can learn as much as from days of painting without truly 'seeing'.

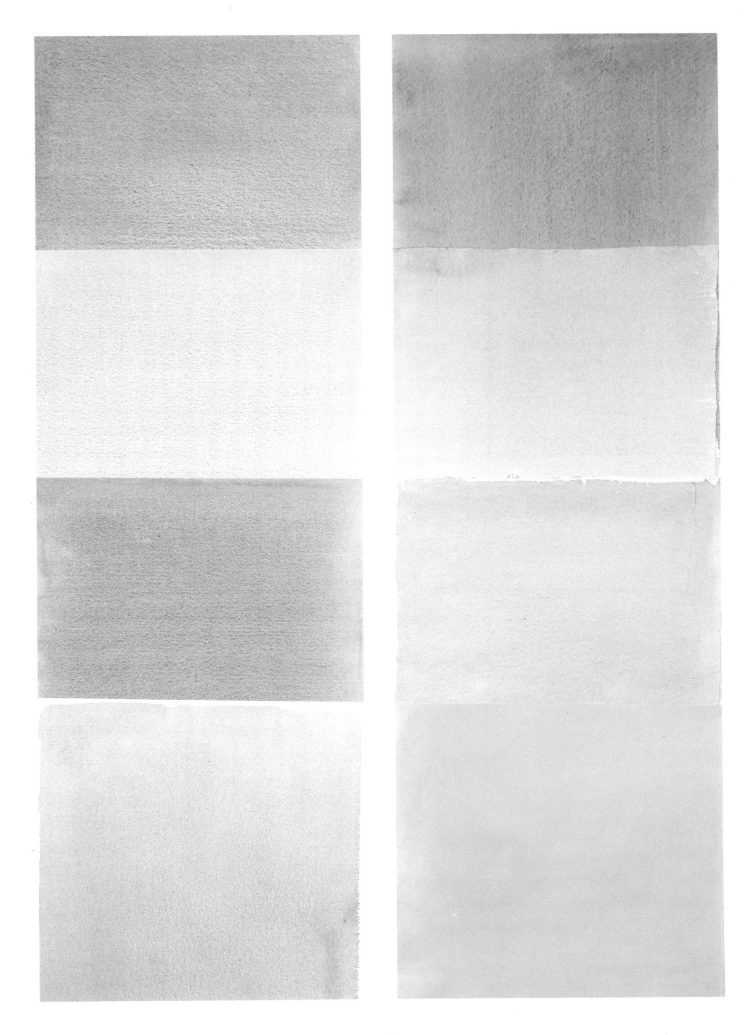

First Projects

Look around your room and select a few objects that you find interesting. Set them up as a group on a table top.

The projects on these pages are variations of the same exercise: painting objects in three tones. The steps involved are the same for both groups, and can indeed be usefully copied for all three-tone exercises.

Step 1. Lightly draw in the main areas with a pencil as a guide to where your washes will be placed. Now mix a very light wash; it should be just a little darker than the white of the paper. Experiment on a piece of spare paper to make sure you have the right tone – not too dark and not too light. Lay in the wash on all the areas that are just darker than white – most of the picture in the example opposite, except for the glass, the pot, the white plate and the outline of the glass bottle. Wait for the wash to dry.

Step 2. Mix a darker, middle-tone wash by adding more pigment to the one you have just used. Pick out some of the detail in the objects. In this example it is also used to make the background darker than the table. This will give the main tone for the shadows of the objects. Wait for the wash to dry.

Step 3. To complete this three-tone exercise, mix a final and darker tone. It should be darker than the last wash, but not black. Use it to pick out the details in the objects. Look carefully at your subject and decide where this tone will be most effective in completing your picture.

Repeat the exercise with a similar group of objects, but stand in a very different position, so you can see how the light affects the shapes, and the tones.

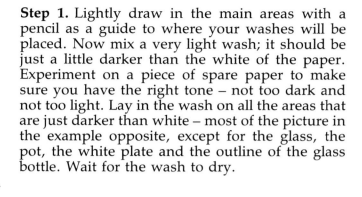

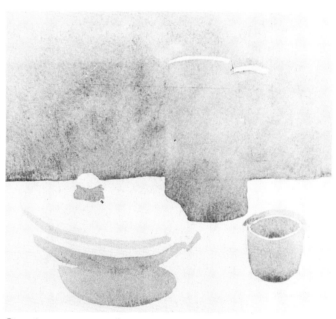

Step 1.

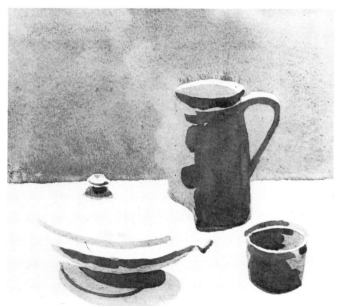

Step 2.

Step 3.

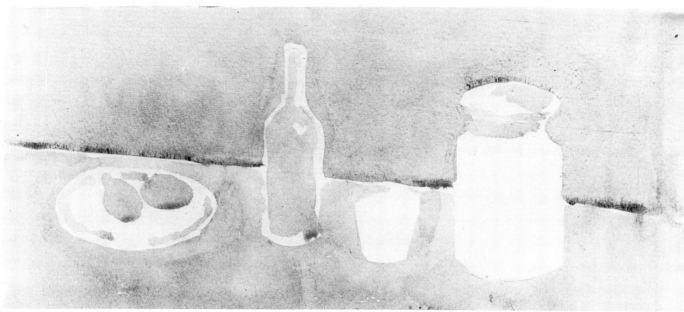

Step 1.

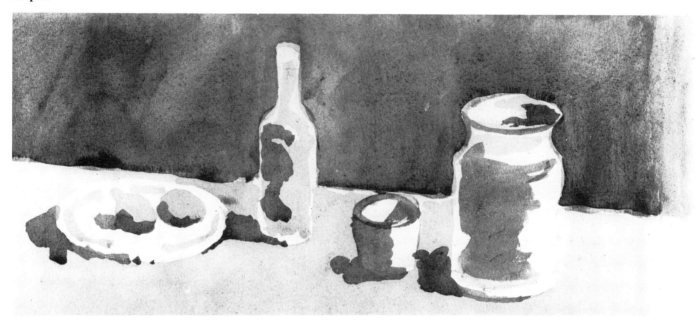

Step 2.

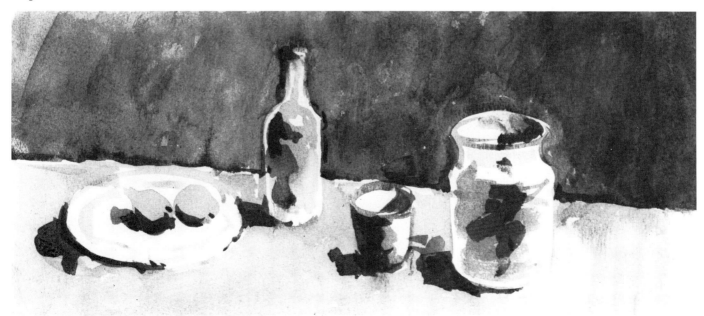

Step 3.

More Tone Projects

Try some exercises based on three tones. You can use a grey wash, based on black watercolour pigment mixed with water, but it may be more interesting to experiment with colour.

Look out of a window, using a Claude mirror, or take a photograph. Decide on the darkest tone, the middle one, and the lightest tone.

First paint in the sky with a very light wash, using a 1in. (2.5cm) decorating brush or a squirrel mop. When this is dry, use more pigment to fill in the middle-distance tones. Let this dry, then paint in the final – darkest – wash to describe the objects nearest to you.

Try this over again with another subject, using a single colour.

A New Technique

'Wet on wet' is particularly useful when a very watery effect is required. However, it relies to some extent on accident, and you should practise in your studio before using it on a painting. Although it may at first seem beyond your control, in time – and with experience – you will find it surprisingly accurate; it is not as random as it seems.

Wet your paper all over with a large brush. After a few moments, wipe off all the excess water with a cloth or sponge.

Paint on the colours immediately. You can add as many as you wish, starting with at least three: blue, neutral grey and warm ochre or brown-grey. Draw into the wet surface and allow the colour to run until the desired effect is achieved. It is best to tilt the paper slightly back at an angle, as normal. However, you may be more successful if the paper is flat, or tilted to the left or right, depending on where you wish the colour to run on the paper.

Step 1. Draw in, very lightly with pencil, the main outline shapes of the objects in the scene in front of you to indicate where your washes will go. Then use a light-toned wash to lay in the large, light areas. The sky is the main area to be covered; leave white, unpainted areas to make clouds. Allow time for your wash to dry before painting the next wash, or you will have runny, blurred lines where the washes meet.

Step 2. Look carefully at your subject and decide which parts are of a middle tone. In this example the foreground trees and bushes, the windows of the houses and the shadows under the clouds are the main parts to be painted with a middle-tone wash. Once again, allow the wash to dry.

Step 3. Finally, decide where to place the darkest tone. In this painting the dark wash is necessary mainly in the foreground trees and the shadows of the windows.

This completes your picture in three basic tonal washes.

Step 1.

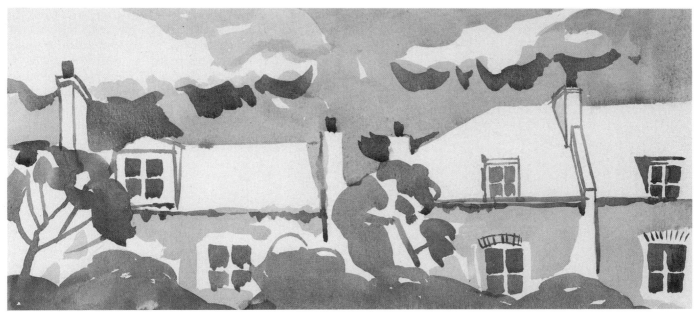

Step 2.

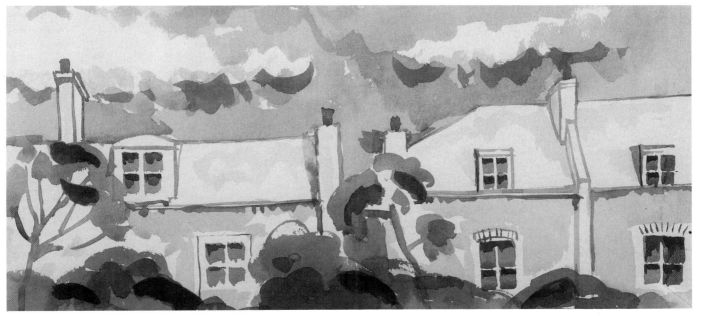

Step 3.

A View of the Garden

It is always useful for artists to look at familiar things in a new way. This project is based on the view from a window, looking down into a garden.

The following exercise will give you a very striking, almost abstract picture which needs to be seen from a distance. Hold your own finished sketch very near to your eyes, and then prop it up at least 4ft (1.25m) away. The blobs and shapes will gradually resolve themselves into a simple picture. Learn to look at objects in terms of shape and form as well as identity. It will help you to see as an artist, to simplify your work.

When you concentrate too much on details you lose the sense of a wider perspective in more senses than one. Not only will the result seem cramped and uneven, but you may find that you have an excessively important piece of paving-stone at the front, all its pebbles and shadows carefully in place, but a messy patchwork of green and brown where the shrubs should be.

If you would like to practise fine work, make a very careful study of a detail; concentrate only on a few pebbles, a leaf, the head of a flower. Then you will be able to practise both kinds of technique.

Step 1.

Step 1. Paint in the lightest tone, in this case the curve of the trees, the line of the path, and so on. Learn to see the abstract shapes, the white space around the areas you paint. It might be useful to make this first step twice, and keep one painting pinned up to study; you will begin to understand how the line you draw encloses space.

Step 2.

Step 2. Add the middle tone, defining the shapes and smaller bushes along the path. Work quickly with a confident hand – this project depends on its curves and contrast to be successful. Look at the tree-trunks in the foreground. They are left white and you have to work around them.

Step 3. Finish with a few details sketched in a darker tone. Never work too long on a sketch like this after you begin. It is better to try it three or four times with slightly different views than to work on one version over and over again until the paint is heavy and dull.

Two unusual factors are the height of your eye-level, which makes the paths intersect at different angles, and the bright sunlight, which cancels out the use of the lightest tone to show distance. Obviously the actual view from your window will be different, and that is what you should use for this study. Don't copy this project exactly, but make the ideas and suggestions work for you, in your own surroundings.

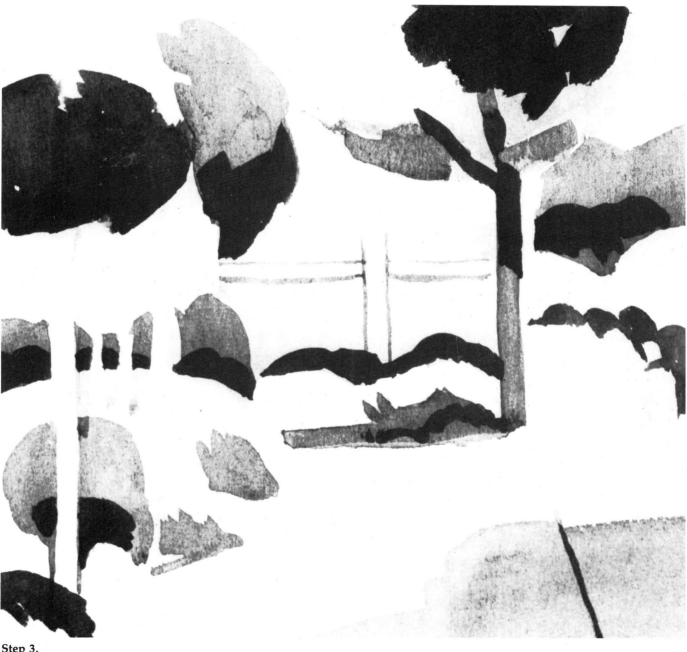

Step 3.

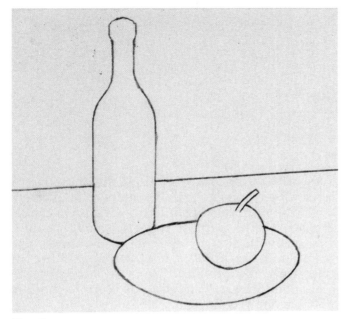

Step 1.

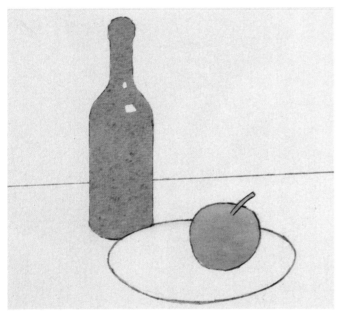

Step 2.

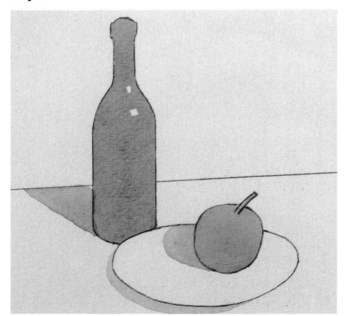

Step 3.

Tone and Colour

Tone is important in composition generally, and, combined with colour, is an essential element in painting. The interplay between tone and colour should always be reflected in your work. Look at modern and historical paintings and try to see them in tone as well as colour. Try to visualize a brightly coloured picture purely in terms of tone.

Select a few household objects – a wine bottle, a plate, and some fruit. Arrange them simply.

Step 1. Draw their outlines very lightly, in hard (2H) pencil, so that you can just see the lines.

Step 2. Is the bottle green? And, if so, which particular green? An apple would be a different green – mix one that is as close to the original as possible. If the plate is white, you will have to look hard before painting it; start by blocking in the main colour areas with a No. 7 sable brush – as you did with pastels in Lesson One.

Step 3. Next, look at the colours in the shadows and highlights. Try to identify them. Paint the colour of the shadow cast by the plate on the table, then do the shadows created by the bottle and fruit.

Always be conscious of tonal values when you work in colour. When you paint in colours – which vary from light to dark – you automatically paint in tone.

Step 4. Look carefully at the details. Some very delicate washes of colour will be necessary, particularly on the white areas, and on the small, darker areas.

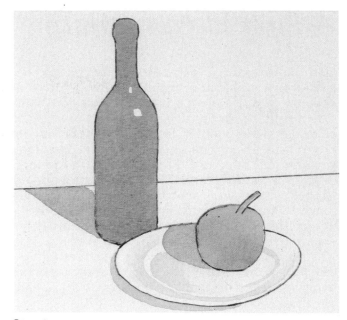

Step 4.

Step 5. Use very dark green to add other details like the cone shape at the base of the wine bottle, and also to strengthen the shadow under the plate. The fruit will need some dark blue or brown lines, drawn with the point of the brush, to increase the strength of the shadows.

Although the shapes are deliberately simplified, and only a few tones of their colours are used, you should have achieved a successful representation of the objects.

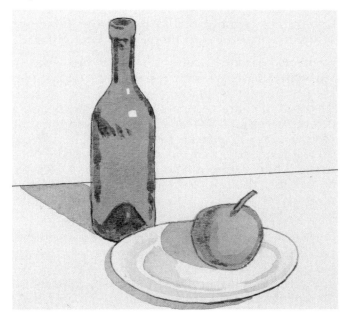

Step 5.

Step 6. Now pin up your sketch, and stand back at least 3ft (about 1m). See if there are any additional touches you want to make, but don't try to put in every detail. At this stage you want to be able to work freely and securely.

Try the same project with another group of objects, choosing contrasting shapes and colours. Keep the shapes simple and your brushwork direct. Use primary colours and never try to go over the objects if the colour is really misjudged; it is much better to start on another piece of paper.

Once you have achieved a successful result, you will have learned all the basic techniques of watercolour.

If you find yourself bewildered at a later stage with something that does not seem to work, come back to this simple project, and go through the steps carefully with a new group of objects.

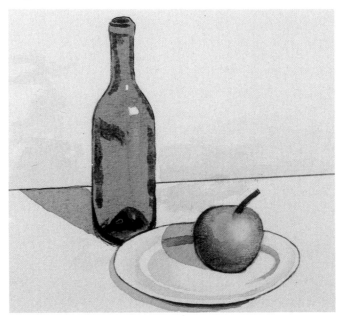

Step 6.

A First Flower Painting

Here is a chance to combine all the things you have learnt so far in a brightly painted group of flowers. If you have a garden, try working outside directly from the subject. Choose any group of flowers not too far from each other so the group will fit on one sheet of paper. You may work from a bunch of flowers in a vase indoors, or from a potted plant. Make a few preliminary studies with colour, matching the tones in each flower with your eye. Remember that most living things are not flat colours but subtly shaded, so experiment with combinations and washes. You will need time for the studies to dry before you can judge the result; use the interval to make pencil sketches of details – the curves of a petal, the shape of a leaf.

Learn to use your garden as a natural resource. Many painters make elaborate plans for outdoor expeditions without realizing that they have one of the finest sources of inspiration near at hand.

Even the smallest patio can give you endless subjects. Close-ups of flower-heads and leaves are continually fascinating and each one of them has its own character; pots of all shapes and sizes can be rearranged to suit your mood and the time of year. If you want a higher viewpoint, try sitting on top of a ladder and looking down – you will be amazed how different the whole scene looks. Do be careful, though, to make sure the ladder is properly supported: you will need both hands free for your work.

For those without a garden, parks are useful. If you are at home, potted bulbs are particularly pleasant to draw; they often look as if they are growing naturally in the ground. Concentrate on the flowers themselves as in this iris study – their colour and scent add to the atmosphere while you are working.

Step 1. You will be working on a fairly large scale compared to the previous projects, so choose a comfortably sized piece of paper, with a good, rough surface. This is quite important, because most of the painting is done directly without preliminary washes and tones; the paper needs to be textured enough to catch the paint and hold it without dripping. You also need to use your arm as well as your wrist, to give freedom of movement to the brush. Draw the main outlines of the flowers very lightly with a hard pencil. With a complicated subject it is best to have some guidance. Begin with the yellow flowers, adding water as you work to lighten the tone.

Step 2. Mix the next darkest colour, in this case a blue-purple, and paint it in, letting the colour run into the yellow where it seems appropriate. Remember that flowers, like all natural things, are made up of subtle, shifting colours, so don't try to achieve a flat, single-colour effect. The shaded colouring is one reason why watercolour can be so attractive when used for floral studies.

These two steps are in black and white, so look at the last stages for the way the colouring has been achieved, then back at this page for the tonal values and the texture.

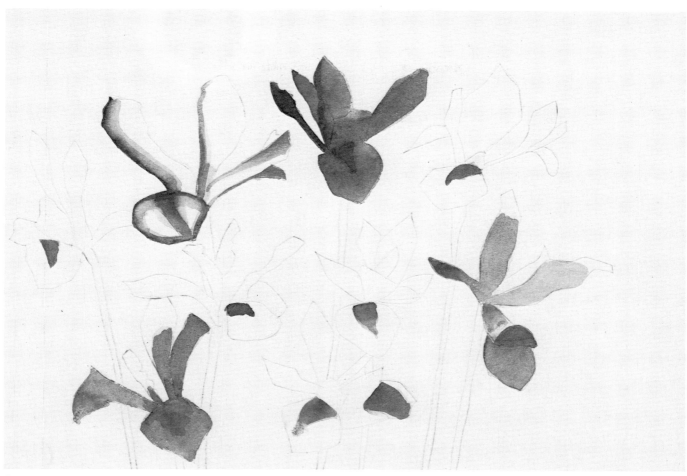

Step 1.

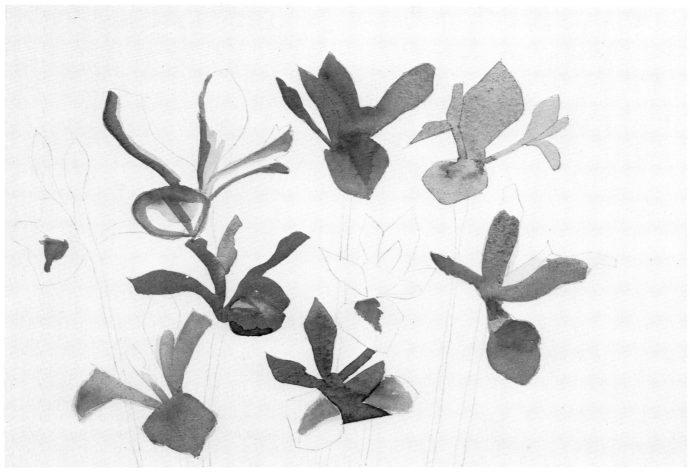

Step 2.

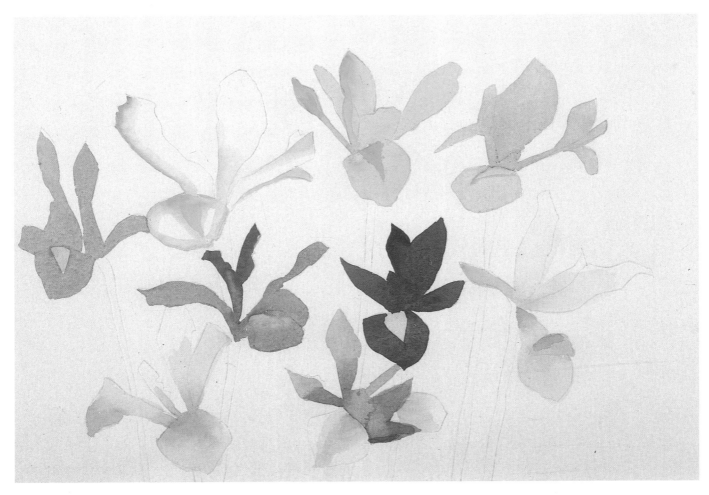

Step 3. Add the red flowers, using a strong red for the dark flower, and a watered-down red for the very light pink flower. As you are working directly it is better to try it out on a piece of paper by your side rather than put a new colour directly on the painting. Use enough water to keep the brush moving easily, but not enough to drip. Keep the shaded tones by twisting the brush slightly to pick up more or less of the paint – it will give the effect of natural variation.

Step 4. Mix a brown wash, and paint it quickly over the background. It is an irregularly shaped area so you will not be able to obtain an even wash, but don't worry – the effect will be better if it is shaded.

Step 5. Add a few touches of darker green to the background to suggest the leaves and foliage behind the flowers, and add more detail to the flowers where necessary. Use a fine brush, and a light touch. Pin up the finished picture after it is thoroughly dry, and see if you have been able to capture the sense of freshness and open air. The exact shapes and colours are not as important in this impressionistic study as is the effect of a garden, and growing, living plants.

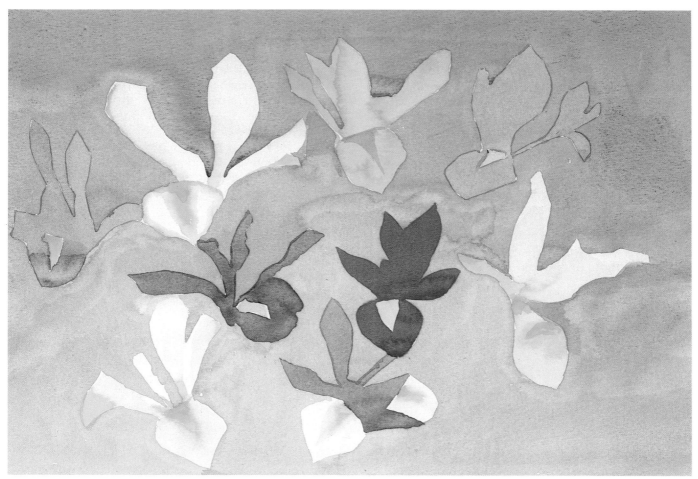

Step 4.

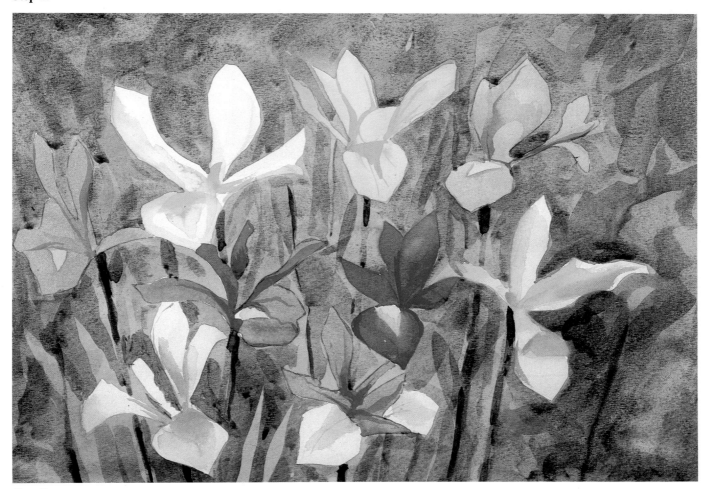

Step 5.

Looking at Watercolours

It is more difficult than it might seem to see watercolour paintings at their best. The medium's most evident quality is the transparency of colour which gives the finest examples a unique glowing lightness. Yet because of this fragile quality watercolours are almost always framed under glass, and all too many small museums and galleries are badly lit, or the paintings are hung so that light reflects off the surface of the glass, making it almost impossible to see the pictures.

The first priority, therefore, is to choose your objective with care. Take the trouble to go to a good exhibition or a museum with a fine collection.

It will help to come to the paintings with a fresh

mind; if you have been to a gallery before, find an artist whose work is new to you, or one picture at least that you have not read about or looked at before in books. Let the quality of the painting speak for itself. Don't think about technique or perspective, just enjoy what you are looking at. Let the statement be strong and clear, and then walk away for a few moments. Then come back to the painting and try to identify what has given it that very special quality.

Concentrate first on the general impression given by the painting. Most watercolours are light and fresh, in that they look as if they were newly painted, just taken off the easel and pinned up on the wall. This is partly because of the transparent colour, but also because the technique has

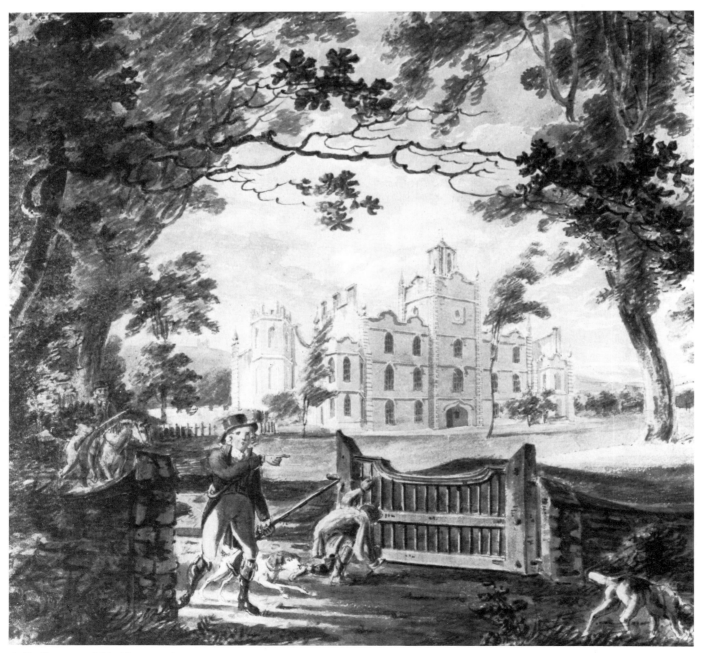

A Gentleman and his Manor; Anonymous

evolved from that very transparency; the colours have a glow of life because they are usually painted in layers with overlapping tones and slightly blurred edges caused by the damp paper.

Of course, if you are looking at a Dürer, the lines will be meticulously clear, the detail sharp and very hard-edged. Nevertheless, the colours do not have the solid screen effect of oil painting – it seems as if you can look right through the leaves to the veins underneath.

As with drawings, there are two main types of watercolour: working sketches, and paintings that are intended to be finished pieces. 'Sketchy' watercolours are accepted as works of art in their own right, and it is often difficult to tell which category a painting comes into.

It hardly matters – both types are fascinating to look at, and instructive for students. On this visit, choose one of each kind and compare them.

Look first at the sketch. Economy of line and effort is evident. A road is two light wavy edges in brown, a flower two or three strokes of green with a blob of colour on top. The strokes are lively, and easily recognizable as brush-strokes, perhaps zigzagging across the paper. Although there are only a few lines, all the important elements are there. Composition which seems lighthearted – and may even be instinctive – is the result of years of practice.

You will probably find a recognizable and classical use of proportion and masses – a good reminder that the eye selects a pleasing composition almost without knowing it. Our aim as artists will be to use what we see rather than impose an artificial standard.

Colour is obviously important, but also look for the subtle use of tone – the variations which give the tonal values of any one hue. Watercolours are ideal for training your 'tonal' eye; the layers are often distinguishable, especially if you look closely at the details. Some tones are made by colours layered on the paper, others by mixing paint on the palette.

Look for outlines and areas. If the colours blend at the edges they will have a soft, misty effect; or they may be separated by thin or thick spaces of unpainted paper, giving a harder sharper edge. Details are usually found in finished 'studio' watercolours rather than sketches.

Now look at the finished painting, and compare its more glossy effect with the simpler sketch.

How is the texture achieved? It is difficult to apply watercolour in the tiny precise strokes that can be made with a pencil, and equally difficult to use it to make thick layers like the impasto of oil painting. Dry-brush technique, with a stippled effect on dry paper, can work very well, but if the picture requires a great deal of detailed texture the artist may have added another medium. Opaque white gouache (not strictly watercolour, but very useful) is often used for highlights. A pen adds crispness to outlines.

Remember that watercolour is the most difficult, but in some ways the most satisfying, of all painting media. It does not have the austerity of black-and-white drawing or the lush depth of oil colours; instead, it is a luminous contribution to the vocabulary of art.

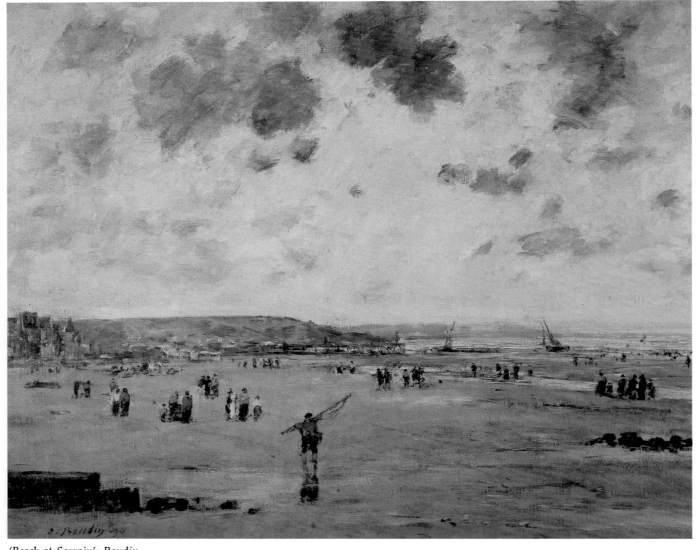

'Beach at Sarrain'; Boudin

Lesson Three
Oil

Painting has developed through the changing needs of individual artists, and the people and institutions they worked for. It has a history of constant development and experimentation.

Before the introduction of oil painting in the early fifteenth century, the most widely used method of painting was tempera. In this, powdered colours were mixed with fresh egg yolk (thinned with water) or, sometimes, with the whole egg. Tempera, which is still used today, dries within minutes, and modelling – the equivalent of shading in drawing – to create three-dimensional objects can only be done by cross-hatching one colour over another.

Oil paints developed as the result of efforts to find, firstly, a binder that allowed slower and more accurate working, and a richer colour quality through blending and glazing; and, secondly, a medium that gave greater flexibility in experimenting, altering and correcting.

New surfaces for painting on, and various brushes with different types of animal hair, have been added to the artist's repertoire over the years. However, although the choice of pigments available today is far greater than in the past, the basic technique is still much the same. Even the oils used for mixing with the pigments – linseed and poppy – were in use in the fifteenth century.

Through the ages the images and interests of artists, and the way they see the world, have added – step by step – new and diverse subject-matter. Oil painting in particular has kept pace with changing attitudes as civilization has developed, reflecting and recording its evolution. A broad kaleidoscope of subjects has been painted in this medium, from the biblical and allegorical paintings of the Renaissance to the landscapes of John Constable (1776–1837) and Samuel Palmer (1805–81), and tiny miniatures on ivory and bone; from the savage satire of Francisco de Goya (1746–1828) to the quiet intimacy of the interiors of Pierre Bonnard (1867–1947); from the paint-encrusted canvases of Vincent van Gogh (1853–90) to the calm, serene abstracts of Ben Nicholson (1894–1982).

Oil paints were first widely used in the 1400s when pigments made from plant and mineral dyes were mixed with boiled linseed oil to give painters a new freedom in detailed work done over a long period. Jan van Eyck (c.1384–1441), who probably achieved the greatest success, observed and recorded his surroundings in such exquisite detail that it is difficult, even with a magnifying glass, to comprehend the fineness of his work. Dieric Bouts (c.1415–75) and Roger van der Weyden (1399/1400–64) were two early Netherlands painters who also worked in oils.

They used wood panels, grounded or primed with white and animal glues.

Flemish painters working in Italy in the fifteenth century probably introduced oils to their Italian counterparts. Piero della Francesca (1410/20–92), who worked in oils as well as in fresco (water-colours laid on walls or ceilings before the plaster is dry), developed his art in both techniques, with no obvious transition from one medium to another.

Artists moved from one country to another, as they do today, and methods and styles traversed the known world. The theories of Paolo Uccello (1396/7–1475) about the laws of perspective, for example, were soon adopted by other painters.

The Venetians may have been the first to use canvas surfaces. Wood, the generally accepted support for oils, suffered from the damp in Venice's humid atmosphere. Similarly, conditions in Venice were not ideal for fresco painting – practised in Italy from the thirteenth century, and perfected in the sixteenth – as the plaster was likely to flake and crack. The introduction of canvas allowed work to be completed in a studio before being moved to its final location – and moved again relatively easily when necessary.

During the Renaissance, Leonardo da Vinci (1452–1519), Masaccio (1401–1428?), Andrea Mantegna (c.1431–1506), Raphael (1483–1520) and Titian (c.1487/90–1576) all explored the new medium in very different ways.

Da Vinci wrote that oil painting 'should be smooth if not enamelled, effacing all traces of the artist's hand; the further removed the work from the individuality of the artist's hand, the more meritorious the work'.

Titian, on the other hand, developed a calligraphic manner of painting. Although his early work was traditional, his strong personality required freedom and directness to convey his feelings. Oils gave him the scope to question and break with conventional pictorial composition. His pupil Palma Giovane (1544–1628) described his method:

'He laid in his pictures with a mass of colour which served as the groundwork for what he wanted to express. I myself have seen such vigorous underpainting in plain red earth for the half tones and in white lead. With the same brush dipped in red, black or yellow, he worked up the light parts. In four strokes he could create a remarkably fine figure, then he turned the picture to the wall and left it for months without looking at it until he returned to it and stared critically at it, as if it were a mortal enemy. If he found something that displeased him he went to work like a surgeon. In the last stages he used his fingers more than the brush.'

Within these constraints a variety of styles evolved. The Italians worked in the classical manner, expressing ideals of beauty and harmony, while French painters developed a naturalistic style, which became increasingly realistic; their work was often based on everyday life, with portraits of real people.

During the sixteenth century, despite the Church's dominance, private patronage by wealthy merchants and noblemen encouraged artists to defy tradition and paint scenes from civic and secular life.

The Venetians in particular developed another new aspect of painting: the subtle use of layers of oils to convey atmosphere through colour harmony and light. Towards the end of his life, Giovanni Bellini (c.1430–1516) was absorbed by this problem.

Landscape painting, which began tentatively in about 1508 with the *Tempest* by Giorgione (c.1476/8–1510), soon became a skill in its own right with the idyllic and allegorical themes interpreted by Nicolas Poussin (1593/4–1665) and Claude Lorraine (1600–82) in the seventeenth century.

In the same century Holland was becoming a powerful and wealthy trading nation, with a flourishing mercantile class that provided patronage and the impetus that led to the birth of Dutch genre painting. Seascape, landscape, townscape, portraiture and interiors were added to the repertoire of biblical and allegorical themes, as artists faithfully described the world they lived in. Cloth, metal, wood, skin and water were closely scrutinized, and recorded in scenes of everyday life – works devoid of idealization or beautification. These detailed paintings were made possible only by the use of oils.

Rembrandt van Rijn (1606–69) departed from this tradition of highly finished detail – although he had never been to Italy, it is likely that he knew Titian's work with its freedom of execution. His broad, fluid treatment on stained grounds that range from dark to light, the vigorous quality of his drawing, and his use of impasto and chiaroscuro, ensure his position as one of the world's greatest masters of oil painting.

In England, the wind of Continental change came to the court of Henry VIII with Hans Holbein the Younger (1497/8–1543). Sir Anthony van Dyck (1599–1641) was court painter to Charles I; he had been a pupil of Peter Paul Rubens (1577–1640), the great Flemish painter and diplomat. Both Holbein and van Dyck painted many fine portraits.

Genre painting continued to flourish. Still in England, William Hogarth (1697–1764) depicted eighteenth-century high and low life in sequences of paintings, a form of story-telling. *The Rake's Progress* and *Marriage à la Mode* both comment sharply, with great wit and observation, on the

state of society. In France, Jean Baptiste Siméon Chardin (1699–1779) recorded the lives of ordinary people, and also painted exquisite still-life pictures that surpass those of the Dutch, who, although famous for their skill and brilliance, can perhaps be criticized for allowing technique to be an end in itself. Chardin's still lifes have a quiet humility; his technical mastery is the tool, not the purpose, of his work.

Jacques Louis David (1748–1825), the official artist of the French Revolutionary Government, recorded historic events in compositions on a scale, and of a grandeur, reminiscent of Paolo Veronese (c.1528–88) in sixteenth-century Italy. Although painted in oils, their effect is more like that of the great frescoes.

The early nineteenth century saw a conflict between two schools of thought. Jean Auguste Dominique Ingres (1780–1867), a pupil of David, was a champion of classical art and antiquity. Eugène Delacroix (1798–1863), his opponent, was the romantic painter of fiction, and radically opposed to the traditions of Academies and Salons. He rejected studies of classical statues, and the disciplines of classical traditions; he was interested more in the spontaneous use of colour, and in the excitement of using paint, particularly oils, to express imaginative ideas.

Delacroix admired the works of the English artist John Constable (1776–1837), who, like Joseph Mallord William Turner (1775–1851), moved outside the studio to make paintings and studies on the spot. This new method of observing nature *in situ* was adopted in France by Théodore Rousseau (1812–67), Jean François Millet (1814–75) and Jean Baptiste Camille Corot (1796–1875), who worked in the area around Barbizon to record peasants in the fields and the fleeting effects of weather and light. Larger works, however, were done in the studio.

The late nineteenth century was a time of rapid change. As the Impressionists pursued direct painting in the open air, capturing the spirit of a moment, virtually any subject was recorded on their canvases; landscapes, cafés, railway stations, cathedrals, shopgirls, and (especially) the life of Paris and its boulevards.

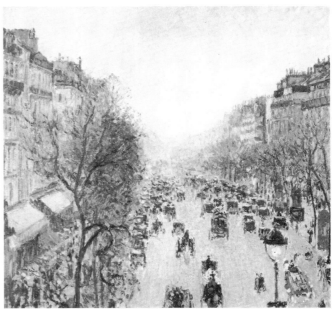

'Street scene in Montmartre'; Pissarro

There were also imaginative, almost spiritual works, such as the paintings by Claude Monet (1840–1926) of his garden and water-lilies. (He was described by Paul Cézanne (1839–1906) as being 'Only an eye but my God what an eye!')

These direct, spontaneous paintings in oils and watercolour outraged Academies, Salons, critics and public. How deliciously wrong they were! Art no longer had any restrictions. Led by van Gogh, Paul Gauguin (1848–1903) and Cézanne, the Post-Impressionists – the name derives from the London exhibition arranged by Roger Fry in the winter of 1910–11, called 'Manet and the Post-Impressionists' – developed and extended so many ideas that it is almost impossible to count the number of movements that have evolved since the start of the twentieth century.

Encouraged by rapid advances and the speed of change in technology, artistic activity in the last eighty years has encompassed Fauves, Cubists, Surrealists, Dadaists, Expressionists and Abstract Expressionists (who use colour, surface and shape as a means of expression, without resort to visual images or subjects). Nevertheless, figurative painting has never been entirely neglected; even 'abstract' art often has a figurative basis.

Colour Wheel in Oil

Oil paints have kept pace with developments in art so that, today, the artist has a choice of refined colour ranges and quality materials. Admittedly, very few artists today are likely to reach the heights achieved by the great masters of oil painting. Nevertheless even a beginner can learn the basic skills that are common to all painters: how to see, and understand, the complex visual material in the world around you.

A great deal can be learnt just by looking at mixtures of a limited range of pigments on your palette. Trial and error play a large part in matching colours, but you will eventually become familiar with their properties. Although every colour and hue can theoretically be achieved from the primary colours, in practice the pigments don't comply with the rules. It may be necessary to supplement a limited palette with extra colours.

Follow the directions on page 14, and paint a new colour wheel using the primary palette, which is surprisingly versatile. If at first you cannot create a vibrant green by mixing blue and yellow, persevere and see what you achieve. Viridian and monastral green can be added later, for variety. This is also true of ultramarine. A beautiful blue, it is very flexible when mixed with other colours, but it will not produce all the necessary shades. Other blues can be added, as you learn the spectrum.

The first colour wheel you painted was an exercise in applying and mixing pigment in precise proportions. This is more of an experiment in colour. contrast and in mixing directly on the canvas. You see that I have added a few squares of colours on the bottom to try out cool recessive blocks against points of warm colours, and vice versa. Make your own versions and try to contrast the textures and surfaces as well as the colours.

When you have finished, keep the wheel pinned up in a corner where you can use the spectrum as a base for trying out new mixtures; in the well-worked example opposite I added daubs and blocks over a period of six months or so, while I worked on different paintings.

The left side of the wheel is full of modified tones of browns and mauves which I use in landscapes; look at these against the clear greens on the right. When the canvas is filled up, make another wheel rather than paint over the old one, or you won't be able to go back and see what you have tried out already.

For amusement as well as study, make a wheel with textured colours – perhaps red and yellow dots in the same wedge, green and mauve, or simply black and white. This will give you a greater understanding of the Impressionist technique which revolutionized the academic world in the late nineteenth century.

Try the same study with patterns – zigzags, stripes, waves, checks, or whatever intrigues you. Colour is a subjective feature of everybody's work. Although there are only particular colours in the spectrum, we see with our brains as well as with our eyes, and you may find yourself using the same kind of palette over and over again.

Every artist can be 'fingerprinted' by the use of colour as well as by brush-strokes and technique. People talk about the 'blue period' of Picasso's work as if he might never have used blue tones before or after. Obviously artists concentrate on a particular subject or type of painting, often according to the mood they are in. But that concentration should not be allowed to overpower our ability to try other colours or paint different subjects. This is particularly important for beginners, searching for an individual style.

Look at your work critically every month or so. If you find a whole portfolio of browns make sure you paint something in vivid and brilliant colours. If everything is in strong primaries, set aside time to make at least three or four studies in quiet, subtle greys and creams.

With a really intelligent approach to painting, and indeed to the whole subject of art, your choice should be made with knowledge.

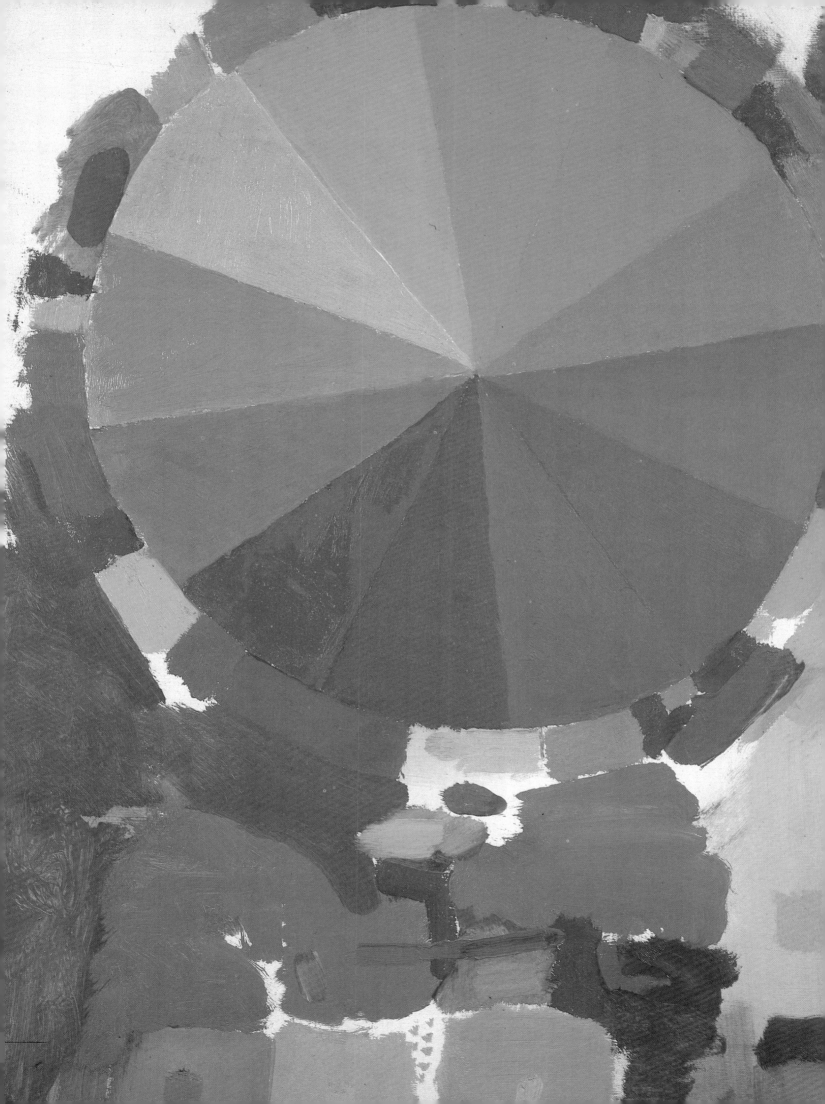

Materials

A permanent place to work, even a small corner on a landing, is a priority. Oil painting involves more clutter than drawing or watercolours; tools will accumulate, odds and ends are necessary, and there is no doubt that most oil pigments leave a trace of odour in the air. It is also extremely annoying to have to pack away your easels, palettes, brushes and canvas after every session. You will also need somewhere to put wet paintings which may take days, or even weeks, to dry.

Basic equipment can be fairly simple, but should include an easel. Of course you can use a chair or prop a board on a table, but these are short-term substitutes. If you are to progress at all, you should budget for reasonable requirements. See the appendix for a beginner's shopping list.

A studio or radial easel has many advantages. It is firm, and will support a canvas of up to 5ft (1.5m) high; you can stand or sit to work, and the canvas can be raised or lowered. If you want to work outside and can afford only one easel, buy a travelling model. However, you will have to be a little more careful in how you work. Applying thick, sometimes very thick, oils is a much more vigorous exercise than using watercolour or drawing materials.

A paint table for brushes, turpentine, palette, etc. is also important. Size is unimportant, but the table must be sturdy and stand squarely on the floor. An old chest-of-drawers from an auction sale or the attic can be used as a table and also provides storage space. Try to find one with a number of small drawers instead of a few big ones. Then you can keep your brushes, tacks, knives, and other equipment separated.

You will need two flat, broad-based receptacles that won't fall over when brushes are dipped into them and held against the sides. One is for turpentine, the other for a cleaning spirit. Glass jam-jars are excellent, but plastic pots will soften or crack and leave a sticky mess on brushes and work surfaces.

These items, and a palette, are the only necessities. However, you may eventually want to acquire a few other aids.

Extras

A reducing glass lets you look at your work as if you were standing far away. This is very useful in a confined space where you may be too close to get a realistic view of the painting. It also simplifies form: detail fades and you can see the basic drawing, shapes, tones and colours.

A smallish mirror is another 'eye'. If you look at a reflection of your work you will see it as if it was a new study. It is all too easy to become familiar with an oil painting which may take a long time to finish, and an unexpected angle provides a visual jolt.

If possible, build a small rack into an alcove and use it to store new boards and canvases, dry and just-finished and half-completed paintings, and keep examples of your work for future study.

If you run into problems with a painting and want to put it aside, store it where it is easily visible. A solution may occur while you are working on some other project.

Floor coverings, if any, should be expendable. There is no known way of keeping oil paints from spattering occasionally, and worrying about a carpet or new rugs will distract and inhibit your work.

Light

Northern light is undoubtedly the best to work in – there is little variation in its quality during the day – but is not essential. Blinds, curtains or shutters can be used to keep light in the studio as even as possible. Never work in direct sunlight, which plays havoc with tones and colours.

Ordinary electric light bulbs affect the yellows in a painting. Strip-lighting affects the blues. Daylight bulbs or grow-lights used for plants will help. Or try a 150-watt bulb and a 4ft (1.2m) strip-light, which can be combined to give a reasonable imitation of daylight. Spotlights are too harsh and too bright, but it is useful to have one available for casting dramatic shadows from the side.

Palette-knives

A palette-knife is good for mixing paint and can also be used as a painting tool, to apply paint to a picture or scrape it off if necessary. Although it is versatile in the hands of an experienced practitioner, it can produce very crude and mannered works.

As your experience grows, it may be fruitful to experiment with knives. However, they are generally best used with brushes to extend the medium's versatility.

An old-fashioned kitchen knife from a junk shop can often be adapted – the 'whippier' the metal, the better. Always make sure the blade has been rubbed down and blunted.

Brushes

Brushes are expensive, and it is therefore sensible to choose only the ones you will need to start with from the vast range available.

Sables, the most expensive, are used to make precise, accurate marks in details, and for applying glazes to produce flat, simple areas of paint. More resilient than similar brushes made from squirrel and other hairs, they will last far longer if properly looked after.

Tough, resilient hog-hair or hog-bristle brushes are used to establish masses. They come in four basic shapes: flat (square-ended), bright and filbert (both flat with rounded tips), and round (with a tapered end). You will probably use rounds more than any other brush. A good-quality brush keeps its shape when loaded with paint.

Nylon brushes can be excellent and very hard-wearing. However, they lack the 'touch' and 'feel' of sable, and lose their points all too easily.

Some cheap brushes with squirrel-, camel-hair, etc. will give good service. A small assortment of sizes, from half an inch to two inches (1.3–5.1cm), is useful for painting in the first basic colours or establishing broad, simple masses.

House-painting brushes are essential for priming boards and canvases.

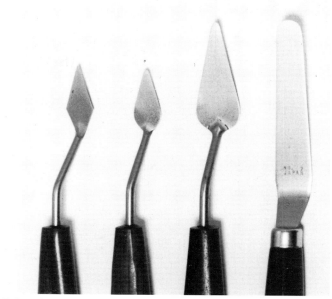
Palette-knives

Caring for Brushes

Brushes must always be thoroughly cleaned after each painting session. Use turpentine substitute or paraffin – pure turpentine is expensive. Never allow paint to dry on the brush. Although it can be dissolved with brush cleaner, the hairs or bristles will become brittle and soon spoil.

After cleaning, wash the brushes in soap and water. Make a lather in the palm of your hand and press the brush gently into it. Make sure all the hairs are covered, and that the soap reaches the ferrule in order to get rid of the turpentine. Rinse in cold water, and repeat two or three times. It is important to keep the ferrule clean. If paint collects near its base the brush will lose its elasticity.

Store brushes lying down in a drawer, or head up in a jar. Use a roll of stiff paper, fixed with a rubber band to protect the heads of expensive brushes. Special cylinders can be bought for travelling.

Correct storage is absolutely vital. The shape of a brush left standing head down in a jar will be permanently ruined. This applies particularly to fine, expensive brushes.

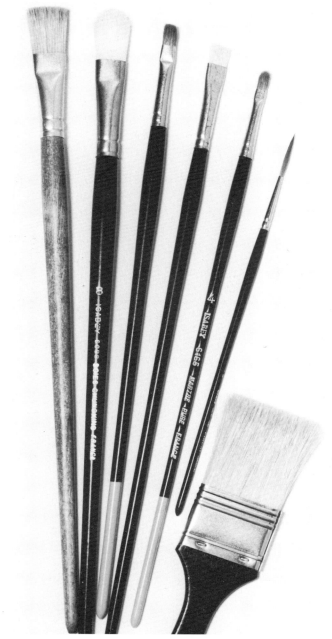
Brushes; the thick example on the right is a house-painter's priming brush

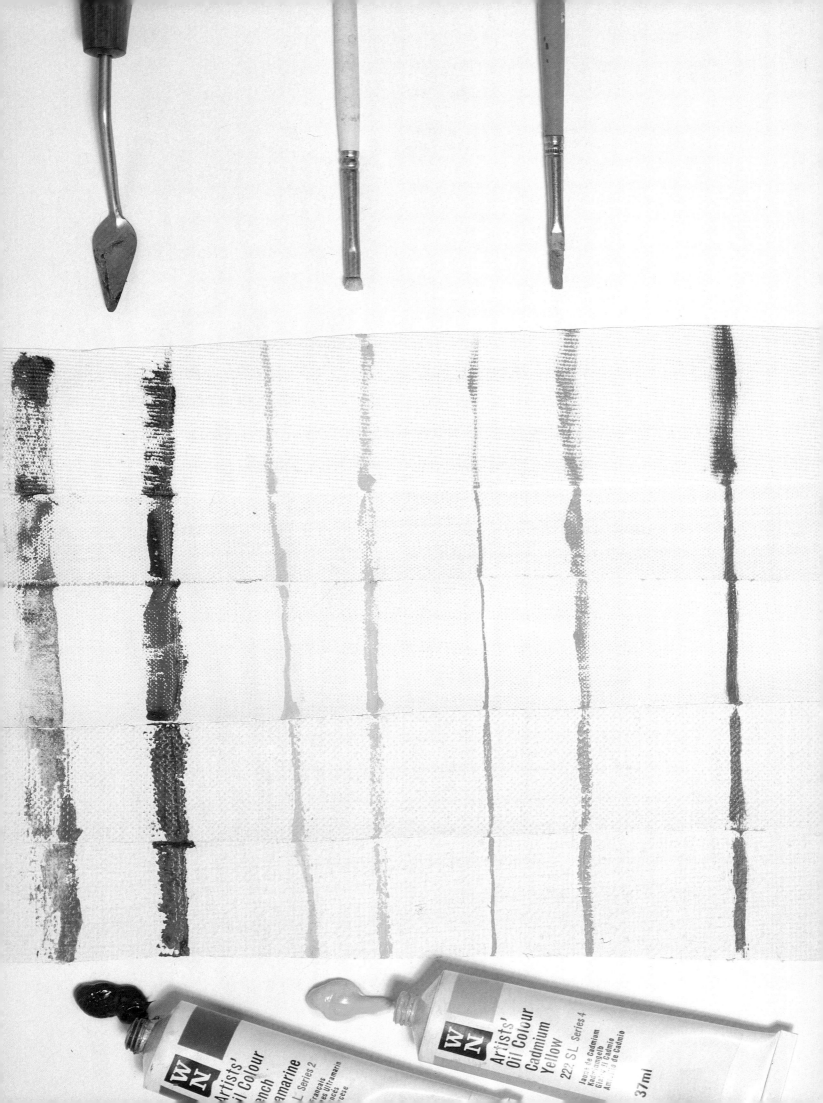

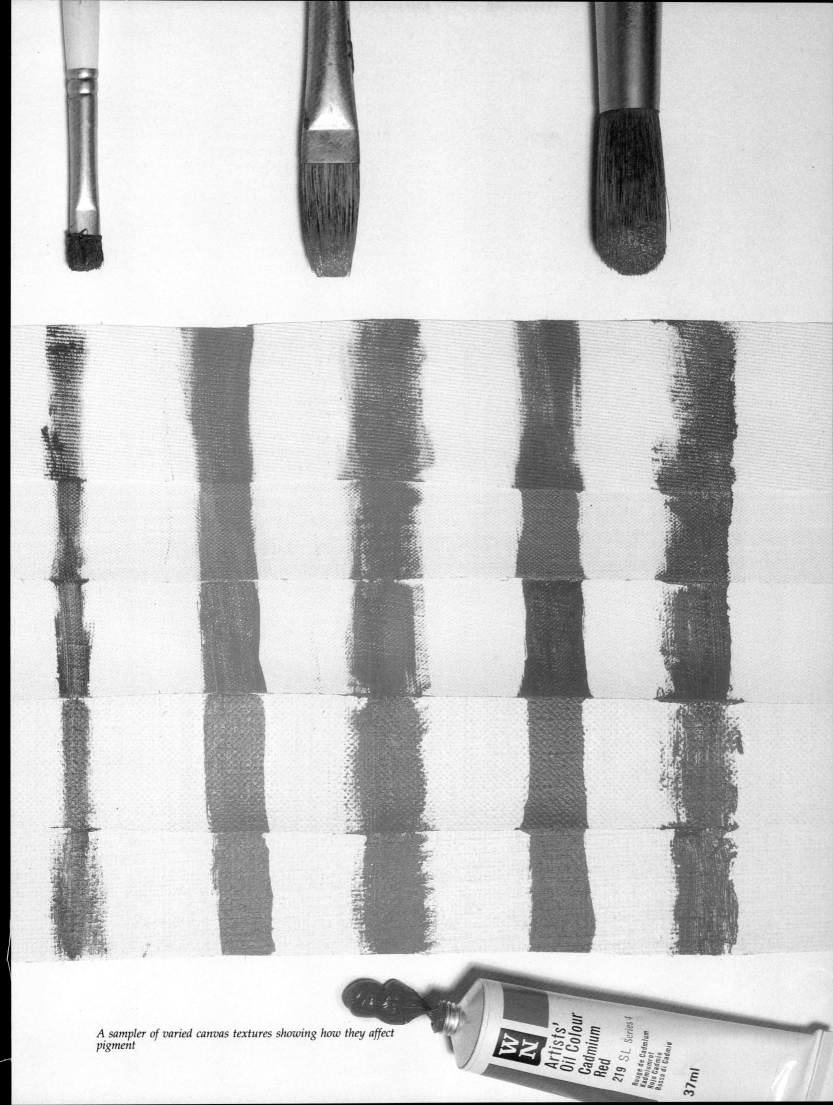

A sampler of varied canvas textures showing how they affect pigment

Surfaces

Manufactured surfaces on which to paint range from oil sketching pads to relatively inexpensive stretched canvases. However, the earlier exercises in the book are mainly experimental and at this stage it will make economic sense to prime (and batten if necessary) your own surfaces. The following all provide excellent supports at little cost.

Cardboard and strawboard are cheap and provide good working surfaces if primed well. Inexpensive offcuts of hardboard are easy to find although they may need smoothing and sanding. They are firm, too; small sizes won't need extra support, but boards over 48 × 36in. (121 × 92cm) should be battened to give a firm surface. Hardboard must be sandpapered to roughen its glossy surface and give the primer a key.

Plywood is also relatively cheap but, as with hardboard, larger sizes require battening to provide a rigid support.

Various materials can be used as grounds on small panels: bed-sheets, cotton shirts, small fragments of old canvas. A surplus set of sails kept me supplied for some time.

Never use any material made from synthetic fibres unless it has been specially manufactured for painting. The oil in the paints dissolves some synthetics, and you may find holes in your favourite picture.

All surfaces, of any kind, must be primed before use, and canvas in particular must be properly prepared. If you don't take this precaution, the oil will eventually rot the material.

A variety of surfaces from fine to coarse

Priming Boards and Canvas

Use a commercial primer – they are inexpensive and widely available – but be sure to buy the right one for the paints you are intending to use. An oil-bound primer is not suitable for acrylic paints.

Use glue size, available as a powder from decorating shops, to make your own priming mixture.

Mix the powder with water, and apply it thinly to the surface with a decorating brush. The layer should be quite thin, so that the surface is just tacky when you touch it. If the layer is too thick it will crack as it dries.

When the size is thoroughly dry, apply two coats of a good, oil-based (or acrylic-based) white or neutral undercoat. Brush it on without trying to smooth away the marks made by the brush – they will give the board added tooth. This is not necessary if you are working on canvas.

If you want to experiment with textures and underpainting, lay the primer on a little more thickly, and work in various directions – vertically, horizontally, or a combination of the two.

You can also stretch a muslin over the board and glue it on with the size, which should be mixed rather more thickly than normal. Leave a generous overlap to stick to the back of the panel and glue a sheet of paper onto the back to counteract warping. Finally, apply the primer.

Emulsion or acrylic paint can also be combined with a clear plastic gel as a primer.

Apply the mixture, not too thickly, directly to the surface, moving the brush from side to side, then from top to bottom for a good textured key.

When the emulsion is dry seal it with another thin film of gel to prevent paint from sinking into the surface and drying matt. The medium is quick-drying and painting can proceed on the same day. Linseed oil and undercoat paint are alternative sealers but take longer to dry.

PVA, a clear acrylic finish, can also be used to stick muslin to hardboard. Follow the method given for glue size above.

Equipment for priming

Unprimed canvas

Primed canvas

Oil Paints

The selection of oil pigments at an art supplier is positively staggering. Yet, for beginners, so much choice can be counter-productive. Not only are the names and similar colours confusing, but the broadness of the range may lessen your enthusiasm for mixing your own palette.

Turn away from temptation, and choose just five tubes of paint: white, yellow, red, blue and black. These will produce almost all the hues and tones you will need; special colours can be added when necessary, once you understand why some tints cannot be mixed on the spot.

Artists' oil paints are expensive. If you are working to a budget start by buying students' colours. They are less finely ground and have a considerable amount of additive, but are perfectly adequate for experiments, and for underpainting. You will eventually need the better paints for finished paintings.

Experiment by painting pairs of squares, in the same colour but in the two grades of paint. Some colours will show up well in both artists' and students' colours; some are only successful in the best grade.

Some mixed colours should never be used as they have a tendency to leak into the rest of the palette. Prussian blue is an example.

Start with the following colours: titanium white, cadmium yellow, cadmium red, ultramarine blue, and black.

Red, yellow and blue together will make browns and greys, red and blue produce lilacs and mauves, and, as every child artist knows, blue and yellow make green. The depth and intensity of these secondary colours varies according to the proportions in which you mix the basic pigments.

Oil paints can also be thinned with turpentine and applied in washes like watercolour, or scumbled and worked over the canvas without the addition of any liquid.

Paint thinned with an extender, used for a wash

Extenders

Most pigments are already blended with an oil such as linseed or poppy, and you can thin or extend the paint with turpentine. Always use pure turpentine from an art store or supplier; white spirit or turpentine substitute can contain impurities that affect the colour.

Linseed oil can sometimes be used to thin paint, but be careful to use only small quantities; it slows the drying process, makes lighter tones yellowish and discolours them, and may cause the pigment to wrinkle as it dries. However, it is useful if a painting has dried out before you have finished working on it. Brush the oil over the whole surface, then remove the excess with a soft rag. Press hard and lift the rag carefully – don't wipe the surface or you may blur the brush-strokes.

This oil treatment softens the paint and in a few moments the painting will be ready to take more work. The oil also brings the colours back on a finished picture if the pigment was too thin and has sunk into the canvas.

Another way of keeping colours bright is to apply a light coat of retouching varnish with an atomizer. It is blown on in stages as the painting develops so that all the layers retain their freshness. Always make sure the paint is really dry first.

It is also possible to mix paint with equal quantities of retouching varnish, linseed oil and turpentine. This keeps colours bright even after the paint has dried. Experiment with a small painting; work on one side with this mixture, and on the other with the usual paint and turpentine. See which you prefer.

Drying gels and mediums are sold in many art stores. Although they affect the colour in the long term, they are useful if time is limited, if you are working outdoors – or if you are impatient.

Paint straight from the tube, used with very little turpentine

Starting to Work

The most adaptable and versatile of the media, oil paints vary according to the surface to which they are applied. Paper, wood, glass, metal, plaster, leather, canvas, and synthetic fibres have all been used. Each has a characteristic effect on the quality of the paints.

Two basic techniques have developed side by side: the 'layer' method, and alla prima.

In the first, a single layer of colour is laid, and successive layers are applied to build up and develop the image, so that tone and colour are glazed and blended. The paint of each layer must be dry before the next is added. 'Thin' layers are put on first, 'fat' last, with thick impasto paint reserved for the top. If thick layers are applied first, cracking is almost sure to result.

In alla prima wet paint is worked into, and onto, wet paint; and the study must be completed within the drying time of the pigment – one or two days, depending on the thickness of the paint. Freer and more spontaneous than the 'layer' method – paint is applied in a broad, fluid manner – alla prima has been adapted to modern techniques, using spray-guns, masking-tape to create hard edges, even a bicycle to spread the paint (though this is probably bad for its tyres – and hard on the canvas). Pigment has also been dripped or splashed, and it is possible to apply it with trowels, rags, knives, fingers and hands. However, alla prima can be used finely, with the utmost delicacy, to record minute details.

Alla prima

Traditional layer technique ; Murillo

Modern layer technique

Special Oil Technique: Impasto

For a really thick consistency, use a knife to build up layers called impasto, with paint straight from the tube. If it is first laid on blotting-paper, some of the oil will be soaked up and the paint will handle more easily and dry out a little faster.

You can also add enough varnish to make the paint fluid so that it can be easily mixed with sand, plaster or sawdust for body and texture.

A distinctive surface can be achieved by laying such textured paint over the canvas, then wiping it off to leave only the pigment trapped in the rough surface or 'tooth' of the canvas. Scoop excess paint away with a knife and store it in a covered tin to avoid wasting too much expensive pigment.

These are only some of the methods you can use – individual artists are constantly exploring the potential of oil, and the medium's frontiers are always being extended. So many factors are involved – pigment, brushes, canvas – that it will take time to find the one or two styles that suit you best. Don't fall into the trap of settling into only one style of painting. This will simply inhibit you, and stop any real progress. Experiment and explore all the time. Even if you fail occasionally, you will develop your confidence in handling oils and gain a broader understanding of the medium. Eventually, as much through trial and error as by following some particular school of painting, you will find the technique which suits you best – your truly individual approach to art.

Be critical of what you do but, above all, keep painting. You will eventually find that what you leave out is as important as what you put in.

The entire process of learning to see, to make choices and decisions, is fascinating. Don't hide your efforts. Put them on display, at least in your own room. Studying these paintings – however clumsy and inexperienced they may seem – will help you to understand your faults and virtues, and enable you to remedy the former and develop the latter.

A Surface Project

Start by priming your surfaces. You will need some hardboard panels of the same size. Stretch muslin over each board, making sure it is large enough to be folded over the back of the board. Glue a sheet of paper on the back of each board to prevent warping.

Coat the surfaces with a commercial primer, or use two coats of glue size mixed with water. Then apply a thicker coat to just half of each board. Let the boards dry thoroughly. Choose a few simple objects, with not too much surface decoration.

1. On the first board, paint the group of objects quickly, working right across the surface with its two different thicknesses of primer, and using

broad brushes and thinnish paint. Experiment with a limited colour range such as white, ultramarine and cadmium red.

1.

2. Put a coloured ground of raw umber on the second board, then put white over that on half the surface, brushing it on at right angles to the umber section. Let it dry. Make another study, again working right across the white and umber surface.

Try various methods of applying the paint and using your brushes; different shapes of brush will produce different surfaces.

For large, flat areas of colour load the brush with turpentine to thin the paint and lay a wash. Use this method to create a gradation from one colour to another.

These different methods of application will give each study a character of its own. Explore the possibilities of stippling paint, and use individual points of colour to achieve an optical mix.

Such experiments will help you to appreciate the qualities of different paint surfaces, and you will learn how to use materials imaginatively.

2.

Experiments with Surfaces

Oil paints also have a special quality of depth, so you can make the brush-strokes add an extra dimension to your work. The triple image below shows how three different colour ranges on the same white canvas give three very distinct impressions. It also (by comparing similar areas such as the three versions of the field in the middle foreground) gives a clear example of the many kinds of brush-stroke that are useful in all but the smoothest style of painting.

The sections also show what you can achieve with tone; the first part is pure tone, moving from dark in the foreground to paler tones in the back. The second, middle, section is based on cool colours and tones, with greens and blues. The last section includes the full warm palette of tone and colour moving from sunny golds in the foreground to a paler sky full of clouds and shadows.

Opposite; make a sampler with a variety of surfaces from smooth (old denim, top right) to rough (coarse hessian, bottom left)

Drawing and Oil

There are two basic approaches to drawing as a basis for painting in oils.

Whichever method you use, remember that it is essential to compose the picture. Sharp observation and dexterous handling of paints mean nothing if they are combined in a poor composition. This applies equally to beginners and to experienced artists.

The first approach is to make preliminary studies on paper. That will enable you to decide on the final composition of the picture, and become familiar with the subject, before committing yourself to paint.

It is useful to do a sequence of drawings on one subject, so that you build on experience and learn to compare different approaches. When you have decided which study to use for your painting, cut two right-angled pieces of card and move them around on the drawing to establish the final shape of the composition.

The second method is to draw directly on the working surface. Charcoal is probably the most flexible medium, as it can be dusted off with a rag if you change your mind about your basic sketch. Before you start using paint make sure you get rid of any excess charcoal which could show up on the painting, especially in lighter areas.

Light pencil or watercolour can also be used; or

A first study, on paper, for the painting on page 243

thinly mixed acrylic, provided the primer is not oil-bound.

Before you start to paint over the drawing, reinforce the main outlines with underpainting. Use a thinned oil colour such as raw umber and a medium to small sable brush. Remember that the paint can be wiped off with a rag, if necessary. One of the advantages of using oils is that the 'bones' of the work can change shape until you are happy with the final composition.

The choice between making preliminary drawings on paper or directly on the working surface is up to you. Select the approach that suits your style and way of working, as well as the circumstances. If you are outdoors, sketching on paper may be easiest. But remember to work directly from the subject to the working surface every now and then.

Very simple outlines in thin oil

More complicated drawings in charcoal and thinned oil tones

Drawing Under Oil

This project is concerned with flat shapes and silhouettes. Concentrate on achieving tonal accuracy, and quality of surface – the paint must be thick, but not so thick that brush marks are obtrusive. At the same time you will become more familiar with the tools of the artist's trade.

Place a few plants or kitchen utensils on a white table or tablecloth, against a white wall. Concentrate on their contrasting shapes, arranging them simply but in such a way that they produce interesting negative shapes.

Step 1. Use charcoal as a drawing medium. It can be easily altered, and the purpose of drawing before you paint is to allow for changes of mind. This study is intended to show you how to arrange and appreciate shapes, so don't worry about tidiness.

When you have completed your drawing, choose your paints. Keep to a simple range of colours. Put some paint on your palette, and mix it with a little turpentine or linseed oil.

The mixture should be fairly thin, allowing you to keep your brush-strokes light and spontaneous.

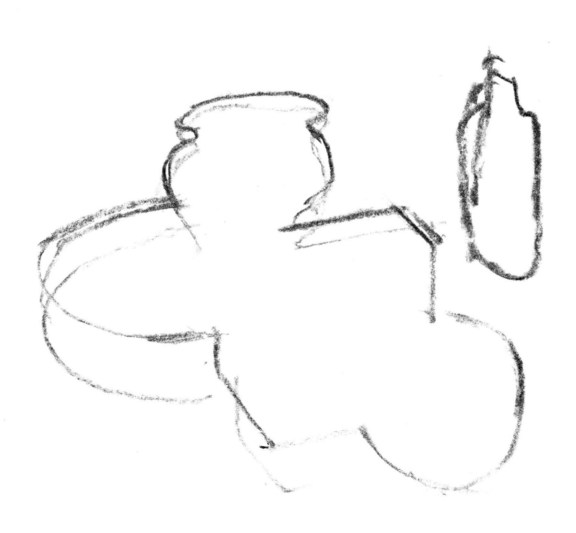

Step 1.

Step 2. Now fill in the shapes with a No. 6 or No. 8 hog-hair brush, keeping them flat and in silhouette. Wipe off unsatisfactory attempts quickly with a rag. Use a No. 4 sable or No. 2 hog-hair brush to point up the lines of the objects, and then fill in the flat areas. As before, don't be afraid to erase anything that doesn't please you.

Don't make the paint too smooth. Brushes make characteristic marks that are individual and responsive to your hand, giving a very personal look to even the smallest sketch.

Stop from time to time, and take a step back to examine what you have done. Study the marks made by your brushes. Remember that simplifying the objects won't mean that they lose their identity. On the contrary, this very simplification will define their relationship to each other and to the surface on which they stand, and it will imply depth, even though you are working in flat silhouette.

Spend some time exploring different viewpoints – the group will look totally different if you are standing up rather than sitting down. Bear in mind the section on perspective in Lesson One.

Remember that the finished composition must relate to the shape of the canvas. A long board will be best for a wide picture, a tall one for a narrow group, and so on. For this study use a work surface about 16×20in. (40×50cm).

Step 2.

Elements of Composition

In many paintings composition is built up of various levels of structure: perspective, tone, colours and pattern.

All may be of equal importance, or one or more may predominate.

As you start to paint, it is essential to recognize each of these interdependent elements and to decide how to incorporate them in your picture. Otherwise you will have to correct and readjust basic faults at a stage when you should be able to concentrate on finishing your painting. It is particularly frustrating for a beginner to find that a poor composition and unplanned relationships of colour detract from carefully observed, finely executed detail.

Learn to analyse the underlying elements in works by other artists.

Look for the drawing underneath the surface: this is the foundation of a painting, its ground plan. It is especially important in oil painting, which takes longer and is more reflective than other media. It is a basic element in the vocabulary of art, which you will learn to combine with others to create phrases and sentences.

Sketches are one of the best ways of working on the differing elements in your paintings. They allow you to experiment over and over again with viewpoints, with angles and perspective, with colours and with tonal values.

You can make your sketches in a variety of media; the artist who thinks about painting will always carry a sketchbook of some kind, together with a pencil, a ball-point pen, or a stick of charcoal.

These sketches illustrate the elements which will be combined in your final painting.

Finally, colour. Black-and-white sketches are of course more limited but they are so quickly done that even a few words written on the page will act as a memory bank so that you recall the scene with surprising exactness – especially if you work up a colour sketch soon after you return home.

Different techniques, depending on the individual artist, can be used to create an illusion of space and depth. The section on perspective in Lesson One includes exercises and experiments in formal perspective drawing – take time off to study your projects again.

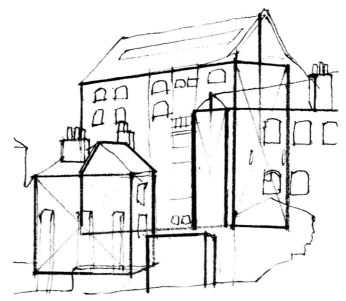

Perspective in line for practice

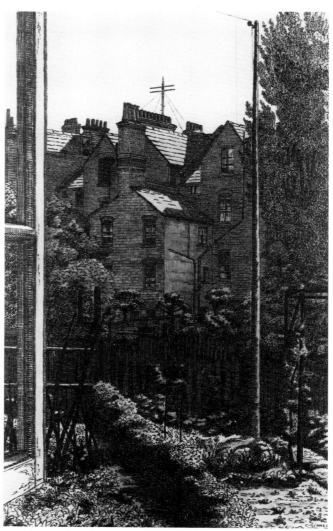

'London Backyard'; Ginner. A composition with perspective, line and tone

Using shapes to create pictures in tones and colour; these oil sketches progress from the first tones to a recognizable still life

Perspective and Colour

Colour operates to provide perspective in the same way as the monotone strips of black and white you have drawn before. First make a chart using yellows, reds and blues in progressively lighter ribbons of colour. The darker pure-pigment squares will seem to be nearer than the furthest squares which are mixed with increasing amounts of white.

Make another chart with contrasting squares, and see how the squares seem to change size as the colour changes.

Colour can also be used in a very specific way to create perspective by means of tone shapes.

Look back at the drawings of circles and cylinders in Lesson One. Find a circular fruit – an apple is ideal because of its many colours, but an orange would be too plain. Put the apple on the table and draw it in perspective as illustrated in the centre of the illustration below. Using black and white only, give it shadows and highlights. Then blend all the tones together to create a smooth sphere, as in the example on the left.

Now look at the apple again; you will see all sorts of shades and speckles in reds, greens and yellows. Draw the apple with your dark paint, but then colour it in, keeping the blocks of your perspective drawing, but using colour instead of black. Immediately the apple becomes solid and natural – a little rough in shape, with the changing tones of fresh fruit – even in this simplified sketch.

Give yourself a variety of problems by buying a dozen apples of different kinds and degrees of ripeness. Put them in a box or other container, and one by one take them from a first sketched sphere to a three-dimensional representation, with varied colours, irregular shapes, and slightly different angles.

Using Tone in Compositions

Tonal range consists of gradations from light to dark as in a black-and-white photograph. The lightness or darkness of an area in relation to other parts of a painting is its tone value; and a work can be described as high- or low-key depending on whether its general tonality is light or dark.

Because darker tones seem to stand in front of lighter gradations, a good tone structure will reinforce other methods of creating depth. Tone can accentuate weight and drama in a composition; and, because of its varying gradations on round objects, it can be used to distinguish them from flat ones.

Tone is simple to understand – but constant practice is required in order to paint it successfully. It can be difficult to visualize oil paints in terms of tone because the very intensity of their colours distracts the eye. For this reason it is important to practise seeing tone values before beginning to paint seriously with colour.

By comparing the objects you will see that bright colour is not necessarily the strongest tone. A Polaroid camera would show the comparison at once, but you must learn to see it with your eye.

Tone Studies

Using a No. 6 or No. 8 hog-hair brush, paint ten gradations from white to black on board or canvas. Start with pure white paint and gradually mix in more black until you reach pure black.

The darkest tones will appear to stand in front of the progressively lighter shades.

Paint a simple picture using the same gradations of black and white to create a tonal recession of objects from dark in the front to light at the back. Choose a subject with a fairly long perspective – at the end of a room, or the view from a window or down a road.

This study shows how tone can create a sense of depth – which may not be obvious in reality. If you get bored with black and white, try using tones of red or blue mixed with white.

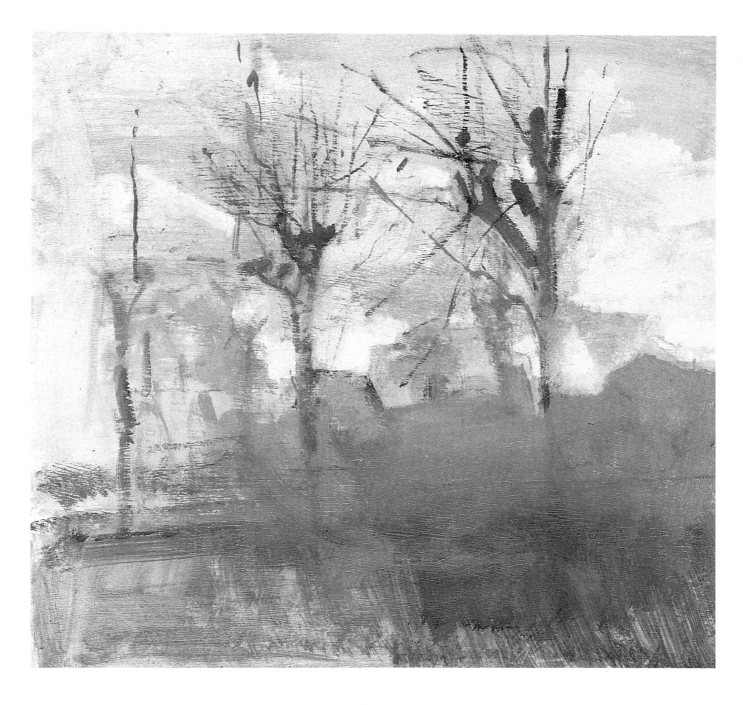

Colour and Light

Colour also responds dramatically to changes in light. Paper-covered boxes of exactly the same shade of red or yellow will look very different in sunlight, in semi-shade, and in full shade. This phenomenon is also used to create depth; it acts as a two-dimensional perspective aid.

Divide a square canvas into horizontal strips. Now take your primary colours right from the tube and paint small squares of each colour along the top strip. Think of the strips as a set of steps.

Fill in the strip underneath with squares of the same colours but in a darker tone. You should have a sharp edge between the different tones.

Now imagine a band of sunlight falling across the next strip – or 'step' – and add plenty of white to your primary colours for this row of squares. Below this again, paint in another, darker strip.

Keep on in this way, working down each colour in turn. With nothing more, you will see depth, light and shade all in one simple study.

Remember to keep your brush as clean as possible or you will muddy the colours and soften the sharp edge of the 'steps'.

Then look again at the oil colour wheel on page 99 and see how the gradations of colour change in combination and in contrast.

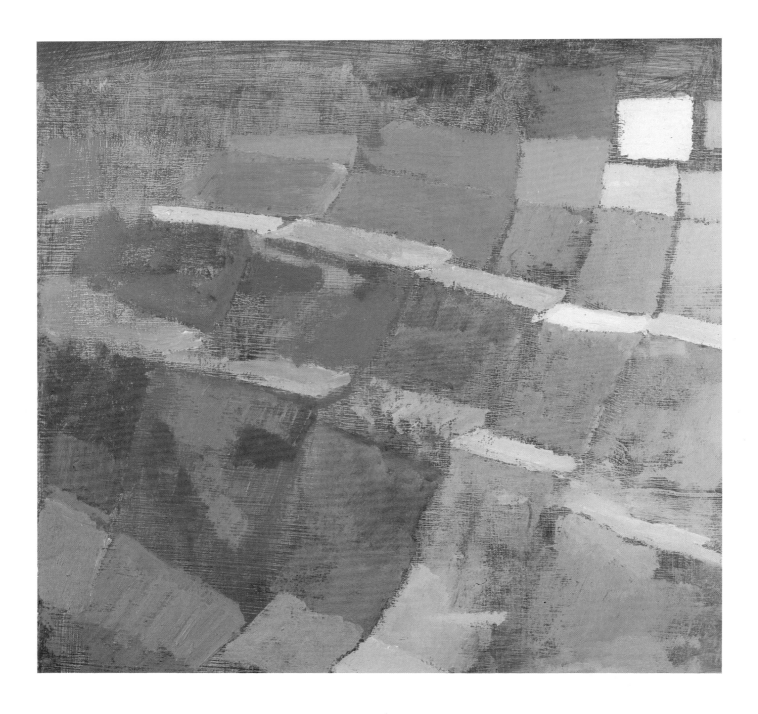

When the steps are finished you will have an interesting picture in oils of how colour changes in different lights. In this example I painted the tones in the bottom row as they would be seen in electric light inside a room.

The blue is very dark and rather mauve, the red is almost deep orange, the green a forest colour, the white distinctly grey and the yellow a gold-orange.

As the steps move upwards and outside to natural light, the colours become lighter and clearer. The blue is now a bright sky-blue, the red is much cooler, the green has become blue-green, and the white and yellow squares are near to their pure colours in the spectrum.

Look below at the two studies of a woman in a chair. The pose is almost the same, but two very different families of colour tones were used – the result is startling. On the left, a brilliant group of reds and yellows give a warm impression, with pinks and yellows in a few simple lines adding a further feeling of sunshine.

The second study was done late in the afternoon. The pose is drawn from a different angle. Almost all the warm colours have disappeared, leaving the underlying blues and turquoises to predominate.

You can use the changes in natural light to help you look at the effects of colour, or put filters or coloured acetate over your own electric lights and make studies of the effects.

A Philosophical Journey in Paint

In these first three lessons we have discussed painting and all its elements – the philosophy, practical applications and techniques of the activity known as art.

At this stage in your work, it is important to come to terms with the medium you are using; with its quality, its sensitivity or lack of it, and with the handling and communication that occurs between an artist and his materials.

Oils are particularly appropriate for extensive and practical experimentation because their physical presence is more intimidating, and at the same time more flexible, than that of other media.

The thick paint which comes out of a tube is, of course, already a mixture of pigment and a binder. It would therefore be interesting and useful to try making your own paints.

As described in the earlier sections on raw materials, all paints are made from pure pigment, which itself comes from various materials: clays, carbons, minerals and artificial chemicals. The ideal pigment will remain true to its colour no matter what the temperature, and despite exposure to light and to acids or alkalis in the air or in other materials.

Buy raw pigments in their powdered form – the earth colours are appropriate and exciting to use. Try out different binders like linseed or poppy oil, or experiment with more unusual ingredients such as nut oils. Raw, cold-pressed and refined versions are normally available, and each will impart a slightly different texture and tone to the mixture. Artificial oils are also on the market but have not yet been perfected and may cause considerable problems, both when you use them and after they have been on the canvas for many years.

Put the powder on a clean sheet of glass, sprinkle with a little oil, and mix with a palette knife. Then grind slowly with a glass pestle until the oil and the powder are evenly amalgamated.

Mix the same powder with different oils and see how each one handles, how the colour is affected, and what happens to the texture after the paint dries. These changes are dependent on the surface, the amount of binder – and extender – the ingredients in the paint itself, and even the weather. You will learn by experience which colours are most likely to sink into the surface, which change perceptibly (usually growing duller and lighter) as they dry, and which retain their freshness and sheen. There will be distinct qualities associated with the different depths and richnesses of tone.

Some artists always grind their own paints, and you may find that it increases your understanding of the medium, and gives you greater flexibility especially with some of the more difficult colours. There is obviously considerable satisfaction in creating your own materials as well as your own pictures. However, most practising artists eventually find a commercial product which has most of the qualities they prize, and are willing to sacrifice some part of the craftsmanship of art for the convenience of ready-mixed pigments from tubes. This applies especially to anyone who does a reasonable amount of outdoor work; studio-ground oils are much more difficult to store and transport.

Now try your paints on primed canvas. Spread them with the palette knife you used to amalgamate them, and see how the occasional lump of powder creates a streak or blob of colour. The colours may need regrinding with the pestle, or you may enjoy the uneven effect. As you work, try to grip the palette knife as lightly as possible. See if you can feel the texture of the paint, transmitted through the tool to your fingers. Experiment with small changes of direction, flicking your wrist to make curves, rotating it to create circles.

It is a fact of nature that few movements of the body are truly angular. Straight lines seldom come naturally. Practise moving your wrist and arm in comfortable companionship. Try standing with the knife held out, or come close to the canvas and bend your elbow, moving the paint up and away from you, almost with a swimming motion.

Take some ready-made oil paint and repeat these movements, holding your knife as lightly as possible and trying to feel the difference in resistance as paint textures change and develop.

Now, do these exercises using a comfortably large brush. An important aspect of painting with oil is the broad effect you can achieve with quite simple strokes. Unlike the precise lines of a pencil or a thin watercolour brush, the larger brushmarks contribute to the picture in a much freer idiom.

To study what you are doing on canvas you will have to step back over and over again and look at the effect, then step forward, add a few strokes, and step back again.

Experiment with acrylics as well, blocking out colour changes and concentrating on the feel of the paint under your knife.

Sensitivity to touch is one of the key distinctions between an artist and a person who is just using paint. Children playing with mud and water soon learn that there is a basic sensual delight in creating patterns with their hands and fingers. Cooks find that kneading and mixing is a kind of

relaxation therapy. Potters work on clay with an inner rhythm and tension that creates individual shapes no matter how consistent the moulds. So it is with oil paints. The rhythm of working the brush back and forth, the half-turns and circles, the stabbing motions and the wide sweeps all create a physical reality unique to the artist.

As you work with different tools keep changing the mixture, adding different proportions of binder and extender to the pigment, so that your hands get to know the feel of the paint, its resistance to movement and the ease with which it travels over the canvas or stubbornly sinks into the fabric. If you have some extra pure colours, mix them with oil. You will see how different colours soak up varying amounts of the blending agent, and you will also begin to understand that colour is not only visual but tactile.

We cannot stress too strongly that these exercises and experiments should be tried again and again throughout the year. They are not only the first steps in truly understanding paint, they are also a continuing dialogue between your eyes, your hands, and the medium.

As your knowledge grows, so will your expectations. At first, almost any result which bears some resemblance to the subject will be satisfying! But as you work and learn, you will become more ambitious. You will demand more of yourself and of your material as you see the potential in a subject but find it difficult to re-create what you see in your mind.

Never be discouraged by the gap between what you imagine before you begin, and what you achieve. Each attempt is a challenge, each new idea leads you towards what you will be able to do the next time, or the time after that.

Many art students are astonished to find that their teachers also make similar journeys with each painting: an idea becomes an image, translated into physical reality.

You will often be disappointed, aware that what you wanted is not quite there, that the work has somehow developed a life of its own, to be acknowledged and coaxed towards a goal – a goal that may well be very different from the concept you held in your mind when you put the first strokes on canvas.

Nevertheless, all artists know – or continue to hope – that the challenge will be met, if not this time, then the next. Certainly paintings can change and grow to reach an identity of their own making which also expresses what the artist wanted to achieve.

Remember, too, that you will be your own severest critic. However, you must not allow yourself to be destructive. Understand and appreciate that there will be failures, but that you can learn as much from them as from your successes – sometimes even more.

Learn to 'let go' when necessary. If a painting constantly eludes your brush and your eye – set it aside. Perhaps you will come back to it eventually, perhaps you will simply paint over it. Either way, the activity simply of making a painting will have been immensely valuable, teaching you more than all the lessons you read in a book.

Of course, we are not suggesting that you stop reading! Not only because we hope to offer you guidance and assistance as you work, but because there are many books about painting, and all the arts, which may spark off new directions or new philosophies, all grist to the mill.

When you read a description of how a particular artist painted, try to see how the technique works for you. Experiment with sketches in different styles, with small Op Art patterns, abstracts, realistic mini-paintings that are soon completed and with special effects for cloudscapes or techniques of creating light and shade. Provided you borrow on a small scale, you will not be copying, but you will be making your hands and your eyes more flexible and more appreciative of the problems which other artists have faced, and sometimes solved. Oils, which quickly make the effects you want, are particularly useful for this kind of experiment.

Finally, learn to think about what you are doing. As often as you can, take the time to look carefully, to observe, to store up sights and visions for the future. Driving down a road will offer new compositions at each turn, new shapes with every passing cloud. Learn to think in painterly terms. When you read about charcoal, visualize the pigment in your mind – grey and rich, not quite black. When you listen to music, see if you can associate colours and tones. Imagine that you are designing a cover for a record of a particular composition. What would it look like? Which pigments would reflect the colour of the music?

Read poetry for its own delight, but occasionally imagine a painting which might spring from a similar emotional state. At first you may see only the yellow daffodils in Wordsworth's famous sonnet, but try going beyond them to an impression of spring, portraying the promise of new life and the first flowers in less realistic terms. With that added sensitivity, even the most prosaic flower study will take on a glowing freshness.

If you have a favourite novel, think about how you would illustrate a scene: the colours, the light, the atmosphere. Many writers 'paint' with words, so try to turn words into paint.

Never imagine that art exists in a vacuum. It lives through your eyes, your mind, and your hands, and the more you use all three, the more confident and capable you will become as a painter.

Extra Project

Colour Study

A very useful exercise is to make a one-colour study which will enable you to practise achieving all the subtle differences there are in a single colour range.

Decide on one of the primary colours – here I have chosen a brilliant red – and assemble a group of objects in that range. There are many variations on the theme: a red pepper, a box, a red apple, an orange, a bunch of everlasting flowers in oranges and yellows, and so on.

You may want to find a sharp contrast to heighten the effect – I had a white brush with a red handle in the kitchen which just suited my purpose.

The first step is to lay a basic undercoat on the canvas, using a mid-tone of your basic colour. Keep the strokes in one direction to create a smoothish surface, with enough markings for texture but not enough to distort your quick painting.

I found the objects I wanted to paint while the undercoat was drying, and arranged them, testing out a few groupings to help the colours mix and clash.

Your next step is to try some of the tones in short strokes on one side of the canvas, using your eye to match what you see. Put squares against squares, and move the objects if necessary to create an interesting study.

Finally, sketch in all the objects with your chosen mix of reds from your palette. Use a little black to darken some of the colours, and yellow to sharpen the orange tone and provide impact and even more excitement. Then put in the white touches with your paint thick enough to reflect the pure colour.

I cheated a bit and used a touch of blue on the wall, but that was artistic licence!

When you have finished, try painting a single object in a single colour, but with all the gradations you find in shadows and textures.

Make another study in a cool range, perhaps blue or green, and hang them side by side so that you can study them easily at different times of the day. An understanding of just one colour and all its tones can be transferred to give you mastery of the entire spectrum.

Looking at Oils

Woman Seated by a Window, an oil sketch on paper by Edgar Degas, is breathtaking in its simplicity: a beautiful example of controlled understatement, subtle colour and economic rendering. The woman is seen in three-quarter profile and is almost completely silhouetted; she seems to merge into the background, yet her head and hands stand out clearly as areas of sharp tonal contrast.

The range of colour and tone is minimal; white and earth red – possibly venetian red – comprise the light and mid-range, and a mixture of the same red and a blue – possibly deepened with black – provide the dark areas. The drawing is acutely observed, yet the mood of the painting is atmospheric.

The woman's form is stated with deceptive ease – the modelling on the hands and nose, and the hint of light reflected on the jaw, are created with deft touches of paint.

Ignore the figurative element in the work and look at it with a different eye. Analyse the linear structure, the composition, and the use of pattern and different surfaces – all are central elements in painting. In particular, look for the primary influence – the handling of flat areas to create harmony and tension without the need for much depth.

Everything in the picture is obscured and shown as flat shapes. The chair, a flat outline in the bottom left-hand corner, echoes the horizontal window-frame. The vertical line of the frame is just off centre and cuts across the diagonal line of the figure. These shapes are the painting's main structure. In the upper half of the canvas, the skyline hinted at in the distance accentuates the bridge of the woman's nose and her brow, while her left hand and knee are the focus of the lower half.

The dress is painted in a thin wash that fades out at the hemline. In complete contrast, the sky is laid on quite thickly with a stiff brush; these textures create tension against the quiet, two-dimensional rendering of the walls. The simplicity of the shapes, their placing on the canvas, and the variety of ways in which the paint has been handled within the overlapping areas, combine to create a perfect composition.

You can learn more from this one small painting than from a whole roomful in a museum. This wonderful little sketch stimulates the imagination and demands participation. There are some historical clues to how the artist's mind worked. Degas was very interested in classical painting and in Japanese woodblock prints. This can be seen in the tonal contrasts and in the simplicity of the shapes he used. He was acutely aware of the design element in painting, and a fine draughtsman; nothing was left to chance, even in tiny sketches that give the impression of having been completed in just a few moments.

Beginners tend to try to draw and paint everything in front of them. Learning to see as an artist involves isolating some of the elements in order to make sense of what would otherwise be a confusing visual experience. With examination and analysis you will eventually gain a greater appreciation of the parts, and so learn to cope more readily with the whole.

In *Woman Seated by a Window*, the predominant elements are the importance of shape and the artist's awareness of the boundaries that dictate the structure of the composition. Look at how Degas handled paint in the various areas and compare his approach with similar techniques used by other painters. You will learn just by looking and thinking. It has been said that 'if you are going to steal, steal from the rich'. Degas had a wealth of ideas and a richness of vision that are fruitful sources of knowledge for the student artist.

Part II
The Practising Artist

The first three media lessons are intended to increase your understanding of art as a concept, regardless of the medium in which it is expressed; and at this stage it is worth restating the basic principles of painting which we hope you will have been practising in the first few months of this course.

The key to all art is learning to see, and learning to record what is seen in visual terms. In practice this means training yourself to look at the three-dimensional world, and to translate what you see into marks and shapes on a two-dimensional surface.

This is basically true whether you work from objects in front of you or from memory, a theory or your imagination, under emotional stress or in moments of great calm. Your perception of what you see influences the messages your eyes send to the brain; we are asking you to look, to observe, to think, over and over again in every lesson. Keep that in mind as you work: it will affect your artistic ability in varying degrees as long as you continue to draw and paint.

One major problem is often mentioned by beginners who are asked to paint an impression of reality, a reflection of the substance and quality of the objects in front of the easel. They think that this would be merely 'copying', whereas the truly artistic work should reflect the artist's feelings rather than just record the visual world. It is an unnecessary worry.

You cannot lose the integrity of your individual vision. Even your tiniest sketch will bear the imprint of your personality.

These lessons will train your eye as a teacher trains your tongue in a new language. A child learning to speak first listens to sounds made by its parents; its first reading exercises are judged on this basis. Similarly, in art, reality is the best yardstick for judging how successfully your artistic vocabulary has been learned. Remember, too, that no matter which artistic 'ism' becomes your ideal of what an artist should say, it is always better to work from a basic skill, with the knowledge and understanding that accompanies its mastery, than from ignorance. There are as many different styles and forms of art as there are artists, and although you will eventually decide which of these best expresses your feeling about the world, a 'vocabulary' is essential. Art is, after all, a visual language, made up of marks and shapes, colours and tones, rather than words. As with words, it is necessary to learn how to transcribe, and combine, them.

As your artist's skill and vocabulary develops, you will be able to express increasingly complicated concepts. The approach will be entirely yours, inspired by your perception.

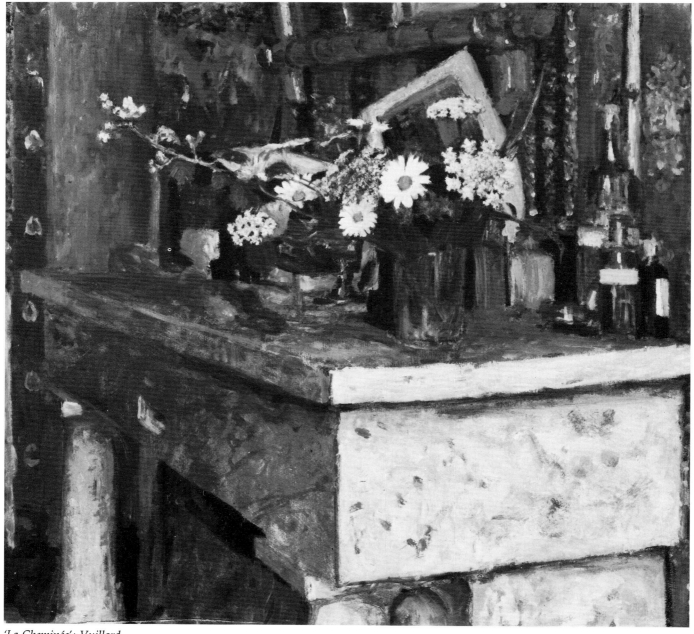

'La Cheminée'; Vuillard

Lesson Four
Still Life

The first cave paintings were of animals and huntsmen, and most early Christian artists concentrated on human figures in works depicting the lives of the saints. However, the earliest patterns on tribal pottery or fabrics were most often derived from nature – vines, leaves, flowers and fruits.

As Chinese and Japanese artists developed their skills, the philosophical content of their symbols was adapted to become an intrinsic element in their artistic vocabulary. A single branch, or an isolated blossom, encompassed a world of meaning.

Celtic and Viking artisans also adapted nature, but they abstracted natural designs and used them for the intricate, strapwork patterns that are such a feature of their metalwork. These linear patterns were in turn adapted by medieval illuminators working on manuscripts, who often included a flower or fruit in their calligraphy of ornamental letters. Such natural objects were also occasionally attributes of the Trinity, the Holy Family, and individual saints, who were pictured with an appropriate symbol: a lily, a rose, an apple, a loaf of bread.

In the Middle East symbolism had taken its own course. The portrayal of holy figures was forbidden, and their symbols were adapted instead. Paintings and woven rugs were elaborately bordered with intricate designs, which sometimes also covered their surfaces, and were almost always based on stylized flowers or fruits.

Like so many other concepts, still-life paintings as we know them first began to appear in the Netherlands and Germany, as artists used groups of fruits and flowers as part of the settings for their larger paintings. A table by the side of a figure might have fruit and a bottle of wine, while a depiction of the Last Supper would certainly contain bread and wine.

A lovely painting by Peter Paul Rubens (1577–1640), shown on the next page, depicts Mary and the Christ Child with a rambling rose on one side, a flower-patterned Persian carpet on the table, and bowls of fruit and flowers. The illuminated manuscript Mary is reading, with its floral border, would have been painted only a few centuries before, when the carpet was woven, and the little landscape in the background could be any of Rubens' paintings.

Studies for sections of paintings were made in conté, chalks, charcoal and, of course, watercolour and oils.

At first these sketches were admired only by other artists, but gradually patrons also began to appreciate the skilful techniques used to represent sun-ripened fruits and fragrant flowers. Increasingly, secular buildings were decorated with depictions of these subjects.

'Mary and Her Child'; Rubens

very subtle colourings that produced an unheard-of richness, and an emphasis on the sensual pleasures of food and drink. It was this instinctive and earthy emotional background that so attracted the early Impressionists with the chance to paint their own intimate surroundings: a simple pine table, a plate of bread and cheese.

These more informal still-life paintings became an important part of the artist's repertoire, perhaps simply because the subjects were always to hand and, being uncomplicated and ordinary in themselves, could be easily manipulated to create unusual images inspired by the new vision and concept of art rather than classical tradition.

Paul Cézanne (1839–1906) is probably the best-known exponent of such studies but in fact he was only one of a group of painters working in a similar vein in Paris, during the late nineteenth and early twentieth centuries.

As the Impressionists moved out into the open air, following Eugène Boudin (1824–98) and his friend and pupil Claude Monet (1840–1926) still life as a main subject lost a little ground, re-appearing now and again as part of the larger scene. The Cubists – Georges Braque (1882–1963) and Pablo Picasso (1881–1973) in particular – actually revived the original form, fascinated by the potential of the shapes and forms lurking within the simplest apple or orange on a plate, and many experiments combined the rounded shapes of plates and fruits to build up complex and angular patterns, the colours broken up into squares and rectangles, but still recognizable.

Henri Matisse (1869–1954), especially in his later works, often turned his whole canvas into a celebration of flower and leaf shapes and colours.

Flower studies, however, are always popular – perhaps because our appreciation of flowers is

At first, they were still not considered 'Fine Art' by contemporary critics; but today it is accepted that studies such as the watercolours of wild flowers and grasses by Albrecht Dürer (1471–1528) are masterpieces by any standard.

Two concepts of flower painting developed quickly: botanical illustrations, similar to Dürer's sketches, which ornamented many herbals and medicinal treatises; and imposing flower studies consisting of great bowls of mixed blooms in dark, rich colours, sometimes with fruit in the manner of the Rubens' painting – all spilling onto a polished table. Although the arrangement may have been informal, the flowers were carefully chosen and each dewdrop was deliberately added to create a spectacular effect.

Jan van Huysum (1682–1749) is one of the best-known Dutch painters who painted in this way. Some of his full-blown and grandiose bouquets include a butterfly or a hovering bee.

It was Jean Baptiste Siméon Chardin (1699–1770) in France who truly revolutionized the concept of still life. He took the techniques and skills which had been lavished on larger and more imposing subjects and transferred them to bowls of fruit and simple kitchen ingredients.

His fascination with the effect of light was also important in creating atmospheric effects and

Still Life; Cézanne

engrained and traditional whether or not we are interested in painting; and flowers add their own particular kind of decorative beauty to almost every gallery, and to many homes.

The delicate watercolours (mostly amateur) done by Victorian ladies always delighted viewers, professional or not. The tiny posies and daintily painted flowers have inspired many modern painters, even those whose best-known work is in a quite different vein. Many of the bright, clear colours of flowers and plants have been used, as Matisse used them, in decoration and fabrics rather than in actual paintings.

With the exception of flowers, still-life subjects today are very different from those of the past, and a group may include a guitar, a scarf, a doll or a poster. Close observation of ordinary objects has resulted in many realistic studies and unusual groupings are much more common than the dead pheasant and bowl of fruit that decorated so many Victorian dining-rooms.

For modern painters, the most prosaic still-life subjects can be infused with charm and unexpected colour to create delightful works that may also be a social statement about the way we choose to live.

'Peonies'; Houston

Starting to Work

To explain the very basic vocabulary of the different media, we have dealt separately so far with drawing, watercolour, and oil painting. However, in practice it is difficult and illogical to maintain this separation. Even so-called pure painting involves drawing, because defining the areas for the colours is simply drawing with paint. And although there are essential differences between watercolour and oils, the all-important principles that underlie the selection and translation of what is *seen* into shapes and colours are the same for both.

From this point onwards each lesson has a theme, a subject rather than a medium, and drawing and painting are combined within this approach. Although the problems relevant to each technique will be isolated to some extent, so that they can be studied in detail, there will be increasing emphasis on the need to appreciate that drawing and painting are basically the same activity.

'Still life' is the name given to groups of objects arranged on a table or some other flat surface. Shape and colour can vary immensely. Subjects are easily available and can be readily understood and recognized. The choice of colour, position, lighting, and the variety of objects used is controlled by the artist.

A still life is unaffected by weather and does not have to be moved to a specific location. Nor is anyone else involved. The artist simply sets up a group in a room, and starts work. However, a still life can also be extraordinarily responsive to changes in light and atmosphere, and is capable of tremendous emotional power. Three simple apples, for example, can sum up an entire way of life. On a plain white plate, on a pine table, they are the essence of country life; in glowing candle-light, on a silver bowl, they encapsulate all the luxury of an abundant banquet.

Selection

Still life, like landscapes, portraits and figures, involves drawing, describing space and light, and mixing the right colours and placing them in the correct relationship to each other. The following exercises will help you to understand these elementary principles.

The great masters of still-life painting were adept at capturing the beauty of light and colour, their skills reflected in details of glistening fruit skins, dewdrops on flowers, or shimmering glasses. Try to match the enthusiasm that shines through their work, even in these early exercises which will be concerned more with testing your newly acquired skills than with showing them off. Look around your home and select objects that are important to you, and which you find visually exciting. This excitement will be transmitted to your picture – and the viewer. You will certainly work with less conviction if you paint something you find dull and uninteresting. Remember that the true artist can be intrigued even by mundane objects like nuts and bolts.

For your first group, select objects for their different qualities of shape, form and colour: the sheen of an apple, or the rough surface of an orange; crockery with cutlery; a white cup, saucer and plate; a dark green wine bottle on a heavy linen cloth.

Choose one 'mechanical' object such as a hand-whisk, mincer or pair of scissors – you will later check the accuracy of your drawing against this. Don't include too many objects and colours in any one group. Fruit on a plate, or a few simple flowers in a glass, will be far more appealing than a large collection of objects in a variety of colours and textures.

Too many objects; choose three or four only

Simple kitchen groups

Even simpler flower study

Setting Up

Find a place where your still-life group can remain undisturbed for as long as necessary – perhaps for a few days. The corner of a room is ideal; instead of seeing the objects against a flat surface you will be able to use the angle of the wall as a reference. Alternatively, make an artificial corner with pieces of board and card.

Put the objects on a small table, or a tray or board – anything flat that will allow you to look slightly down on them. Arrange them so that they link and overlap – they should not be separate or isolated. Remember to mark the position of anything that is removed, so that it can be easily returned. Restrict the space beyond the group by placing it close to its background; use a wall, or a flat piece of board or card if necessary.

If possible, light should be thrown from above so that there are not too many shadows or strong, highly contrasted lighting effects.

For this first study it would not be sensible to spend a great deal of time arranging the objects. A good composition does not automatically produce a good drawing or painting; the time is much better spent working. Three or four drawings from different points of view will allow you to discover the best position from which to work.

Apple alone in watercolour; preliminary study

A popular grouping

Finally, decide on the position of your easel or pad. All drawing and painting is from memory, even if objects are directly in front of you. It is impossible to look simultaneously at them and your work; and most people's visual memory is weak. To prove this, look at a plain glass tumbler, then turn your back and try to draw it. Note the number of times you have to look again – and how inaccurate your drawing remains – and you will understand just how difficult it is to retain even the most simple information.

Place the easel so that you can look quickly from the still life to your work with as little movement of your eyes as possible. It is generally best to look slightly sideways at the objects. Some people always find it easier to work glancing round one side of the easel rather than the other – try this out for yourself.

Whatever you decide, a comfortable position that allows you to look easily and quickly from objects to your painting is of the utmost importance.

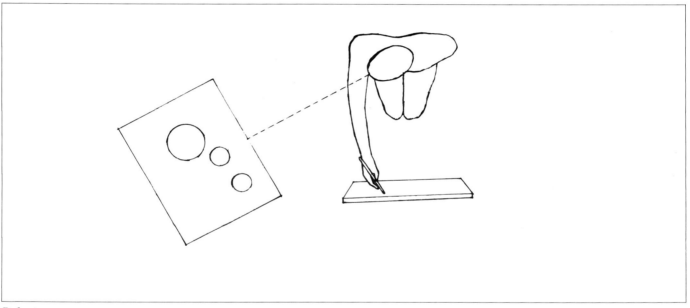

Bad set-up

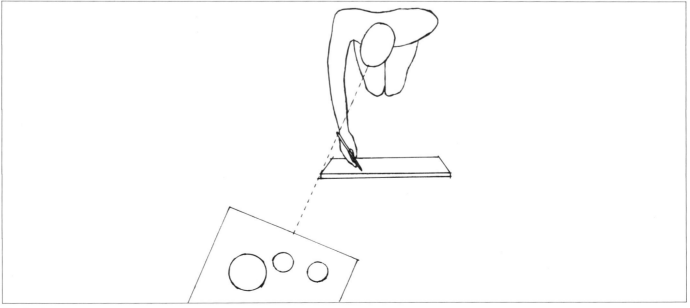

Good set-up

143

Pots and Pans Project

Bear in mind all you have learnt about positive and negative shapes, and the use of straight vertical lines – curtains, wallpaper, the corner of a wall – as references to draw outlines accurately. Put together your first group of pots, pans and other kitchen utensils.

The drawing project at the end of the first lesson showed how to combine different drawing media to produce line and tone, creating the illusion of form. Look at your group and decide which medium to use: charcoal on its own, conté as in the illustrations, or two or more media together – ink and wash, or charcoal, pencil, black conté and wash. Try to avoid pencil on its own. It is surprisingly difficult to handle and there is the risk that you will become completely submerged in the problems of merely producing shading.

Put your first studies of rectangles and cylinders somewhere close by so that you can refresh your memory without stopping work too long. These shapes will inevitably form the underlying structure of many objects.

Remember that drawing isn't just copying the light and dark areas in a still life. It is concerned with analysing shapes and forms, and suggesting their solidity, mainly by using combinations of line and tone.

Step 1. Using a charcoal pencil, lightly sketch in the horizontal lines which are the front and back of the table. Indicate the positions of the various objects on the table, looking carefully at the shapes of the spaces around and between each object. This will help you to achieve an accurate framework within which to work.

Step 2. To give the objects form, and to indicate the flat plane of the table top, use a middle-tone wash to brush in simple areas of tone. Look at the darkest areas and establish these first. Pay particular attention to the ellipses of the jug, pan and pan lid.

Step 3. Look carefully at the areas of light and shade, and fill out the shapes with a lighter wash. Where necessary, deepen the tone of the darkest areas. Use the pencil and a heavy line to emphasize the outlines. Check the relationship of the pan lid to the pan – would it actually fit? Do the blades of the scissors look as though they could cut?

Step 4. As you work, continually check the spatial relationships of the objects and their tonal values. Bear in mind the mechanical construction of the objects. For example, check the way that the handle is attached to the pan lid. Use a firmly drawn pencil line and light areas of wash to define the shapes of the objects and their places on the table.

Step 1.

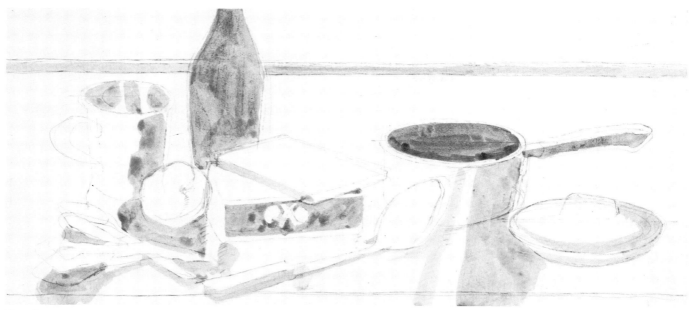

Step 2.

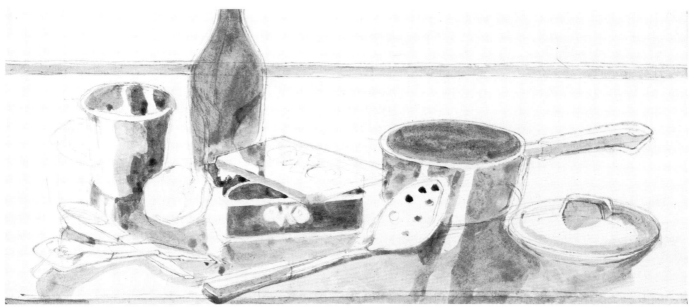

Step 3.

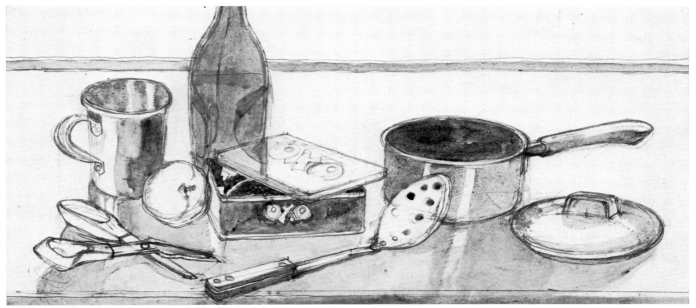

Step 4.

Fruit and Vase

Because the background to this still life had large areas of blue and blue-green, I decided to draw on dark blue paper. Naturally a paper this shade will affect the hue of the pastel colours, but the dark paper showing through the pale pastels will give the drawing a delightful texture.

Before beginning the lesson, study the still-life group and determine if there is any predominant colour which can be picked up in the paper you use. Let it also influence the colour range of the pastels you work with and try to use the tone of the paper to your advantage, employing it for either highlights or shading. Look also at the texture of the various objects you are drawing – are they mostly rough or smooth? This can also be

picked up in the paper; think how easy it would be to draw the skin of an orange using a rough-surfaced paper.

Try to keep the drawing developing as a whole, at approximately the same rate; and don't get involved with just one isolated section. Although some experienced artists build up their work by completing one part before moving on to another, it is extremely difficult for beginners to keep the correct relationship between the various sections unless you work all over the subject.

Step 1.

Step 2.

Step 1. Begin by sketching in the main shapes of the still life, using a colour that is as near as possible to the colour of the paper. Concentrate on achieving accurate proportions and check that the size of the sheet of paper is suited to the scale of the still life.

Step 2. Introduce the main colours of the group as broad simple areas of colour. Don't just fill in the sketch. Use it as a guide, but make the colours work for you by using them to define the shapes.

Step 3. Now look for elements of pattern and texture, such as the striped cloth resting on the green tablecloth. Continue to work on the shapes, defining their positions and relationships by the use of line and tone. Try to put in those elements which will give the composition depth, such as the edge of the table.

Step 3.

Step 4. Finally, turn to the fine detail that will lend realism to the likeness, such as the reflections in the glass vase. Look at the skin of the fruit and put in small touches like brown lines down the sides of the bananas. Use brighter hues to give highlights to the fruit and search for the tints that, when mixed with the basic colour, give life to the fruit. These mixes are achieved by laying pastel colours one over the other and then softly blending them together with your fingertips. The green cloth is also smudged to resemble the texture of velvet.

Remember when working with pastels to hold the chalk in the tips of your fingers, and to keep the rest of your hand away from the paper. In that way you will avoid unwanted smudging.

Drawing can be an end in itself, or a tool for study. The quickest way of responding to something you see, it also allows artists to experiment with an idea for a painting. Changes can be made in a still-life group, for example, as the ideal composition emerges through a series of studies; the distribution of light and dark areas can be analysed and possibly altered.

It would, of course, be perfectly possible to paint from this group, and to use the knowledge you gained while drawing it for the watercolour and oil-painting exercises. However, separate still-life subjects are suggested for both painting media, to widen your experience of working from different kinds of objects and to compel you to tackle changing problems of seeing and translation. In this way you will discover which subjects suit your individual way of working.

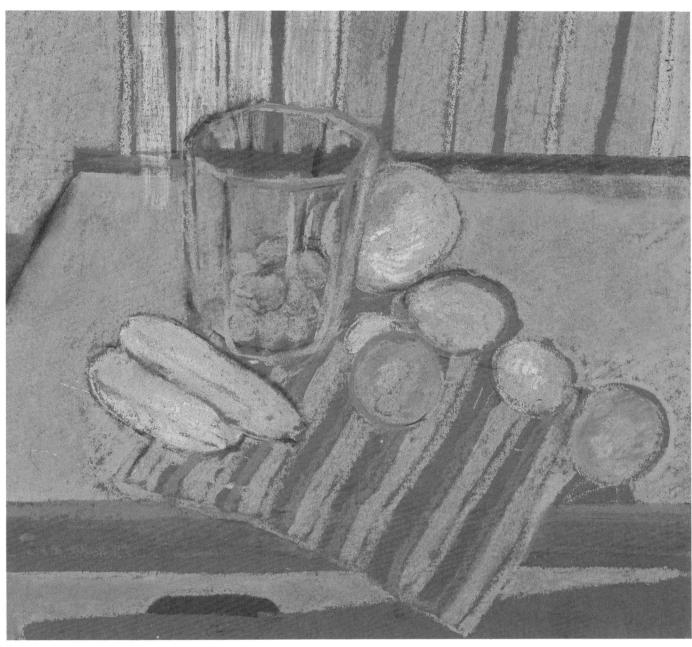

Step 4.

White on White 1

More advanced studies and sophisticated touches can be included in your next watercolour. But try them out on their own first, as small studies.

To show a small white highlight on a white cup, start by doing the basic shape in a very light beige, grey or blue wash, leaving only the area of the highlight.

On this page you will see how to paint a white cup or plate on a white cloth or background. Start with simple tonal studies, breaking the objects down into three shades of grey so that the problem of tone is fully resolved before you start painting. You will find a surprising amount of colour in this combination of whites, although its range may be limited to warm yellow-greys and cool blue-greys.

Photograph to check tones

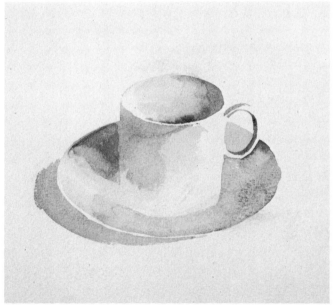

1.

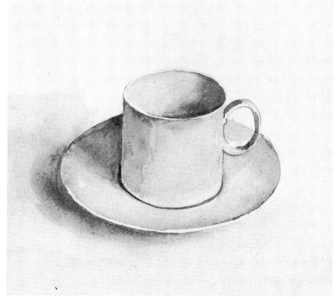

2.

White on White 2

There are many tones in white, more than most people realize.

When you have finished your cup and saucer in watercolour, try a more complicated example in oils. The problems will be different, because you can work over and over again until you achieve just the right variation.

Set up a board, and paste or tack onto it bits of fabric, crumpled paper, a cardboard box, a bit of ribbon – anything you have that is white.

As you work you will begin to see that white is seldom white, and at the end you may have a picture with more colour than some of your ordinary studies.

Work as quickly as possible the first time to put in a background of umber, then a layer of toned grey that will help to define the actual objects. Draw in the main shapes with a medium-sized brush, using pure white.

Mix a slightly blue-, grey- or greenish-white (depending on the light conditions and the objects themselves) and mark in the shadows and textures, using a flat medium brush for the flat outlines, and a rounded sable for the tones.

Painting of a white-on-white collage; see how many whites there are

Basic Project in Watercolour

To explore the potential of a subject you must keep an open mind. Don't settle too quickly for one result, or one point of view. Try to put yourself in the role of artistic investigator, examining the evidence from every angle. This may mean looking at a still life as pure shape or pure texture. Look at the work of other artists: how did they set about getting the most from a subject? Vincent van Gogh returned again and again to paint a simple bowl of potatoes, a theme he first worked at as an art student. Other artists arrange a still life and paint it several times as it decomposes. (For obvious reasons, fruit and vegetables are the best choice for this kind of exercise.) The use of different media and a slight rearrangement of the same objects are often sufficient for your purpose, and by doing several studies of the same still life you may achieve one or two paintings that come somewhere near the image you wish to convey.

Preliminary Sketch

Draw the group very lightly, using the brush. Work with a simple outline first, then stop to look carefully at each subject. Although all of them are rounded and of different colours, they will have certain similarities in tone. Some parts of the fruits will be dark, some medium, and some will catch the light and look considerably brighter than the rest of the group.

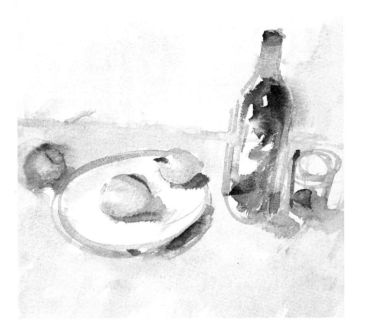

Step 1. Limit your palette to no more than three additional colours. Look carefully at the objects and then draw them onto the paper, using the most neutral of the colours you have chosen. Concentrate on the shapes of the objects and also the shapes of the spaces between them. Indicate any shadows.

Step 2. Using the other colours, wash in the relevant flat areas of the objects. Be sure to leave areas of white paper as highlights. When doing this step, refer back to your original tonal sketch and try to see the colours and washes you are painting in terms of their tonal values only. Don't concern yourself with achieving an exact colour representation of the objects: you are experimenting, attempting to come to terms with the natural limitations of a medium while at the same time getting it to do what you want it to. Try some experiments on a scrap of paper to see how bright you can make the colour, or how dark. Also, try out various methods to see which produces the most satisfactory results.

Step 3. The conclusion of your investigation into tone is reached with the final painted details, using the darkest range of tones within your limited palette. With watercolour paint this can be achieved by either mixing colours or else using very little water so that the colour is quite dense.

This is also the time for final judgements about the decision you made in the first tonal study. Look at the finished painting here, and imagine the tones of the table top and background reversed. The painting would be severely out of balance, with all the dark tones at the bottom. This is the main feature of the creative process – constant re-evaluation of decisions rather than slavish adherence to first impressions.

Step 1.

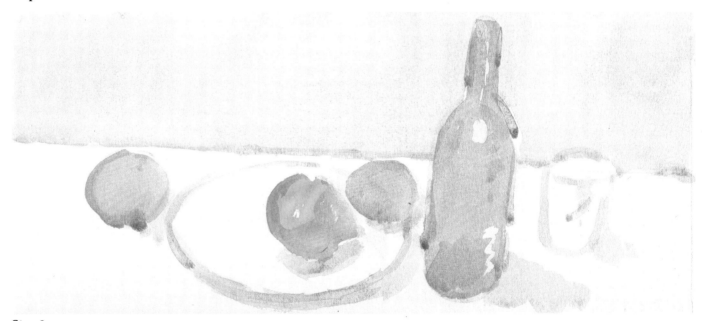

Step 2.

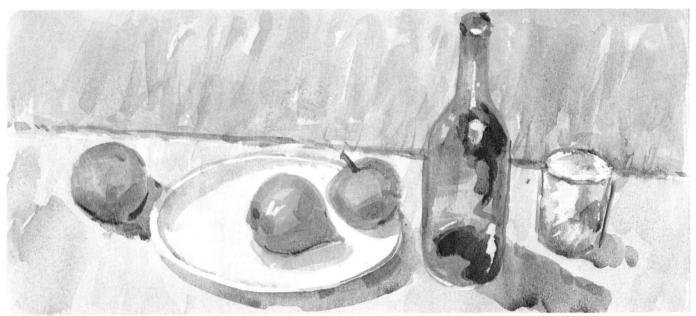

Step 3.

Wine Bottle and Fruit Variation

The exercise in this section will make use of skills learnt in Lesson Two: laying and grading washes, and leaving areas of white in the middle of a wash.

For this first real watercolour painting make use of the special qualities of the medium. Look for lightness, plenty of air around the subject, and colour based on subtly layered washes rather than the heavier solidity of paints.

These objects may be simple but painting them need not be an academic exercise. Try to see them as shapes that pick up and reflect light, cast shadows, and generally contribute to the complicated interplay of the visual world.

Your task as a painter will be to record their shapes, tones and colours accurately in your picture. You will also need to analyse and re-create the highlight on a piece of fruit, the different shades of 'white' on the plate and cup – all the important qualities that make each still life unique.

Don't be inhibited as you work. Develop your basic skills, but remember that enthusiasm is almost as important as technique, and will pay positive dividends in your finished picture.

Step 1.

Step 1. Take a selection of objects similar to those in the previous still life, and rearrange them. Bring another light nearer to the group and move your easel just a little. Now study the arrangement, comparing it with earlier work. You will see that the different viewpoint alters the shapes of the objects, that the brightness from the additional light lifts the overall tone. Make a quick watercolour sketch, reducing the picture to tones of only one colour; to do this you will really have to look at the objects, ignoring detail, colour and form.

Step 2. Now look at the cup, saucer and plate. Being white, they have no inherent colour and you will have to paint the shadows they produce. Tonal accuracy is very important here. Look again at your preliminary studies to check the accuracy of the shadow tones compared with those of the bottle and fruit. Make sure the tone values of the colours you finally put on paper are no darker than they should be.

Step 3. You have a simple drawing in three tones. Now use various shades of ink or colour to make up intermediate tones, and let them help you to blend one part of the study into another. Let the paint dry now and then, in between working on the drawing, and be careful not to use too much water.

Step 2.

Step 3.

Another Variation

Step 1. Take a clean sheet of medium-texture paper and paint the basic shapes of the objects. Start by mixing a green wash that matches the overall colour of the wine bottle as closely as possible, and paint the shape of the bottle in the correct position.

Step 1.

Step 2. The basic tones and colours of each object are now established. Allow the paints to dry, and then decide what to add to this basic composition. You may find that only a few additions are necessary to complete the picture. These will certainly include some washes to describe other important colours and tones in the subject.

Step 2.

Step 3. Distinguish between the shadow and the basic overall colour of an object. Now look at the plate, cup and saucer, and tablecloth. Check with your tonal studies again to determine whether the whiteness of the cloth is lighter than that of the plate. Decide on the darkest areas of shadow, and the lightest, and lay down washes of the correct colours and tones. You may have to go over your efforts several times to achieve the required effect – always allow the preceding wash to dry, or the picture will turn into an uncontrollable, runny mess of paints.

Step 3.

Step 4. Add background and shadows. Look back to your preliminary studies to see how these relate to the overall tone of the fruit. The shadow may also be a different colour from the original wash – perhaps colder, with some blue.

Step 5. To complete the painting, 'draw in' dark lines to bring out details, such as the apple stalk, or where the cup meets the saucer, or where the base of the bottle meets the tablecloth. Use a No. 6 brush to make simple strokes that won't lift the washes. Practise this technique on a separate piece of paper before applying it to your finished painting.

Finally, set your watercolour aside, let it dry, and then put it on an easel or chair so that you can study it in comfort.

Step 4.

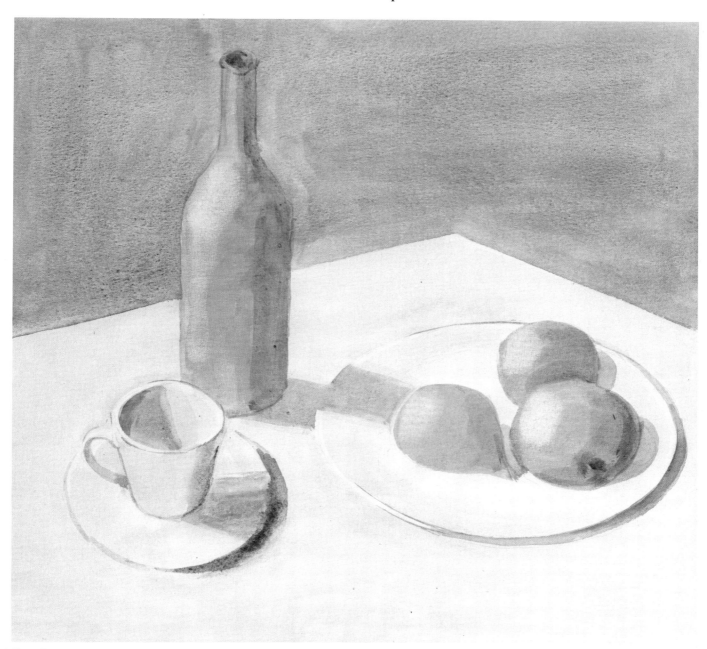

Step 5.

Unusual Still-life Subjects

Hard and mechanical drawing, good practice for perspective and basic shapes

Making boxes into an abstract; black on black instead of white on white

A light charcoal sketch of apples in a market; working outdoors means you have to be quick and light – see Lesson Seven for helpful comments

Studying Shapes

The rich colours of still-life groups have always attracted oil painters. Elaborate studies of dead game birds ornamented every Victorian dining-room, while crowded bouquets sprinkled with dewdrops hung in drawing-rooms and halls.

Here you can see a very simple study which is none the less full of interest for painters – green apples lying in a shallow bowl. This very easy exercise can be as exciting as a major painting of a buffet table laden with exotic luxuries.

Still-life studies are particularly useful for beginners working in oil. Provided you can put your group somewhere where it won't be disturbed, you can spend as much time as you like on your work, scraping and overpainting until you begin to feel pleased with the result.

For the same reason it is a good idea to paint your first groups in artificial light. Its quality won't change and you will be able to work for an hour or two at any time of the day or evening.

Look at the number of green tones in the apples on the right – everything from almost pure yellow to browny-green. Make studies for yourself, one using only three shades – light green, mid-green and dark green – and another using all the in-between shades you can see.

Don't worry too much about the absolute roundness of the fruits: concentrate on the tones of colour and the flecks of brown, the shadow, and the stems. Work boldly.

Now look at the bowl, a simple shape holding the apples together. It is also lit from the side, so that the rim of the bowl is soft white and blue at the top, and full of fascinating shadows and reflected rose colours as well as greens at the bottom.

The final touch is the yellow ochre edge to the bowl which establishes its shape, curving to echo the curve of the apple.

Make up your own study with a few fruits similar to the ones in the illustration – apples or pears, for example. Find a bowl or plate for them with a very simple pattern.

Oils are full of saturated pigment, so try out the many tones you will need on a spare bit of primed hardboard. The shapes are no different from the ones you have drawn again and again, and with oils you can paint over funny lines or bulging corners as often as you like.

A still life can be formal or informal. Because oils take longer to use and dry than other media, it is worthwhile looking for attractive groupings that are pleasing in themselves. However, casual arrangements on a kitchen or dressing-table are excellent for practising your growing awareness of shape, structure and form, as well as colour and tone in oil painting.

Do a number of studies, working sufficiently broadly to appreciate the subject properly. Make sure there is little or no background to draw attention away from the glowing colours.

The study has also been reproduced in a much smaller size, so you can see how much you lose in 'presence' if you try to be too confined and are too tightly tied to little studies.

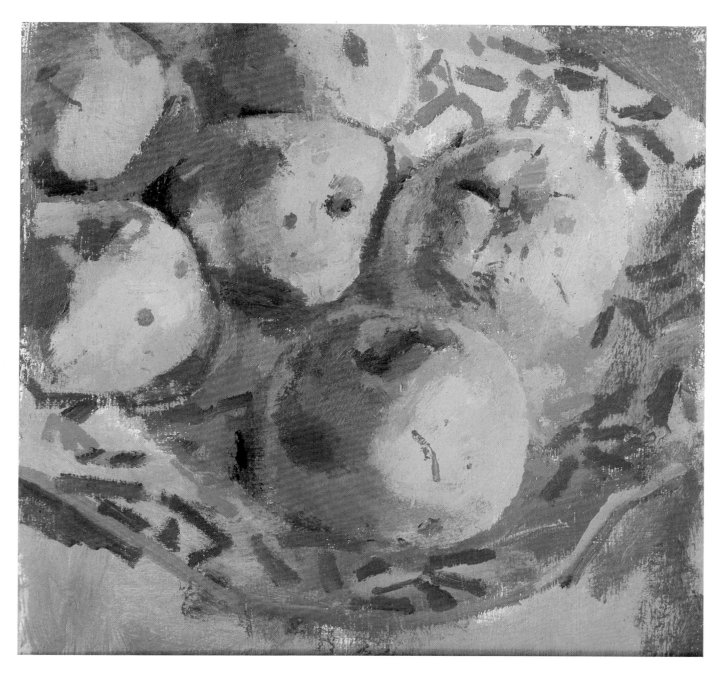

Plants and Flowers

Once you understand how plants are constructed it will be easy to make rapid sketches, such as the one shown here, a study for the painting on page 163.

Sketch for painting on page 163; always try a study like this before you begin to work, to make sure it fills the canvas

It is important to remember that the natural shapes of flowers and plants can be rendered in several ways: with free and easy linear gestures that give an impression of the shape, with blocks of tone and colour that give a general description of the hues and shades, or as careful, detailed drawings which explore the exact construction of the buds, flowers, leaves and stems.

For your first attempts at this type of drawing, choose a plant with a simple structure, one with large leaves and single rather than double flower-heads. Pick several specimens and keep them in water and out of the sun.

Use a medium-hard pencil and cartridge paper, and keep a good point on the pencil, sharpening it frequently as you work. Begin by drawing the stems first, and the rough outlines of the leaves and flowers in their approximate positions.

Next, examine how the separate parts fit together. Dissect one of the spare specimens to see how the leaves are attached to the stems, how the petals wrap around each other and overlap, and how the pistils, stamens and sepals are constructed. Look at the leaves: are they smooth or roughly textured, is there a main rib, is the tracery of veins feathery or symmetrical?

Try to put down what you see in smoothly flowing lines rather than hesitant scribbles.

Finally, add small details like serrations on leaf edges, hairs and thorns on stems, and so on.

1. (overleaf left). Choose a few blooms, and put them one by one into a plain jug. Try to keep the arrangement as simple and casual as possible, letting the brilliant colours of the sweet-peas make their point with no competition. Choose a related background and container; I found a white jug and stood it on a white cloth against a very pale wall. Look back at your white-on-white sketch, and use what you learnt in that about the colours in white to give substance and shadow to the jug and cloth.

Block in a pale background – in this case I used a soft bluey grey. Paint over the whole canvas – the flowers will stand out well enough. Put in the blooms before the stems, or they might not look natural. I mixed the red pigment with a little white and a touch of yellow for the top, leaving the pure red for the lower petals. Sketch in the green stems very quickly so that the line doesn't waver.

On the jug I left a few very light brush-marks so the sides might seem slightly transparent. Make sure the green is really fresh – add some white and a tiny touch of yellow to the pigment, with a slightly darker stroke or two for the buds and the leaves. Remember when you are doing this sort of sketch that the amount of paint needed for the flowers is really quite small.

Now add a few darker shadows under the jug and along its side, and let it alone. This sort of fresh, summery feeling can be spoiled instantly by too much detail and too tight a hand.

2. (overleaf right). Find another, dark, container and a few more flowers, to experiment with the same grouping in another colour palette. Cover the canvas with a dark brown ground, or match it to the jug, as long as they are both dark. In this case the jug is a little more sophisticated: the brown of the glazed top is different from the bisque base.

When the ground, the basic jug, and the cloth have been painted in broadly and they are quite dry, add the red flowers. You will see immediately that the brown comes through some of the petals to give more form and shape than you had in the first version. Use a sharp purple for the wild flowers, and for the line of highlight on the glazed top of the jug.

Finally add the green stems and leaves, working with fairly thin pigment so that the brown ground shadows and shades the leaves without any more detail.

Keep both paintings side by side where you can see them. They produce quite different effects but both should give the impression of simple country flowers, with all the freshness and just-picked quality that that implies.

For both paintings, use a medium-sized brush for the backgrounds, but a fairly small round brush for the flowers and stems – and above all, handle the brush lightly. If the stems look stiff and unnatural your arm and wrist were probably too stiff. Practise on an old canvas or a board, simply letting the brush mark lightly but surely down the surface. Try painting tufts of grass in the same way until you have confidence in your touch.

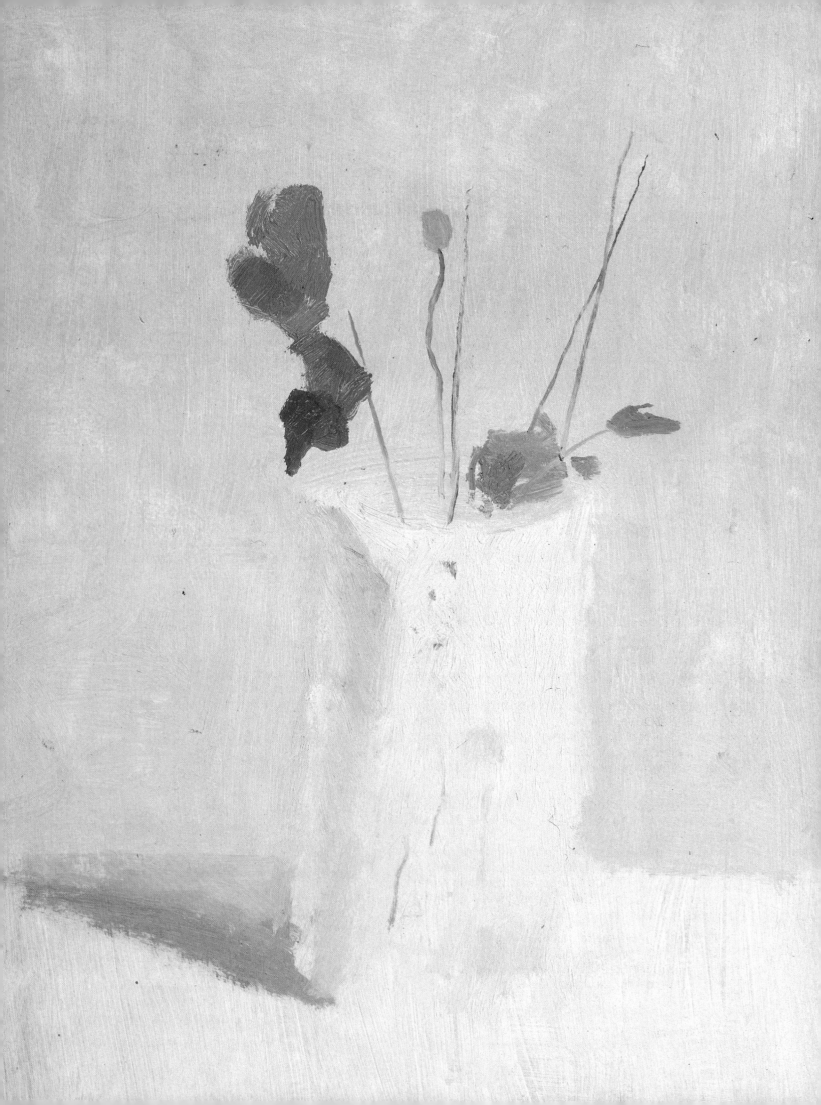

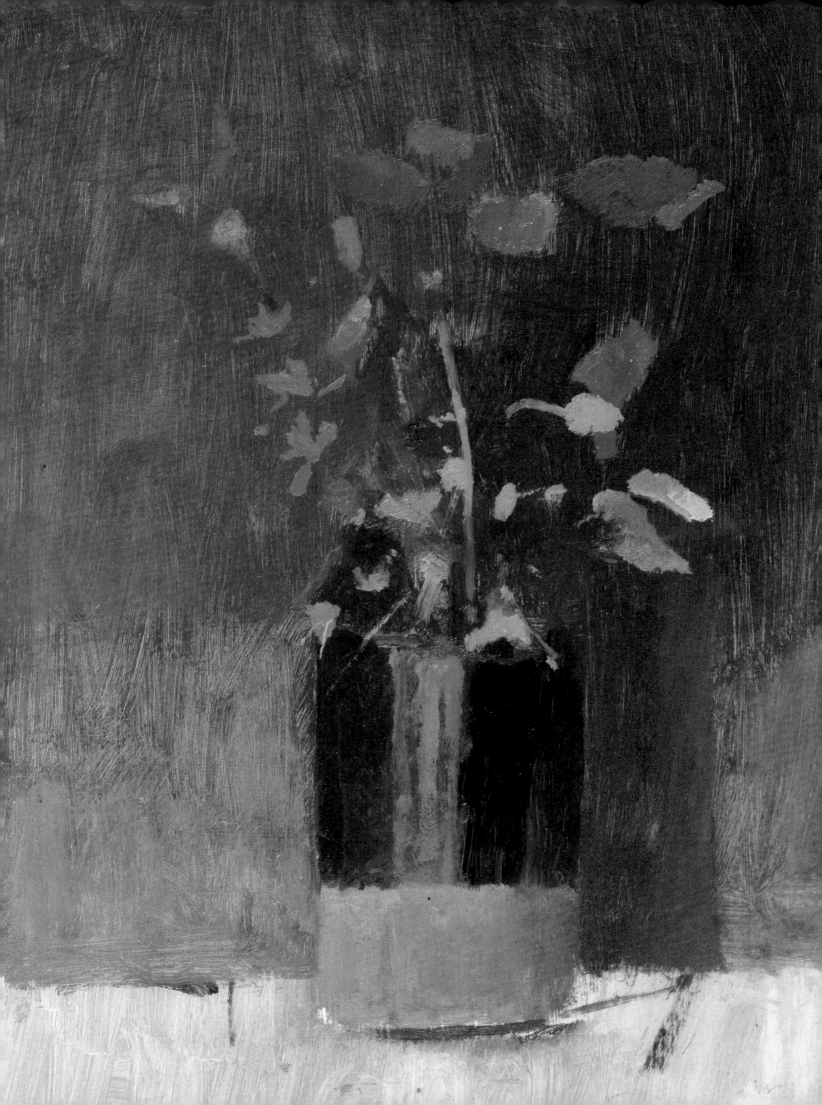

1.

Flowers can be part of a still life, or a separate subject. This study shows how you can use a kind of visual shorthand to create the illusion of a bunch, or vase, of flowers. If you look at the work of other artists you will see that some translate clusters of small blooms into blocks of solid colour. Others combine different textures and brush-strokes to give the impression of highly detailed flowers.

Try drawing a bowl of flowers to get a feel for the way the stems curve, and the outlines of the petals, or flower-heads. If you find this difficult, use a grid as reference and sketch in each shape square by square.

Flowers and plants, whether they are growing in a pot or picked and arranged in a vase of water, have movement: their leaves and petals respond to moisture, temperature, and even the time of day. Thus it is useful to be able to work quickly.

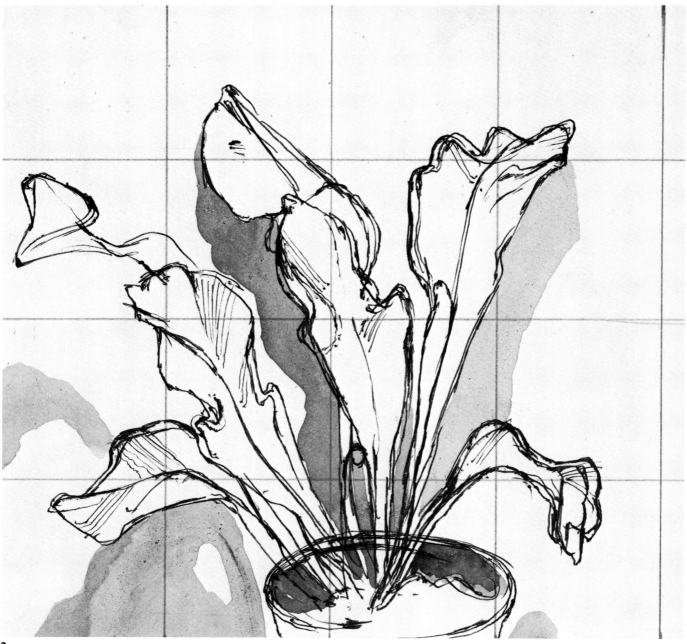

2.

1. A potted plant was chosen to study the way leaves curve and curl, a 2in. (5cm) grid being first drawn on the paper to provide a reference for determining the degree of curve of the lines.

2. A wash of diluted black ink was quickly applied to indicate shadows and to fill out the pen line.

3. A thin ink wash was used to make an impressionistic study of a geranium, only the basic shapes of the plant being depicted.

4. The charcoal study of the same flower is more detailed, showing how the petals and leaves are constructed, and how they are attached to the stem.

Use all different types of media to do flower studies, as the variety of techniques you employ will affect how you render what you see.

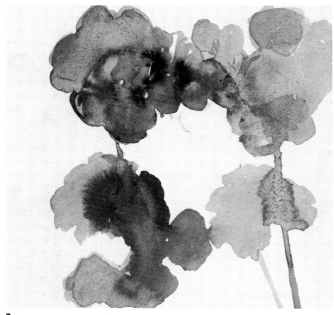

3.

4.

Still Life in Oil

Before you begin an oil painting of a potted flowering plant such as this, place the plant on a stool or small table against a simple background. Cover the table with a cloth to give an extra colour or texture to the composition. Place it so that the light is coming from one direction only – in this case the light came from a window to the right – and position your easel about 4ft (1.2m) away from the subject.

Step 1. Using a No. 6 hog-hair brush and a mixture of ultramarine and burnt sienna thinned with turps, roughly sketch in the main shapes, placing them carefully so that the subject area nearly fills the whole canvas without coming right up to the edges.

Step 1.

Step 2. Start putting down the main colours of the subject and the background. Work over the canvas as a whole and avoid getting 'stuck' in one area. Once the main colour areas are blocked in you may begin to concentrate on developing details of colour and shape. The interest in this picture was the painting of white flowers against an off-white background. In painting there is rarely a pure white; rather it is a reflection of all the colours surrounding it, and this must be shown by tinting the white with background hues. Thus, the flowers are tinted with cobalt blue, raw umber, and yellow ochre.

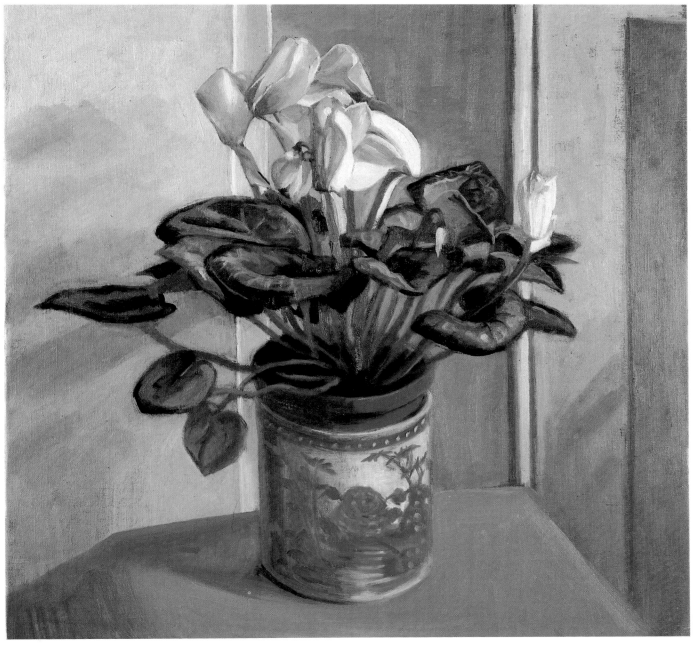

Step 2.

Still Life with Quilt

When you are ready to tackle something larger and more complicated, make sure you choose a subject related to your previous projects, but with enough variation for it to be interesting and new.

Here many of the shapes in other studies have been brought together: the round oranges and apples, the banana, and a white cup. Additions are a small pineapple for contrasting texture, a more complex jug to practise curves and shadows, a big platter, and, for extra attraction, a patchwork quilt pinned up against the wall; this has a lovely pattern of simple shapes, and it also makes a pyramid around the group.

What may seem like a big painting has, in fact, simply been painted close to the subject, so that the square canvas is filled with it.

Step 1. Set up your easel right near the table, so you are looking slightly down into the group. Put a neutral-coloured undercoat over the canvas and, while it dries, make sure you are happy with the arrangement; experiment with the lighting and make a few preliminary paper drawings of individual details. If you are really worried about proportions, make a grid from tracing-paper and slip it behind the fruit, standing it against the platter. It will provide a useful guide to the basic shapes in the front of the group.

Step 1.

Begin to sketch the group, using a brown or raw umber paint and a fairly stiff brush. If you are not sure about the curve of the platter you can even use a compass and pen to mark out the shape on the canvas. Concentrate on getting the shapes into position, then make up a thin wash in blue and sweep it over the rim of the platter. Go right around the dish – don't worry about the line of the quilt at this stage.

Step 2. Use blue to go over some outlines,

especially the two vertical lines which lead the eye upwards and make a good frame, and the shadows on the jug. Mix a few simple washes in the colours of the fruit, and paint them in very simply; work in the three basic tones you have been using in previous studies.

Add the top of the pineapple in the lightest brushwork, with just a few of the lower leaves painted in very simply.

Brush in a light green around the rim of the bowl.

Step 2.

Step 3. With a light grey wash, paint in the platter with a circular arm movement so that the brush-marks describe the shape too. Use a dusty pink for the pattern on the jug, soft cream for its body.

The white mug can be painted in with the simplest shadows at the front to give it depth, and to add a three-dimensional effect. Darken the various shadows on the table underneath the bowl and on one side of the jug. Begin to paint in

the quilt lying on the table, experimenting with reds and pinks. Use a flat square brush, and try to cover one square at a time – you can tidy up the edges later.

Fill in the pineapple leaves over the grey platter.

Stop for a little while and move back to look at the group and at your painting. This is always an important moment, but it is especially vital when you work so close to the subject.

Step 3.

Step 4. Now you are ready to add some modelling to the fruit. Deepen the tones to create rounder figures, and put a few fine brushmarks on the pineapple to show its markings.

Fill in the rest of the pattern of the quilt, in blocks of flat colour. Scumble over the platter with a layer of glaze and umber to give it life, adding some white to the top for a highlight. Deepen the shadows under the bowl on the left, and watch how the pattern of the octagons changes shape as they fold to lie flat on the table.

Add some extra highlights to the pears and oranges, and a little extra glossy white to the base of the bowl for texture.

Line the handle of the jug with a bit of darker blue, and do the same with the white mug. If you cannot seem to get the curved handles in the right place, scrub them off and start again, with the tracing-paper grid placed just behind.

See that the shadows under the plate are dark, without using black.

Let the picture dry thoroughly, and then put a coat of varnish on top to keep the colours bright. Hang up the finished painting; you will have a project worth keeping in full view.

Step 4.

Extra Projects

The introduction to perspective, in Lesson One, described how it can be used to check the scale and accuracy of a drawing. In the paintings reproduced here, the artists have deliberately ignored its conventions in order to create particular effects.

In the late nineteenth century, many artists painted a considerable number of still-life pictures, often to develop theories about painting. Because they were trying to produce a feeling of solidity and depth without using conventional perspective, their drawings do not attempt to reproduce exactly what they saw.

They were prepared to distort objects in order to create a balanced arrangement of shapes and forms; and would paint them as though the surface on which they were resting was tipped backwards or upwards towards the viewer, if this meant that the relationship between objects could be better expressed.

Using objects to express ideas was taken still further by a group of artists led by Picasso and Braque in Paris, from about 1906 to 1914. Derisively called Cubists, they argued that painting should be concerned with constructing a reality rather than copying it.

Here are two suggestions for everyday objects which can be distilled into more abstract shapes and unrealistic colours. Look at ordinary tools and furniture to find the underlying structure and express that in drawings, then in a different medium, perhaps oils or pastels. Don't aim for the effect of three dimensions that you have been studying so far, but use the structure to make patterns and shapes. This is a very different kind of perception, and a useful aid in learning to look at objects in a new way.

'Garden Shed Still Life'; Minton

172

'Vase and Flowers'; Kremaigne

174

Lesson Five
Interiors

The spaces of ordinary rooms have a strange place in the world of art and representation.

Throughout the tribal and pre-Christian periods almost all known art was religious in purpose, picturing gods, spirits, or abstract images of natural forces. Occasionally, as in Egypt and Rome, the everyday life of the people was also painted onto frescoes, carvings, tombs or furniture. The clothes, tools and the pictured surroundings give us some idea of the immediate environments, but such information was not necessarily intended to be realistic, and the attention of the artist was always focused on people and on symbols of labour and recreation.

With the advent of Christianity, the Church became the single most important patron of Western art, and almost all the great medieval works of art depicted religious subjects on a grand scale.

However, we can be grateful to the Flemish painters of illuminated manuscripts who created hundreds of tiny paintings, still devoted to scenes from the lives of saints or apostles, but often miraculously detailed with furniture, curtains, books, jewellery and all sorts of personal possessions scattered somewhere in the tableaux.

With this tradition, it is not perhaps so surprising that the first real secular paintings of interiors come from the Netherlands. Artists like Jan Vermeer (1632–75) and Pieter de Hooch (1629–after 84) painted the world of ordinary people where the individual was part of the scenery rather than the main feature. The sitters were often in groups, such as card-players and drinkers; even a single figure was usually anonymous – a woman reading or spinning, and so on.

'Lady Standing at the Virginals'; Vermeer

In these paintings for the first time, perhaps, the room is the true subject – not the classical columns and architectural fantasies of earlier Church paintings but delightfully genuine homes and meeting places, rooms with windows and shutters, cool bare walls and simple furniture.

Gradually the use of interiors became more commonplace, although the figure never lost its vitality. Many portraits and scenes from the fifteenth century onwards are basically interiors, the objects in the room sometimes completely overpowering the figures.

This kind of social portrait reached its height with the French engravings of the eighteenth century which were so full of drapes and ribbons, tables, chairs, fallen garments, burning candles, fringes, cloths, curtains and patterned carpets that the human subject almost disappeared.

A word must be said about architectural and trade illustrations. Many builders and designers made watercolours of the proposed plans, and since they often designed the interiors as well as the exteriors, we have these to give us an impression of style, space, and social habits. For example, paintings by John Carter in 1788 show us exactly what Horace Walpole chose for his 'Gothick' house, Strawberry Hill, and sum up an entire movement in literature and art, eventually revived by the Pre-Raphaelites who often used Gothic motifs to surround their figures and landscapes.

Victorian genre painting followed with its moral expressed in the appearance of the room and intensified by stylized human beings – a weeping mother, a suffering child or an arrogant soldier.

English and French ladies also drew rooms for their drawing masters and sometimes for their diaries. However, with the rise of the artist as an individual, and with the personal view of life which characterized the late nineteenth and twentieth centuries, the empty or almost empty room finally came into its own as a proper subject for fine art.

A simple bedroom with a lamp and chair could express a whole personality. A room at Arles by Vincent van Gogh (1853–90) jumps from the canvas and surrounds us with energy.

An empty motel room by Edward Hopper (1882–1967) embodies the desolation of the spirit. In a totally different way, Aubrey Beardsley (1872–98) summed up the entire turn of the century in the 1890s with his stylish drawings – often wicked caricatures – for the *Yellow Book* and the *Savoy*, two new literary magazines. This drawing opposite, for a *Savoy* cover, shows the figures as unusually pleasant, so decorated and patterned that the room has much more presence and style than the cast of characters.

'Bar'; Beckmann

Many of the early twentieth-century painters chose domestic rooms, but *Bar* by Max Beckman (1884–1950) has an extra dimension of atmosphere – it was painted in Paris in 1939, as World War Two began.

An interesting genre of modern painting has developed from the super-realistic school which first became popular some thirty years ago with the young John Bratby (*b.* 1928) at the forefront of the movement – the equivalent of 'kitchen sink' novels and plays. Working places, garden sheds, factories, crowded cupboards, and indeed kitchen sinks filled with pots and pans, were all used as subjects important in their own right – just as novels and plays about ordinary life were achieving considerable recognition. Although this style has become so commonplace as to be unremarkable, it remains as a strong reminder to artists that 'interiors' do not simply mean prettied-up living-rooms.

Today, interiors are used most often as settings for figures and portraits, with much less formality than is found in Victorian genre paintings, but with equally intricate and fascinating details; inexperienced artists should look at such paintings carefully, for they show how much of the spirit of a particular place can be conveyed with the careful delineation of details such as fireplaces, windows and personal possessions.

Starting to Work

Simple interiors, part of everyday life, are often overlooked by beginners who dream of painting exotic tropical landscapes or faraway cities. In fact, your immediate surroundings are overflowing with new subjects and the decision to recreate them on paper or canvas will be an important turning-point in your development. It reflects that vital moment when you begin to look at familiar objects with an artist's eye, newly aware of the environment and how it can be drawn and painted to communicate ideas, feelings and emotions.

Preceding lessons have concentrated on small subjects – household utensils, a table top, a shelf, a mantelpiece. Now space will expand and your eyes must readjust as if you were in a strange country to record some of its unique features.

For the painter just beginning to explore a personal landscape, a favourite room is a good place to start. It will be accessible in every kind of weather, and reasonably well lit no matter what the time of day or evening.

After the relative simplicity of the still life, there will be more complicated compositions to make with new and exciting shapes – chairs and sofas, curtains and shutters, carpets and floorboards. There is also the vital lesson of what to leave out – if developing an artist's eye is about learning to see, it is equally about learning to select from what you can see in order to make artistic sense.

In many ways this is an extension of earlier studies; the rules of observation apply to small groups of objects, within a limited field of vision, and also to the variety of new materials, and subjects in this wider area.

Line, tone, colour and composition have a direct bearing, and presentation and interpretation will, as always, depend on the individual.

You will be able to do the same with your own room – which will express what you feel as well as what you see. One of the benefits of beginning with a place in which you enjoy working will be the extra dimension it brings to your appreciation of your surroundings.

Composition

When you piled up vegetables and fruits you learnt to form a satisfying composition: a group of objects with one spoon as the peak, a bottle as the dark substantial shadow which gave weight to the whole, and so on. Now you must learn to do the same with a room.

To begin with we will concentrate on the technical abilities involved in drawing a larger space in three dimensions. The end of the room is further away from you than any subject you have attempted before – 10ft or 12ft (about 3m or 3.5m) at least from the easel. There are some practical rules of more advanced perspective which you can use, but they are no substitute for looking, hard and carefully, at what is in front of you, and drawing it accurately. Remember that the human eye has a limited field of focus – only what is in front of you will be truly clear and exact. You will also see objects around the edges, perhaps even the whole of the room, but not clearly.

Your small group has become a much bigger space, and the eye will develop a natural focal point. The part that composition plays now becomes very important indeed. Somehow, in close-ups such as a still life, the subject can be almost anywhere on the canvas – the very table top or mantelpiece makes a natural frame. A crowded, vibrant fruit-and-flower study will look right – so will a single glass or a plate. In a room there is no natural frame such as a cloth or shelf – here, perhaps for the first time, it is your eye and your eye alone which will provide the order and theme for this exciting excursion.

Awkward group placed flat against wall

Too much of a single piece of furniture

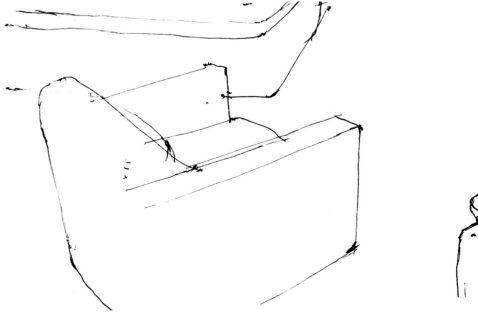

Just right; a coherent group that looks like a room

Rooms in Perspective

A room is a clearly defined space with lengths, heights and widths that can be accurately measured.

The following study is concerned with a new aspect of drawing: the problem of correctly recording the main directions of walls, windows, tables and shelves – in short, the more complicated aspects of perspective.

Choose a corner, if possible with shelves or a mantelpiece and nearby furniture. Make a drawing in line only, using pen and ink or a ballpoint or felt-tip pen, so that you have to commit yourself positively to directions. If you make a mistake, redraw the line in what you judge to be the correct place.

You will be looking at the right-angle of the corner from one side. Drawing this is both a problem in perspective and a way of creating an illusion of solidity and space in the finished work.

Don't get discouraged by your first attempts – it would be more than a little unusual to get the angles correct the first time without a great deal of reassessment.

A plumb line will help, especially in old buildings with walls that slope slightly inwards or outwards, but in most cases it is possible to use the natural vertical line of the corner itself to relate to other angles, as you can see.

The main directions of the shelves and mantelpiece were assessed by comparing them with the vertical end of the mantelpiece (the left-hand side). The diagram below shows how the parallel (horizontal) lines were extended, using a ruler, to check that they met at a single vanishing point at eye-level – in this case just below the lower shelf of the mantelpiece.

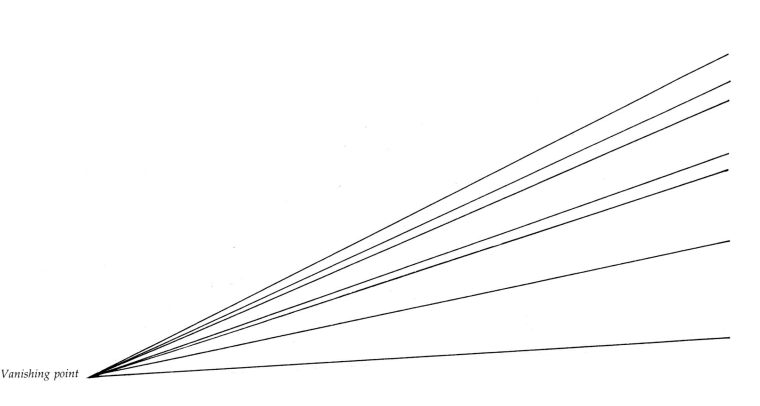

Vanishing point

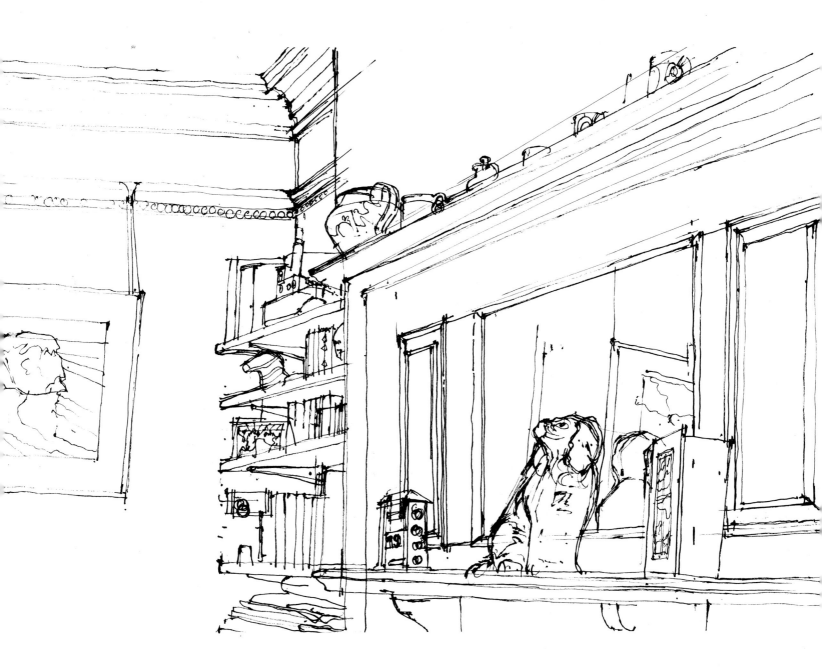

Textures and Fabrics

Fabrics and textures are an important element within any interior composition. There may be shag carpets on the floor or braided rag rugs; the windows may be hung with velvet drapes or lightly covered with patterned lace. There is the texture and grain of furniture surfaces: glass or wooden table tops, chrome frames to chairs, vinyl seat covers, and so on. All these surfaces must be represented in your drawing, so it is worthwhile to attempt several studies, translating into line and colour what you observe to be the distinctive characteristic of each texture.

The studies on these pages are drawn from a chest-of-drawers which has had various articles of clothing pulled halfway out of the open drawers.

1. Because the orange/yellow of the chest-of-drawers was the predominant colour it was used to sketch in the main shapes of the piece of furniture and the clothing.

2. Next, the main colour areas of the drawers and the fabrics were introduced and the shapes more clearly defined. To give the drawing depth, the top of the chest was drawn in.

3. To complete the drawing I concentrated on mixing the colours of the fabrics and the wooden drawers. This was done by overlaying the pastel colours until the precise tint was achieved.

To emphasize the subject's three dimensions I developed the drawing of the objects on top of the chest-of-drawers, and began to indicate the various textures of the clothing, stressing the difference between the soft fabrics and the rigid angularity of the wood.

By smudging the green pastels with my finger I was able to show this fabric as soft and fluffy; the lace pattern of the black lace underwear is indicated in firm line; the blue and the white fabrics were patterned and this has been shown quite simply, as has the texture of the wood grain by streaking burnt sienna and ochre through the body colour.

1.

2.

3.

Rendering the same subject in a variety of ways helps to improve your technique and your powers of observation.

4. In this drawing I reduced the chest-of-drawers to line and the clothing to flat areas of colour.

5. The emphasis is on the wooden drawers, contrasting the tints of the wood against the background. This drawing has a more atmospheric quality because of the soft blending of the pastels.

6. By not blending the pastels, the colour of the paper is allowed to contribute to the textures and tints of the drawing of the chest-of-drawers, while a gentle smudging of the colours of the fabrics gives them a soft feeling.

7. While every effort has been made to draw in the basic shapes accurately, the colours have been uniformly smudged and blended so there is little difference in texture.

4.

5.

6.

7.

Chair in Conté

Space is created in drawing by establishing the correct relationships of scale between objects and by the use of tonal contrast. If line is used alone, the strongest line will appear to be nearest to the viewer. The same is usually true of tones. The strongest lines and darkest tones should therefore be used for foreground objects. Dark lines or tones in the background will generally make it look too close to the foreground.

However, it is also the contrast between light and dark which causes the illusion of space, and it is possible with practice to contrast a light foreground object with a dark background.

Put a chair between your drawing position and a wall, another piece of furniture or some other object. It should be far enough away to be seen as a whole, but not so far away that it blends into the background. Drape a coat or soft garment over part of the chair.

Start by using both line and tone to draw the group so that it seems to be the appropriate distance from you and from the background. A chair can be a difficult subject. Be sure to keep its basic form firmly in mind; and draw the part hidden under the garment so that you can get the drawing of the garment right.

When you have established the spatial relationship between your subject and its background, complete the details – the creases and folds in the fabric, for example – using a combination of line and tone.

You will need to make a number of drawings from different angles to appreciate all the ways you can look at this simple group.

Step 1. The preliminary sketch for a study such as this should be done thoughtfully. It is the framework upon which you will build the final picture. Notice how the structure of the chair is drawn and redrawn to arrive at the correct relationships between all the angles. It helps to draw the object as though it is transparent: that way you can easily check positions and perspective.

Step 1.

Step 2. Gradually introduce details such as fretwork on the chairback, rushing on the seat, and the hang of the clothing draped across the chairback. Be quite firm when defining the final lines of the drawing, remembering that the heaviness of the line will cause it to advance towards the viewer. There will be some unwanted lines after all the reworking you will have done; these can be obscured by using white conté. Use it to trace over the lines and then smudge them together. These areas will also add interest and a feeling of solidity to the chair and fabric drapes.

Step 2.

Part of a Room

One of the most challenging problems an artist can tackle is drawing middle-distance perspective. It is surprisingly difficult to depict the depth of a room (or part of a room) when the view is from not very far away. Outdoors you have the physical reality of the scene stretching away into the distant horizon; indoors, it can end just a few feet (about a metre) away from you.

Arrange some furniture as shown in this drawing, placing one or two pieces against the wall and another piece in front; leave enough space so that you can walk between them. Position yourself a few feet from the table or whatever is in the foreground. Now think about the distance between you and the furniture and between the objects themselves. Study the angles made by intersecting lines. Study the tone of the scene – which are the lightest and darkest parts? Think about how the principles of perspective can be turned to your advantage.

This drawing of a small part of a room has solved the problem well by exploiting the principle that dark tones advance and light ones recede. Notice how the back wall and the pieces of furniture against it are much darker than the foreground,

and how the floor, which many people would be inclined to make dark, is lighter. Visually, the space has been shortened, and the angles of the table, seen on a diagonal, all draw the eye from the front to the back of the drawing.

Step 1. Restricting your drawing implements to pen, ink, and red, brown, and white conté, begin by blocking in the main shapes of the furniture. Indicate the corner of the wall and floor in brown conté. Treat the objects as though they are transparent, so that you can clearly see the construction of angles and get the perspective organized. Study the lines and note where they intersect; this will help you to get the furniture in the right position.

Step 1.

Step 2. Develop the sense of depth by hinting at the changes in tone throughout the drawing. Don't get involved in just one corner: work over the entire picture so it remains balanced.

With red conté emphasize lines that will help convey the feeling of depth – as seen on the table top, which has been outlined. This will also make the lines 'jump out' of the drawing, putting them very much in the foreground.

Step 2.

Step 3. With black ink or conté and fine line, pick out details in the darkest parts of the drawing, and emphasize the shape of small objects within the composition, such as the telephone and the flowers in the vase on the table. Use white conté to give bright highlights to the objects, and to indicate solidity. Rubbing out will also make highlights, but they will be too soft.

Step 3.

Get up and walk around in the part of the room you have just drawn, and then return to the drawing. If, when looking at it, you feel that you could actually pass between the table and chest-of-drawers or whatever, then you have succeeded. If not, ask yourself why. Are the tonal relationships wrong? Are the angles incorrectly drawn? It is only through constant looking and questioning that you will understand how to put three dimensions into two.

This project has been shown in brown and in black, simply to point out that colour alone will not give you the effect of texture and detail which will make your finished drawing satisfactory. Look at the markings on the chest-of-drawers below, and the fine outlines of the details on the chair and the edge of the table in front, and the bunch of flowers. This is all achieved with pen and ink.

Never be dismayed by not having a wide variety of materials to work with; you can follow all the lessons in this book with pen, pencil, ink, and a few colours, and you will have made basic equipment work for you in the most productive way.

Step 4. As always, the final step is to define the shapes and details of the drawing. Look carefully and decide if there are any unnecessary lines. If so, they should be obscured with white conté as otherwise they will be obtrusive and distract the eye of the viewer. Try to keep most detail to the objects in the foreground, as this will reinforce the feeling of distance between front and back.

Step 4.

Space in a Room

A painting of an interior is not simply a drawing to which colour has been added. The closed environment of a room is rich with luminous tones and numerous effects of light and atmosphere, all of which radically influence the way the interior is interpreted. These effects may to an extent camouflage the dimensions and even the perspective.

A room, or part of a room, can be an enormously complicated subject. The simplest approach is to start by deciding on the composition – the area to be painted. Even here you will be faced with a number of choices; a plain wall can be more interesting than a door, a simple table and chair may be more rewarding than a complex, cluttered group. Or you may decide to have no objects at all and concentrate on the changes of light and colour between the walls, floor and ceiling.

Make small perspective drawings and tonal wash studies from different positions. These will give an impression of what the final painting could be like, and help you to decide which composition you like best.

Analyse the colours around you. These may seem sombre compared with outdoor landscapes and other subjects, possibly because the light is not very strong – corners are often poorly lit, particularly when natural light comes from a single window.

However, this does not mean that these areas are dull. On the contrary, if you look carefully at the shadows and dark parts of the room you will see that they are often richly coloured though low in tonal value.

Try to achieve a colour balance between the light and dark areas when you paint your first room. The colour of walls and objects in the light will probably be bright, but corners or objects in darker parts of the room may be a muddy grey. Try, however, to maintain brilliance of colour in all parts of the composition by looking for the warm browns, rich deep reds and cool strong blues that are present in even the darkest shadows; and do your best to eliminate black and dark grey from your palette. Your work will gain immeasurably in quality.

Two views of a room in similar tones; compare with sketches on page 246 for the effect of a simple colour change.

190

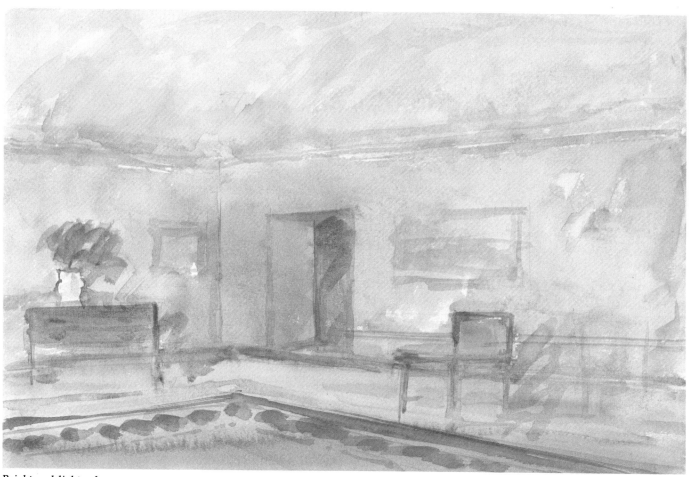

Bright and light colours

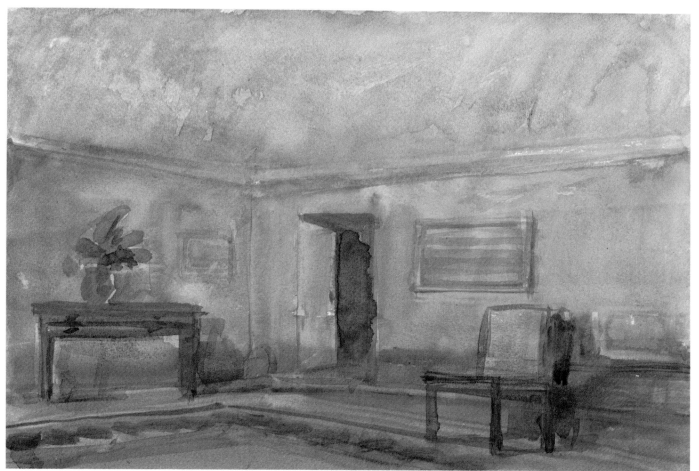

Dark and rich colours

Chair in Watercolour

Step 1. Start by drawing the outline of the chair on watercolour paper, using a hard pencil. Look at the chair and analyse where the light falls and which is the darkest part. Now decide on the tonal values created by the play of light and shadow. Try to restrict yourself to choosing three main tones from the enormous range you see at first. Then decide on the basic overall colours of the chair and its background. For this chair I used raw umber – with yellow highlights.

Mix tone and colour for the main washes of the background. Try them on a separate piece of paper and, if they are accurate, lay them in (they may look rather darker than you expect). Paint on the basic colour of the chair.

Identify the highlights on polished, shiny surfaces – they are normally on the rounded areas closest to you. The best results are usually achieved by leaving the paper unpainted at this stage. The alternatives – 'scratching out' with a sharp knife, or 'sponging out' the colour when the wash has dried – are less satisfactory.

Step 2. When the first wash is thoroughly dry, decide where to put the wash on the background. It will be tonally darker than the first, and the colour will be different. It is worth spending some time deciding on the precise colour required and how warm or cold it should be.

Experiment with layers of two or three washes on a separate piece of paper, possibly painting over your first attempts. The second washes will be darker when placed over the early ones. Paint evenly and quickly, removing any excess with a dry brush. Remember, if you overwash by using too much paint, you may lift some of the colour with a slightly damp sponge.

Step 1.

Step 2.

Step 3. Allow the second stage to dry, then lay in the darkest of the three main washes. If this is only necessary for details or small areas, draw it in with a No. 4 brush. Use a flat, even wash for any larger areas. You should now have a finished picture of the chair.

Step 3.

Step 4. Finally, look again to see if there should be an even darker version of this last tone to indicate the shadows which the legs cast on the floor, and which the back casts on the wall.

Step 4.

A Complete Room

Artists normally take a much wider angle of vision when deciding what to paint in a room than they would with other subjects. Interiors often look like photographs taken with a very wide-angled lens, showing more than would normally be seen.

This makes an interesting picture but also results in unnaturally exaggerated angles.

Although it is perfectly acceptable to paint more than you could see from one single point, it is important to be fully aware of the distortion that results.

Position your easel so that it is facing one end or side of a room with chairs, cabinets, pictures on the wall, fireplace, carpets, and plants – all the usual clutter. Use a hard pencil to indicate the positioning of the objects, making the composition as interesting as possible.

Now follow the guidelines laid down for the chair, starting with the basic initial washes indicating main tones and colours, and finishing with the shadows cast by the furniture.

Before you attempt any of the longer projects, make small sketchbook studies of your immediate surroundings. Paint as many different aspects as possible at various times of the day and evening. You will find that putting everyday objects on paper poses interesting problems of construction. The amount of detail you include will depend on how near you are to the subject and on the time available, but don't count only on long sessions – constant practice is immeasurably more instructive than one tiring day, when your concentration will be poor.

Step 1. Drawing lightly with a hard pencil, divide the paper into the main areas of ceiling, walls and floor. Indicate the position of windows and doors. Study the room and try to decide upon the tonal values. You will be working from light to dark, so begin with the lightest area. Perhaps the door is painted white or the window has sunlight streaming through it: such areas should be left unpainted. Block the remaining light areas in with an appropriately tinted wash. Next, decide the middle tone, in this case the walls.

Step 2. To show that the view includes the corner of the room, apply a darker tone of the first wash. Remember to work around the light areas at the door and window.

Step 1.

Step 2.

Step 4. The room is a frame for the objects within it; once the frame is constructed, begin to place the furniture, etc. Look at the shapes. Working from dark to light (as most furniture is wooden and darker than its surroundings), sketch the shapes in pencil and then wash in the colour.

Step 3. Now introduce the second colour. Before doing this, look for areas that are similar in tone to the first, lightest wash. Here, the ceiling has been added (in blue) in the same tone as the beige walls. Try to prevent the washes from bleeding into each other too much (although this can be turned to an advantage, providing hints of shadow).

Step 5. Move to the next lightest tones, like the rug on the floor, and show these as flat areas of wash. It is a good idea to try these washes on a separate piece of paper to be sure you have the correct tone. When this stage is dry, add any darker tones needed and allow the work to dry thoroughly. Your picture should be beginning to take shape.

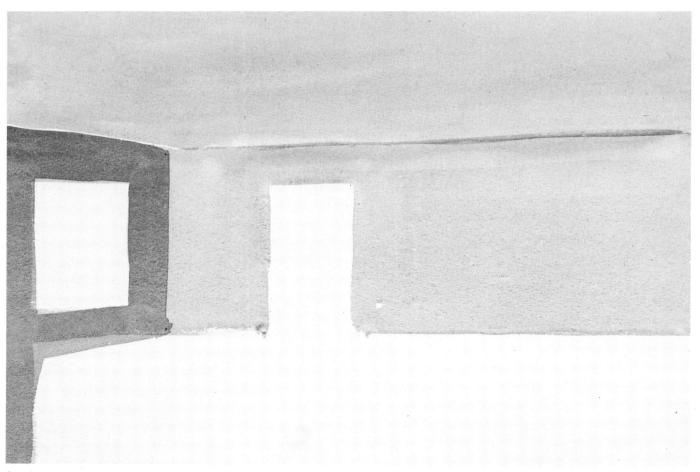

Step 3.

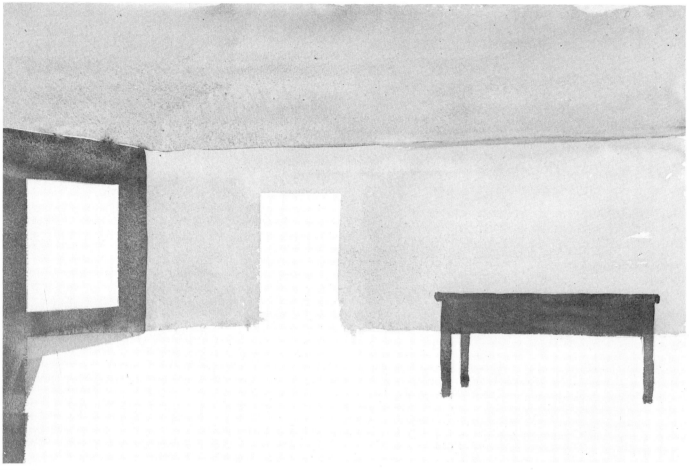

Step 4.

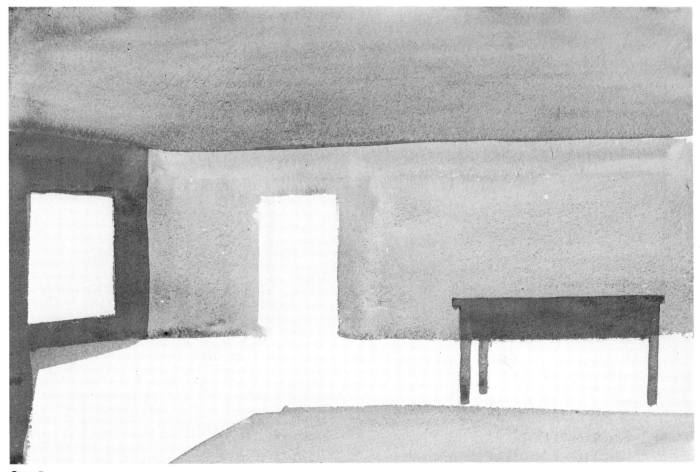

Step 5.

Step 6. With darker tones of the colours you have used so far, begin to add shaded areas such as the shadows cast by furniture on walls and floor, or the drape of a tablecloth so that it indicates the table edge. These washes must be carefully applied as they are the tones which shape the objects, give a feeling of depth and space to the room, and generally give the composition a three-dimensional feel.

Step 7. Shadow is made up of a gentle gradation of tone from light to dark. Try to match your colour washes to these uneven patches of tone, trying them out first on a separate sheet of paper.

Step 8. Finally, put in special accents of bright colour where necessary, and pick out details with a brush and a darker toned wash.

This method may seem very slow but it is essential to decide on the various tones and hues, and to learn how to organize the tonal sequence from light to dark. If these stages are omitted, the colour composition of the final picture is likely to be very confused.

You may have had some difficulty in controlling a picture that contains so many colours, tones and planes, but don't be discouraged – instead, ask yourself what went wrong. Is the basic composition too complicated? Are there too many colours and difficult tones? Are there so few, with such little contrast between them, that the painting becomes dull and lifeless? Check the tonal range: it may be too limited, from white to mid-range with no very dark areas. As a result the whole picture could be too light.

When you have identified the problem, try again, using the same careful method. To make the exercise more interesting, move the easel a little and paint the view from a slightly different angle. Then pin both paintings up side by side to study the difference.

It is also useful to paint the same subject in a high key, with a middle tone of grey as the darkest tonal value, and the white of the paper as the lightest.

Finally, use an enhanced colour range to make a brightly coloured painting.

These studies demonstrate the range of possible approaches to a single subject, and show how colour, key and tone can be varied in any water-colour you paint.

Step 6.

Step 7.

Step 8.

The Kitchen

The kitchen is one of the most satisfactory 'studios' for home-based artists. A variety of subjects is usually provided by pots, pans, tables and cabinets – not to mention all the complicated equipment used for special dishes.

The Dutch were masters at conveying the atmosphere of this centre of the home, often usefully adding a moral about thriftiness or efficiency as well! This early seventeenth-century etching has all the best ingredients: a lovely multi-paned window, pewter dishes and mugs on the plate-rack ledge, and everyday cooking utensils scattered on the table. The two women form a group in front of the smoking fire, their dresses richly shadowed by fine lines and rhythmic curves.

A little pot Is foen hot.

N Venne inuen. Quan queboren fulpfet

Een kleyne pot/ door weynigh vier /
Die maeckt terftont een groot getier.

Dutch etching; early 17th century

Any modern kitchen could give you just as interesting a picture. The corner of the room, the cooking range or stove (instead of the fire), rising steam from a pan of vegetables or soup, plates and dishes – all these help to make a collage of shapes and patterns, lit by a window, a chandelier, or simply a kitchen light.

The breakfast table is another favourite domestic subject. Often used for informal sketches, it provides a fascinating combination of objects and occasionally figures.

This sketch of a family 'room' was actually made on a balcony – you can see its rail in the foreground – overlooking a small patio or deck outside a holiday home. Breakfast is almost over, and the table is a crowded still life of bottles, cups, plates and so on.

The lines of the patio's boarded floor make a strong statement, emphasized by the parallel side of the table, and its own boarded pine top. Look, too, at the country chairs – just two crossed lines and a few strands, and it is clear that the seat is caned. At the back, an unusual hooped-back double seat forms a focal point.

Two of the figures have been sketched in lightly, but they are not really important to the composition.

Shapes Near and Far

Before beginning to explore the problems of depth, volume and detail which will arise as your viewpoint expands, try to appreciate the quality of flat shapes, and how they change and solidify when seen from different angles and distances.

1. and 2. See how your distance from the chair dictates its scale and that of the window, and how it can also alter your perception of the actual colours and patterns of the fabrics.

Remember, too, that light is an important element in painting, even though it is constantly changing; in both the two quick oil sketches below the light is as much a part of the composition as the chair or the scarves.

Close up, the fabrics dominate, and those which are sheer lend an abstract quality to the painting, while the chair becomes a group of flat shapes like the fabrics themselves.

Move away to the other side of the room and suddenly the group becomes a shimmering mirage of an empty chair dappled with red and yellow; the effect is entirely different.

3. A group of students was asked to draw studio furniture – easels, paint-trolleys, chairs, etc. – in silhouette, using only flat colours and regular shapes. Because their subject matter was so restricted, their awareness was heightened: the decorative content and contrast of the various shapes were easily isolated and intensified, yet the results were surprisingly three-dimensional. The studies had solidity and depth; the objects seemed to be standing on a real floor in a real studio.

Isolating visual elements in this manner will not destroy the illusion you wish to create. On the contrary, it will teach you an important lesson in your progress as a painter.

When you paint a small group like this, you can focus on the chair, or on the patterns, or on all the elements as the students did with their easels and tables. Each approach will create an entirely new set of problems and require that you adjust your techniques to solve them.

1.

2.

3.

Details and Objects

Interiors are full of objects and details and you should spend some time looking around you and sketching individual items. Not only are they interesting in themselves, but they may be useful in other pictures.

Often the setting of a portrait includes a good deal of background information. Look at the girl below, pictured in colour on page 491; this is an example of an informal painting in which the room and its appearance means as much to the viewer as the sitter. A chest is just behind the seated girl, with a table-top mirror, and to the right a lower table top is crowded with books, papers, and boxes. A picture on the wall adds to the scene, and in this case both the picture and the table top are cut in half.

Try looking at different portraits and see how much you can learn about the settings from the details around the main figure.

Victorian genre paintings were usually crowded with details and full of miscellaneous objects which might seem to bear little relationship to the main subject, but each one contributes one more note to the viewer.

Make studies of single pieces of furniture, of squares of fabric, and patches of curtain; working in detail on small pictures and sketches will help you understand the underlying components of structure and tone, so that when you go on to make your detail into an object in a painting, a few strokes may be enough to re-create an entire piece.

Rooms often contain dozens of small objects, and you may be confused by the choice, the apparent feast of material. Think of what the room would look like completely empty. Draw in the walls and the corners, even the floor boards under the carpet. Imagine how the light would change with no fabric or wood to absorb it. If you do have a corner or an attic or a spare room, especially with no curtains or window covering, paint it first as it is, then add a chair or a table, a few bits and pieces, and perhaps a throw rug or even a piece of felt or wool thrown over the floor. Paint the same area again, but take note of the different tones and colours which the reflections and absorptions create.

If you find you enjoy painting interiors, there are plenty of models to study. There are dozens of decorating and furnishing magazines which have photographs and studies of empty rooms every month; they will give you many ideas for new angles and effects at very little cost. Then too, learn to look at your own home, and the homes of your friends and relatives; there will be an infinite number of studies you can make learning each time about how to create an atmosphere of personality without a person.

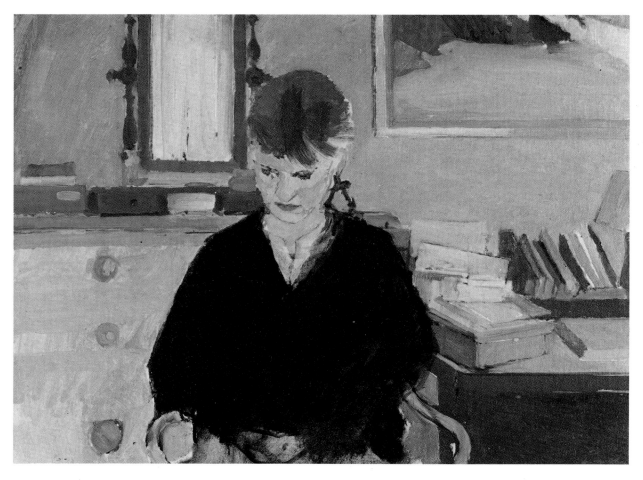

These two sketches of a table which you will also see later in the book, are reminders of the value of line and tone in a drawing. The pen-and-ink sketch gives a clear feeling of the table's proportions, its shape, and the texture of the bamboo from which it is made. The charcoal drawing renders the table in tone and, through the use of light and dark, shows it standing in a sunny window. The drawing is much more atmospheric and the attention given to the flowers and plants threatens almost to overwhelm the table itself. But to see how the table changes in the wider view, look at the painting on page 243. In this it becomes a rather indistinct part of the whole.

Yet without the line and tone studies, and an understanding of the table by itself, it would be very difficult to formulate just the right impression, the considered image, for the major composition when the table becomes merely a supporting element.

Table and Wall in Oil

Very often a part of a room can be used as a practice exercise in depicting walls and angles, as well as a brief return to the problems of a complicated group of objects. Here the table surface is emphasized by a separate glass top, and a wall which turns away from the viewer.

Push a table against the wall. Cover it with a plain tablecloth laid square or diagonally, leaving it slightly rumpled so that interesting folds and creases are created. Make sure the light is good – and experiment with additional lamps, which will reveal changes in plane and variations in texture.

Step 1. Draw directly with white paint on a sienna undercoat, outlining the shape of the table and the lines of the wall. The cloth does not extend over the whole table, and the plain surface is very similar to the wall behind it.

Getting the folded edge of the tablecloth right is very important – there should be sharp but subtle change in colour, and a change in brush-strokes.

Sketch in the apple, the box, the shape of the vase and flowers. I started to add other pieces of fruit, but left them unfinished.

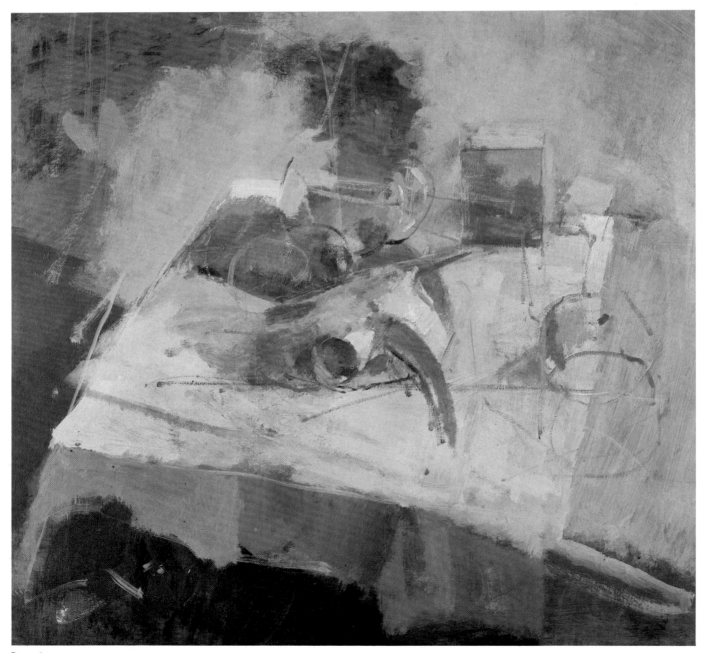

Step 1.

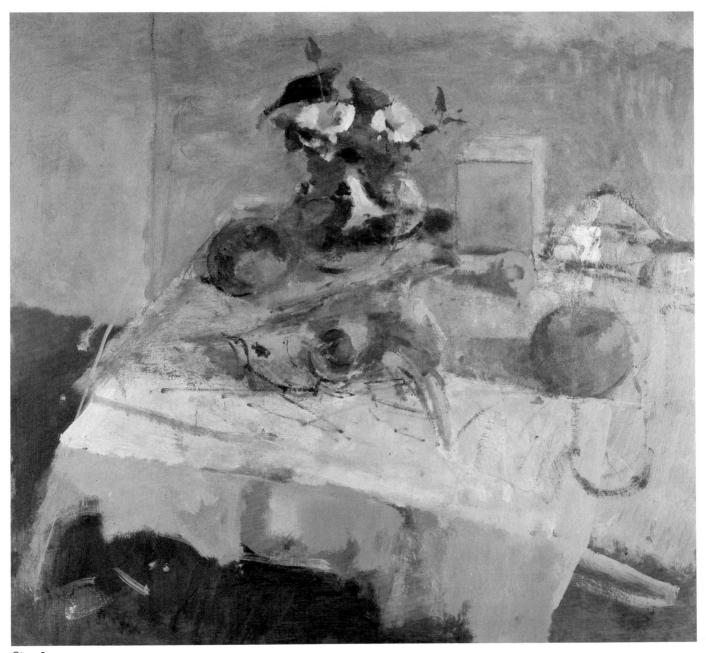

Step 2.

Step 2. The flowers become a natural focus for the entire picture because of their top position and the strong contrast of white against green. A central focal point usually makes a weak painting, but here the continuation of the table behind it and the quieter break in the direction of the wall balance the entire group.

In all these projects, look for a particular aspect of painting to work on, and then try another sketch, another study. You need plenty of practice in handling brush and paint, and in direction and emphasis as well as pure reproduction. The greatest mistake new students make is to attempt the perfect painting every time.

When you have got this far, leave the painting alone and begin another – perhaps the same table with a different group of objects and from a different angle, as seen on the right.

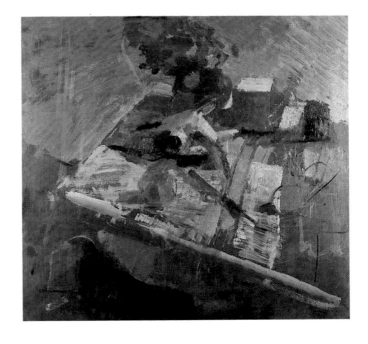

Depth in Perception

The rules of observation which applied to small groups of objects apply just as well to the variety of new materials and subjects found within the wider space of a room.

Take a small notebook and go into a room which you may not use very often – a spare bedroom perhaps, a garage, or a hallway that is simply a passage. If there is no chair, bring one with you and sit down in an unusual place, maybe with your back to the door, or facing a corner. You must be able to see a good part of the room, if possible from a new viewpoint.

Whenever you start a new subject it is a good idea to go back to the basics you are sure about. Look at the walls and the corners, find the angles and sketch the space lightly. Try to give greater depth and dimension than your previous sketches showed, using two pieces of card (above, right).

The archway on the right is an example of the kind of 'framing' you will be looking at later in the following chapter; here it acts as a frame for a lovely staircase; such a drawing would also be a good exercise of your knowledge of perspective. The stairs, even in a tiny sketch, must seem to climb, with the treads growing thinner as the perspective changes.

A particular point to note is the tiny ledges formed by treads overhanging the risers. Look carefully at your own staircase and try to recognize the important details and how much of what you see should be included.

The hand-rail is important too, serving as a guideline for the eye – see how quickly it carries you up to the landing, where it curves to the left, then takes you from the landing to the next set of steps. Your mind will follow these steps up to the next floor even though they cannot be seen, and that ability – to capture the mind's eye – is the real accomplishment of a good drawing.

Sometimes, as you have seen with the hallway and staircase on the opposite page, just a few simple details can create the feeling of depth. There it was the edges of the stair-treads showing how they rise; in the drawing below it is the simple use of a hanging shade.

Try covering the shade with a bit of paper or even your thumb, and you will immediately see how the sketch grows flatter and less three-dimensional.

This is a preliminary sketch for an oil painting. I moved all around the room, looking for just the right place to be able to capture the sitter and the setting, both in the appropriate mood.

Never be afraid to spend time on these first drawings. They will give you a vital sense of just what you want to paint.

If you are not too aware of how your viewpoint will change the finished picture, then mark out 3 ft or 4 ft (about 1 m or 1.2 m) intervals in a curve, with a window, a still-life group or a small furniture group as the focus. Make a sketch from each place you have marked, then pin up all the sketches in a line. You should have something like a travelling camera shot, with each sketch revealing a new angle, and new approach.

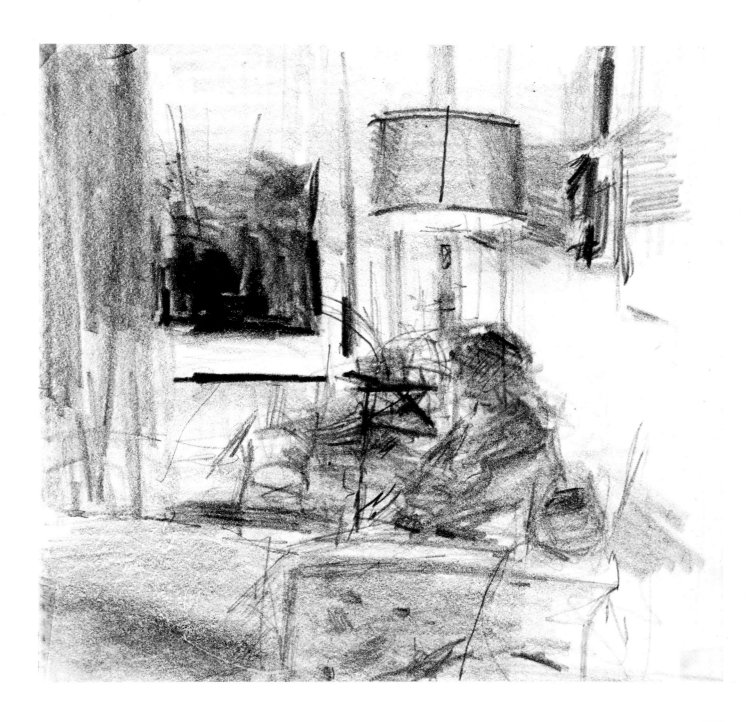

Pattern in Oil

This section deals with patterns and textures; shapes, colours, fabrics, designs and the surface differences between materials such as wood, metal, china and glass.

Detailed observation can take many forms, from the obsessive finish in seventeenth-century Dutch still-life paintings, accurate down to the last dew-drop, to the more simplified colour studies in works by Cézanne. Both approaches can be equally successful and both depend on careful observation.

Lay a few printed dresses or scarves on a table or bed and paint them just in terms of pattern. Accentuate the decorative quality of the composition by contrasting colour, texture and patterns with simple flat areas.

Work broadly and freely. Make marks, dots and lines in different ways. Apply paint densely in some parts, more openly in others. Vary the direction of your brush-strokes through horizontal, diagonal and vertical. Place smooth areas against textured ones. Build up the contrasts in the painting and emphasize different surfaces and changes in colour and shape.

Set up a group of patterned objects, including an upholstered chair and a table covered by a table-cloth.

Ignore tone and colour changes. Instead, just look at the patterns and how their shapes alter. The space between stripes varies according to the planes on which they lie. A pattern changes direction if the form beneath it varies. A checked tablecloth or dishcloth hanging directly down over a table looks different from different angles.

Make a series of studies on paper and experiment with the various ways of using and painting patterns. Work first in monochrome, then colour, using fine brushes and thin paint that isn't too liquid.

Patterns made from printed scarves on a chair

A garden view

Above is a marvellous example of patterns and textures interpreted in a broad way, with enough detail to make up a recognizable picture. It also shows that it is possible to find interesting, even exciting, subject-matter in the most unlikely places.

Simple shapes in a slightly abstract style

Detail from 'The Stable'; McCubbin

A direct contrast is provided, left, by a detail of a painting showing every crack and cranny of an old shingled roof. The paint has been laid on thinly so that the canvas itself acts as a texture, the spaces reflecting broken mortar and weathered surfaces.

Highly precise details are difficult for students and should not even be attempted for some years except in sketches or detailed drawings. The effort and concentration that a detailed painting would need are better expended on the broad qualities and impressions which are so important in creating a work of art. Look for the effect of colour rather than its actual place in your work.

Of course it is quite enjoyable to work occasionally on a very small, very precise scale – try working up a section of your crowded *Still Life with Quilt* into an abstract of tiny patterns.

Extra Projects

One of the greatest advantages of working indoors is the number of unusual subjects you will find in your own home or your immediate surroundings. Unusual for the average leisure painter, perhaps, but not for the great artists who painted everything they saw – a single chair, a pile of nuts and bolts, a piece of meat.

Learn to see everyday things in a new light. The sheen of freshly caught fish is entrancing, all silvers and purples and rosy greys. But don't forget to eat them quickly after a few studies – the smell of one forgotten kipper or decaying crab can overwhelm even the largest house!

Furniture is a special kind of prop, useful later for painting and sketching portraits, and important in room settings and interiors, where even the most mundane object can be set off as something magical and strange.

Below is a drawing of two old-fashioned sewing-machines. They were set up on a table with a screen to create an unusual group for an oil painting, on the opposite page. In the drawing the precise shapes are clear, but in the dark painting, only the metal wheels shine here and there, so that you can gradually pick out their shapes in the purple gloom. The printed scarf adds a very important splash of colour, echoing the fabrics hung on the screen.

Look around your own room. Try to see shapes in a new light. A mirror can come in very handy; hold it at an angle to the subject, then look at it through the mirror, not directly. Suddenly there is a very different painting – the tilted top of a wooden chest, all scarred and grained with years of hard wear; the strange folds of fabric on your simple curtains, the distorted pattern of a chair where the arm and seat meet.

If there are beams or cornices in your home, see them as angular supports, crossing and criss-crossing in an abstract pattern. Kneel down on the floor, and paint a simple square of the carpet or stained boards. A few hangers on a rail swing to and fro until they settle into a fascinating jigsaw of wire and shadows – an especially useful exercise in perspective as they never stay exactly parallel to one another.

Light can be an important aid in this voyage of discovery – move the lamp around too, so that the light falls from different angles, and creates new shadows.

Once you have spent a few afternoons making these studies, you will see your home and its contents in quite a new way.

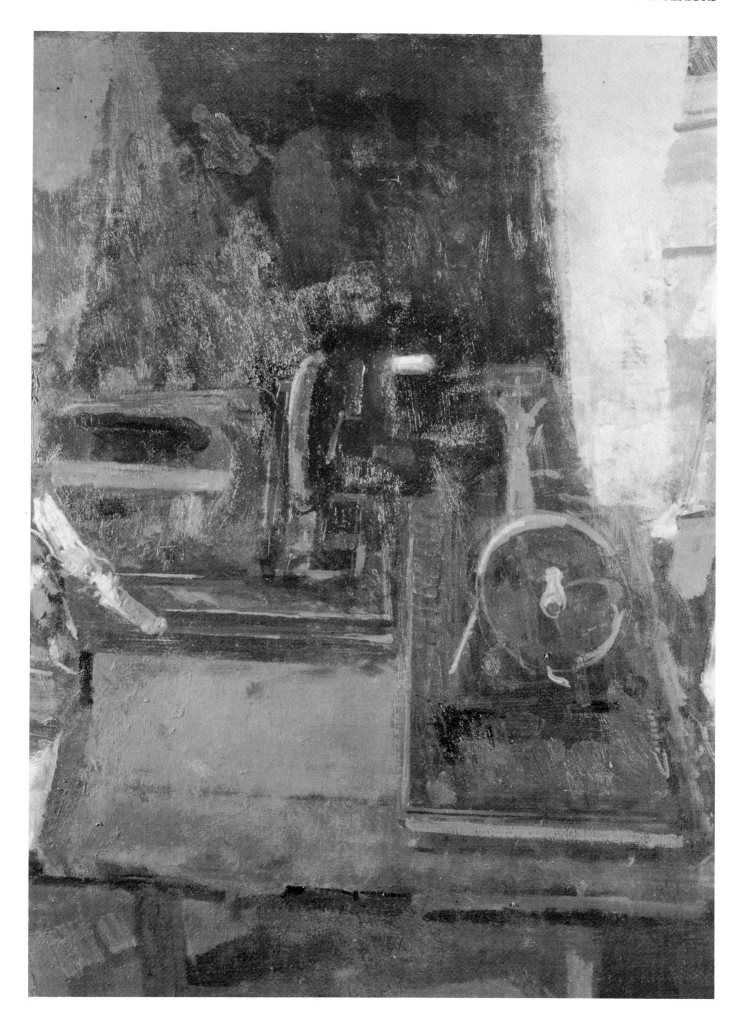

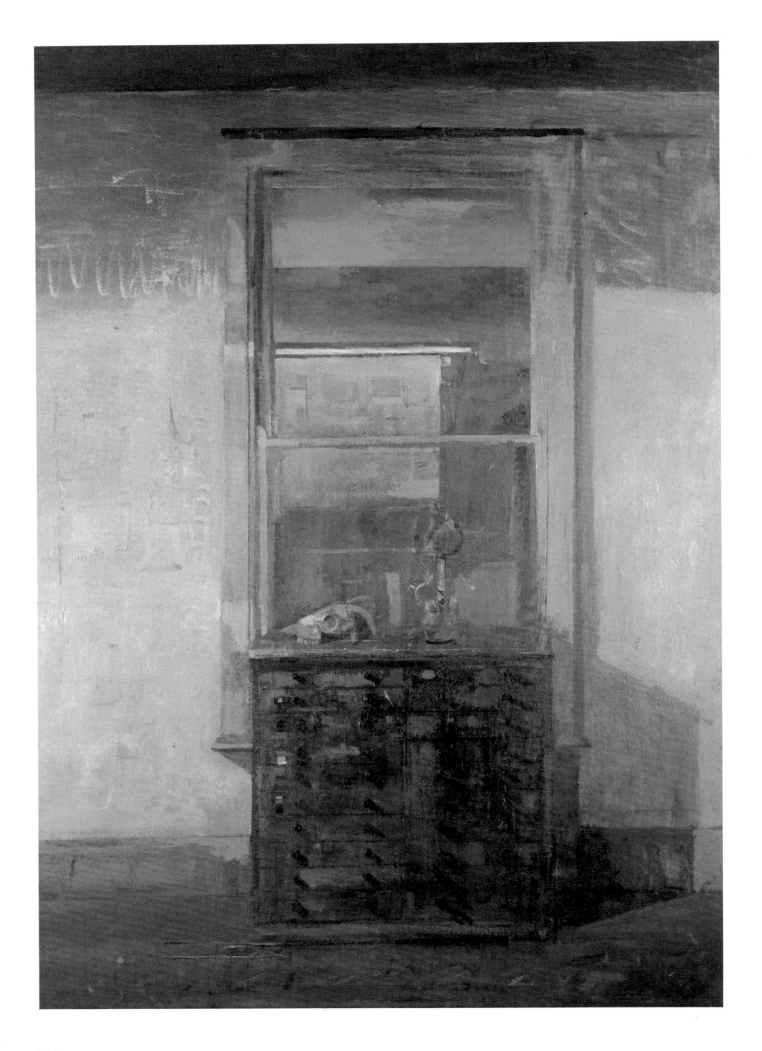

Lesson Six
Inside Looking Out

The interior of an empty room as an artistic subject is a fairly recent innovation, but the view through a door or window has a much older history. It is one of the earliest pictorial themes, long established in religious paintings where figures were framed in doors or windows from which they – and the viewer – were allowed a glimpse into the gardens of Paradise.

Artists saw the subject as a symbol of present confinement and future freedom. The aspect of anticipation must not be forgotten either – if a closed room was a setting waiting for a play to begin, then an open door or window was an indication that something important was about to happen.

In the past, as we have said, that something was likely to be a promise of happiness in the afterlife, a symbolic glimpse of Eden. In a lovely panel by the late fourteenth-century artist Stefano Gassetta, *The Charity of St Francis*, the sleeping saint (on an elaborate bed) dreams of the celestial city, shown floating in the air outside his window. Many scenes of the Annunciation had open doorways with distant landscapes and angels just beyond, and hundreds of the small illustrations in medieval illuminated manuscripts had doorways with people coming and going.

Gradually the secular aspects of such paintings became more pronounced, and the inside-looking-out painting became a technical device to lead the eye into the distance, rather than a symbol of the heavenly path.

Such vistas have artistic purpose as well, by allowing the painter to show off his ability to create depth and distance, and his imagination in the creation of fantastic castles and landscapes. By the seventeenth century the fantastic had become the tangible. The viewer was brought straight into the room by the marvellous detail of paintings by Dutch artists like Jan Vermeer (1632–75), with their mastery of the effect of light pouring into and becoming part of the interior, darkening the surrounding walls but highlighting the subject with incredible delicacy (see page 175).

Open doorways are real because someone is coming in or going out; a window is open to let in the air, to frame a few leaves or a glimpse of the sky, and, most of all, to give an impression of light.

Another use of vistas seen through windows and doors is found in Japanese prints, especially those of the eighteenth century where they seem a part of the complex design, almost invisible among the patterns and contrasting flat areas of colour.

In the West the eighteenth century was the period of romantic landscapes and classical imagery and interior scenes fell into disfavour although they were often used for working sketches and studies.

Illustrations remained popular, and gradually the principle of story-telling through art came back, though this time in a purely secular vein.

The Victorian painters loved genre scenes, and their patrons and clients bought variations on almost every possible theme, as described in the introduction to Lesson Five (pages 175–177). Many interiors could be immeasurably improved with the use of light and shadow, and the open window or door became commonplace in the genre vocabulary.

In the example below by William Henry Hunt (1790–1864), there are at least three levels of appreciation for the viewer.

The first is the interior itself, a country store-room or scullery. Hay piled with broken furniture in a corner, pots and pans standing on the floor, peeling plaster and old bricks are all painstakingly reproduced with considerable technique and skill.

The second is the young girl, who is more than simply a prop. She is painted clearly enough for the picture to be almost a portrait, though obviously rather an informal one as she has been 'interrupted' while peeling apples.

The third level, and the aspect which interests us most, is the light coming through the open window and the exterior scene of a sylvan landscape. This is the very aspect which the artist emphasizes by calling the painting *The Maid and the Magpie*.

An even more precise story is told in *Not at Home* by the American artist Jonathan Eastman Johnson (1824–1906). The lady of the house is seen quietly slipping upstairs while her drawing-room, seen through an archway, is flooded with light from an

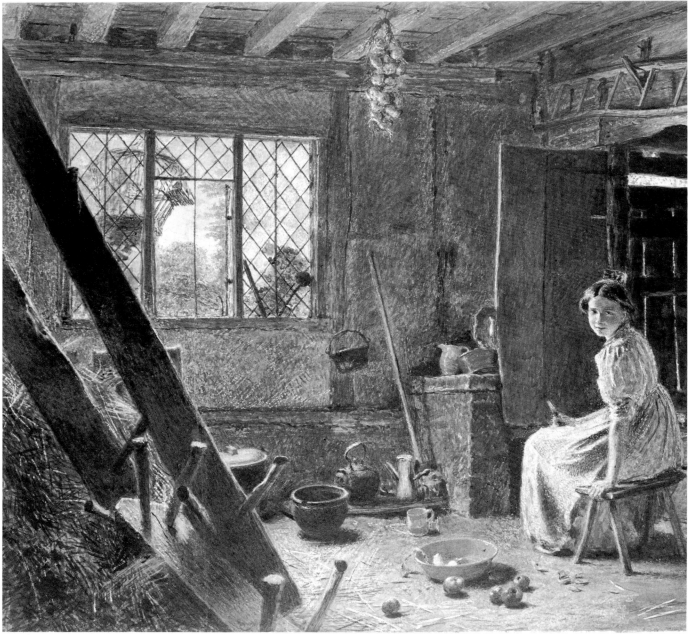

'The Maid and the Magpie'; Hunt

unseen doorway. This was painted in the 1870s, and *Interior*, a relatively unknown work painted by Pierre Bonnard (1867–1947) in 1898, illustrates the same kind of effective contrast. In the foreground is a quiet hall in sepia and browns, while through the doorway the dining-room is filled with domestic bustle and bright patterns.

Bonnard, Maurice de Vlaminck (1876–1958) and Édouard Vuillard (1868–1940) all painted interiors, but Bonnard was most deeply involved with the problems of a double image; a remarkable number of his paintings have open windows or doors.

Edgar Degas (1834–1917) was fascinated by ballet dancers and the glamour of their performances, but some of his liveliest and most charming drawings are simple backstage sketches like the one below; the mirror on the wall reflects one dancer getting dressed in a nearby room, while the girl in the left foreground is doing her hair. This use of a reflected subject appears again and again in art, adding a sense of mystery, a feeling of life going on beyond the walls shown in the painting itself.

In the late nineteenth century, the Impressionists were fascinated by the effects of light on objects. They began by depicting light outdoors, and the need to learn to paint on the spot meant that studio and interior paintings were yet again neglected for a while.

In many paintings by Henri Matisse (1869–1954) the frame and doorway are used purely decoratively to supply linear design in a flattish plane, and there is little change in the value of light from the interior to outdoors.

This patterning had also been particularly noticeable in the work of Aubrey Beardsley (1872–98) who loved to use a half-glimpsed view and cut-off design in his compositions; many of his black-and-white prints and drawings have open windows, doorways and spaces within spaces making used of simple sinuous lines (see page 177).

During the 1920s and 1930s new groups of artists produced paintings remarkable for the feeling of atmosphere and mood which they convey. In many settings the attention is focused on quiet figures, but the rooms in which they are seen have a strong personality of their own – golden, warm and redolent of domestic content, or angry and violently claustrophobic, with almost nightmarish landscapes.

Paul Nash (1889–1946) developed his own version of the inside-outside theme in the 1930s, setting empty frames and screens in Surrealist and imaginary countryside.

During the Cubist period, there were some inside-outside paintings in the new style, but there are very few examples from Abstract art, except for some portraits.

In recent years Pop Art with its fascination for symbols derived from advertising and the consumer-oriented world, has again made us conscious of our homes, and the rooms we live in. The portrait *Mr. and Mrs. Clark and Percy* by David Hockney (*b.* 1937) is centred on a quiet Regency terrace seen through a shuttered window. Peter Blake (*b.* 1932) uses closed doors and windows, often three-dimensional, which suggest unseen vistas – perhaps even more evocatively than open doors would.

Certainly, the world beyond our own enclosure seems to be a stimulating and productive subject for the artist.

'Backstage'; Degas

Starting to Work

This lesson moves on from drawing and painting an interior to including the additional space that can be seen through a window or open door. It will introduce you to landscapes and townscapes, both emphasized later; and will make use of the basic need to create a structure – a front and back – in a picture. It will also make use of perspective, and tonal recession and colour changes. Your range of experience can be extended to record variations between interiors and exteriors, and to emphasize contrasts between near and distant objects. Natural and artificial light may be combined in one picture, and you will see that the framework and geometry of the interior echoes the outside world.

Up to now drawings and paintings have been made indoors, under relatively controlled lighting conditions. As soon as you begin to work with outdoor light, however, the quality alters radically. Make sure the difference shows up in the appropriate areas of your sketches.

Train yourself to observe your surroundings, even when you are not painting. Carry a sketchbook at all times and draw, and make notes when you see special combinations of colour.

Work freely and allow the pictures to develop their own character. Handle the paint in the way that is easiest for you. Eventually you will develop your own individual method of working.

Study the paintings to see whether any parts seem out of context – a doorway that is too yellow for an evening scene, or a green that is too bright for a rain-swept view. This can easily happen with the change from the inside light to the outside.

Finding a Subject

Drawing or painting a view from inside a room poses two related but different basic problems: how much of the interior should be in the picture, and how much of the outside view should be included.

Start by deciding on the position of the window-frame, a very important factor. Too much or too little frame will unbalance the composition and detract from the desired effect of looking through an opening.

Then study your position in relation to the window. Stand as far away from it as possible, with your back to the opposite wall; your width of vision through the opening will be very limited. Then move towards the centre of the room and observe how your angle of vision widens as you come closer to the frame. Finally, stand right up against the window. This will give an unnaturally exaggerated wide-angled view.

These two basic ingredients – the amount of frame, and your position in relation to the window – must be balanced to create a successful composition. They will also determine the overall light and dark areas in your picture.

Make quick sketches from several different places before starting a larger drawing or painting, and don't ignore what seem to be uninspiring subjects. Even a straightforward view through a small opening can be very effective. The window may be divided into a number of panes, or the sill could support an interestingly shaped vase. Use these preliminary sketches to prepare your final composition.

When you have decided what to draw, it will be useful to have a chair or stool so you can work comfortably. Thinking and studying new problems and different solutions can take time, especially for the first few sessions.

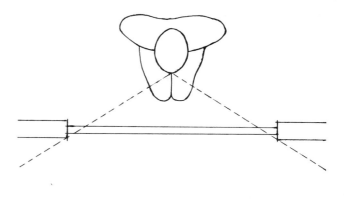

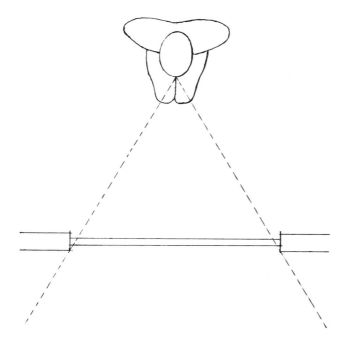

These two sketches are examples of what happens to the picture when you move your easel and chair backwards or forwards.

Try for yourself by moving your chair, and note what you can see each time. Remember, though, that when you begin to paint or draw the scene you will have to allow for the easel or a drawing-board in the space between your chair and the window.

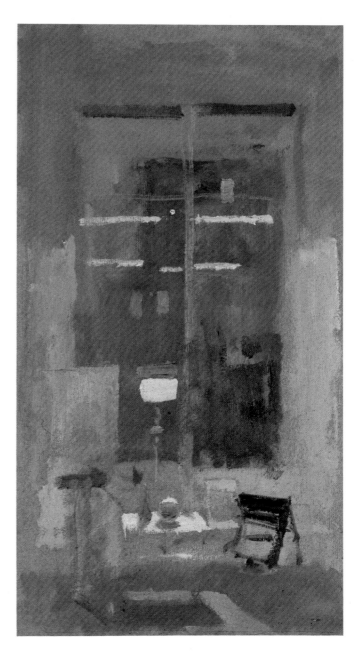

Scale

Many of the objects you will want to paint will be much further away from you, and from each other, than in previous studies, and the problem of interpreting scale will be more critical. It is vital to draw or paint what you actually *see* rather than what you think is there.

Stand somewhere in the middle of the room where you can see both interior and exterior spaces, and look out of the window. The trees, houses or buildings that it frames are very big in comparison with it, and unconsciously, therefore, you are likely to want to scale up the background. However, if you try to work on this basis you

will enlarge the trees and other elements so much that they won't fit into your window-frame.

A Polaroid photograph can help to show what is really there: you must learn to understand that the seemingly large window frames small images of much larger objects.

Because of this difference in scale the view will change more radically than in previous exercises, unless you keep your head very still as you work. Move your head just a few inches from left to right, and objects in the distance will seem to shift by several feet.

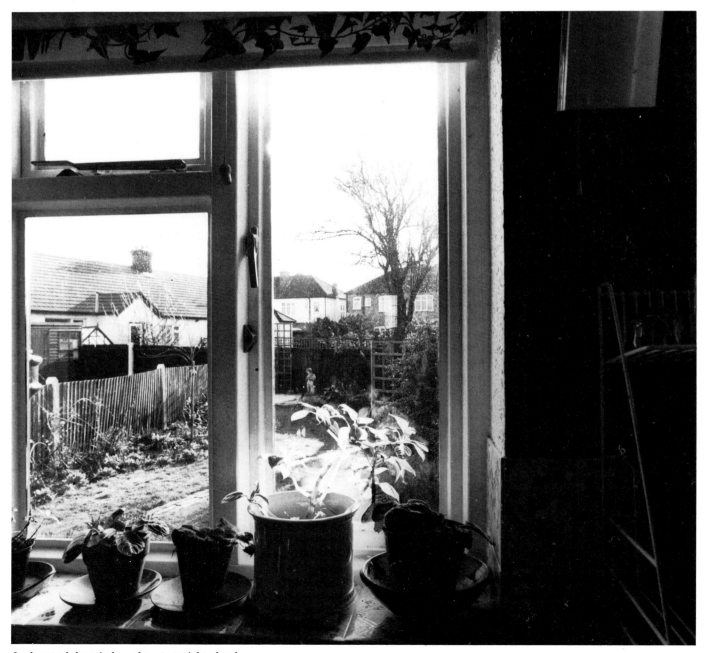

Look out of the window almost straight ahead

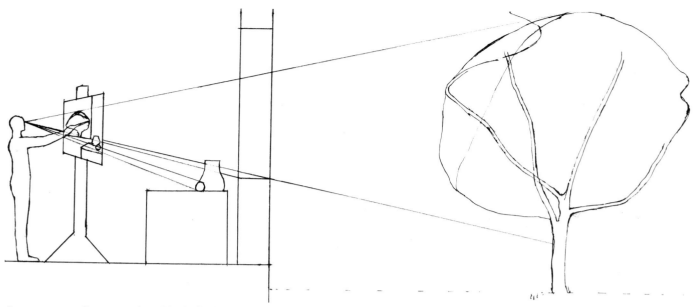

Large tree, small vase on the table; both should be in proportion

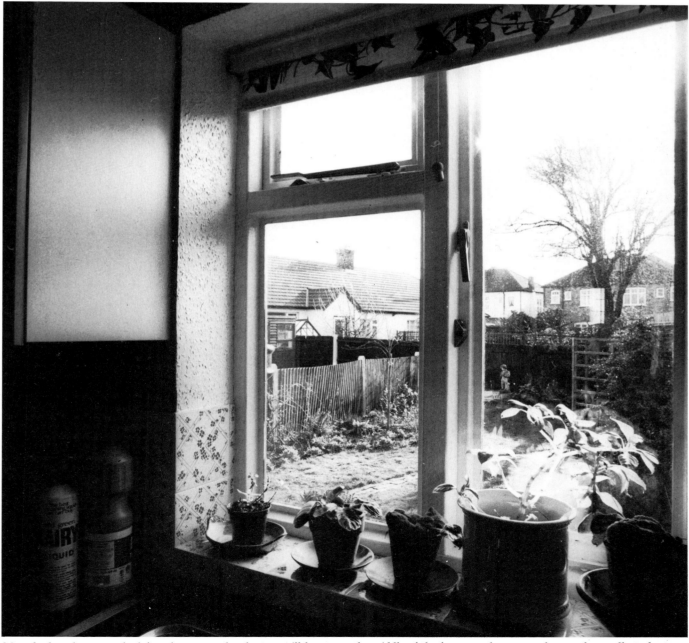

Move back and turn to the left – the gate under the tree will be nearer the middle of the frame, and you can also see the smallest plant on the windowsill

Depth

In any drawing or painting the artist's chief aim must be to show accurately the spatial relationship between the objects or figures in the composition. Success in this will depend upon the artist's powers of observation and his or her understanding of perspective.

To reinforce the feeling of depth, artists can also make use of tonal perspective and colour perspective. In the example below, tonal perspective has been used to establish the distance between indoors and out. Because dark tones appear nearer than light ones, the curtains and wall are black and deep grey, while the view through the window is worked in much lighter tones. In reality this may not be how the walls, etc., appear, but

an artist must use the various devices at his disposal to translate what he sees into a drawing or painting.

Another optical trick that artists can use is colour perspective: warm colours advance while cool colours recede. In the example on the opposite page, the same view is drawn in vividly coloured pastels. Notice how the warm colours – yellows and oranges – are kept to the foreground, while the view out of the window is drawn in blues and greens. Again, these may not be the actual colours, but artistic licence permits most things.

Perspective is what gives a painting or drawing a sense of depth, and it is created in a number of different ways.

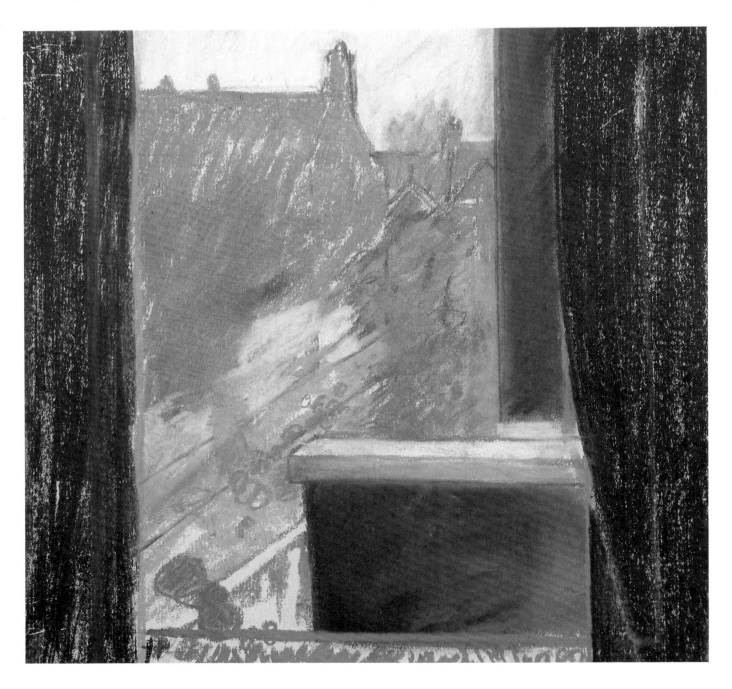

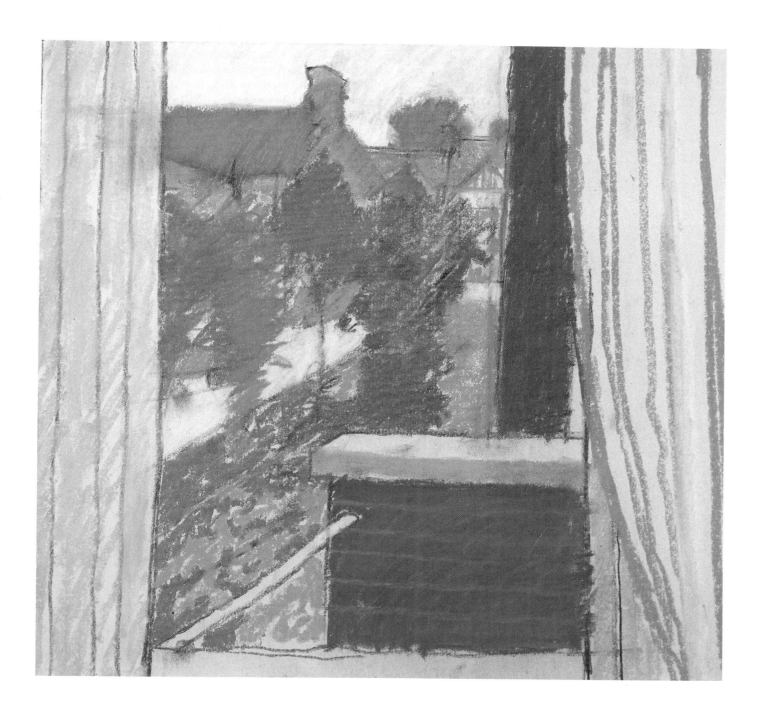

Night Scene

Drawing and painting at night is an unusual way of studying the contrast between an interior and exterior, and learning more about the problems of assessing tone values.

As daylight fades, there is less tonal contrast between the inside of a room and the scene outside, a change that presents some interesting problems.

First, you will have to decide how much light you need to work by. Too much means you will not be able to see anything outside. Too little, and it will be too dark to mix your colours. Experiment by making a series of small studies until you get the balance right – possibly over several days so that lighting conditions are consistent.

Second, tones will be very dark compared with those of normal bright daylight or sunlight. You will have to decide whether to translate them into normal tones and colours, or paint a very dark picture.

Step 1. Using a charcoal stick on its side, cover the paper to make a medium-grey ground. (Into this the main shapes of the drawing will be worked, with a soft eraser to lift light areas and the charcoal to render dark ones.) Then sketch in the main lines of the window-frame, buildings and roadways in the view.

Step 2. Introduce the light areas of the view by rubbing out the relevant parts of the ground. The darker tones of the sky, the fence railings in the middle distance and the buildings should be worked on at the same time, so that you are dealing with the drawing as a whole rather than concentrating on only one part of it.

Step 3. To complete the drawing, rub out the brightest areas with the eraser. In this example the highlights on the fence railings are most visible and also serve to give depth to the composition, taking the eye from the window-frame in the foreground, around the corner of the building and into the background to the left of the drawing.

Step 1.

224

Step 2.

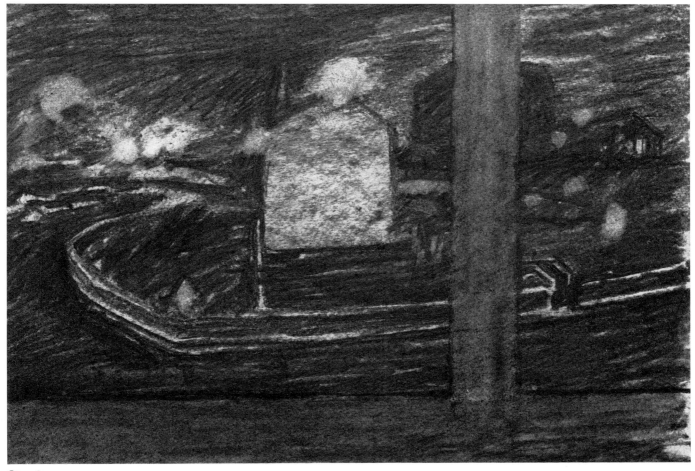

Step 3.

View from the Top

A built-up city street seen from above is an intriguing subject for an artist. There is something peculiarly romantic about looking down on the rest of the world, detached from the bustle and noise below. Although such a bird's-eye view would have been considered ugly a century ago, many modern artists enjoy getting to grips with its varied angles and planes, even though there are none of the traditionally pretty elements such as gardens or parks.

For speed when working, black, white and brown conté were used with charcoal.

Step 1. When you are working from a high vantage-point, streets, buildings and other architectural elements can easily be seen as simple shapes. Begin the drawing by blocking in the outlines of the most prominent ones with charcoal, keeping the line-work to a minimum.

Step 2. Study the view, and with black and white conté indicate which are the darkest and lightest areas of tone in the drawing. Because you will be working over the drawing in black, use the brown conté to emphasize the more important curves and planes within the sketch.

Step 1.

Step 2.

Step 3. Now begin to develop the middle tones, and to add details such as dark windows, rooflines and other structural details. These may be developed in line or tone as the situation demands; try to use them to give depth and movement to your drawing.

Step 4. Complete the drawing by strengthening tonal contrasts, and use line to fill in further detail. Try to work quickly but without sacrificing accurate rendering of the forms. Use the brown conté to suggest red-tiled roofs.

Remember that in a view such as this the shapes of the buildings are the main focus of attention, and detail is there only to tell the viewer that what he is looking at is a street scene.

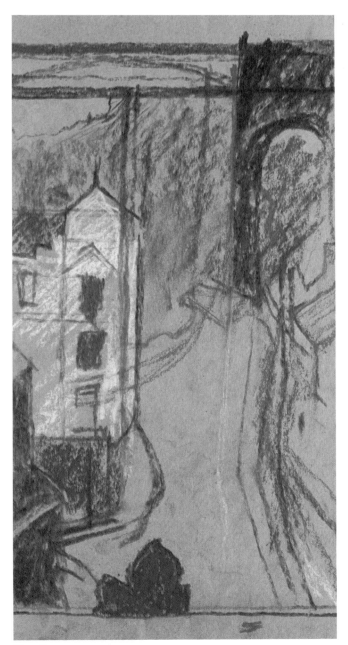

Step 3.

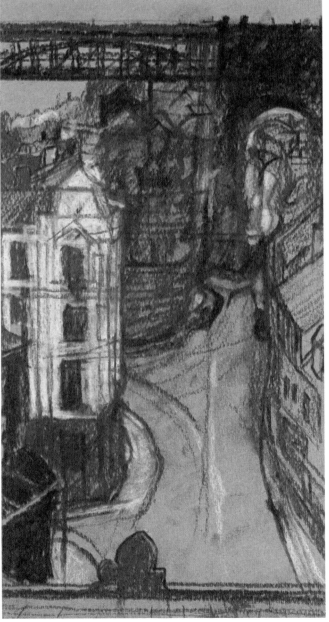

Step 4.

Variations in Tone

A tonal drawing can create an illusion of space and depth and also record patterns of light and dark, while a black-and-white photograph is a good reminder of pure tonal effect; but neither can match the reality of the visual world. Nor can the colours on an artist's palette begin to reproduce nature's variety of light and dark tones. A great deal of judgement is therefore required to determine how the real world can be modified to come within these limitations.

In addition there is linear perspective, discussed in Lesson One. You will recall that it is based on the idea that two parallel lines will eventually converge at a vanishing point on the horizon, and that from these lines the relative sizes of objects can be calculated.

Pencil tone chart

Tone and linear depth in pencil

228

Make a series of tone charts for every colour, like the ones here. Use all the tones as references. Compare a dark tone in a scene with your darkest reference, a light one with the lightest.

To assess tones, half-close your eyes so that details disappear and colours lose their intensity. You will then be able to see adjoining areas purely in terms of tone, disregarding their colours.

The more experienced you are, the wider your range of tone and colour-mixing will be, even in the so-called monochrome black and white. For the beginner, the best approach is still to start with three tones – dark, medium and light. As you paint more and more, you may wish to add intermediate shades.

Charcoal tone chart

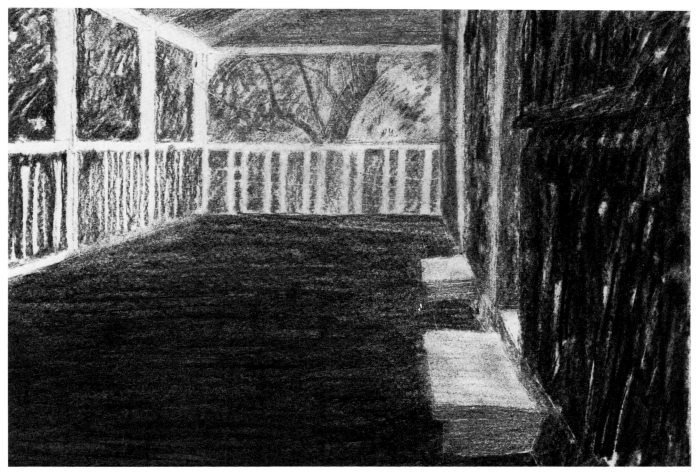

Tone and tonal depth in charcoal

Colour and Tonal Contrast, Inside and Out

Density of tone and colour are important factors in all compositions but the remarkably wide range of contrasts in even a simple view from a window is particularly fascinating.

The contrast in density between the interior and the scene outdoors can be high or low. Achieving the correct balance is vitally important – and probably the most difficult aspect of painting this subject. The greatest difference in tone value is likely to be between the dark inside of the frame and the daylight scene outside.

Half-close your eyes and look at the window to see the strongest effect. If you keep your eyes wide open there will be less of a contrast.

Changes in the direction of sunlight, and variations in its intensity, also affect your work: the colours, tone values – and even shapes. In summer, light falls from a high trajectory and casts short, hard shadows. The winter sun, low on the horizon, floods a room with light, casting long, luminous shadows full of colour.

Buildings or trees seen against direct sunlight are reduced to silhouettes.

Colour may be high key or low key, and its overall hue cold inside the room and warm outside, or vice versa. Its strength, and the contrast between the interior and exterior, will be another deciding factor in your composition.

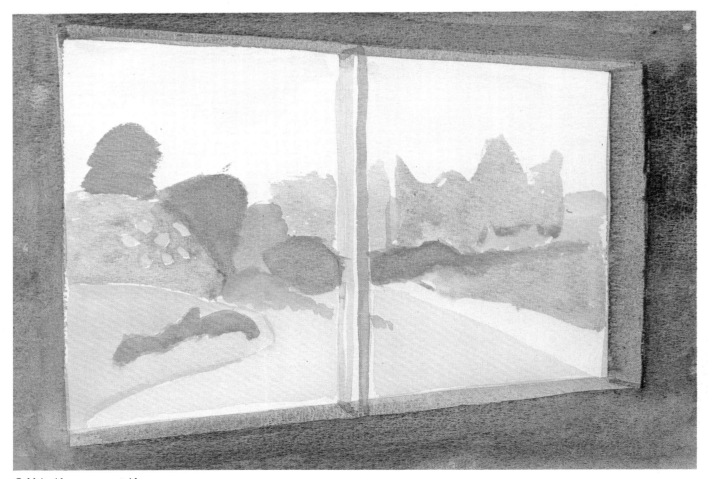

Cold inside, warm outside

Reflected Tones

Tone may also be affected by reflected light. Experiment by placing coloured objects with shiny surfaces where they will reflect onto the cards. Repeat this experiment using a white card and you will see how brightly coloured objects can affect your white window-frame.

Most window-frames are white, and will be seen against the light, with reflections from outdoors as well as inside.

Eventually you will be able to enhance or reduce colour and tonal contrast to create a particular effect. However, it is important to start by making accurate tonal and colour studies. The attempt to master these factors will help you to recognize and understand 'normal' contrast.

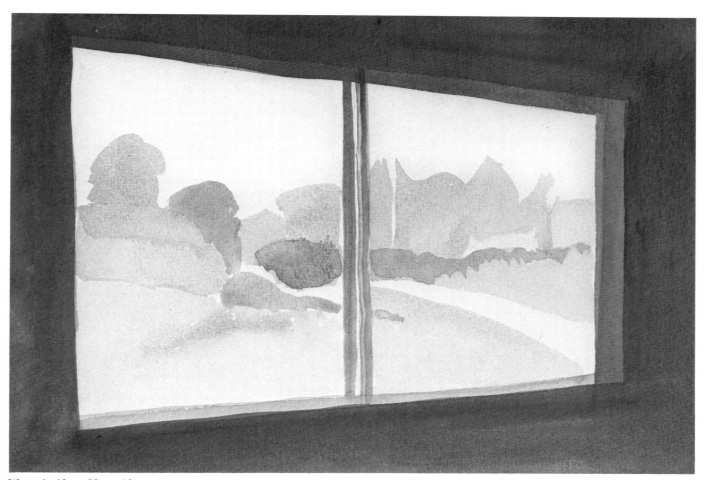

Warm inside, cold outside

An Open Doorway

A view through an open doorway provides a ready-made framework within which to create heightened tension in composition.

Step 1. Position your easel so that you can see a fair amount of the doorway and inside wall, as well as the scene outside. Lightly draw in the main shapes on the paper. Break down the broad masses, subdividing them into areas of related greys and whites. In this example the wall is mid-blue; the blue wash is applied, providing a frame for the rest of the composition.

Start by developing a simple tonal structure, as in previous studies, using ink and a wash. Pin these earlier studies up where you can see them.

Step 2. Wash in the framework of the doorway with a pale grey. Use a very light green for the shapes outside, working in simple, flat areas of colour. Leave the brightest areas unpainted so that the white of the paper will give highlights. Once the light areas have been established, fill in the basic intermediate washes.

Step 1.

Step 2.

Step 3. Put a second wash on the door-frame and inside wall. Draw in the shape of the open door and begin to indicate more detail in the outside view. Paint in a warm green for the trees, mixed from yellow and viridian green. Mix a light green wash for the grass, keeping this lighter in tone than the trees but about the same intensity as the blue inside.

Step 4. The problems involved in combining an interior and exterior in the same painting emphasize a number of elements which are common to most subjects: contrasts in tone, texture and shape; simple flat areas against complex forms, such as a building compared to a tree; dark against light.

Look critically at your subject and decide on the best way of using and interpreting these varying elements. You may use them to create a series of steps within your painting which will link the interior with the view. The floor or the wall may lead to the outside, or the enclosed space of the room can be used as a foil to the greater depth of the exterior.

Step 3.

Step 4.

Step 5. The floor will become lighter aś it moves from your vantage-point to the doorway. In this example the gradual change from dark to light is achieved by using a wash of light red, and washing it out with clean water to leave white paper at the threshold of the door. You will find this easier to do if you turn the work upside-down.

Make sure the painting is absolutely dry. Larger washes can afford to bleed a little at the edges without causing too many problems, but details must be sharp and clear.

Step 6. Now begin adding those details which will give the painting atmosphere and texture, and bring the picture to life. Add structural details to the door and develop the shape and shade of the trees. Also indicate the sky, leaving white areas for clouds. Shadows at both sides of the door and the addition of a table and vase of flowers reinforce the feeling of being indoors.

Step 7. There should be a reasonable amount of contrast in tone between the inside and outside: that is the real essence of this project. Look carefully again at the scene before you select any final details that can be shown by lines drawn with a fine brush-point or else by small additional areas of wash. The pattern on the floor, the stone squares outside, the leaves of the trees, and additional brush drawing all give depth and movement to the finished painting.

Step 5.

Step 6.

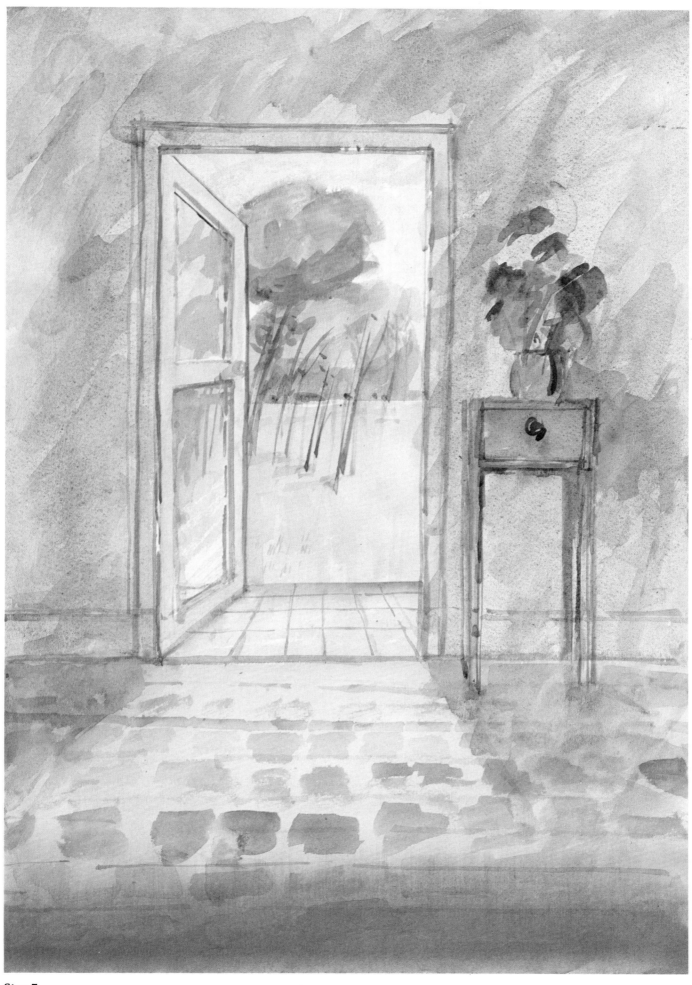

Step 7.

Asymmetrical and Symmetrical Framing

One of the most interesting aspects of painting from inside looking out is that 'inside' need not actually be an interior: the idea of framing the view relates to many sites, some of them wholly outdoors.

It seems that our eyes are pleased by such groupings, because the frame gives us a context for the picture as a whole.

1. Symmetrical framing is one of the oldest tricks known to man, and it has been used in a wide variety of ways. This early Middle Eastern carving is almost completely symmetrical, with the twin standards on either side, and the two snarling devils held up in almost identical poses.

2. A more sophisticated design is seen on this Persian seal, found at Thebes; the palm-trees on either side are almost identical but not quite the same size, and the principal image is centred under an almost symmetrical bird-god.

1.

2.

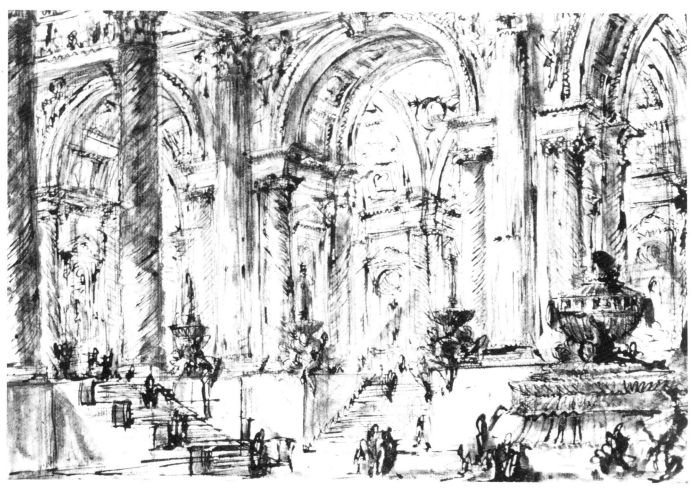

3.

3. In the West we have gone through nearly every variation of the framed picture. A classical sketch by Piranesi shows how relatively simple columns and arches repeated again and again, vanishing into the distance can give an impression of architectural grandeur.

4. A small sketch of a woman working in the kitchen shows how the frame of the dominant figure is quite enough to give point and value to the entire image.

This off-centre vertical line on one side, with a strong horizontal line (formed by the top of the chair and the top of the jelly-bag) has, since the late nineteenth century, become a favourite composition of artists, while the classical, purely symmetrical pattern has lost its pre-eminent position.

None the less, you can see how any kind of frame helps the eye to 'pull together' all the elements of the painting, and create a coherent statement and a pleasant and satisfying image.

4.

Colour Unity

The easiest way to understand colour unity – the predominant warm or cool colour in a painting – is to make comparisons.

Paint three simple studies of the same view under different conditions.

Now compare the three sketches. The colours will be vastly different and should evoke the time of day when each study was done, and what the weather was like.

In these working sketches it is important to concentrate on creating compositions made up of broad masses and limited colour groups rather than to produce finished paintings; the aim is to learn what to look for in a subject and to consolidate basic principles. Even so, it is possible to end up with a satisfying picture – the simpler the approach, the more striking the ultimate effect.

Follow two basic rules when recording subjects for reference.

First, keep your drawing or painting as simple as possible. Trying to create a complex work from such complicated material will result in a study full of unrelated objects.

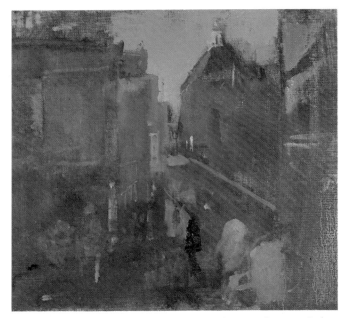

Night view from a window

Second, avoid working for long periods. Because of changes in the direction and quality of the light, you will constantly have to adjust parts of your picture, and it will be impossible to create a harmonious composition. Work for a short spell each day at the same time in order to see your subject under consistent conditions.

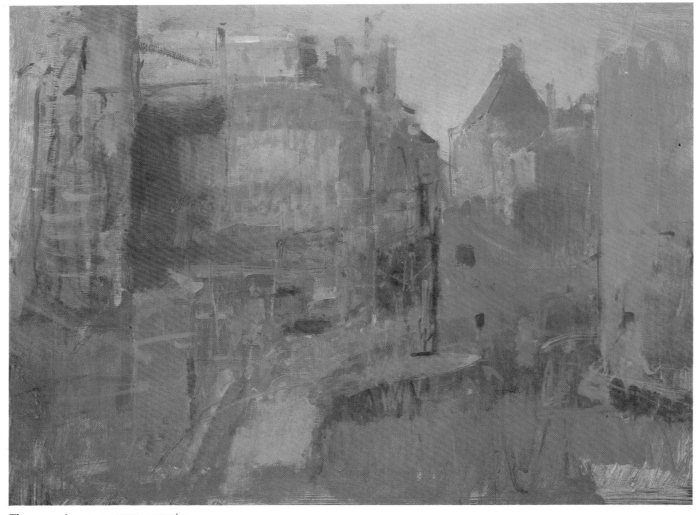

The same view on a summer evening

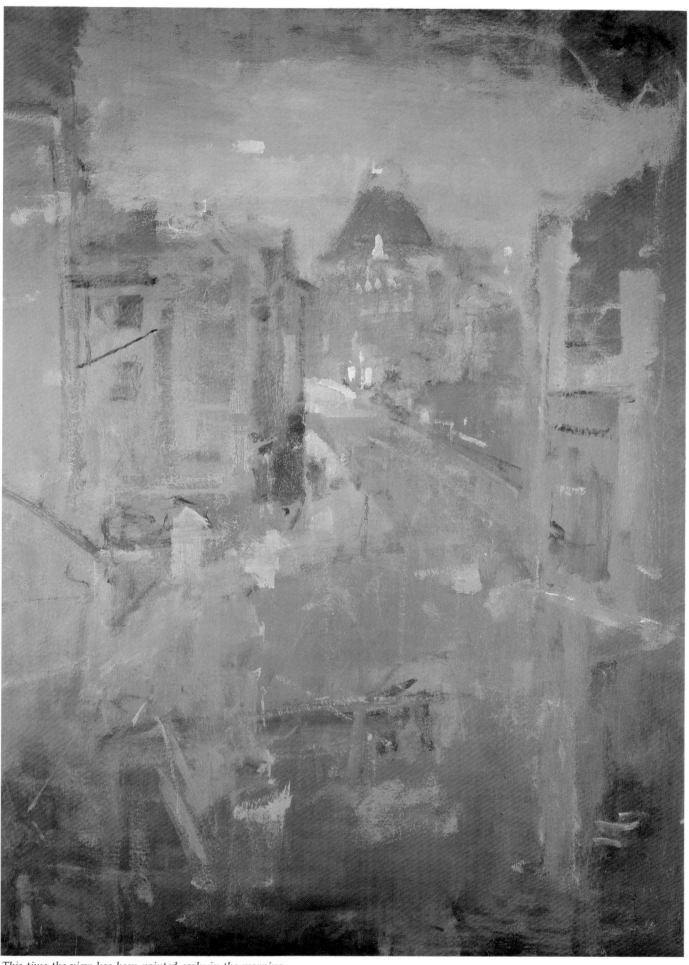

This time the view has been painted early in the morning

Developing a Personal Style in Oil

By now you will have realized that my work is very different from the work of either of my two colleagues.

This has developed only after years of work, and considerable experience in many different media until I found a way of perceiving and reflecting what I saw to my own satisfaction. I have mentioned this now because this project is one of the first long oil studies you will be attempting. It took me over a month to work it through from the first idea to the version on the following pages, and it will probably be worked on again over the next two years. Oil painting is not something that I would recommend to impatient students.

You must also recognize that a style of your own will come equally slowly, and in any case may be different at different times in your artistic career. Far from being a matter of handling detail, or some other form of expertise, it may show itself in greater understanding and artistic sensitivity.

In the course of these lessons, we advise you to try different subjects, different media, and also different styles and approaches to the problems of paint. Throughout the book we have included works by other artists as examples, and in projects, because we have been anxious that the advantages of listening to individual voices should not be lost.

The Project

During the warmer months of the year, the scene through the door to a balcony outside my studio makes an irresistible picture. Inside all is dim and rich with colour; outside is the sunshine, the bright air, the sense of freedom under the trees and a view far past them to the distant horizon.

I have used the scene many times, so I knew where I wanted to put my easel, but the table – a new addition – caused some problems.

You will see on page 205 that I drew the table itself in different media. Made from a delicate, fake bamboo, it added just the right touch to the composition, but I was unsure how it would look. Those first sketches were in tone and in outline. The next sketch I made is on the right, with the table in its place by the window. I used charcoal to emphasize the patterns in sunshine and shade.

In the illustration on the far right I began to work directly onto the canvas. An undercoat of raw sienna and umber gave me a good background. Over this, when it was bone dry, I washed in the inside walls of the room in a thin, brown mixture, working quickly in broad strokes to outline the framed doorway and the side window.

Art students at schools and colleges are able to talk to their teachers and to each other, gaining knowledge and experience through their conversations. For students at home, whatever their age, it can be difficult to see how work is progressing, and how it compares with that of others. This is one reason why we suggest you visit galleries and museums as often as possible. Admittedly, paintings don't talk back. Or rather, they don't talk back until you learn something about their own way of communicating; when you do, every sketch will be a daily lesson, and each major painting a study for a month.

The problem of not being able to communicate with other artists remains, but we have tried to think of most of the practical questions we are asked, and to suggest appropriate answers. This is one reason why the three of us give our individual opinions – this is no bland, homogeneous treatise!

In the past six lessons you have been looking and, we hope, translating what you see into action – drawing and painting – and then into thinking about what you have done.

This in itself will answer some of your questions; and it may be that, in becoming your own critic, you will be able to find more honest and individual answers in privacy than many students at a more formal school.

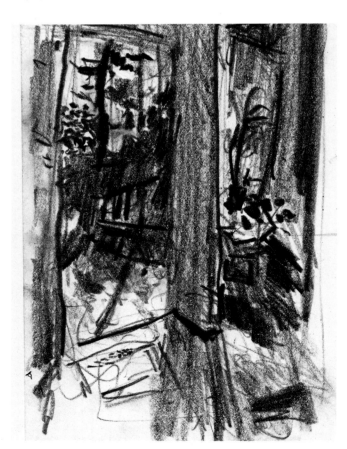

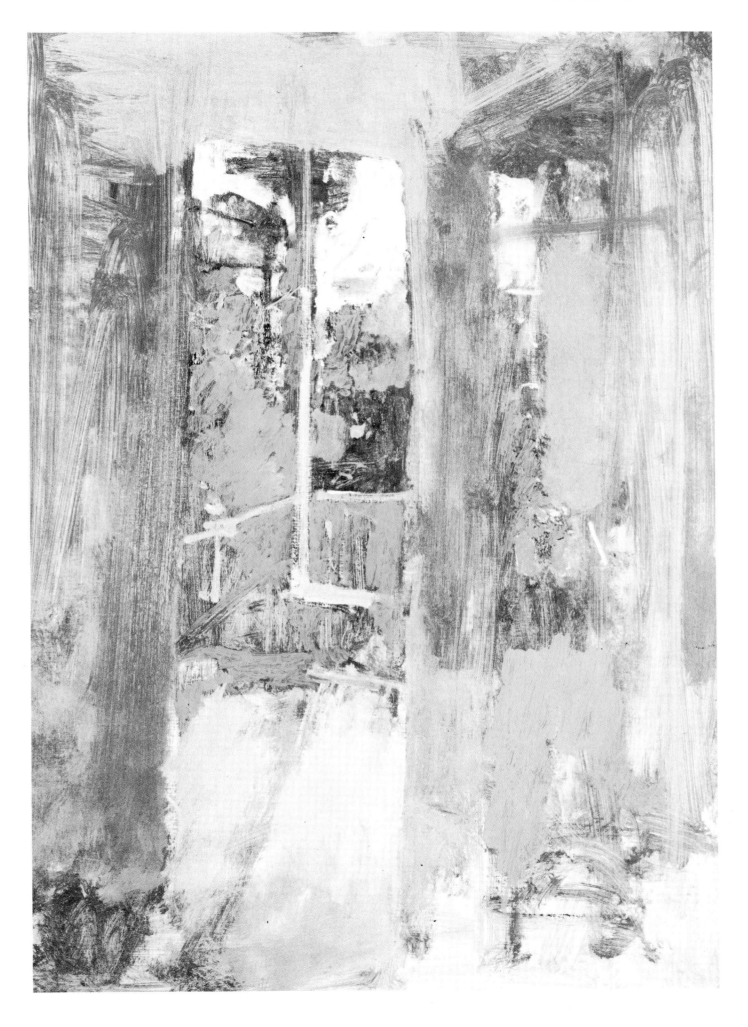

When the initial wash was dry, I began on the balcony and the trees beyond (see below).

As the sun came streaming in, it lifted the colours of the wood and the rails to a much brighter tone. I added yellow and white to all the colours, and emphasized the vertical line of the roof support instead of the vertical line made by the tree. (The latter can be seen more clearly in the sketch.)

The roof support and the rail seemed to make a pleasant geometrical form in the midst of the heavy, irregular brush-strokes. In the finished example opposite, the interior wall has taken on a grey tone, and there is little detail in this part of the painting. I gradually drew in the trees, first as rippled shapes in green, then with short strokes of lighter green to suggest leaves. I cannot say too often that it is vital to move back from oil

paintings to see the effect of even the simplest strokes. Several feet may not be enough – make sure you look at the easel from 4 ft or 5 ft (well over a metre) away before you decide how much more you should do.

Finally, I added the last strokes to shadow the rail and lift the vivid colours of the flowers.

For a very different kind of approach to the same idea of looking outside, look at the painting on page 214. I painted that some twenty years ago, and although the technique is much more academic in its attempt to approach reality, you can see (I hope) that the younger artist was just as concerned with light and texture; and my favourite accessory in still-life painting was on the chest – a sheep's skull.

Inside a Shop

For the artist, looking outside need not end at doorways and windows. Learn to find unusual subjects and viewpoints by choosing many different kinds of interiors or closed-in spaces which have some sort of relationship with an exterior view.

The truly adventurous might ride in a balloon, sketching the terrestrial landscape through the guy-ropes. The less intrepid could experiment by sitting at the mouth of a cave, drawing the clumps of grass, bracken, shrubs and rocky ground outside. But the sedentary painter will encounter just as many fresh ideas while seated comfortably inside a shop, looking through the display window to the outside world.

In these two examples, drawn from just such a vantage-point, the supports and struts of the display-shelving form an additional frame for the street scene. Some of the figures are shown peering into the shop, looking at the bowls and vases which make up yet another complicated design. Other people are seen waiting for a bus or friend on the street outside.

The artistic results of using an unusual viewpoint are very strong. These are striking working sketches from which it will be easy to work up a finished painting.

Inside Outside Light

You have seen in earlier projects how quickly the weather can affect the light in a room in which you are working, and alter your painting. When you look out through the window, the phenomenon is even more marked, and the difference can be startling.

On the right, moonlight penetrates gently into the studio, making it just possible to distinguish some of the furniture. The ghostly impression is enhanced by the vertical lines, which give the impression of height and mystery – although in fact the room is quite low. You can try 'altering' your own rooms in the same way, changing the effect with the help of a little artistic licence.

In the example in the centre, sunlight floods through a large picture window, illuminating the whole corner, creating dark shadows beneath the sill, and fading even the rich natural greens in the garden to a yellow haze.

Below are two studies of a room, one in pink and one in blue. Although these illustrations are in fact two stages in colour separation, you can see immediately how strongly the emotional 'image' is affected by the change. The pink room seems flooded with the delicate white light of early morning, the details sharp and clear.

The blue room is dark and shadowed, the table in the corner a mere blur; the time seems to be late evening, while the garden outside is still light.

Here are two more pictures, changed by the simple effect of light. They seem two completely separate paintings, and in fact they *are* separate this time.

The smaller picture was the first sketch, with greens and whites laid on over the raw umber base, and the chair barely sketched in, its shadow a blur of blue and purple in the sunlight. The larger picture is a more finished sketch. As I worked on into the evening and the greens faded to mauve, the walls bleached out to cool whites and greys.

Try painting the same picture in the morning, afternoon and evening, for example, or on a bright sunny day, an overcast day and during rainy weather – such changes are worth waiting for. Concentrate on organizing the main areas of the painting, rather than details. Make complementary charts to check the colour balance. It is also useful to make quick tonal notes of transitory lighting effects in a sketchbook, for reference when the light changes. Dull or overcast days affect the balance of a scene; greys, blues and mauves are accentuated, even indoors.

Greenhouse View

A room with more than one light source presents an interesting interplay of colour and tone. The wall in which a window is framed may be lit from inside, possibly even from another window. Or the lower part of an interior window-frame may be in the light so that half the framed outside view is in light, half in shade. These variations of light and tone are also found in greenhouses and conservatories. The former are particularly rewarding subjects as they provide internal space within a landscape, and almost endless complexities of light, tone and colour.

A door or french window opening into a garden or conservatory will link interior and exterior scenes more closely than a window.

Step 1.

Step 2.

Step 3.

Step 1. Begin by lightly drawing the main outline of the greenhouse in pencil. Then use a charcoal pencil to sketch in the plants in the foreground. The difference in weight between the two types of line will immediately give a feeling of depth to the drawing.

Step 2. Mix a medium-grey wash of diluted ink and use it to indicate the greenhouse roof and window-frames. This is the middle distance, so it should be lighter in tone than the black line used for the plant.

Step 3. Using the pencil, begin to develop the drawing of the view seen through the greenhouse windows. Do not overwork the line; keep it lighter than areas of wash. Put more detail into the foreground plants.

Step 4. To finish the drawing, work up the detail of the background, introducing figures and including an indication of the textures of trees and other objects seen outside the greenhouse. But remember to reserve the greatest amount of detail for the plants in the foreground, putting in areas of shading and highlight wherever necessary. The transition of tones from light to dark, as rendered by the strength of line and wash, is what emphasizes the contrast in scale between what is seen as background and foreground.

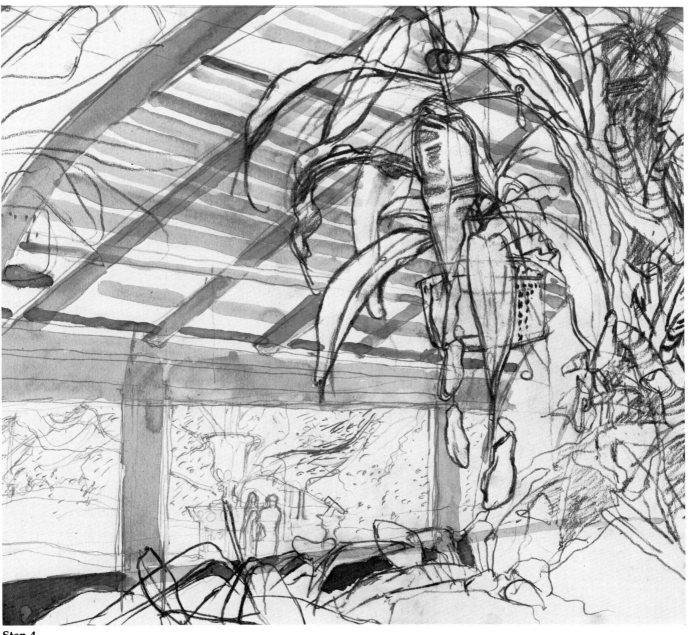

Step 4.

Light Inside, Dark Outside

This project deals with making a finished drawing of an illuminated interior seen against a night-time exterior. Such conditions provide an opportunity to interpret familiar objects in unusual ways. They may be shown as silhouettes or shadows: brightly lit edges may be all you need in order to suggest the shape of a chair or bowl. And the distinct lightness and darkness will offer dramatic contrasts in colour range; artificial light floods an interior with warm yellows, reds and browns, while the outside will be mostly cool violets, blues and indigo.

The drawings shown here capture these conditions in pastels; the room and view outside are reduced to basic colours and shapes. By the use of black paper as the ground, the darkest area of the drawing is quickly established and the tonal value of all the other colours is related to this.

Step 1. Begin by drawing the predominant horizontal and vertical lines, and use these as a reference when positioning the objects. The composition is not quite symmetrical.

Establish the position of the main objects and draw them as simple shapes; leave areas of greatest detail to last. Draw the table top, and use the negative areas created around objects to check the accuracy of their shapes.

Step 2. Continue by developing the colours of the interior. In this drawing the wall framing the outside view has been indicated in yellow. At the same time put down the brightest areas, which will probably be the lampshade and objects placed directly below the light source.

Introduce the view through the window and the details of more complicated objects like the basket.

Step 3. Almost all the colour areas have been modified by adjusting their tone in relation to the darkness outside. The detailed areas are finished and the view through the window hinted at by a general indication of light areas. Reflections and highlights on cups, saucers and table top intensify the image of a dark night seen from a warm, glowing, lamplit interior.

Step 1.

Step 2.

Step 3.

Extra Projects

Using a framework to set off your picture suggests all sorts of new subjects. Here are a few very different ideas, in a variety of techniques and media.

The first and most traditional is a simple but effective view of the artist, seeing himself reflected in the mirror, and using the mirror-frame to create the frame for the drawing.

This world-within-a-world effect harks back to many famous studio paintings of artist and model; but the project is easy enough for you to begin, with a sketchbook and long mirror hung on the wall or above a mantelpiece.

If the mirror is tilted slightly away from the wall it will give you a better reflection of the room as well as of your face. This will make for a more interesting sketch.

Keep the lighting subdued so that the reflected beams will not disturb your sight when you raise your head. If you find the position of your head awkward, try looking up slightly under your eyebrows, but keeping your face tilted down. This sketch was done in pen and ink, the tone added with close strokes and a little cross-hatching. If you do want to use another medium, try fine conté or a very fine watercolour brush. Do not choose charcoal at this stage; you will find it difficult to obtain the rather delicate suggestion of reflection.

When you have finished this sketch you can attempt a tone version in charcoal or wash, which will give a very different impression – look back at the two drawings on pages 228–229 to refresh your memory of tonal variations.

This quiet picture of an inner courtyard is an oil painting of the early twentieth century, by an unknown painter working in Spain. The archway in the background acts as a frame for the entire picture, giving a sense of enclosure and intimacy to what could be an empty, cold space.

It is an example of the realistic style which you have seen in another artist's work in Still Life with Quilt and will find in Double Portrait. Try the same style with an arch or door framing a view.

Such carefully detailed studies are very different from the more impressionistic oil sketches that are used through the book, but they should help you to understand that style is very much a question of personal involvement. It does not matter how you choose to paint; it does matter that you choose to paint carefully and continually.

The feeling of depth and texture and solidity is something you must learn to convey, and you can only do that after you have learnt to see these things with your own eyes, not through the lens of a camera.

This is not to denigrate photography, which is an exciting field full of artistic possibilities and promise. But it is a quite distinct medium, with its own principles and problems, and the solutions which it offers are not the same as those which the new artist will find working unaided.

When you begin to work outside for the first time, you will find that there is a great temptation to run away from the difficulties. But persevere – the effects will soon show in the quality and individuality which your paintings will achieve.

We have stressed over and over again that the photographs in this book are not for you to copy; they are suggestions, examples, ideas, inspiration. Of course, photographs and illustrations are useful as reminders and notes. They help you to see easily what you will eventually see without the need of extra props. Later, too, you will be able to use photographs and collages for copying unusual subjects which you would never be able to find for yourself (landscapes from abroad, or native costumes of an oriental town), but it is vitally important to continue working from three-dimensional objects in front of you.

'La Grenouillère'; Monet

Lesson Seven
Working Outdoors

This is essentially a practical lesson, an introduction to moving outside and making drawings and paintings in the open air. Views from windows can produce exciting pictures, but if you rely on working from the convenient comfort of indoors your choice of subject will be extremely limited.

In addition, many people have a deep desire to paint nature 'in the raw'; intense visual and emotional experiences can be triggered by a view, a glimpse of sun through the trees, an empty street at night. It is extremely difficult to reproduce these sensations unless you work directly from the scenes that stimulated them. Visual memories require constant reference – remember how difficult it was to retain the image of even a simple still life when you turned your back on it?

A major problem with working outdoors is its inconvenience. Although it can be delightful in perfect weather, days that start off pleasantly can become windy and rainy. And artists working in the open are an immediate attraction for the general public.

You may be fully involved in your picture, and unaware of anything but the scene in front of you. Suddenly, to your astonishment and embarrassment, you realize that you are the focus of attention, surrounded by curious observers. Some may offer helpful suggestions. You will overhear a few complimentary remarks and some derogatory ones. Inevitably, there will be the usual puzzled inquiry as to what you are drawing or painting, and why you have not managed to make it look like 'the real thing'.

All this can play havoc with concentration and certainly inhibits beginners. Try not to be embarrassed. Simply continue working and try to be polite. You may want to sell your pictures and the general public could well be your patrons!

Inquisitive animals can be equally off-putting. They won't ask questions, but dogs and cows move around and upset your materials, and generally disrupt your work. You may simply have to move, or settle for a few quick sketches and come back another day.

Because of these problems, landscapes and street scenes are often actually painted in studios, from sketches and studies made on location. However, if you compare the sketches Constable made outside, working from direct observation, with his 'Academy' paintings, completed indoors, you will see that it is well-nigh impossible to emulate spontaneity back in the studio, even though you may be able to re-create other important qualities. Completing work on the spot will give you invaluable experience.

Monet made his own private landscape by building an elaborate garden, and then painted the famous and magnificent water-lilies series. Purpose-built gardens are a touch impractical, but it is possible to work in privacy from a car or van. Remember, though, that your choice of view will be limited to where you can position the vehicle. Ideally, you should learn to work with enough concentration to shut out distractions and to ignore interruptions.

Working outdoors will widen your scope enormously. Individual subjects such as landscapes, cityscapes and waterscapes are considered in later lessons, but they all share the advantages and disadvantages of drawing and painting directly on location.

The first problem is so obvious it is often overlooked. Projects so far have been concerned with a well-defined framework: a jug, a bowl, a room – or, as in the previous lesson, the view through a window.

But where do you start when you move outside? A scene may look quietly beautiful or interesting and busy, but suddenly you cannot see the outline of a 'real' picture.

It is tempting to imagine that almost any other view – a picturesque village or a beach once seen in summer – would make a more attractive and coherent subject. Everyone has this feeling, an artistic version of the pastures that are always greener on the other side. It is all too easy to wander around, unable to settle anywhere.

The best advice is – start work, regardless. Try a few quick studies first, and use your viewing-frame to decide on a composition.

You will find that even unpromising material will form a picture. Although drawing or painting is more enjoyable if you are interested in a scene – and you are less likely to give up – it is important to remember that it is not the subject, but what you can find within it, that matters. The apparently simple corner of a square, or a tree and a bench, can be full of interest and excitement.

It may also help to take a camera (it need not be loaded) and look through the viewfinder – an apt name. The intense imagery of a concentrated viewpoint can be immediately appealing.

A related problem is trying to find a foreground. When you first set up your easel outside, everything will seem to start some distance away. If you move closer to an object, it will seem to block your view. This phenomenon will be considered later.

Objects in your first studies were separate and clearly defined. This will also change. The lines in landscapes and other outdoor subjects tend to be blurred. The shape of a plant or tree is usually more difficult to outline than that of a jug or chair. You will have to search for form and structure.

Then, too, outdoor subjects do not necessarily contain clearly separate colours. Some views seem to be made up almost entirely of greens, and you will have to achieve contrasts using only tone and the various degrees of warmth and coldness in this single colour.

Light is also changeable and, except in city or village scenes, is misty and difficult to capture with a single line. Shadows move and waver with the breeze; sunlight shifts every second; clouds are blown by the wind.

Working outdoors involves many problems – and far more pleasure than you can imagine, provided you are physically and mentally prepared to adapt yourself to its very special needs.

Special Equipment

Some artists take only pencils and a pad when they work outdoors. Others need a complete portable studio and a car to transport it. Don't go far from home for your first projects. Your own garden or a neighbouring park is a good place to start, particularly if you are worried about people looking over your shoulder. If you live in the country try the nearest field or a farmyard. Plan carefully and take all the necessary materials in one easy-to-carry bag – an almost essential piece of equipment.

Although a radial easel can be moved, you won't want to carry it around too much.

A folding sketching easel is handy for working outdoors. There are many kinds to choose from, in wood or metal. Some are very complicated, with attachments for palette and paintbox. Choose one that is light enough to be carried fairly easily, but make sure it is robustly constructed. It is liable to be dropped, and any easel holding a painting is likely to be blown over, even by a mild breeze. It is always advisable to take some strong cord – nylon, for example – and suspend a heavy object such as your bag or paintbox under the easel to make it more stable. Tent pegs securing the legs to the ground will also prevent the easel from being blown over (see p. 281).

Give considerable thought to your working position, even in moderately windy weather. The easel may be secure, but a board or canvas will wobble about alarmingly. It is very difficult to paint when your working surface flaps backwards and forwards.

You will also need a light but sturdy folding-stool. If you decide to work standing up, which allows a better view of your work, it can hold your palette or materials so that you don't have to reach for them on the ground.

Water is useful for drawing, and necessary for watercolour and acrylic painting. Use a screw-top jar or some other pot. Take separate supplies of clean water so that you can renew your painting water from time to time and clean your brushes of the heaviest layer of paint. Lightweight plastic containers that held soft drinks are ideal for this.

Make sure they are spotlessly clean. Sticky residues will spoil brushes and papers.

Carrying-frames for wet oil paintings are available from artists' shops; or you can make one for yourself. Put a cork on each corner of the front of the painting, then push pins through from the back into the corks. If you are using board, drill tiny holes through the corners before you leave home. The corks act as 'spacers' for a sheet of card, the same size as the painting, which is put over the wet canvas. Tie board and card together with string.

Many well-equipped newcomers to outdoor painting march off into the countryside wearing light clothes, as if they were going to work in a studio. Of course, if you are by the sea on a warm, still day with people sunbathing on the beach, you don't need to be dressed for a monsoon. However, the sunbathers can leave after only a few hours, and they are probably more protected from the wind than you. You may be on the beach for the whole day – not just during the warmest period – and are likely to be on a higher level where you can see more. Inevitably, you will be more exposed to the weather.

Take a windproof jacket or pullover for protection, even in summer, and a heavier jacket and sweaters in spring and autumn. Winter is a problem; it is difficult to paint when you are muffled up in a thick coat and scarf. Try to wear older clothes which will have more give, and room for movement. Gloves are essential while you are choosing a site, and during the short rest-periods when you look at what you have done – there is nothing worse than trying to control a brush or pencil with stiff, numbed fingers.

Whatever the season, it is sensible to take something to eat (and drink). Otherwise you may have to decide between leaving your work to appease a nagging appetite or thirst, and staying on, hungry or thirsty, to capture a particularly fascinating and fast-fading effect of light.

These suggestions may seem amusing and superfluous. However, many would-be artists will testify that, without forethought and preparation, a pleasant jaunt to paint outdoors can turn into a bitter test of endurance.

Starting to Work

Any subject can be looked at objectively or subjectively. You have to decide whether you intend to draw or paint exactly what you see, or if you want to use the scene to convey a message about your emotions or the atmosphere. This is particularly challenging when you are working on the spot, within the more limited time span of an outdoor excursion.

There is also the practical question of whether you are doing a finished work, or sketches and colour notes that will be used later as the basis for a larger studio composition. The approach you adopt will condition what you achieve. Before you go out it is therefore essential to decide not just what you intend doing but also why.

Artists who draw or use watercolour outdoors nowadays normally aim to produce completed pictures or at least attractive, finished sketches. This is by far the best way of capturing the essential spirit and mood of a scene – it is difficult to retain freshness and character in the memory. Of course, this is not always as easy as it may seem. Even experienced artists can work all day only to find that their painting is not what they had hoped it would be.

1. The first study concentrates on line and was begun in pencil, and then developed with coloured pencils and charcoal. Finally, black ink was used to emphasize pebbles on the beach and the rippled surface of the water.

2. A tonal study was made, with diluted brown ink and a thick brush. Linear qualities and texture were disregarded and the attention focused on areas of light and dark, and also on the contrast between the complexity of the shapes in the foreground and the simplicity of the background.

3. This study combines the information gathered in the previous two drawings with observations of colour. Blue and grey-brown washes are used to record the colour density of sea and beach.

Below, line, tone and colour were put together to paint a highly detailed seascape. Boats on the horizon, people in the middle distance, and the reflections created by light playing on the water make this drawing a complete visual statement.

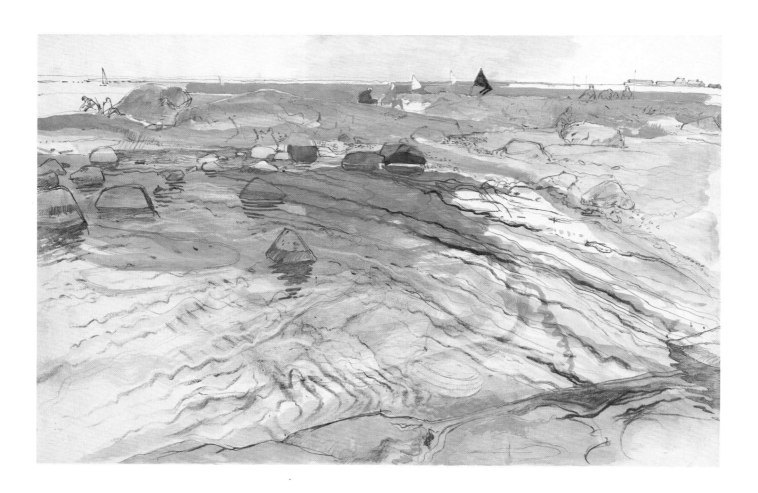

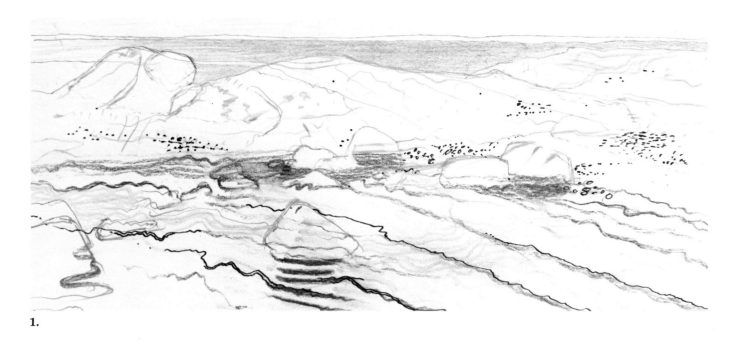

1.

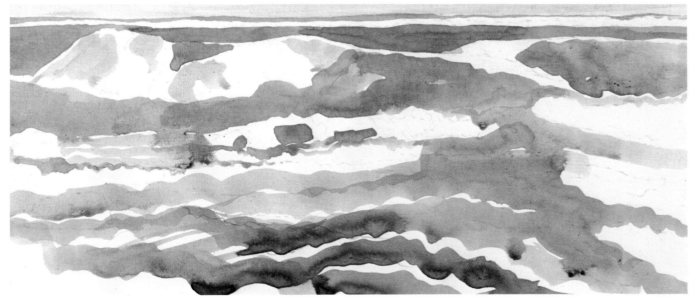

2.

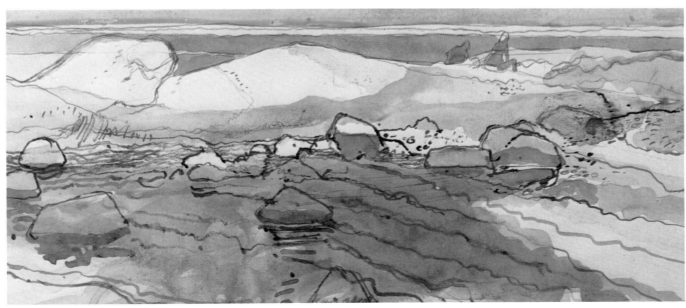

3.

Preliminary Sketches

Strictly speaking, a sketch is the rough plan for an entire painting, and a study is a drawing or painting of a detail for eventual use in a larger picture.

Experienced artists sometimes use a kind of shorthand to record information quickly when working outdoors. The areas of a drawing may be numbered to indicate tone values – all the lightest are 1, the next lightest 2, and so on. The colours of a landscape may be described with words on the drawing, rather than in paint or other colour medium. An example of this is shown below in a brief tonal study done in ink wash; additional notes about the colours and their warmth or coolness are written over the relevant areas.

Try to simplify what you see, and think carefully about the overall effect. How much of the picture will be sky? Is the general tone dark or light? Where is the light coming from? In which direction are the shadows cast? Which is the darkest object and which the lightest?

Make notes on the paper, next to the sketches.

Learn not to spend too much time on a single feature. Do the overall sketches quickly and lightly.

There are three main ways of reproducing shapes originally drawn outside. If the drawing and painting are to be the same size, the outlines can be traced lightly onto the working surface. Another method is to use a spiked wheel, and prick the shapes through.

However, drawings made outdoors are generally smaller than the eventual pictures, and the most common method is to 'square them up' and transfer them to proportionately larger squares on the working surface.

When you transfer by redrawing it is always difficult to preserve the spontaneity of the original sketches. The finished picture can be lifeless, with stiff shapes that look like cut-out sections of stage scenery. If you must work from a drawing, transfer only the largest shapes, then work from the other sketches. This will help you to avoid producing a painting that has a 'paint-by-numbers' appearance.

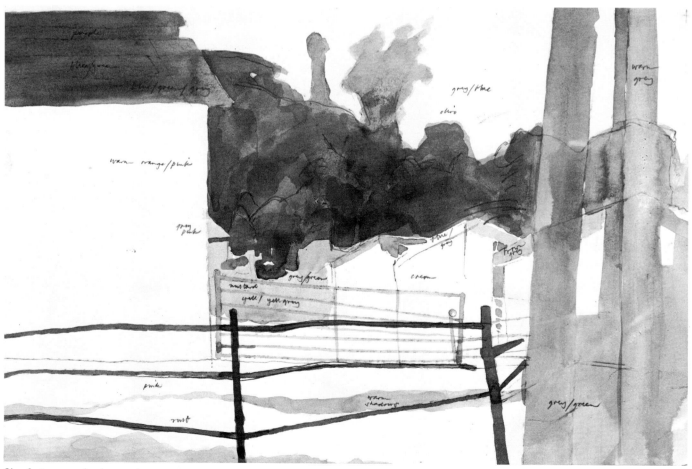

Simple tones and colour notes

Grid for transferring to different surface

The grid transferred with the outline ready for painting over

Using Sketches Indoors

Pastels are an efficient medium to use when making colour sketches because the colours can be easily blended to produce the many tints and shades of the landscape.

Concentrate on putting down only those areas of colour which will remind you of the atmosphere of the place as well as of its actual appearance. Do not bother to put in detail; you should be making small studies of cloud shapes, textures and other small features of the scene to refer to later when you are working on the main painting.

Never leave white areas between colours in these sketches, even if there are highlights. You can be deluded into thinking that the colours are accurately contrasted when it is in fact the white spaces between them that create this sharp effect. When you work indoors from the sketches, the finished picture will not have the correct balance.

1. Pastel sketches like this are an excellent means of recording the colours of a landscape. The scene was looked at through half-closed eyes and visualized in broad areas of colour. Then the outlines of the shapes were lightly sketched in pencil and the colours added.

1.

2. This painting was done in the studio, with the use of all the visual memos gathered while outside. It was done in acrylic paint on heavy white paper. The squared-up sketch was used to enlarge and transfer the composition, and the tonal study and pastel sketch provided the information about colour. The painting was done quickly so that the finished work would retain some of the freshness of the initial impressions of the landscape.

Quick-drying acrylic colours are extremely useful for on-the-spot sketches. However, it can be difficult to repeat the colour effects in the studio with a different medium. Also, unless you constantly remind yourself, you will reproduce the colours of the sketch rather than the colours you saw. What you are aiming for with all the studies, notes, squared-up sketches and so on is a comprehensive memorandum that will provide you with as many details as possible.

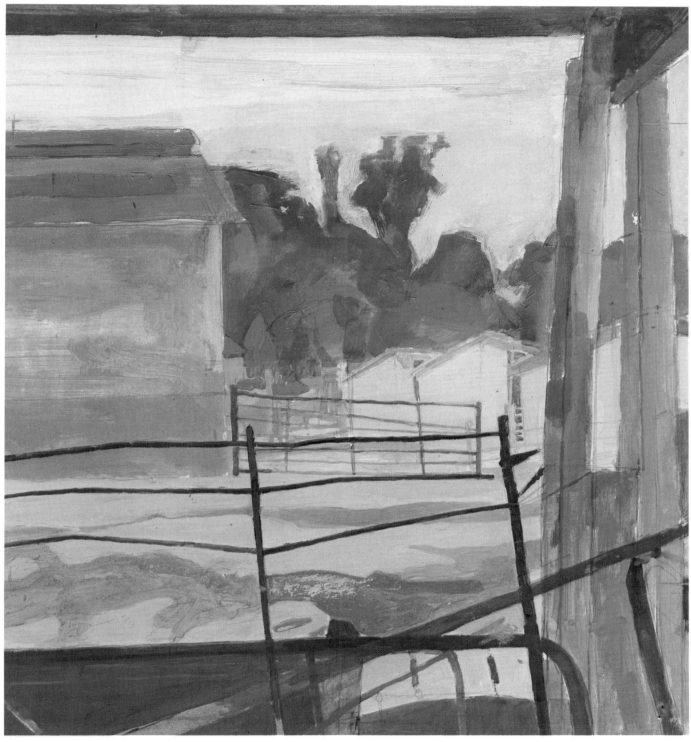

2.

Making Tonal Notes

Gradations of tone between black and white play a major part in most visual images. When you are working outdoors it is important first to establish the main tones of the scene, and then build the painted image.

Basically, you should aim at having three tones plus black line in your picture. You will find that limiting yourself in this way makes it much easier to work out the tonal separations, no matter what the subject.

One of the best ways to assess the tonal values of a view is to look at it through half-closed eyes.

Study the scene, mentally blocking out the details, and try to decide which areas tend most to black and which to white. When you have found these, look for the mid-tone areas.

You will then have to mix the right washes to correspond to the density of these tones; the brightest area may not in fact be very bright, and so on.

Eventually this way of looking at a subject will come automatically, and decisions about tonal values will be made unconsciously, but none the less intelligently.

Step 1. Decide which is the darkest area of the view and mix a suitable wash. Do this by adding the black watercolour paint to the water.

Remember that you will be working black into this wash for details, so don't make it too dark. At the same time, tones will appear to be lighter when they are dry, so also allow for this when mixing.

Lay in the main dark areas. At this stage the painting will look extremely simple, but do not try to draw in too much detail – this will be added at the final stages.

Step 1.

Step 2. Prepare a mid-tone by adding water to the wash you have already mixed. It should be midway between the dark wash and the white of the paper.

Study the scene and then paint in the mid-tone areas. In landscapes these will usually be the sky and main foreground areas.

Step 2.

Step 3. Begin to add details such as shadows and other features, like windows, that will give an indication of the subject-matter of your painting. You will probably find that the dark wash will be the correct tone to use.

Step 3.

Step 4. Now draw into the picture, using a small brush and a tone which is darker than any of those you have used so far. But it should not be pure black.

Draw with the brush as though you were using a pencil, filling in such details as trees and branches.

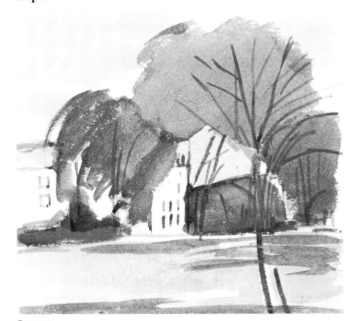

Step 4.

Step 5. The picture should now be almost complete and be a fair representation of the scene before you.

Look again at the subject and try to find the darkest details that will give depth and character to the painting. Mix a small amount of black watercolour with just enough water to make it run off the brush. Alternatively, you can use the paint straight from the tube or pan by first dampening the brush a little.

Again using the brush like a pencil, draw in the final accents of tone. It will be like bringing a fuzzy image into sharp focus.

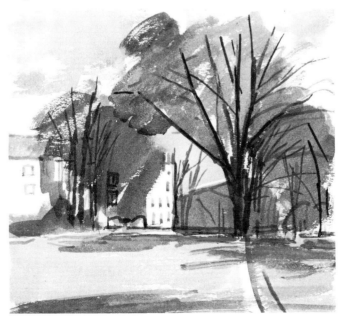

Step 5.

Watercolour Sketches

Watercolours are especially useful for making quick, imaginative sketches that allow you to try to capture a compelling bit of scenery. Be sure to include a strong feature in your first attempt – a splendid tree or group of rocks, a sharply angled hill or a formal paved garden.

The sky is always changing and full of movement, a particular problem with working outdoors. Clouds and cloud formations alter continually. As the sun crosses the heavens, shadows change direction and what were light trees against a dark background become dark trees against a light one!

Fortunately, watercolours provide a relatively quick means of recording impressions and ideas. Practise until you are able to paint rapidly enough to overcome these difficulties.

Step 1. Once you have decided what to paint, try out the effect of the scene by making small tonal sketches in blue and green wash and line, aiming to record the main features.

Step 2. When you are happy with your choice of subject, do a few more sketches to capture the fleeting effects of nature. Decide on the predominant colour and its hue. Is it the light green of a spring meadow, or the gold-brown tone of autumn hedges? Are the clouds dark against a light background or light against a darker one? Or, as so often happens, are there cloud formations that are both dark and light?

Step 3. Try to retain the freshness and spontaneity of your initial statement. Do not become overly involved with detail; this is especially important when working outdoors. When you feel that the picture has achieved some of the excitement of the scene, stop working, stand back and look at what you have done. If you consider it represents a clear reminder of the scene – stop. Then begin another picture and try to take it further – but only if you feel you can do so without killing your original impression.

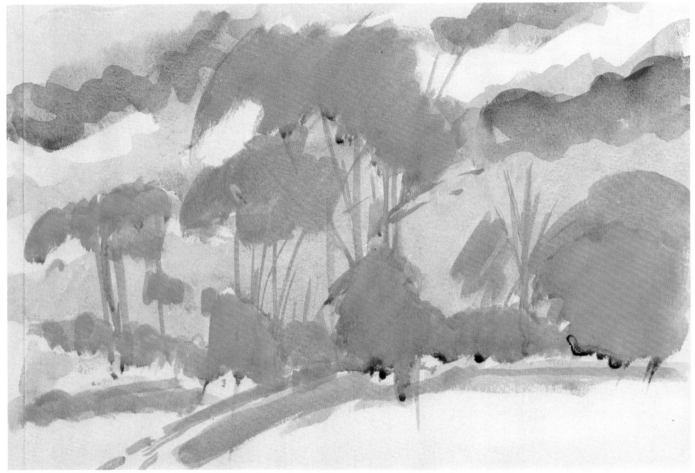

Step 1.

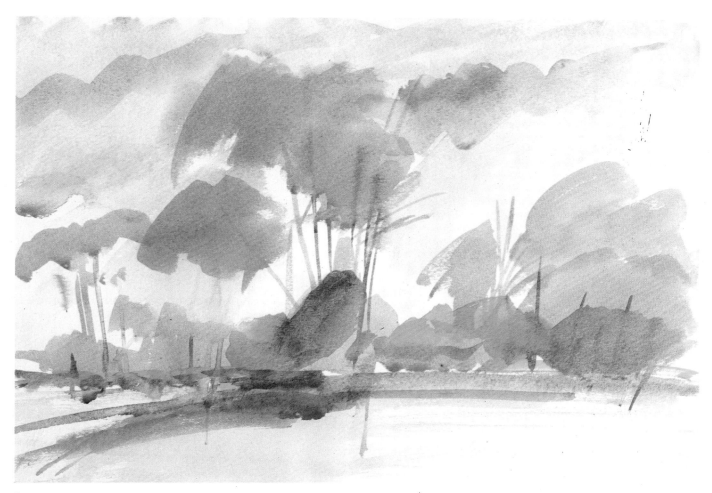

Step 2.

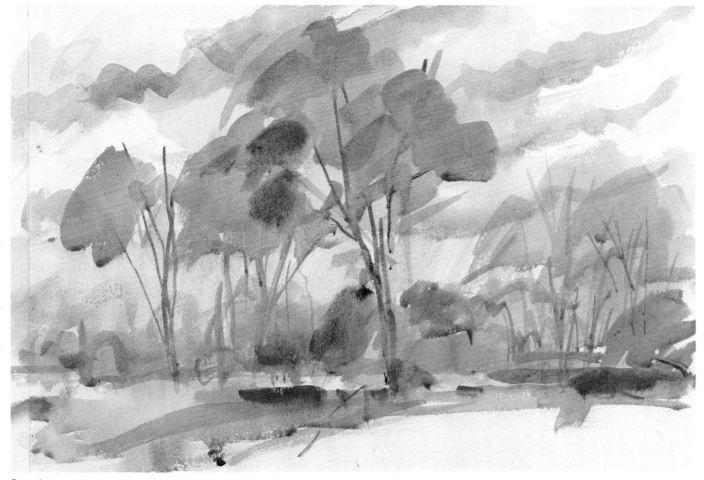

Step 3.

Quick Monochromes

Experiment with quick monochrome washes, in one or two tones, with pen and ink details. Use a medium round sable brush. Also do lighter washes on grey or cream paper; use opaque white to add highlights.

1. Grey wash in one tone; ink details added while wash is wet.

2. Grey wash in one tone; ink details added when wash has dried.

3. Grey wash in two tones; ink details added.

4. Lighter wash on grey paper.

5. Lighter wash on cream paper; highlights added in opaque white.

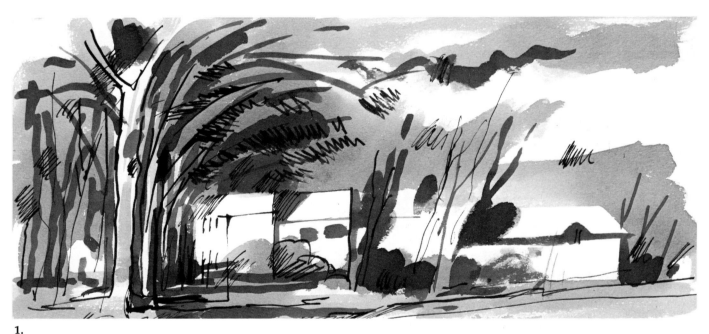

1.

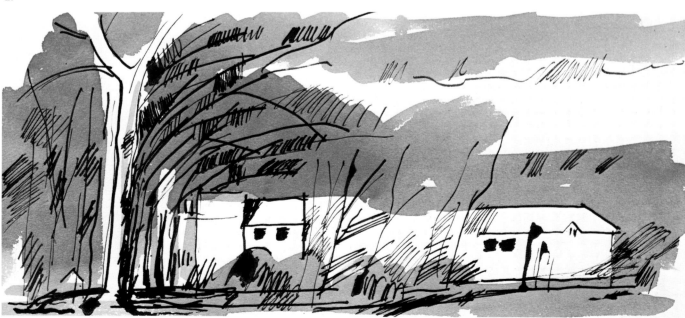

2.

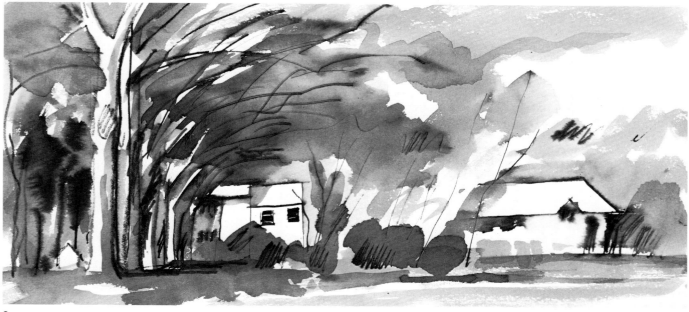

3.

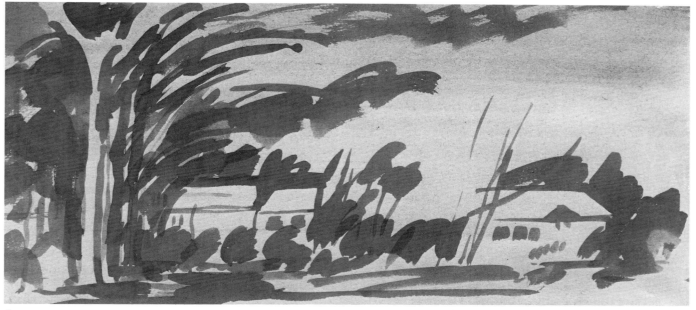

4.

5.

Pre-painted Washes

A light-blue or grey wash applied in the studio will save time when you start work. You could even have a collection of sheets with various toned washes, ready for outdoor use; some should have the top half already washed with light blue. The bottom can be done on the spot.

Once you are outdoors, start by laying some darker colour and shadows on the pre-painted wash. The sky will be almost complete, with no need to wait for the first coat to dry – and you will be able to concentrate on sketching the scene you have selected.

White clouds can be added with white gouache or acrylic, or the washing-out technique can be used. To remove colour from pre-washed paper, dampen an area in the dry wash with a small sponge or cloth and carefully remove the colour pigment. This leaves the paper almost white.

Washing-out can be used to make highlights on water or, indeed, on any subject, indoors or out. Although it is particularly useful in outdoor sketching, it can also be used in the studio. Practise the technique at home.

With experience you will learn what kinds of washes and toned papers suit your special requirements and the various colours of the landscapes in your area.

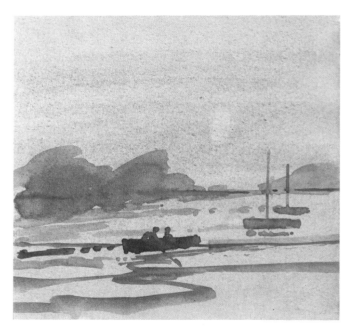

If you prefer to do all the work on the spot, you will have to wait for each wash to dry completely before you continue – unless you are painting 'wet on wet'. Patience is a necessary part of watercolour painting. Some artists find they make better use of their time if they work on two – or even three or four – pictures during the same session.

Here is an assortment of washes that could be prepared at home to be taken out later on painting excursions. Look carefully at the main colours of nearby views and prepare washes which will correspond.

Working in Winter

Watercolours take time to dry thoroughly, even in warm weather. On a damp, cold day they may never dry completely, which makes winter scenes a special challenge. Do these studies as quickly as you can.

Work in black and white using a dark wash with a narrow brush for the first study, black indian ink and a medium nib for the city scene. Keep the contours crisp and the pictures will sparkle, even without colour.

Remember the advice on keeping warm. Fill your pen before you set out, and even if you are in a hurry to get home to the warmth make sure all the water-bottles are firmly capped and your paintbox shut.

1. A country landscape during winter can often be seen in terms of sharp tonal contrast. This is ideal for making quick studies, using only black ink and a small brush. Also, a brush is physically more comfortable to hold in cold weather than either a pen or pencil.

2. When working outdoors it is important to look for the main shapes and put these down quickly. Keep your rendering crisp and the edges of the shapes sharp, and the picture will then sparkle. Don't try to make a highly detailed drawing, but concentrate on capturing the mood and your initial impression of the scene.

1.

2.

272

1. A winter cityscape presents many more contrasts than a country landscape. There are the textures of glass, concrete and stone, the puddles of melted snow in the middle of the street, and the activity of people and traffic to be considered.

As with a country landscape, the main shapes should be put down first, but you must also include the main details which will turn the shapes into buildings, streets, automobiles and so on. To do this, use a wider range of tones; a nearly dry brush charged with just a small amount of wash can be used to give the merest hint of a winter sky.

2. Do try painting this type of sketch at different times of day. This example was made at dusk when shadows were lengthening and tonal values were less pronounced.

Thin washes of blue and violet were used to paint the shadowy forms of people in the street as seen against brightly lit shop-front windows. A solid mid-grey wash was used for the leaden sky usual at this time of day.

On the whole, the tonal range of a winter cityscape is far greater than that of a country scene, and it is this quality that makes the mood of the scenes quite different: the brisk freshness of snowy open fields contrasts with the bleakness of an overcast urban street.

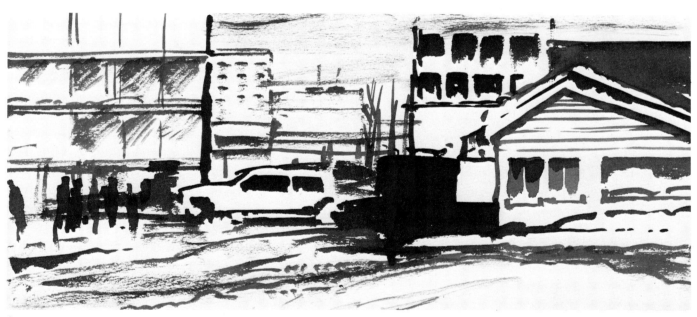

1.

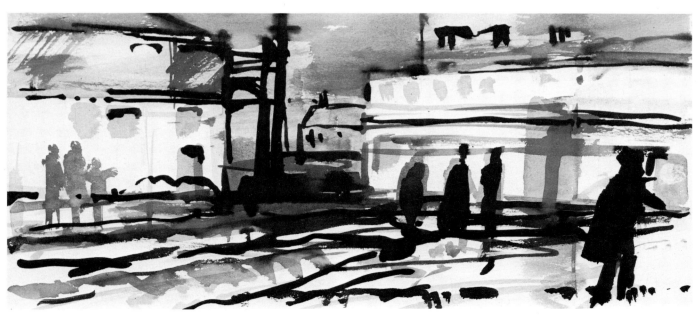

2.

Directional Light

Sunlight, or just strong daylight, affects what you see, depending on its strength and direction. If you look towards a light source, objects are in shadow, and the colour is generally colder than if you stand with your back to the light. With the sun behind you, objects seem closer and the general colour tone is warm. Side-lighting, when the light comes from the left or right, produces side shadows, increases texture and accentuates details. Buildings and mountains with strong side-lighting have a sharply pronounced three-dimensional quality. Top-lighting, when the sun is at its height, usually makes the picture flat. Back-lighting, at sunset or dawn, will give you a silhouette effect, sometimes with a halo of light around the outline.

Study other artists' works to see where the light is coming from and how it affects their pictures.

Photograph the same subject from four different directions: into the sun; with the sun behind you; with the sun on your left; and on your right. Pin the pictures on your studio wall and study them closely. Decide on the most appropriate lighting for that particular subject.

Working outdoors exposes you to all the changes of light that occur even during an overcast day. However, if you can find a position that is shaded from direct sunlight, you will have a neutral light – almost like studio lighting – in which to work. Sit in the shade of a tree, the shadow of a building or even in a car.

Strong sunlight, sharp shadows

Cool sunlight, grey shadows

Sunlight, flat on

Side-lit

Sunlight, back-lit

Drawing Outdoors

There is a tradition in outdoor painting – seascape, landscape and townscape – of using sketches, drawings and colour notes as a basis for later work in the studio. This method was once more popular than it is now, but it is none the less still valid. The assumption that most outdoor scenes are painted on the spot is largely correct: the popular image of an artist totally immersed in his work as the hubbub of daily human activity surges around him is familiar to us all – and many contemporary works to be seen in galleries and exhibitions have indeed been made from outdoor sketches (often supported, it is true, by the evidence of photographs).

Collecting artistic impressions has several advantages. Having made some studies and brought them back to the studio, you will probably find that there are vital pieces of information missing from them – details which you may have deemed unimportant or which merely escaped your notice. When you go out to paint the next time, you will be more aware of the type of information you need to collect, and will thereby increase your skills of observation. This sort of experience will teach you that making working drawings from which to paint later is different from simply making outdoor sketches.

Tonal impressions of the influence of natural light on the subject, colour notes describing overall hue or the relationships of colour within the composition, shapes and textures that give the subject vitality and dimension – these are just a few of the mind-joggers that an artist's notebook should include. Such records can be made either as written descriptions or as small drawings, in colour washes and line; often the written word is used to enhance the drawn image.

For cityscapes, records of architectural detail and of street furnishings like phone-booths, fire-hydrants, post-boxes, cars and buses – all the amazingly varied elements of our daily lives that are so commonplace we no longer see them – are all-important. An effective way of gathering this type of information is to use a camera, preferably with colour film as even the grey of stone, concrete and steel is richly varied in hue.

No matter how carefully you keep your notes you may find that being divorced from the actual setting makes recollection of the image difficult. To overcome this, try to look at your sketches as if they are the original view: half-close your eyes and recall the other things that contributed to the scene, such as birds singing, car-horns honking,

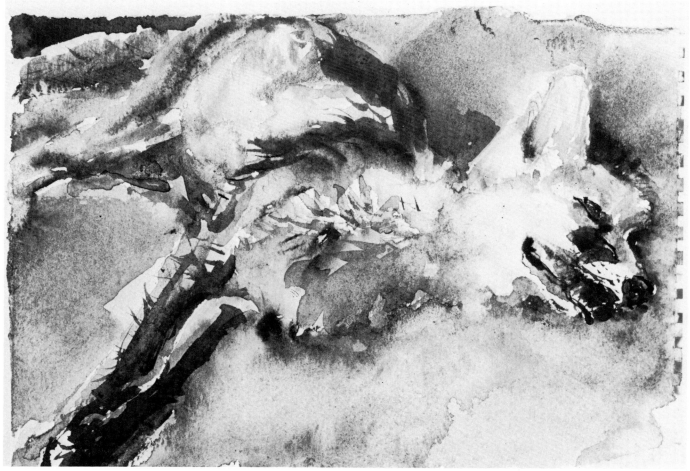

Tonal notes in watercolour: 'Dead Fox'; Measures

the smell of newly mown grass or exhaust fumes. All these stimuli influence your perception and will help you to recall the original inspiration.

One great advantage of working at home is that you can continue painting whatever the weather, using artificial light to increase the time available to you. But since artificial light produces its own colour, you may find the difference between it and natural light distracting. An interesting experiment would be to use 'daylight' bulbs, and even to blend the colours of artificial light by using tinted bulbs. Though you will never be able to re-create the subtle hues of natural light, the attempt may teach you actually to look at the quality of such light – the sparkling brilliance of sunlit colours after the atmosphere has been cleansed by rain, the peach-coloured light produced by the golden-orange of a setting sun.

All art is based on observation and this in its turn must be disciplined to be of any value. Vague recollections are of no value to the artist: know what you are looking for and why, and record it. Then look again for what you have missed.

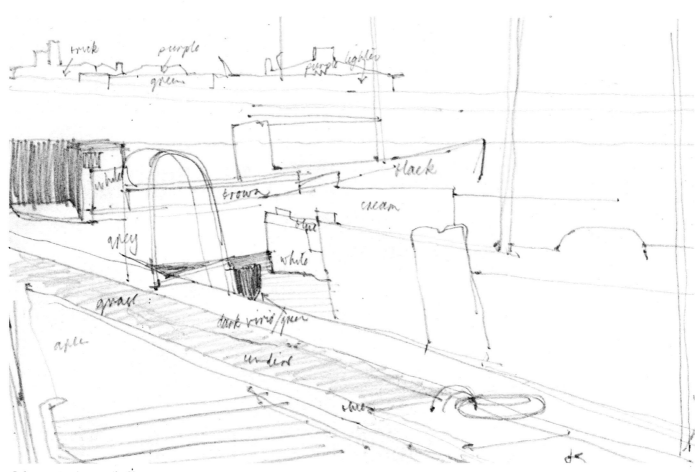

Colour notes in pencil; Simpson

Seasonal Palette

Drawing Media and Pastels

When working outdoors you will probably find that your basic range of colours in chalks or pastels is insufficient and must be added to. This is because the colours prevalent in a landscape are different from those used for figure drawing or still life, and when working outdoors you will want to save yourself the time it takes to mix the required colours. Also, when mixing pastels and chalks it is sometimes necessary, as you put the layers of different colour over each other, to fix the medium at several stages – not an easy thing to do on a windy day.

But this is not to say that you should try to do entirely without mixing – you must guard against organizing a range of colours that you use un-mixed, over and over again. Drawing and painting are concerned with looking for 'particular' shapes and 'particular' colours, and are only successfully found by seeing through fresh eyes.

The main colour of the landscape is green, and the main problem will lie in assessing the wide variety of tints and shades it contains, as well as their relative warmth or coldness and their tone. Bearing this in mind, add several greens to your range, as well as yellows, blues and browns.

Experiment by mixing a wide range of greens before you set out, but do not preconceive too many ideas about the types of green you will find. For example, try mixing black with various yellows, and blue and brown together to make some rich dark tints. Using yellow as a base, try to make light greens, endeavouring to retain as much 'greenness' as you can without losing the inherent value of the colour.

Study the examples on these pages and try to make similar swatches yourself, so that some of the colour-mixing problems you are likely to encounter outdoors can be anticipated before all the other problems of 'working on the spot' are confronted.

Spring

The springtime landscape is one of vivid, clean greens and yellows. The sky is usually a cold blue tinged with grey, and brickwork cleansed by rain often appears a brilliant red. Call up your personal memories of a spring landscape and try to visualize the colours it contains. Look at your range of colours and determine what could be added to achieve these imagined hues, either as unmixed colours or else as ones made with a minimum of mixing.

Summer

This season holds the most varied range of colours because it retains many of the hues of spring, while as the season progresses autumnal shades begin to appear. Warm browns and ochres will emerge as the greens begin to lose their clarity and freshness. During late summer the light dims and colours begin to lose their tonal contrasts, and the addition of browns and warm orange, all close in tone, will help to introduce a golden glow to late-summer landscapes.

Autumn

At this time of year, green begins to fade and shades of brown and ochre tinged with red predominate. These colours become much richer than during summer, and they deepen in tone. Introduce a warm and a cool grey to your colour range, as the sky will become the lightest area in the landscape and its colour will often set the atmosphere of the drawing.

Winter

During winter, particularly when there is snow on the ground, a range of cold greys, extending to pure white, should be brought into use. Clusters of bare branches and banks of shrubs will contain deep, rich dark tones, and the spectrum of colours they contain can extend from deep olive greens through warm sienna browns to deep purple. By adding violet and cobalt blue to your colours you should be able to capture the chill of winter.

It is not possible to tell you, except in these most general terms, how to mix colours or which colours to expect in a landscape at a given time of year. The best advice is always to consider the light at various times of day, and during the year to study the effects of the seasons on trees, fields and hedges and then try to reflect this in your seasonal palette.

Weather Problems

The outdoor artist has to be prepared for all kinds of extreme weather. Watercolour painting is naturally impossible in torrential rain, and no one can work on flimsy paper in a high wind. Nevertheless there are solutions to most of the problems you will encounter.

Although watercolours are prone to drying difficulties in damp, cold weather, the pre-painted washes described earlier will help to lessen this particular inconvenience.

It is also possible to protect yourself, and your work, from the rain. Many artists work successfully, and comfortably, in a car, using the steering wheel as an easel. If you can devise a clip to hold your working surface in place, your hands will be free to paint and hold a palette. Alternatively, try sheltering under trees or in the doorway of a convenient farm building.

Strong winds have their own peculiar effect. Equipment will disappear into long grass and ditches. Your easel will almost certainly be blown over – repeatedly. Stabilize it with pegs or a heavy weight, as suggested earlier; or tie it to a post, a gate or a tree. You may find you can paint without an easel. A board can be fixed to any convenient object or placed on the ground and supported by stones and pieces of wood. It can also be laid flat and held down with a foot on either side. Use a pad of watercolour paper clipped together, rather than a single sheet which may be torn away from its pins or staples.

A box or pan of watercolours is more practical than tubes, especially in bad weather. A small cylinder for holding brushes can be slipped in your pocket. Take a heavy glass bottle for clean water, rather than a plastic container, and keep it wedged into the ground.

On beaches and dunes in hot weather you will find that paint dries quickly in the box and that sand gets into everything. Watercolours are better than oils or acrylics as sand won't cling to the surface.

Don't rule out the chance of painting outdoors in bad weather. It will encourage you to work more quickly than usual – beginners tend to be slow, and often try to do too much at a time – and it can be very rewarding. There is something primitive and exciting in being outside in a storm or driving snow, or in a strong wind that bends trees, whisks leaves along the ground and sends clouds swirling through the sky. Take advantage of the fascinating, ever-changing conditions of wind and weather and extend your experience of painting.

Before you go out, make tone charts on scraps of paper that will be easy to carry. Do them in black and white as well as in the colours you are likely to use

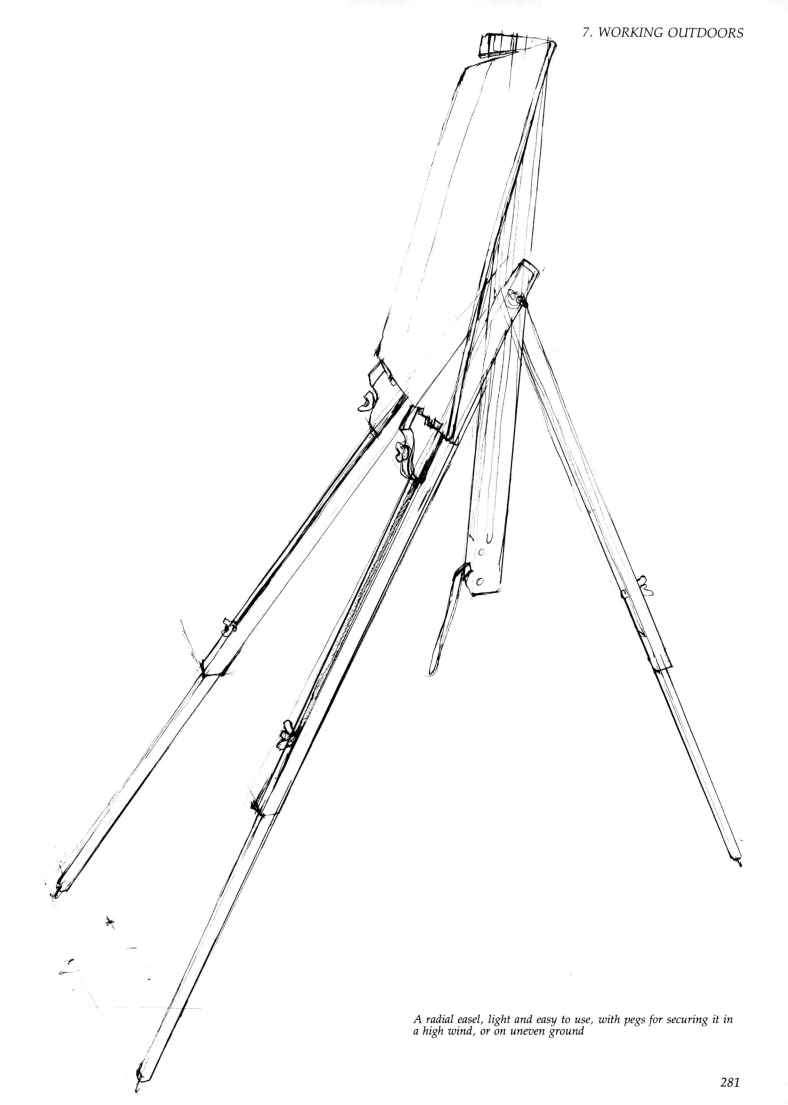

A radial easel, light and easy to use, with pegs for securing it in a high wind, or on uneven ground

Seasonal Palette in Watercolour

An artist will rarely use every colour on his palette. This is especially true when working outdoors, because each season of the year has its own particular colour scheme. An obvious example of this is autumn, when the dominant hues are warm and mellow tints of yellow and brown.

Often a picture can be painted in only two colours, and there is a great advantage in using a limited colour range as it helps you to simplify your painting and concentrate on the basic essentials of good picture-making: composition, perspective, line and tone. It is worth experimenting in the studio with limited colour ranges, for this will help you when you go out to work.

Winter

Tints of blue and grey will probably be all you need for a winter landscape, as sky and trees can both be painted with these colours. You may find the addition of warm browns or ochre useful to indicate where the sun has warmed a field or caught the side of a building; but these colours should be used only in small touches.

Spring

This season requires a palette that contains fresh yellow-green, lemon yellow, yellow ochre and viridian. Other hues will be equally bright, as the light at this time of year is neither harsh enough to make the colours hot and vibrant, nor diffused through clouds and mist so that colours take on a cold grey cast.

Summer

During this season full-strength colours come into play as the bright hues of spring are deepened by strong sunlight. Yellows become warmer, red and orange permeate brown, and the tints of green become more varied. A rich green may be mixed by thinning cadmium yellow and then adding small touches of black until you achieve the desired colour. You can make another type of green by adding burnt umber instead of black.

Autumn

Indian red, raw umber, burnt umber and cadmium yellow will provide the warm range of colours required by this season. Think of tinting green with red, just as nature colours the foliage; you will have a warm brownish-purple with which to paint the lengthening deep shadows cast by trees and buildings, and the furrows of ploughed fields which are often part of an autumn landscape.

Obviously these are merely guidelines to what is likely to be the local colour of any landscape at a given time of year, so don't close your eyes to other hues in the scene. You may be painting a snow scene and find that there are pinkish tints reflected in the snowy drifts, or pale violet in the shadows – in which case adjust your colours accordingly.

As a general rule, however, think in terms of a limited palette when you make your colour selection.

Painting Outdoors

Oils

Equipment for oils, like that used for drawing and watercolours, should be portable, sturdy and able to withstand wind and bad weather.

In addition, oil painters need a travelling-box, fitted with a palette, deep enough to hold all materials (especially bottles for turpentine and linseed oil). Don't forget rags to wipe your brushes, and an extra bottle to pack them in. All canvases should be primed at least one day before you go out.

The sky is a vital element in all outdoor painting, and there are many ways in which it can be interpreted in oils: as a flat area, for example, to contrast with the skyline buildings and trees; or structurally, as a dome over the scene.

On a clear day the sky directly overhead is a dark, almost pure, blue. As you look towards the horizon, the blue changes, becoming progressively lighter and more pastel – there is more atmosphere at the horizon than in the sky above your head.

Experiment with various blues. Extend them with white. Create a progression chart from light to dark, and compare it with the sky.

Additional colours will probably be necessary to match the shades near the horizon; slowly add ochre and white to make a variety of blues, from warm to one with a touch of viridian to give a sense of depth. The exact colours you have to match will depend on the day and the weather.

Look into the light, then turn slowly until you are looking in the opposite direction. Study the way the landscape changes as you move, and the relationship between the sky and sunlit trees. Buildings look like dark objects when the light is behind them. A landscape in sunlight appears lighter against the sky.

Observe, and make studies of, skies against landscapes. Keep detail to a minimum. Concentrate on tone values, colour changes, and main masses and structures.

Although each season has its particular pleasures, there are times when only short periods of outdoor painting are physically possible. In the heart of the winter, for example, an hour may be the limit of endurance. Considerations like this will affect both the size of a picture and the manner of working. A painting should be small enough to allow for quick working; in oil, this will usually only be a basic idea, to be further developed in the studio.

Try to find a subject within striking distance of your studio so that you can easily return to the site to make additional drawings and sketches, and collect as much information as you can; colour notes written on a drawing can be helpful. Very often, when a painting reaches the stage of needing further observation, the work itself takes over and determines exactly what extra information is required.

New ideas will occur to you as the paintings develop. Alternative ways of interpreting and composing a subject can result in a series of works on the same theme: perhaps a scene which changes dramatically in different weather conditions, and at different times of the day.

Many great painters have created a host of different images from a favourite view or the city they live in. Such a theme can become the central drive of an entire life's work. Working outside opens up new horizons in more ways than one, as everyday life takes on new and interesting characteristics.

Making Sketches

Start by making small studies of trees, roofs and so on, from your garden or a nearby park. Look at the variety of shapes and masses in the skyline. Keep the sky simple. Treat both the foreground and far distance as blocked masses. Experiment with where to place trees, buildings, fences and walls.

Use a viewing-frame to decide on the boundaries of your composition. Create a foreground, middle ground and distance – a front and back.

Concentrate on creating an illusion of movement in the sky, movement that seems to stretch beyond the horizon and behind the skyline.

Look for structure and changes of scale in cloud formations.

Look carefully at how the colour in the sky alters from the top of the painting to the horizon line.

Strong simple lines for outdoor tonal notes.

Seasonal Palette in Oils

Oils

Although you should continue using the basic palette, working in the open requires different mixes of colour. Extend the range of colours with which you have been working and find out more about colour mixing.

Viridian gives sharp, cold greens when mixed with white; a variety of rich greens, from sharp to very dark, with yellow; and a near black when it is combined with alizarin crimson. A touch of viridian mixed into ultramarine and white produces a stronger, sharper blue similar to monastral or prussian blue. Prussian blue in the tube should be avoided; it will overpower and bleed into almost every colour in your picture.

Develop your own procedures while you paint outdoors, but continue to work broadly, and to concentrate – almost obsessively – on tone and colour. This is the only way to gain knowledge of colour and its vast range.

Each season has its particular colours. The more you study the seasonal palettes, the more surprised you will be by their variation.

Spring

Sharp yellows; yellow-greens; clear blues.

Lemon yellow will be a useful addition to your palette; a monastral or cobalt blue will also extend and brighten the tones.

Summer

Sharp greens and yellows become darker; rich greens against bright light ochres; reds and amber creep into the landscape.

Add raw sienna and naples yellow.

Autumn

Yellows; ochres; reds are richer and more valued; blues, both warm and cool.

Blues in the sky and horizon are more subdued and atmospheric than during other seasons. Use light red with white, and other reds listed below, to soften and warm the whole blue range. Earth colours are predominant.

Add indian red, cobalt blue, rose madder, alizarin crimson.

Winter

Sharp, cold greens; dark greens; copper browns; hard blues; whites; reds.

Winter colours can be surprisingly vivid, with sharp cold greens even on grey days. The dark, almost black greens of winter evergreens are accentuated by cloud formations and overcast skies. On brilliant, sunny days tree trunks are bright copper brown against hard blue skies. Brilliant white appears in snowdrifts, reds in berried trees.

Working Sketches

Opposite; roof view in line and tone, with notes
Below; roof view in line only

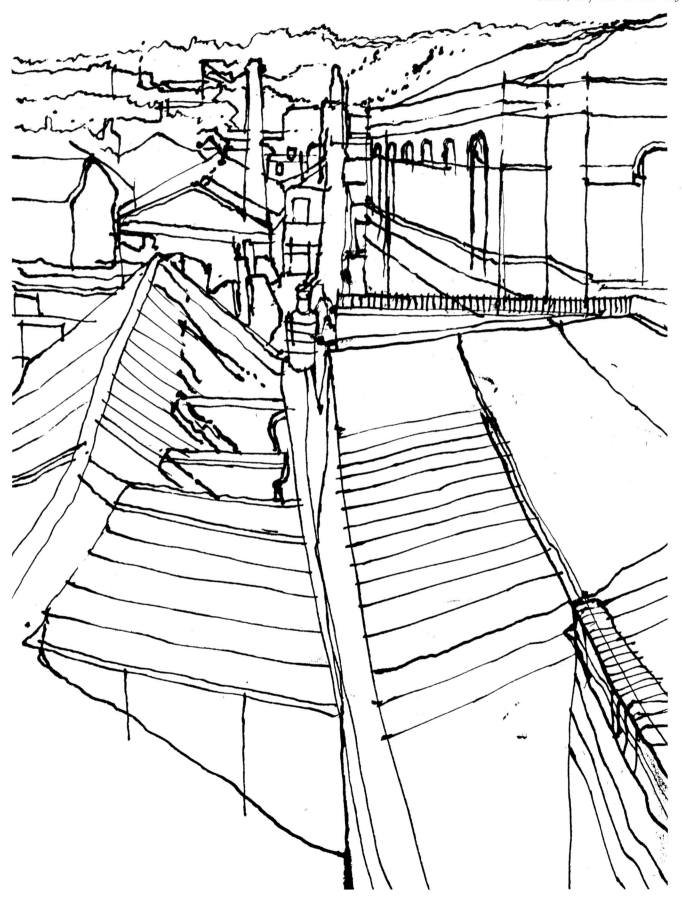

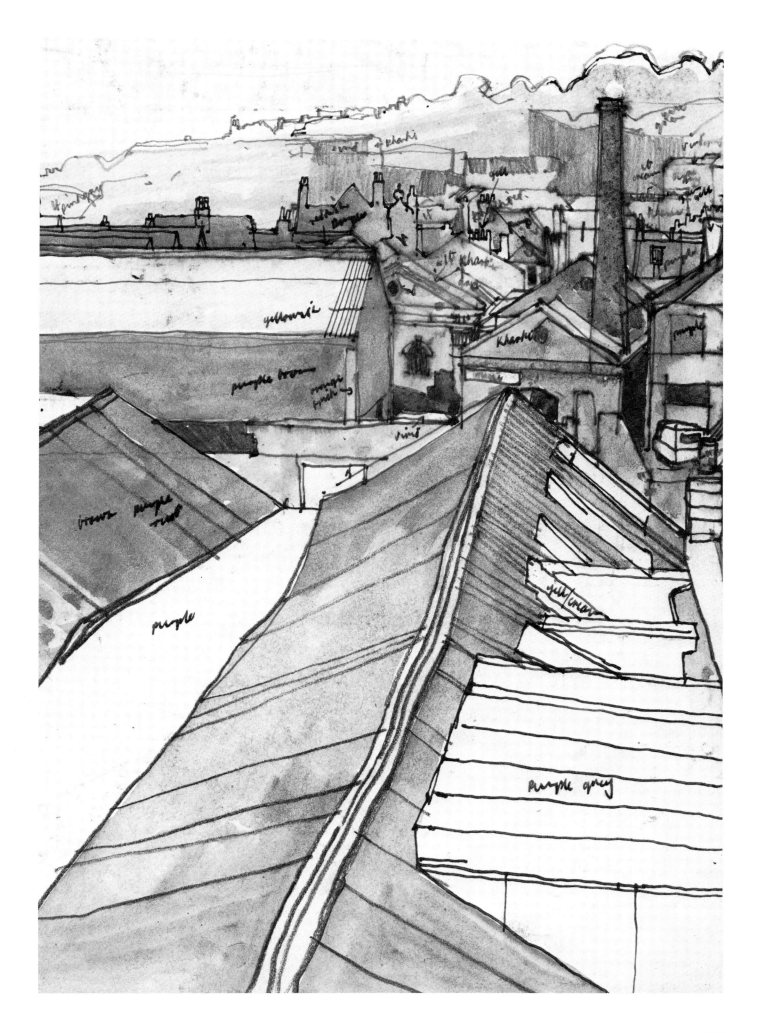

Weather Sketches

A cold winter morning, with greys and blacks

A hot summer day, with clear sunny colours

Figure Sketches

Figures blended into patterns

Figures standing out of the background

Detail from 'Flatford Cottage'; Constable

294

Lesson Eight
Landscapes

Of all the subjects we have looked at so far, landscape is probably the most popular with the professional artist, the amateur, and visitors to museums and galleries. Looking at the countryside in any of its moods, through any medium, seems to give enormous satisfaction and pleasure.

It is therefore surprising that scenes of nature unadorned are relatively new to Western art, having developed mainly in the past few centuries. The very first tribal painters used human and animal forms to personify the spirit of nature, and in the highly sophisticated frescoes of the Middle East men and women hunted, fished, prayed and enjoyed themselves against the merest sketch of a background. In early Christian art saints (and sinners) filled the pictorial area; landscape was confined to a few distant scenes in a corner. Although some civilizations rejected images of people and used foliage and animals, they usually did so in a controlled and decorative manner. Celtic and Viking strapwork, like the scripts and borders of Islamic paintings and the much later curves of Art Nouveau, was never intended to be 'natural', although the artists used nature as inspiration.

Art had developed differently in the East. By the ninth century the Orient's great painters had already concentrated on the portrayal of nature, finding spiritual as well as visual refreshment in

Medieval manuscript illumination

295

'Waterfall with Monkey'; Sung dynasty

rocks, trees, and water. The philosophical and religious images of the Eastern world led away from the human form, and the inner search for spiritual peace gave all kinds of landscapes an additional level of interpretation far beyond their surface beauty. The painters of the Sung dynasty (ninth to thirteenth centuries) created some of the most famous landscapes, mainly in ink and wash, with a few discreet touches of watercolour. The traditions of China and Japan are such that their works continue to influence many modern artists today, as images of the perfect use of minimal strokes to create the maximum effect.

Western landscape really begins in medieval times, albeit in a small and unimportant way. Manuscripts of this period are famous for illuminated letters, and these often contained miniature landscapes, filled with icons and other religious symbols but landscapes none the less. Their influence on the Flemish artists, who painted most of the finest illumination, helped to establish landscape as an art form.

Western painters who learnt from the Flemish illuminators were most interested in reproducing what they saw around them, allowing raw nature to provoke its own emotional response. Albrecht Dürer (1471–1528) was a meticulous draughtsman, fascinated by the complexity of all wildlife; he painted hundreds of incredibly accurate and detailed studies and sketches for his own use and pleasure. Other German and Flemish artists used nature as a major theme in their work, although there was usually a religious subject in the title, even if not in the foreground; *St Jerome in a Landscape* by Joachim Patenier (*d.c.*1524) is a direct contradiction of most previous religious art – the 'landscape' element is very large, the figure of St Jerome very small.

Detail from a sketch; Boudin

296

Pieter Breughel the Elder (c.1525/30–69) was one of the painters who took the next step towards secularization; although his paintings are filled with people, animals, and the general bustle of town life, they make little or no pretence to have a religious content.

He and his fellow painters in the Dutch and Flemish traditions gave us the delightful genre scenes which are so appealing and informative, but they also painted a few pure landscapes of their own favourite places.

True landscape painting began in the early sixteenth century with the *Tempest* by Giorgione (c. 1476/8–1510), and in the seventeenth and eighteenth centuries the growth of transport and the popularity of travel led to the next period in its history. Artists of all kinds began to visit Rome, and came back awed and inspired by what was left of its great classical civilization. They painted wild mountains and valleys with a temple or ruin somewhere in the picture, and occasionally a glimpse of a god or goddess. But artists such as Nicolas Poussin (1594–1665) and Claude Lorraine (1600–80) were interested in a technical vocabulary – the effect of light and shade, clouds and sunlight. They used the countryside as Turner was to use the sea, almost as an excuse for creating pictures rather than as a reflection of the subject.

However, another school of artists had developed from the original Flemish painters. Meindert Hobbema (1638–1709) and even a court painter such as Sir Peter Paul Rubens (1577–1640) painted landscapes for their own pleasure, as an expression of love for the countryside around them. This aspect was especially influential in England: John Sell Cotman (1782–1842), John Crome (1768–1821), Thomas Gainsborough (1727–88) and John Constable (1776–1837) are all associated with East Anglian scenes.

The English school of landscape was in some ways the most vital contribution England has ever made to classical art, and to watercolour in particular. However, there were other influences. Joseph Mallord William Turner (1775–1881) in particular

turned the calmer, romantic elements upside down with a highly emotional regard for towering mountains and deep valleys, all charged with enormous vitality and energy. His passion for colour, light and movement in the elements of nature inspired painters throughout Europe.

Corot (1796–1875), Gustave Courbet (1819–77) and Eugène Boudin (1824–98) were foremost among French painters who, like the English artists, were concerned with the landscapes of their own country. Younger colleagues such as Claude Monet (1840–1926) and Paul Signac (1863–1935), even more influenced by Turner's later work, broke up the elements of light to create a very individual and 'impressionistic' technique which moved landscape away from reality towards all the many images of modern art, both abstract and figurative.

Some more traditional painters remained fascinated by the problems and possibilities of the raw elements of nature. Winslow Homer (1836–1910) created a very personal and vivid impression of the American landscape, while Arthur Streeton (1880–1942) was one of the first to see the grandeur and power of the Australian outback, later explored by Sidney Nolan (b.1917). In England, Paul Nash (1889–1946) and John Piper (b.1903) continued the English tradition, although in a very new way. Contemporary artists have seldom created major works in landscape form, except as inspiration for abstract shapes and colours; sometimes there is little left except a single line of the horizon.

However, all painting is part of its own cultural period, and the pendulum swings back and forward. Today we have become concerned and fascinated all over again by our environment; wildlife photographs and television programmes have taken even the armchair explorer to strange and wonderful places, and an interest in nature has revived many of the traditional techniques of landscape. Once again, flower studies and countryside sketches can be found in galleries to give both pleasure and a sense of place and recognition to all of us.

Starting to Work

Landscape as a subject overflows with potential material. It is unnecessary to search for the magnificent or even the pretty. The surroundings of any town or village have enough character and variety to stimulate plenty of ideas and approaches.

To explore landscape, make as many drawing and painting expeditions as you can, in order to become familiar with the subject. The more information you gather and the more practical experience you gain on the spot, the better your results will be.

Begin a sketchbook devoted to landscape. If you live in a city, find a reasonably sized park that is not too far away. Draw and experiment constantly – even on a business trip or holiday take the opportunity to make notes of views from the train or bus. Make drawings of shapes and tones, observations of colour and light effects, and the forms and patterns of the landscape. Look at texture, and contrasting shapes against the sky and horizon.

All the preceding lessons have a direct bearing on landscape. Although the subject is new, the same pictorial disciplines of composition, structure, form, tone and colour apply; you will be able to transfer your experience to this larger canvas.

The problems of observing, organizing, and deciding how to draw or paint the subject are unchanged. Find a front and back for your picture. Analyse the scene in front of you – the ground plane, the position of trees, hedges and buildings; the way a line disappears behind a group of objects, and re-emerges; overlapping shapes. All these elements will be part of your final painting.

Landscape Notebook

Many landscapes are not drawn or painted directly from the scene, but are re-created in the studio from drawings, colour sketches and studies. You must learn to take notes from which you can make finished drawings or paint in either oils or watercolour.

Without these you will find it almost impossible to complete your work at home. Impressions of what you saw will remain, but returning to the scene would probably provide some unpleasant surprises.

Fill sketchbooks with ideas, and notes on possible subjects. Pastels and watercolour are ideal for quickly recording colour, light and composition. It is not always necessary to trudge miles looking for new material. The same land-scape seen in varying conditions, and changing seasons, will present new facets to study. Or try a change of viewing position; altering the weight and emphasis of your composition may be all that is needed to provide a new stimulus.

Colours are affected by distance, a result of the intervention of light and atmosphere. Objects of the same basic colour – fields, trees, and hills, for example – undergo an optical change as they recede. Dividing a composition horizontally into foreground, middle, and distance will help you to observe these changes. Making a simple chart of the three tones before you start painting will reveal a great deal about structure and the shape of that particular view.

It is easy to be confused by the amount of visual material that has to be sorted and related. Don't worry about detail at this stage. Instead study the relationship between large masses. Keep to the simple basics or the very complexity of the subject will be discouraging.

Concentrate mainly on trees, fields and skies, or natural formations. Don't become too involved with buildings. Later lessons will be more concerned with these.

Landscape painting is not a matter of recording separate skies, fields, trees and so on, but of re-creating an entire scene, with the unifying effect of light and atmosphere. However, it can be helpful to look at the separate elements, the parts of the whole.

You may have drawn previously on coloured paper as well as white. If not, experiment with it now.

The illustrations on the opposite page show the kinds of landscape you can achieve.

1. Brown ink and wash on cream paper; the cream of the paper becomes part of the picture as a whole, and is used to suggest light areas of the sky, the smooth, brightly illuminated sea, and the nearest part of the cliffs.

2. Pencil, blue ink wash and white conté on grey paper; the grey paper is left unpainted for the sky, and for parts of the waves, beach and rocks.

3. Red conté on pink paper; they are combined to create a bold, abstract drawing based on sky, sea, hills and shore.

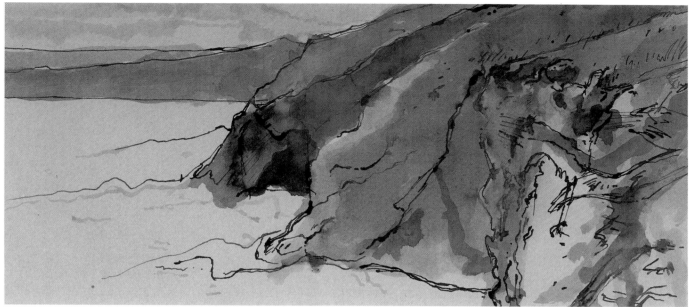

1.

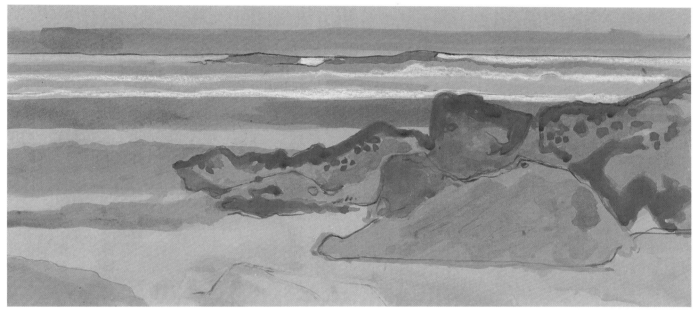

2.

3.

Perspective and Your Viewpoint

Perspective is generally significant only if your viewpoint is high or low. It will make it easier to draw what you see of the landscape laid out before you. A knowledge of the system will help you to repeat the direction and narrowing of roads running into the distance, the sloping sides of fields stretching over the hill, and so on.

Look back at the rules of perspective in Lesson One before you set out. Remember to take a small sketchbook for extra studies, and your cardboard frame or view-finder. These will help you to find a good viewpoint.

When you begin to be concerned with landscapes, the question of perspective will become quite important. For the first time in these lessons you are concerned with considerable distances, and the importance of eye-levels and horizon levels cannot be understated.

Before you begin to look seriously at very great horizons, find a few places that will let you experiment in a much more controllable way.

For the pictures opposite, a park scene, which can be found almost anywhere, was a useful setting. I started work at the top of a hill and, to help the illusion of nature, found a pleasant tree to cast shadows and a framework around the picture.

For such sketching trips near your home, you could carry a reasonable amount of material – a sketchbook, of course, and pens and pencils, and also a small stool so that you need not be dependent on a municipal bench, which is seldom just where you want to work.

Whenever you begin on a new subject, make as many trial sketches and quick studies as you can. Each kind of painting has its own problems, and experience is the only efficient teacher.

The illustrations opposite show how perspective changes according to your viewpoint.

1. This example was made from the top of a hill in the park, looking down past a large oak tree. Note how much of the scene is taken up by the branches and leaves of the tree, with the railings quite small, and the tennis courts simply narrow strips of paving on the left.

2. Halfway down the hill, and the trunk of the oak tree has vanished, while another smaller tree on the left can be seen more clearly. The leaves still make a thick screen at the top. The railings are more important now, and the square of grass in a tinted wash has grown much wider.

3. Down the hill and right behind the railings, which now take up almost half the picture, the background starting right above them. The pattern of the courts has almost vanished, the swings and sandpit of a playground on the right (covered by the leaves in previous studies) are sketched in white chalk.

In all of these studies the pencil outlines were sketched in first, the charcoal added and finally the touches of wash were added in sepia or grey.

For studies like these work in bold shapes and simple surfaces. Don't get involved in tiny details like the seats of the swings, or you will spend too much time on one corner of the sketch. Carry your notebook with you and sketch as much as you can.

1.

2.

3.

Geometric Composition

Paintings often fall into strongly geometric shapes that combine to form a naturally ordered composition. The eye can be guided to important elements in a picture in many different ways. One is linear composition, or placing important material on geometric divisions within a work.

Many ingredients contribute to the composition of a landscape – shape, colour, tone, texture – and awareness of all these parts is essential to a successful composition. Details can even control your reaction to a picture. It is impossible to see a van Gogh landscape without feeling a great sense of movement, as the eye is carried by the strong linear composition.

Even Breughel's crowded scenes which look so haphazard usually have an underlying form. Below, the central stage in the foreground with its two larger figures at the side is balanced at the top by the red flag, while the two corner buildings are on the same level. The vertical of the large tree trunk (left) is balanced by the angle of the corner house on the right, and the sharply defined chimney. The diagonals along the fronts of the houses meet in the distance – that is marked by a single, low-growing tree which stands more or less at the apex, one third of the way across, making the rectangle into a square and rectangle, the golden section of art.

Most of Breughel's work is complex and based on strong geometrical lines which steer the viewer's eye to different parts of the painting.

In the past, many artists emphasized the geometry of a composition by dividing the canvas and deliberately placing important elements on the divisions.

Today, most artists judge the effect of their compositions 'by eye'. However, if you analyse their pictures you will often find that there is an underlying geometrical composition.

Remember that it is necessary to compose a drawing in depth as well as two-dimensionally. Look for an interesting foreground, middle distance and background.

Note, too, that many landscapes contain figures – sometimes many of them, in considerable detail – as part of the scene. Most larger landscapes of the English and Italian schools had relatively few figures, often precisely painted. The Dutch and Flemish painters were more interested in genre scenes of village and town life, and often had many small figures to add life and interest to their paintings.

Detail from 'Village Park'; Breughel

Composition Project

1. Divide a paper or canvas into halves, quarters or diagonals. Sketch a composition over the divisions, with the largest tree-trunk on the far left.

2. Make another sketch, with the same divisions, but changing your viewpoint so that the important features fall on different sections.

Compare the two studies.

The bottom illustration shows how a very different composition can be produced if you turn slightly to the left and look a little more upwards into the tree even if you remain sitting in the same place. The tree-trunk becomes the focal point, almost in the centre.

1.

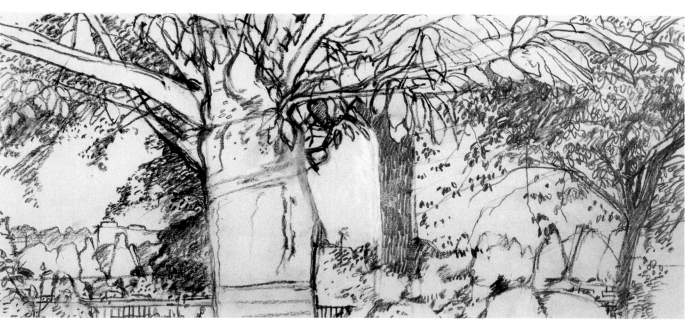

2.

Collage Composition

For a change of medium, particularly on a wet day when it is impossible to work outdoors, make a few collages, using combinations of differently coloured and textured materials. Cut or tear paper, cloth, wood, matchsticks and so on, to create arrangements of pattern and colour. Glue the pieces to any surface – paper or board.

Most people become confused because they tend to look at too much at once. Separate the larger masses and place them in some order of precedence and importance. This exercise will help to isolate the problems of balance, shape, texture and pattern.

A collage is the ideal medium for experimenting with landscape shapes and forms. Trees and rivers don't move easily, and it is useful to work with more tractable materials – think of the landscape as a patchwork quilt you have to fit together.

Creating a collage will also allow you to try out colour combinations that you may find difficult to make when using paint.

The two collages below were made from scraps of fabric and thick paper. Both are based on landscape forms. The first is fairly obvious, with its square 'houses' and tree trunks; the second was used as a study for the painting on page 312 – clouds above summer fields.

Abstract Composition

Abstract is a modern term, used broadly and loosely to describe non-representational, or what are sometimes described as non-figurative, paintings. Sometimes the artist selects or extracts elements from a scene in order to simplify and reform the material.

However, much recent abstract painting is not directly taken from observation. It acknowledges that lines, curves, forms and colour can be organized to produce a beautiful result that does not necessarily evoke something we have seen.

Even though you enjoy working in shapes, never neglect the discipline of learning to draw representational pictures. The two kinds of art should be able to draw from each other, not shut each other out.

Abstract painting is often likened to music, which can be associated with pictorial subjects; 'programme' music tells a story, but it is also an arrangement of pure sounds. In the same way, abstract painting may have an external reference but is primarily an arrangement of shapes, forms and colours.

Try to see a landscape in terms of pure colour, shape, form and texture, regardless of subject.

It may be necessary to make a first study which may turn out to be representational, then make further (and more abstract) studies from this.

An abstract oil painting based on a church tower

305

Colour Field

Colour has its own sense of proportion. It can be stimulating or dull, used in contrast or in related, blending tones, and it can also be affected by the amount of any one colour you use.

Colour field simply has to do with the placing of colour against colour, and it is important in terms of area as well as pigment.

In general, equal amounts of complementary colours tend to cancel each other out. Sunlight can be painted in many different ways, and you usually need very little of the warmer tones to give the strongest effect, especially when the rest of the picture is in the cool blue and grey of a misty day, or the warmer brown tones of early evening. Landscape is very appropriate for studies of colour contrasts and relations. Many times an overall background is highlighted by just one point in a different colour. Use oils for these studies, work as quickly as possible on the basic shapes, then add that one small area. Don't get involved with details at all. Look at the work from a distance to judge if you have managed to create a focal point with just a few strokes.

1.

1. This detail of a study is predominantly blue and grey, with no real point of contrast. The effect is of a grey misty day, the road simply disappearing into the distance.

2. Another grey day by the river, but the single point of pink, and a little turquoise in the left foreground, give a much brighter feeling to the entire scene.

Look at the palette used in these two pictures, isolate the different colours and their proportions; the pink behind the fence, also reflected in the river, has been concentrated and strengthened in the second sketch, so that the sky is quite mauve right at the top.

2.

3.

3. A view from the sea. A stronger blue for the sky, and a bigger splash of pink, as well as a few short strokes in yellow-brown, all blend to make an impression of a sunlit day.

Agricultural Shapes

The countryside is often divided up into fields, and these can play an important part in giving shape and coherence to an otherwise empty scene.

Basically they are simple geometric shapes in tones of green, brown or yellow, forming a pattern of irregular rectangles that lie in a relatively flat layer from where you stand to the horizon. This is over-simplified, of course, but it will help you to think of the landscape in two-dimensional form.

Once again, your viewpoint will affect the shapes dramatically. A picture of fields taken from an aeroplane will give you a very clear pattern, almost like a collage or a patchwork quilt. Even

clumps of trees lose their texture and become simply darker squares of green, perhaps with fuzzy edges. Hedges and fences help to define the pattern, and all these elements combine to make interesting abstract shapes.

As seen below, a field painted from a low level can fill the entire picture, running from side to side of your viewpoint and up the slope without any division.

Try to look at the fields as shapes whenever you can – from a train window, a high building, or even from the bottom of a ditch. Sketch them constantly without any details, just shapes and textures from different viewpoints and different eye-levels.

Colour used to create shapes, perspective and atmosphere

Buildings and Ruins

Town and city buildings in large groups are dealt with in the next lesson – here we will be dealing only with the individual building or farm which might appear in the view.

Buildings play a minor part in many landscapes. The emphasis is on minor, and at this stage in your progress it is important to note that they should also play only a small part in your picture.

Beginners often exaggerate their prominence, increasing their actual size and the intensity of their colour. This is true even when the buildings are in the background. Children's paintings are often house-dominated because it is their home, and mentally very important to them. Painters beginning to draw landscape must be careful not to make the same mistake. Architecture can be very effective, even when it is discreet and low-key, making an effective point though small in size.

On the other hand, a windmill or castle seen at the top of a hill will give height and a focal point to any composition, and should also be noted as a shape against the sky as well as a detailed element.

Another aspect of painting buildings is the quality of texture. Before you start, look at the hard edges of masonry and man-made materials where they meet the soft patterns and colours of nature.

A building will be crisp in line compared to leaves or shrubs. Draw the building first, then add the surrounding foliage so that it blurs the edges.

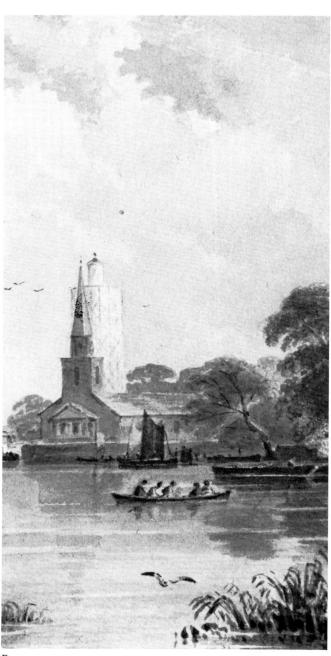

Far away

Close by

Trees and Hedges

Trees can be detailed and highly prominent in the foreground of a landscape, or smudgy, dark accents of colour in the distance.

The conventional approach, used by children, is to portray a tree either as a trunk and branches without leaves, or as a round, dark green shape supported by the trunk. These images are over-simplified and not entirely accurate. However, they do illustrate what most people think a tree looks like. In practice, trees are an integral part of the tone and colour of a scene, and it is difficult to isolate them.

Do some simple exercises. First make a small sketch of a tree from your imagination. The approach is up to you. You may try to paint individual leaves; or indicate their presence by using pattern and texture.

Now compose a large, imaginary landscape. Draw or paint in trees, as a group and individually.

Put some in the foreground, some in the middle ground, and some on the horizon.

Paint these in as many different ways as you can. Some should be highly detailed, others just blobs of colour suggesting greenery. Show some with twigs growing from the branches, others with dense foliage and others with bare branches.

Finally, go outside and make as many studies of trees as possible.

Skies and Clouds

Landscapes present a variety of moods in all seasons and weather: rain, storm, mist, sun, heavy and broken clouds. Observe the relationship between sky and ground, and how light affects the overall colour scheme. A bright sunny day with broken cloud produces brilliant colours that contrast with areas still in shadow.

Find structure in cloud formations. Use their shapes in your composition to echo, and contrast with, those in the landscape.

Clouds are not very different from other subjects except that they move and change, and they can be drawn or painted in almost any method or style, and in any medium.

Look at these examples of details before you go on to make the sketches suggested on pages 314 and 315.

Pen and Wash

A mixture of pen drawing and black, grey or colour washes – a combination of drawing and watercolour or gouache techniques – can be most effective. These studies show some of the effects that can be achieved.

Using the dry-brush drawing technique, or adding details to a dry watercolour with a fine brush, gives more variety of line than you would have with a pen.

This is especially true in landscapes where the marks of the brush add a natural roughness to the edges of foliage.

1. Paint a small watercolour landscape. When it is dry, draw in the details with a pen.

2. Reverse the process. Draw a landscape in indian ink; it will be completely waterproof when dry and you can then add the wash.

3. Make another study in outline using a pen and ordinary, non-waterproof writing ink. When you add the wash colour the effect will be different – the ink will run, giving a softer line, very similar to the appearance of the 'wet-on-wet' watercolours in Lesson Two.

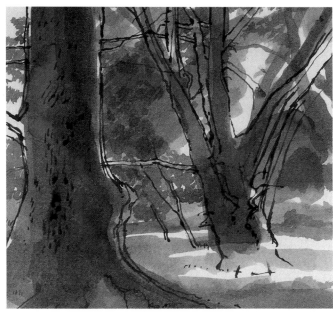

1.

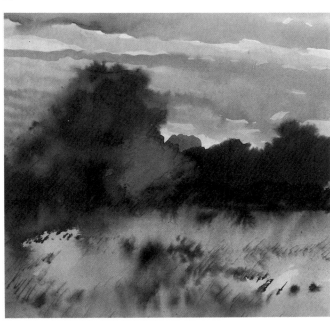

3.

2.

Landscape Sketches and Notes

The examples in this lesson of different elements and techniques of artists' methods are given to help you learn to look at what you see as carefully as possible. There have not been too many detailed instructions because we are anxious that you spend most of your time experimenting for yourself, especially before you begin to work on finished paintings. We cannot emphasize too often the importance of making constant sketches and notes, of changing your viewpoint, the time of day, and the subject-matter. Work in as free and comfortable a manner as possible, taking every opportunity to add to your studies.

Landscapes, unlike many other subjects, are ever-changing. Watercolour, because of its speed, freshness, and ability to capture the fleeting effects of moving cloud, windswept trees and reflections in water, is the most convenient medium to use for this subject.

Inevitably, you will emphasize or exaggerate the moods and effects that you find interesting. This happens in every picture; it seems to be impossible to paint without this personal evaluation. As a result, you will minimize or totally ignore some other aspects of the same subject. A final choice, therefore, will depend not only on what you see but on how you see it. You will also be affected by the works of other artists.

You must decide what you want to say. All types of picture-making are valid, and experience will show the kind that is most useful for you. Keep your preliminary studies even when your painting is finished – the different approaches you have tried will be endlessly fascinating.

Mixed Media

One of the interesting aspects of landscape painting is how well it adapts to mixed media. All through this book we have tried to stress that all forms of art are related, and how important it is not to become settled too soon in one form or style of painting.

The lovely landscape below, of a garden in winter, is a perfect example. The artist felt that no one medium would be able to capture the extraordinary atmosphere of this deserted moment on a dark winter afternoon.

Aside from being an effective technique, the painting illustrates how powerful simple black-and-white lines can be, especially when the artist also utilizes all the grey tones between the two.

First, a watercolour wash was laid over the background in soft grey, divided by a thin pencil line from the darker band of the hedge in the background. Then a very light grey wash was unevenly laid over the foreground to give the soft drifting feel of piled-up snow. Pencil outlines, again, give crisp edges to the topiary, the pillars in the background; a middle wash hints at trees and buildings behind the scene; and the darkest wash fills in the topiary, the balustrade, and the urns. This last wash was kept extremely dry, so that the surface is even and ghostly in the dark light.

A fine pen and a very clean ruler marked out the lines of the wire supports for the roses, and the bare branches that remain to endure the weather.

Finally, to give the effect of drifting snow, the flakes were lifted off the paper by use of the watercolour technique of washing out. It took a very long time and could only be done when the painting was completely and thoroughly dry; otherwise the flakes would have been too large and too 'runny'.

'Rose Garden, Vienna'; Mynott

Five-minute Studies

Quick studies, endlessly useful, capture the eternal, transitory quality of a misty morning with pale washes in light grey and blues; these are only a few suggestions.

Indicate cloud shapes in pencil. For white clouds in a blue sky, lay in a blue wash leaving the shapes unpainted. Add another colour if necessary. Light grey under the white shapes usually gives a fairly accurate impression of white clouds floating across the sky on a sunny day.

For an overcast sky, formed almost entirely of white cloud, paint in two or three small patches of blue – the isolated areas of sky. Next, use a very pale wash of grey and add colour under each cloud bank to indicate shadows, space and recession. Add accents of warmer colour – perhaps a bluer grey – where necessary, to complete the effect.

Although you can use this technique outdoors it will be enormously helpful to practise these basic, and very useful, sky studies in the studio. Most skies can be painted using these skills. The technique of 'washing out' or 'sponging out' – removing some of the colour with a damp sponge to reveal the white paper – was described in Lesson Two and can be used on a dry or wet wash. It is particularly useful for skies – and soft-edged, moving clouds will be more of a challenge than the single-sail boats you made before.

Lay an overall wash of light blue-grey. When it is dry, or almost dry, remove some areas of colour with a small sponge or cloth to produce white clouds. Practise this in your studio before going out to paint.

Cover the top half of your paper with a light blue wash, and allow it to dry. Then 'wash out' some white clouds. Add some light grey-blue brush-strokes to the bottom of the white areas while the wash is still damp, allowing the colour to run gently into the paper. This gives soft shadows to the clouds.

1. Lay a basic blue wash on very slightly dampened paper as you would on dry paper. Allow the second colour, usually a warm grey under the white clouds, to 'bleed' down into the first wash. This gives soft areas under the clouds and can create an impression of strong sunlight or heavy rain.

2. On another sheet, wash out the white clouds as before. This time, allow the paper to dry. Mix a slightly darker blue-grey wash and add shadows to the clouds, either on the bottom of the white areas or just underneath on the light blue wash. This produces a good three-dimensional interpretation of floating clouds.

3. Colour can be used to create depth, moving from strong in the foreground to pale on the horizon, or vice versa, as in the tonal examples in Lesson Two.

Make charts or studies with transparent washes of sharp hard greens moving back to dusky pale grey-blues.

Some landscapes are simply washes of receding colour with narrow brush-strokes suggesting a field, and a distant hill, and the sky just a few faint lines of colour.

1.

2.

3.

Dry-brush Technique

You may want to have a textured effect, which is possible on rough paper. To see what sort of results you can achieve, first choose a piece of rough watercolour paper, then, with a brush which is slightly damp, lift some colour from your pan or palette and quickly run the brush over the rough paper surface. The paint will be caught by the raised texture of the paper, leaving some parts still white. Practise this with different colours and different amounts of watercolour, and also try different paper surfaces. This is usually used last of all in finishing a picture, as it is impossible to wash over the texture without spoiling the effect.

Sometimes, of course, similar effects are possible if you use a stiff brush on smooth paper, but with very little water. It is best to experiment with hog-hair brushes – sables are too soft for the beginner. Make a sample for yourself by dividing up a sheet of paper, and trying out squares or sections with your brush; start with almost no water, and gradually work up to a full wash.

Working from Sketches

One of the most important virtues of keeping a sketchbook is the way you can use your own work, made on the spot, for finished paintings in the studio.

The original painting should have all the information you are going to need – colour, proportions, and enough of the details to remind you later of what you have seen. It need not be absolutely precise and you can work in quickly laid washes for most of the sketch, as long as there is enough to jog your memory days or even weeks later, when you begin to work.

The pictures on these pages illustrate this point exactly. The sketch below was made in the street facing the front of the house. Because it was an attractive subject, the artist decided to keep the written notes on the back – with comments on the brickwork, the leaded windows, the plaque and all the different colours.

Then the sketch was filled in with washes of sienna and grey in various tones. He had to work quickly but there was enough information, together with his own comments, for the immaculately completed painting opposite.

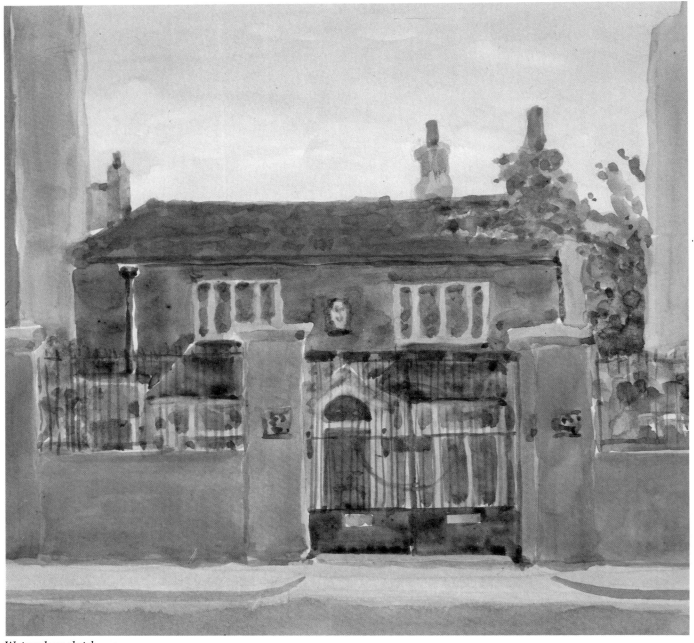

Watercolour sketch

Although these examples are actually of a cottage in a town rather than a landscape, they combine perfectly to illustrate the difference between a sketch and a finished painting.

Look carefully at the two pictures and compare them to see where some artistic licence was employed. In the finished painting the wall on the left has become a stronger vertical because it rises straight without the setback. The ivy now covers the chimney entirely, and the hedge has been neatened enough for any gardener. All the windows and doors have been painted carefully with a very small brush and some guiding pencil marks, and the same technique was used for the brickwork and the iron railings. The actual rails were done with a pen – it would have been impossible even with the smallest brush.

Notes must be clear and precise in order to complete a painting in the studio. This is especially important the first few times you work in this way. Your memory will be untrained and you will be liable to forget vital details – the colour of brickwork or the tone of the ivy – all too quickly.

Writing on the back of a finished sketch is one way to remind yourself. However, if you want to be absolutely correct about placement or shape, go prepared with a thin sheet of tracing-paper big enough to cover the paper completely and be taped to its back. When you have made your first pencil markings flip the tracing-paper on top of the sheet, and make your notes lightly in pencil. Then flip it back and continue with your sketch.

When the sketch is dry, and before you go home, look at the overlay again and make sure you have put down all the information you need. A good point is to add the location. The cottage illustrated is easy to recognize, but landscapes can be more difficult to pinpoint, especially if you are on a sketching holiday, or visiting a new part of the countryside.

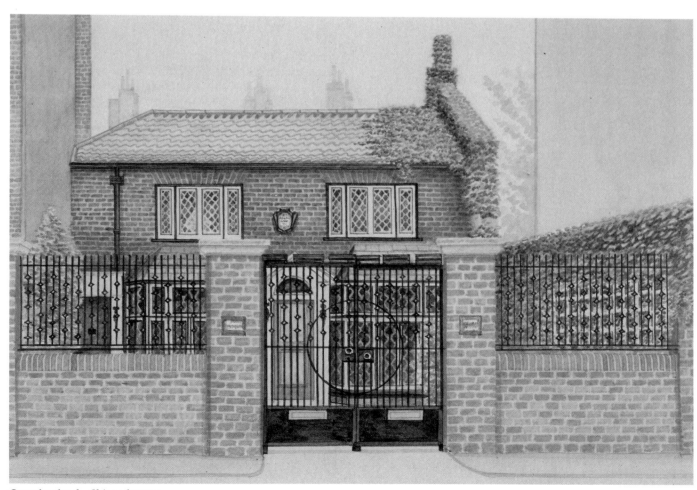

Gouache sketch; Shipperbottom

A First Landscape in Watercolour

A completely finished painting, on the spot, requires careful preparation and forethought. Watercolour is not a very forgiving medium and, although mistakes can be washed or sponged out, it does not take kindly to harsh treatment.

Watercolour is the art of clear, precise statements. It is best to know what you want before you begin, which is why we have been so concerned with preparatory studies and exercises.

Once you have decided on a view, find somewhere comfortable to sit, or use a folding seat. Look at the landscape carefully. Think about its particular features, essential characteristics, and so on. Observe whether the view is dark or light in tone and whether the colours are soft and muted or strong and contrasting. Decide what shaped paper will be best for the scene – very long, almost square, or even portrait shape.

When these problems are resolved, find a suitable piece of paper in your folder. Rough paper is normally used for a large painting, smooth paper for a small one. However, this depends on your personal preference and style of painting.

I started this work directly on the paper, but you may wish to make a few drawings first. Concentrate on the proportion of sky to land, and the outline of the pattern of the fields.

Step 1. Draw in the main composition very lightly with a pencil – this is only a working guide to the main washes, so don't be tempted to make a real drawing of the picture. It should be as light as possible, so nothing will be seen under the pale washes when you have finished.

Now lay in a wash of light blue over the entire area, but leave patches of white to represent clouds, and a strip at the bottom which will be a field. Remember that you will be adding at least another two layers for those three main tones you practised all through the previous lessons. Keep this first wash very, very light, and allow it to dry thoroughly.

Step 2. In this first project, you may find it helpful to draw in the outline of where you want the second wash to go. Use the lightest pencil – it is only a guide for you and must not be visible in the finished work. Add another wash to deepen the blue on the horizon, and let it dry.

While you wait for these first washes to dry completely, try changing your viewpoint, and make a few additional line sketches for practice and comparison.

Step 1.

Step 2.

Step 4. Mix a wash using viridian green and paint in the main shapes of the trees.

Note that there is a band of blue above the yellow, and the trees are above that. The underwash of blue will give depth and distance to the far-off fields, and create a better feeling of wide-open space than simply yellow or green. Add rectangles of colour wash to the top fields, using the same green and yellow, and adding a sienna-red tone to the field on the right.

Mix a darker-brown wash, and using a finer brush mark out the hedges and the main trunks and branches of the trees.

Step 3. Mix a third wash in blue-grey and brush over the bottom of the sky to give an impression of deeper space and movement, and add the same wash to the undertones of the clouds to increase their depth and floating space. Mix a wash in yellow and lay it on the bottom of the picture for the ground.

Let both washes dry completely.

Step 5. Let all this dry completely, look at the picture from a good distance, then add the final touches. Soften the cloud shapes a little with a damp sponge to blur the edges – make sure you use clean water. You can use ink or a small brush to outline a main group of trees, and sketch in very lightly the telegraph poles and such small details. Don't do too much – a little enhancement goes a long way.

Step 3.

Step 4.

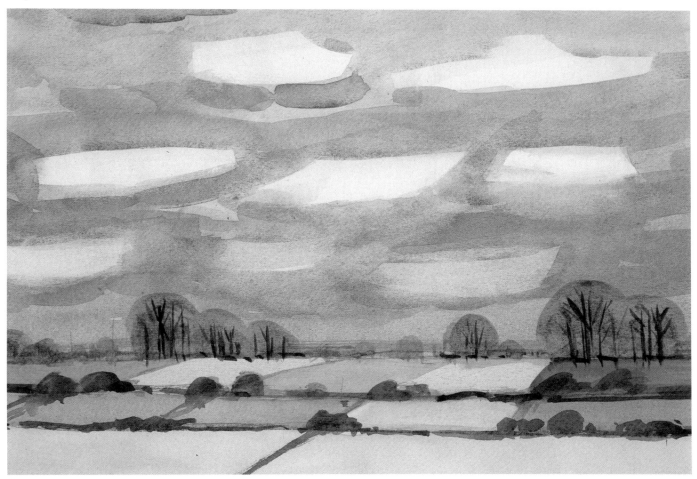

Step 5.

Landscape in Oil

The relationship between what you see and what you paint is conditioned by your attitude towards the subject. Find a scene with interesting shapes and colours. It may be a familiar and well-loved view, one you find on a day out in the country, a real beauty spot or a neglected piece of farmland. Whatever it is, take time to observe and analyse it carefully. Decide on the features that make it worth painting. These may be the shapes of objects such as fields, trees or farm buildings, or the atmospheric effects of colours and light.

You will discover for yourself whether your temperament is suited to a tightly controlled or a broad, free approach. Remember, though, that 'free' does not mean lacking control or observation. The broadest, and freest, sketches by Turner or Degas and the best modern abstract painters are outstanding examples of sharp observation. Tone, colour and shape are as carefully considered as in the most finished and precise classical paintings.

Perhaps no medium is as versatile as oil, and certainly it is easily capable of the variety and unusual effects which are much harder to obtain with watercolour.

Here are two examples of totally different moods in landscape; the one below was painted some fifty years ago in Australia, and it is a detail from a much larger painting of the outback, on a misty autumn morning. Look carefully and you will see that the elements are barely sketched in, and the pale outlines are simply shapes in soft shades of pink and brown.

The dry field opposite, in olive greens and browns, looks much more like what we imagine to be an Australian landscape – in fact, it was painted in England last year.

These two paintings represent very different styles. The tree is carefully layered, almost as thinly as watercolour, while the English field is obviously laid in thick strokes. Yet both give a marvellous impression of atmosphere and mood, exhibiting yet again the versatility and flexibility of oils as a medium.

Detail from 'Misty Morning'; Streeton

324

Everyone responds in different ways to the particularly emotional effect of landscape. Your reactions, and how you interpret the subject, are the most important factors in creating an individual style when you begin to paint.

Remember, oil is a very flexible medium, so don't be afraid of making mistakes. Some of the best paintings come from the worst starts; a bad beginning can, in fact, provide an image to work against. Your mind, as well as your hand, should be flexible. The natural world is infinitely variable. Too much control too soon may prevent your finding an unexpectedly good, exciting picture.

Make a composition in the studio, using notes and sketches made outdoors. Establish the main masses of tone and colour to create the structures of the painting. Work broadly, and allow the picture to evolve.

Lay in simple gradations of flat colour, without clouds or specific forms. Work from the horizon to the top of the sky, then from the horizon to the foreground. Then fill in the forms. Try to work on the canvas as a whole, not just one corner.

Oils are good to use at any level, but take the trouble to learn to use them well and the rewards will be considerable.

One particular aspect of painting landscapes in oils is important for new painters – they can be worked on over and over again. If you go back and find that your remembered image is not very accurate, you can even scrape down the canvas, put on a new undercoat and start again completely fresh.

On the other hand this flexibility can be a problem. If you become dissatisfied too often and expect too much of yourself, you will spend more time scraping down than painting.

Use the paint, don't let it use you. Learn to recognize the advantages of keeping your work for a time at least before deciding to start again. You may be pleasantly surprised a month or two later.

Oil Techniques in Acrylic

Extremely versatile, acrylic paints are relatively new, and can be used effectively in transparent washes, glazes, or heavy impasto. Although various thinning agents are available, acrylics can be effective if they are simply mixed with water.

The paints are waterproof when dry, so one colour can be painted over another with no risk of disturbing the first one – a decided advantage over other water-mixed paints. Drying time is in fact short, making acrylics an excellent medium for using outdoors – you won't have to carry a wet painting back to your studio.

They are also useful for preliminary studies for oil paintings; effects sketched in acrylics are easily recreated in oils.

Another advantage, for anyone who does not like the smell of oil paints, is that they have virtually no smell – but can achieve many of the same kinds of effects.

Use the set of primary acrylics that you bought for your first colour wheel (see page 15); add black and white, yellow ochre and a bright green. Although there is no real equivalent of oil's viridian green, emerald and other similar shades are useful. You may decide to add other colours that suit your particular style.

Choose a different aspect of landscape for this project, possibly a view with brightly coloured foreground objects.

Make a complete painting, on paper, but also do small colour notes and studies that can be used with a drawing to create a new painting in the studio.

Add tone and colour recession, and details. Develop individual features and relate them to the painting's structure.

Remember to start with an acrylic-primed canvas, or coated board. With these wide sweeps of colour, man-made brushes are perfectly acceptable and even add a certain texture of their own. Use a No. 10 or 12, with a fine sable brush for details only.

This semi-abstract landscape was done as a sketch for a larger painting, but it is quite effective in its own right.

Step 1. Pick out the basic colours of sky, distant fields and foreground. Study the proportions of each element, and make the first important horizon line in a mixture of raw umber and blue. The entire line should be completed in two strokes.

Step 2. Now begin at the top with the sky, and work right across the canvas in one bold sweep. Lift your brush before you make the next stroke underneath, or you will have a slight curve, and the effect of this particular study is based on the wide-open feeling of the horizontal lines. Change the mix of colour slightly to soften the light just over the first line.

Don't be worried if you overlap slightly on the hilltop.

Using the yellow, make the same horizontal strokes for the fields, remembering always to lift the brush and keep the line comfortably straight.

Step 3. With a slightly smaller brush, soften the sky with white clouds as simple scallops without detail or shadows.

A dark brown pigment is used for the details, making another hedge line nearer the foreground, shapes of clumps of trees, and an added line of more distant hills above your original stroke. Use the smallest brush to mark in the shed, the square of the farm buildings, and the furrows. See how little definition you need if the proportions are right; from these few lines we see an entire landscape. Always keep your work as simple as possible, and avoid tight emphasis on tiny parts of the canvas. Use every square inch from side to side, and let the fewest number of strokes tell the story.

Step 1.

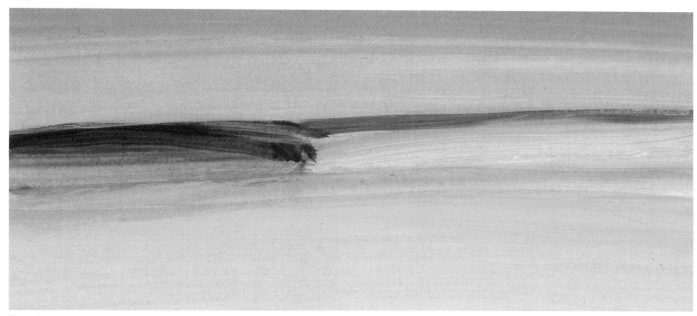

Step 2.

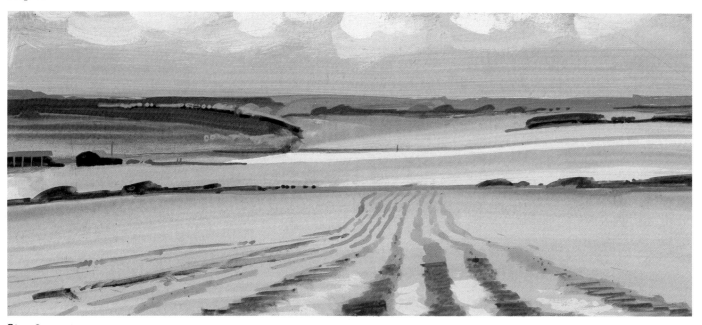

Step 3.

Special Techniques with Oil

Before you begin to work on a finished landscape, try out some of the different effects you will be able to achieve with oil, especially those which are not really suitable for watercolour or pastel.

Detail

A great benefit for oil painters is the amount of detail that can be achieved with overpainting. There is no worry about mistakes or smudgy lines; if the paint does not seem to give the right effect, simply scrape it off and start again. And even more, such detailed work can be achieved with surprisingly simple strokes.

When you start painting, try to do a quick study of some small detail; learn how to handle your brush for those delicate touches which can add up to a really finished piece of art. But do remember to keep the detailed studies separate at this stage, or you will become locked into concentrating only on a small square of the picture instead of looking at the entire effect.

Distance

Distance in oil landscapes is achieved much as with watercolour – the tones receding as the eye moves back. However, with watercolour you start with the light colours and add darker and darker tones; with oils you must reverse the process and begin with the darkest tones, often the foreground, and work towards the light colours which will be laid on top. For this reason a watercolour landscape is said to be worked back to front, while an oil landscape is painted front to back. To get used to this, go out sketching as often as you can, using quick-drying acrylic paints if your time is limited.

Detail and Distance Together

In the painting below, the wooded glade seems to stretch forever into the distance, and is made to seem even longer by the path, the receding figures, and the distant glimpse of sunlight on an open meadow. But look closely at the stick in the foreground. You will see that there is a multiplicity of tone and direction, all combining in a textured roadway full of pebbles and dust.

The small picture on the right shows just how complex these details can be. Learn to build up such details by looking closely at pebbles, sticks, fruits, leaves, and so on. But don't try to put tiny details into a large picture at this stage, or you will get bogged down indefinitely; keep the details for sketches or small paintings.

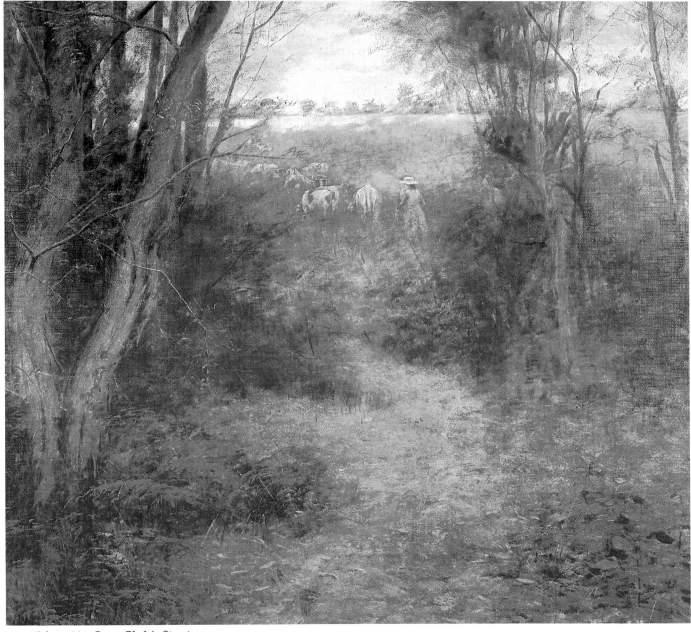

Detail from 'An Open Glade'; Streeton

A First Landscape in Oil

Here are three steps to a hilltop view with all the rich colours of a summer afternoon.

Use a primed canvas, and a basic palette of burnt sienna, raw umber, viridian, cobalt and white. I don't usually draw on the canvas, preferring to work directly from the abstract shapes I see, but you may want to guide yourself with a preliminary outline in pencil. Use a No. 5 sable brush for the main areas.

When you are making these sketches, don't start by trying for too much detail. You are concerned more with an atmosphere, a quick look at a distant clump of trees, a nearby hedge.

Later you will become more proficient and paint more exact pictures, but at this stage it is still important to use oils freely and confidently without getting bogged down in a tiny patch of foreground.

To practise details, carry a sketchbook and draw leaves, twigs or flowers as often as you can.

In the last step opposite, the clump of trees on the horizon is dark and purple-toned; below are two studies of the same clump on different days. Note how completely the time and the weather can alter the entire painting.

Step 1. In order to give depth to the sketch use an undercoat of raw umber all over the picture. When it is completely dry, mix a darker shade and go over the undercoat where the fields and trees will be. Let it dry, then block in the blue sky, the white clouds, the one stroke of pink, and the densest bushes with the viridian.

Step 2. Now begin to soften all the shapes; shadow the clouds, letting them spill over with short, curvy strokes; add more blue over the brown to deepen the sky, and green to shape the hedges and trees and define the horizon. Blend in the pink sky with more short strokes, running the warm colour up over all the browny background and undercoating. Add the splodge of yellow with a small brush.

Step 3. Use a smaller brush here for the details, moving away from the canvas constantly to check the effect from a distance. You will learn that oil paintings on the whole should be seen from at least 3ft or 4ft (about 1m) away. Blend the yellow into the green hedge, add the lighter green field behind it, as well as horizontal strokes for the fields in the background.

Never work on a free study like this with too much tiny detail – it would make the entire picture look cramped and artificial.

Step 1.

Step 2.

Step 3.

Extra Projects

Never be afraid to make use of any other medium to help you with painting. This is very important with landscapes and seascapes, since by their very nature there will be problems with shifting light, changing weather, unusual conditions, and other impediments such as rampaging cows which make it imperative to work quickly, and leave quickly!

The first good point for the beginner is speed. A sudden rainbow, a shaft of sunlight, all can be captured in seconds if your camera is nearby and loaded with film. Don't get involved with meters and specialized equipment – you are taking the photographs for reference, not as art.

The second benefit is to help you with composition. Beginners often find it hard to decide on the best view – in any part of the countryside there are so many possibilities that each stop along the road suggests a new picture to the eye, and hours can pass without a stroke of the pencil or a lick of paint on paper.

For this, a Polaroid camera is the most appropriate, and luckily there are many on the market which are small and handy to use. Limit yourself to a small area and take three or four pictures from different places. Compare them, make a decision, and start to paint. These three sketches were all done on one day.

Give yourself an outside time of half an hour to work on each, no more. There will always be another day, and the more often you go out sketching the more quickly you will improve.

Starting off

The beach

On the way home

Once you have finished your first few projects, you will have established a basic knowledge of what to look for in landscapes that you see, how to choose the best place, and how to create interesting and unusual paintings.

Make it something of a challenge to give yourself a new task every week, and you will learn even more quickly.

Find a pleasant view, and paint it standing from three different places, paying particular attention to the way the shapes change as you move around. Keep the sketches pinned up in the studio to study later.

Try to look for unusual angles: the bottom of a hill looking up towards the sky, a rocky outcrop; even sit in the branch of a tree to give yourself some height.

Take time to change the depth of your landscape. Look for some very closely studied details as well as the far-away abstracted shapes of distant hills.

Change the mood of the paintings. Most landscapes are quiet and dreamy. Try picturing the effect of racing clouds piled up in a threatening sky, rain lashing at leaves, wind-torn hedges, snow-piled hills. Use photographs to keep your impressions fresh, but try to make sketches as well.

Above all, paint, paint, and keep painting. Carry a tiny sketchbook whenever you go for a walk, and try to work at home as soon as you return so that the image in your mind is still clear. If for some reason you are confined to the house for a long period, never be discouraged. Use photographs, use your memory, and even imagine landscapes you have never seen – the dream world is as rich for the artist as any place you think is real.

Be sure to paint outdoors during the cold months as well as in the summer sun. The winter landscape is fascinating, with the skeletal shapes of branches and trees making traceries and lattice patterns against the sky; the structure of the earth itself starts to become visible. Form and movement are clearly defined by the low, raking winter sun. Colours vary from stark contrast to muted hues. Rapid changes in weather provide a kaleidoscope of new effects.

Misty conditions are particularly exciting, with subtle gradations of tone, interpreted in greys and soft browns. Newly fallen snow makes wonderful linear and textural contrasts; a thaw creates a dramatic patchwork of colour against areas of white.

Paint a landscape based on these studies. Lay in the main areas of fields and sky, concentrating on the colour balance. Ignore details. Work fluidly, with easy strokes. Make adjustments; you can wipe and scrape out areas where necessary. Try to achieve an interesting colour composition.

Tonal notes with colour reminders

'Mill Street'; Lowry

Lesson Nine Cityscapes

Artists have always been concerned with the portrayal of their surroundings. Prehistoric clay blocks bearing rows of scratches are thought to represent families and households; south-west American Indians made, and still make, sandpaintings that show dwellings neatly arranged around the central lodge, the axis of their spiritual life.

Broadly speaking, cityscapes fall into two categories: representations of the real world and visions of dreamland. In Western art the earliest examples are probably the views which may be seen in the backgrounds of many manuscript illuminations. Some of these show a fortified village with a moated castle standing sentinel over peasants labouring in the fields below. Others show saints and holy men gathering in the streets of Heaven, its avenues graced with fine palazzos and magnificent cathedrals. Often these scenes were based on real places, although they were most often the product of the artist's fertile imagination.

There were also cityscapes, painted during the medieval period, that were meant to serve as maps for citizens and show in great detail the commercial centres, residential districts and even the occupations and day-to-day activities of the city's inhabitants. Today these paintings give us an impressive insight into the early life of the great European cities. They show everything one should look for on the way to the city centre – the busy harbour and tree-lined streets – as well as city dignitaries and hard-worked apprentices.

Other town views were illustrations, as we use photographs in a daily newspaper, to describe disasters, and scenes of courage or horror. However they were used originally, such little vignettes are immensely valuable to us, because they show over the centuries how villages grow into considerable towns, and towns into cities.

By the sixteenth century, there could be considerable detail and realistic proportions. The small illustration below of the massacre at Haarlem was made to let people know what happened when the Netherlands fought Philip of Spain for their religious freedom, but it is equally fascinating for its view of the city itself – the sea walls, the gabled ends of the houses, and the great central square.

Massacre at Haarlem; 1573

Courtyard drawing; Caravaggio

During the Renaissance, some of the large paintings made by the great artists were studio set-pieces and employed cityscapes as a means of showing off the painter's skill at perspective. In the seventeenth century accurately drawn maps began to replace panoramas.

However, pure cityscapes were never very popular until the nineteenth century, except as backgrounds; even then, most street scenes were confined to drawings and etchings which were intended to be of educational value to tourists or students. In the Victorian period, when many subjects popular today were revived and re-vitalized, city pictures came into their own.

To begin with, they were directly connected with the romantic landscapes popular in the eighteenth century. If an artist was to draw the occasional castle or tumbledown ruin, it made sense to learn something about making buildings interesting. And, of course, elaborate buildings, such as those drawn by Giovanni Battista Piranesi (1720–78) and his students, were used as settings during the classical period, so there could be said to be a certain tradition for the genre.

Early Victorian cityscapes were much less architectural, and more in keeping with the idealized view of country life inspired by the works of Théodore Rousseau (1812–67) and others. A village by William Holman Hunt (1790–1864) is

'Village Street'; Strang

actually called a landscape, and certainly contemporary visitors who looked at his work would have seen nothing but the picturesque and the charming.

This kind of subject was to have a long life, and is still alive today; the illustration below left was painted by Ian Strang in 1946. Except for the paved road and considerably improved condition of the houses, it could have been painted a hundred years previously.

Alongside this ideal village, city life was said to be seamy and infamous, especially when viewed through the eyes of William Hogarth (1697–1764) and such observers of morals and manners. However, by the end of the nineteenth century towns and cities were lively and crowded with shops and theatres – apt subjects for the artist.

In Paris Camille Pissarro (1831–1903) and Maurice Utrillo (1883–1955) were almost obsessively concerned with their capital city and their home towns and villages, and with the lines of roofs, the lights and streets, and the shapes made by buildings, harbours, quays and bridges.

We have grown so used to these evocations of sights and sounds that it comes almost as an anticlimax to visit a particular place in Paris and find you can recognize it without the slightest difficulty, even fifty years or more after it was painted.

Today, artists have learnt to use their own cities as equally inspiring subjects, though they may be less concerned with pretty pictures and more concerned with evoking atmosphere and emotional impact.

The meanest, dirtiest industrial factory has been transformed by L.S. Lowry (1887–1976) into a marvel of form and colour with the smell of coal and dust hanging in the air. The empty Sundays captured in paintings by Edward Hopper (1882–1967) reflect the lonely desolation of American side-streets, while Piet Mondrian (1872–1944) saw something very different on his visits to New York. John Minton (1917–57) encapsulates a lighthearted aspect of the South of France in his Grand Hotel. Ordinary scenes on every street corner offer the artist a hundred different moods, depending only on the mind behind the artist's eye.

'South of France'; Minton

Looking at Cityscapes

Most people live in towns or cities, and this is perhaps the main reason why landscapes are so popular, contrasting as they do with the man-made, angular environment in which we spend so much of our lives. Just as medieval peasants associated the natural landscape with toil and an unequal struggle against nature, so modern man tends to associate the urban landscape with work and the daily trek to factory or office; country landscapes symbolize the romantic idyll.

However, painting involves more than a liking for pretty views. Constable said 'I never saw an ugly thing in my life', and for the artist even strange objects and scenes can be invested with drama and excitement.

The emphasis on preserving engineering artefacts as well as buildings, the development of subjects like industrial archaeology, and the conversion of out-of-date but interesting structures to contemporary use, demonstrate a new appreciation of our man-made heritage. This interest in the anonymous working places, warehouses and mills of the nineteenth and early twentieth centuries has increased both in importance and intensity.

Some of the lovelier cities, of course, have attracted painters for generations, often because of architecturally interesting buildings or special effects of light – the Venetian palazzi, and Rouen Cathedral, for example. However, paintings of very ordinary streets – by Utrillo in Paris, Ben Shahn in New York, and Lowry in Britain's northern industrial towns – can be just as effective. In fact the urban environment probably offers the widest possible range of objects and views. In addition, you have the choice of work-ing from ground level, or finding a position high in a building that gives a panoramic view – often difficult to find when painting a natural landscape.

Buildings are usually clean-cut and precise in shape and form. As a good deal of construction is necessary to make them convincing on paper or canvas, it will be useful to look back at the sections on drawing rectangles and cylinders in Lesson One.

Cityscapes provide an excellent opportunity to study shapes and surfaces. They contain ideal material for composing geometric shapes and patterns, and for interpreting changes of tone and colour. This variety of visual stimulation opens the way to many different approaches in style and imaginative presentation.

Artists have not only painted architecture, they have also portrayed the city's technological features. Gasometers and chimneys are marvellous subjects, their shapes strongly outlined against their surroundings. Gasometers are usually green, red, brown or black; the light can catch their iron framework, casting a lattice of shadows on the curved forms. Chimneys jut out dark against the skyline. Railway bridges and arches form a dramatic frame for a distant complex of buildings. Telegraph poles pierce the sky and cloud-shapes. Wires divide areas of colour or cloud formations, and make a linear pattern against the rise and fall of buildings, roofs and chimneys.

There is also a mixture of architectural styles in cities. The shapes and colours of smartened-up buildings contrast with others that are still dilapidated. What constitutes an eyesore to a town

Abstract treatment of a city street

councillor may be the very subject an artist has been looking for. Beauty is in the eye of the beholder. All in all, it is impossible to suggest all the subjects you will find in a town or city.

Two general points must be made. First, 'picturesque' city scenes have been drawn and painted so many times that it is all too easy to produce a picture that resembles an insipid and sentimental 'Christmas card' illustration. Although any subject can be made into a magnificent painting it is difficult to find something new in an area overloaded with visual clichés – and a beautiful scene does not automatically produce an outstanding painting. The success of your cityscapes will depend on what you can perceive in what you see; conventional prettiness can actually blind you to what is really there.

The second point refers specifically to drawing and painting architectural subjects. Although it is impossible to say that a particular subject won't produce an excellent picture, experience has shown that front-on views of façades of buildings are difficult to paint, for a very good reason. Most realistic or figurative paintings rely on effective three-dimensional as well as two-dimensional composition. Both the shapes and the intervals of space in the picture must be interesting. Front-on views don't offer much space in depth.

You may regard both these warnings as a challenge. If so, think of the drawings and colour sketches you make on location as a first inquiry into the subject, and use them as the basis for pictures to be completed indoors.

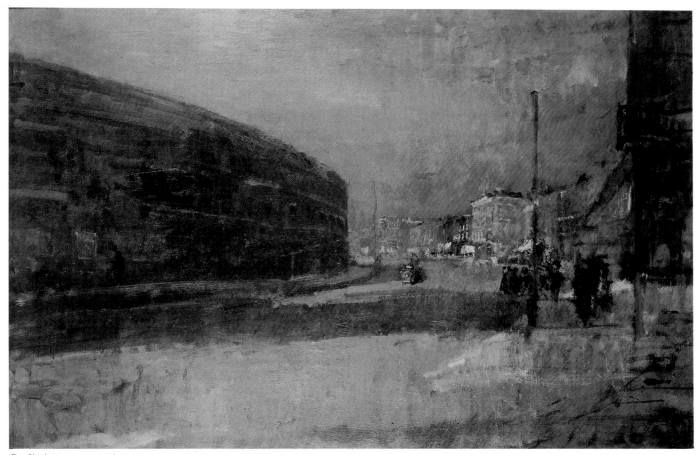

Realistic treatment of a street scene

Starting to Work

Like any other subject, a cityscape requires preparatory work. Make quick oil and pencil sketches of shapes, colours and tones so that you have a store of material from which to work. Note the pattern of light and shade, and how areas of light and shadow affect colours. See how light passes between buildings.

Perspective is important. A building seen head-on makes a square or rectangle in relation to the square of your canvas. See it as a block of colour against the surroundings areas. The same building viewed from another angle will create a strong diagonal movement against the rectangle. Think of the direction, and weight, of shapes in the composition.

There is seldom enough space to paint a cityscape on the spot – and you would have to be very brave to set up an easel for several days in a busy city street. In fact, there is usually no space at all at the window of a public building, or in a doorway. You will have to stand holding your drawing-board or pad, and work as best you can.

By now you will know how to make working on site a little easier – carry your equipment in a compact case, work in pencils or charcoal rather than pen and ink, and use a pad with its own built-in support if you don't want to take a drawing-board.

Below you can see a first sketch of a view which was going to change in seconds; the train had stopped on a bridge over the river, and for a few moments the girders in the foreground made a natural frame for the busy scene below. The skyline was clear but I did not have time to define the buildings.

When you see something interesting, draw it quickly – especially in the city, where objects and people are often moving constantly. Then make a colour sketch at home as soon as you can.

Make at least one tonal drawing of your subject (top right). Do some preliminary studies in your sketchbook, with colour notes and, possibly, details of significant objects in the composition. Use any medium that is suitable for cramped working conditions with no convenient resting place for paints – pencils, charcoal, conté.

At the bottom right you can see the high-level mass of that most ubiquitous of modern city elements, a flyover – proof enough that the most prosaic street architecture can make interesting shapes.

Sometimes you may be compelled to be so close to your work that you won't be able to see it properly. When this happens, break off from time to time, put the work down, and walk some distance back to look at what you have done.

View from a Height

This project is an important exercise in a combination of formal perspective and direct observation. Before you go out to paint, return to the first lesson and refresh your memory of how to put down angles related to the horizon. After you have found your viewpoint, make a few quick pen or pencil sketches of details – a frieze, a window arch, etc. They will help you to be precise in what you see.

Step 1. Using ink and charcoal, begin by indicating the horizon, as the main lines of direction and the scale of the buildings will all relate to this. Indicate other important shapes in the foreground, such as window arches and frames, and fill in your first impression of colour.

This drawing was made from an upper-level window of a tall building that overlooks its surroundings. The subject features the façade and roof of a building seen almost flat-on. The street behind it leads off at roughly a 45° angle.

Step 2. Look at the background and pick out architectural details, always relating their scale to the foreground building. Enlarge areas of colour and develop the foreground by adding more detail, using charcoal and coloured pens. You should now begin thinking about areas of tone and how a feeling of depth can be suggested. A light smudge of grey creates the hazy view in the distance.

Step 1.

Step 2.

There are distinct changes in scale as well as changes in the amount of detail to be seen. The main building has some brightly coloured tiled areas which contrast sharply with the grey architecture in the background.

I decided to emphasize these changes and differences by using deep pastel colours for the foreground, with pen and ink to draw the strong directional lines and architectural details.

Step 3. To develop further the depth of the composition, introduce darkened windows in the middle-distance building. This also establishes the corner of the street behind the foreground building, whose dark roof helps to separate it from the background. Check the colour and position of details, and redraw them if necessary.

For additional studies, move to another window and see how the main lines of the drawing change. Sketch the same building from three or four angles, and keep the sketches pinned up in your studio so that your eye will gradually absorb the information.

Step 4. In the finished drawing the separation of the foreground and background is completed by increasing the amount of detail to be seen. On the foreground the tile and brick patterns are emphasized. Line, used to give direction and detail to the background, also emphasizes the difference in scale between the buildings in the middle distance and the horizon. To create a stronger feeling of looking down, lines run away from the viewer into the distance.

Step 3.

Step 4.

View from a Low Level

Drawings made at street level are an excellent way to practise perspective. In this view the prominent building goes around a corner at a difficult angle and its mass contrasts sharply with the smaller buildings. As all the buildings were seen with the light source behind, they are dark and of much the same tone.

Outdoors, in a situation such as this, you must work quickly. A diluted ink wash is the best way to create a strong and immediate light-and-dark contrast.

It will be exciting to combine several media in the study, so take pens, ink, paints and brushes as well as pencils in your travelling-box.

Step 1. Quickly sketch in pencil the barest outline of the buildings to establish their scale. Put in the main directions of streets and roof-lines, and the most prominent architectural details.

Step 1.

Step 2. Fill in the dark shapes of the buildings, using ink wash. The angle of the largest building is indicated by a change in tone from darkest in the foreground to middle-tone where the building turns the corner to meet the light source. Try sketching some of the architectural details separately in your notebook before adding them to the paper.

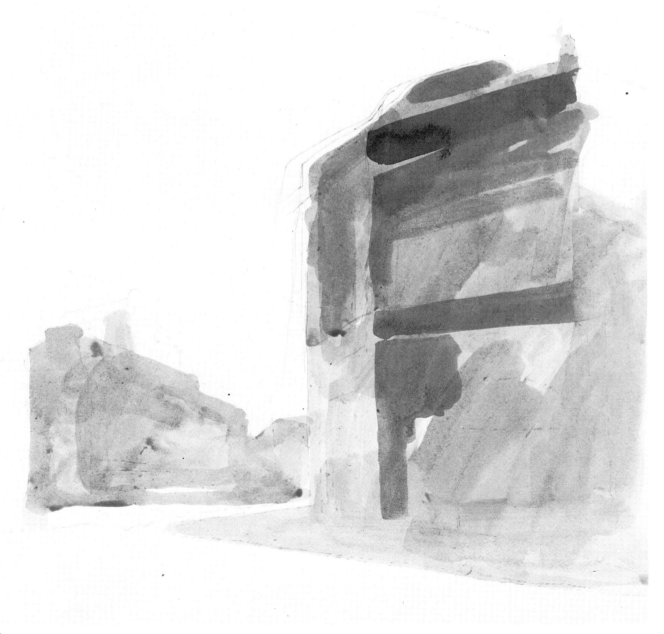

Step 2.

Step 3. To enhance the perspective increase the range of tones. The darkest areas are the furthest from the light. Look also at the colours of the brick and stonework, street and pavement, and try to describe these by their tonal values. Using charcoal, sketch in more of the detail on the buildings, and introduce some people and vehicles.

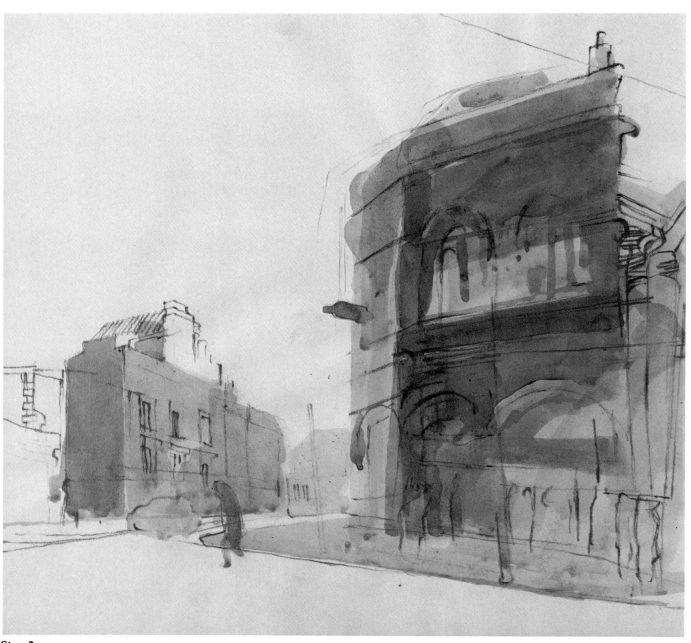

Step 3.

Step 4. Look at the view and, using white conté, pick out bright details such as window-frames and any other elements that catch your eye; in this drawing a white-coated barber standing outside his shop becomes a delightful touch of humanity. Look for the lines that can further develop the perspective, such as the crossing telephone wires overhead, and indicate these with pencil or pen and black ink. Final judgements of tone are made by using undiluted ink for the darkest areas of the large building. Angles and basic verticals are emphasized so that a strong feeling of looking up is created.

Flat – or nearly flat – shapes in closely related colours can be visually exciting. Part of an artist's skill is the ability to see the potential in materials and subjects that seem uninteresting to the non-artist. Constant practice is necessary to develop this high level of perception, experimenting with ways of looking at and interpreting subjects of this kind.

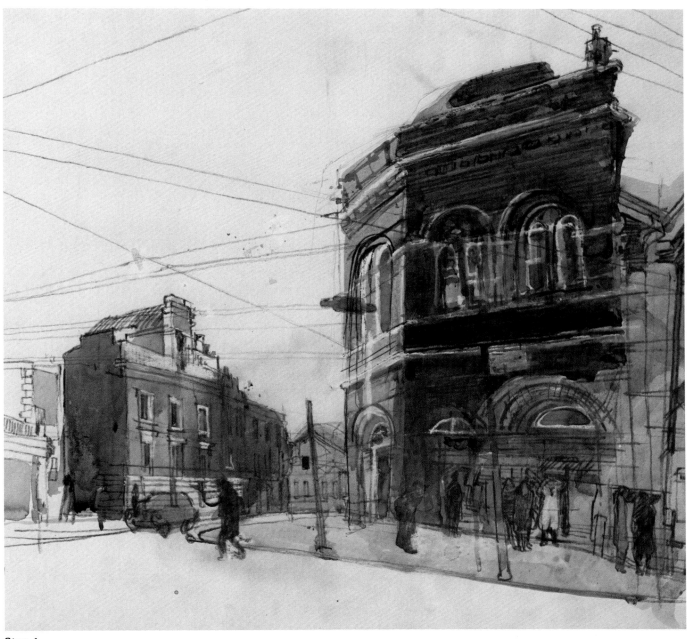

Step 4.

Buildings in Detail

When you begin to work in cities and towns you will discover for the first time that perspective and detail combine together in a very different way from all the previous subjects.

On the opposite page you can see a simple drawing of a house, with a few angles and lines extended here or there, just as they would be when drawing the walls of a room or an enclosed space such as a courtyard.

On the near right is a church tower, totally three-dimensional, enclosed within itself and making a statement isolated from the space around it, yet very much part of the town.

These very different impressions are simply the result of scale. Perspective allows the artist to draw the complicated tower with all its hidden angles and decorations; detail adds the clock, the slats, the carvings on the spire, the pilasters at the corners – all the points which make a distinctive piece of architecture.

Both the simple and the more detailed approaches work in their different ways to create a sense of solidity and strength. This is what you will need to convey in most city drawings and paintings; it will be important to convey your impression of the street as well as of the individual house. Details must be subservient to the whole, rather than relying on their own individual importance.

Look back to the previous project, of a street scene with its strong single building that rounds off the corner; although this building stands out in the painting, it none the less manages to blend into its street with grace.

Details and Perspective

All kinds of media are suitable for recording details. Even watercolour, which is usually used entirely by itself, can be combined with other drawing techniques to good advantage, especially in towns with their masses of precise detail. You can draw a picture in pencil, then add the necessary colour in watercolour, or use waterproof coloured ink or black indian ink, adding watercolour when the ink is dry. It is also possible to produce a different effect by drawing with pencil or inks on top of watercolour washes. This gives a soft blurred line if the watercolour has not dried completely.

Experiment with all these as well as with other media mixtures: oils and pencil, watercolour and pastel, acrylic and ink, chalk and wash, charcoal and gouache – the choice is up to you. You may find a combination of techniques that suits you better than watercolour alone.

The paintings and details on these and the following pages show how the different media can be used.

Most towns have at least one interesting building – a church, a tower, even an old warehouse in a cleared site. Studies of these single buildings will lead you to a careful observation and understanding of architecture without the confusion of a busy urban environment.

Church in town, seen from the river; detail in watercolour is helped by pen-and-ink drawing

Two details from a street scene in Australia; Roberts

'Pure' perspective can be misleading in older districts. Houses are seldom absolutely straight but bulge and curve at strange angles, as does the street itself.

Make a study contrasting flat surfaces with depth. A gap between buildings, for example, has flat walls in the front, set against the depth of the view behind. Notice, and use, horizontal lines to emphasize the diagonal movements and directions of streets disappearing in the distance. Use the changes in scale between tall buildings and small people, and the hardness and angular, geometric quality of the buildings. Try to achieve a sense of depth by interpreting shape and tonal values.

Use the textures and shapes of walls and fences in your work. Explore the different ways in which brushes can be handled to interpret different objects. Use large, flat brushes to create foreground shapes, smaller ones for distance. Don't try to disguise the marks they make.

Look at the difference in perspective as well as technique in the paintings on this page. The detail, above left, is surprisingly complete; most of the window-frames are painted in, even if with only a line. In contrast, the buildings going up the hill in the detail, above right, quickly become simple blocks of colour. Both treatments occur in the same painting; the vanishing precision adds to the sense of perspective.

On the right, the same idea, of a street rising towards the background, is treated very differently. Look at the photograph, top left on the opposite page, for a sharper study in texture and shadow.

Looking down on a busy street; Pointillist period

Railway stations, bridges, tracks, sidings and goods-yards are all good subjects. Perspective, and dramatic changes of scale, are accentuated – these scenes generally contain fairly accurate vertical and horizontal lines. Look at the change in tonal scale and relate it to the linear perspective.

Most city and town paintings have dynamic compositions made up of contrasts of shape, line, tone and colour, with areas of texture and simplicity.

Don't be discouraged by your first failures. It may seem impossible to catch very strong shadows, the special bright colours of people's clothing, an unusual blue tint in the sky, or the depth from the foreground to the horizon. But keep trying – the results will always teach you a surprising amount about yourself as well as your paintings.

Pencil detail

Before and after; how one small wall can change the perspective of an entire street

Ink drawing of a river scene on the Thames; Minton

352

It would not be sensible to work on a large painting outside, even on a deserted street, so concentrate on making fairly advanced sketches that emphasize special points, and then work on them at home – going back as often as you need to, and checking your first impressions and your perspective. Perspective will of course play a particularly large part in city scenes – buildings seem to make patterns which look like examples of perspective set out especially for the artist; so go back and read the sections on learning to see.

Pencil sketch of a hilltop church

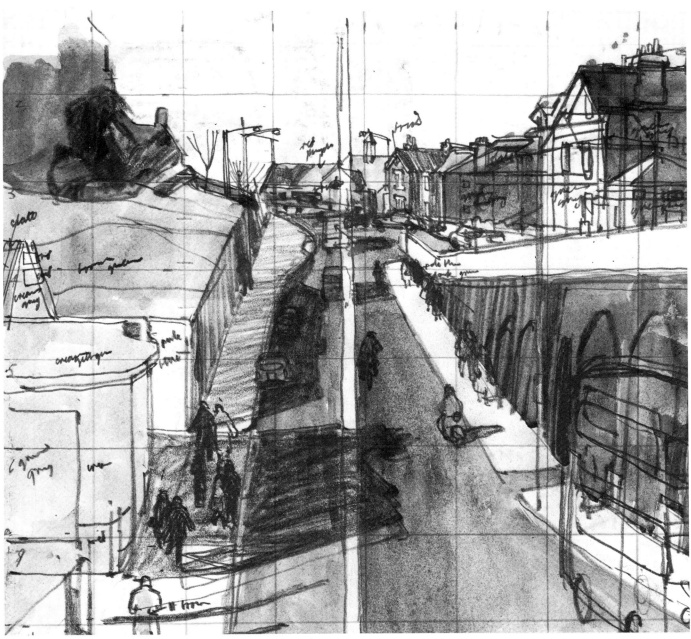

Charcoal drawing of town street using a grid to help perspective

People in Cities

Cities are the habitat of people, so it is not surprising that figures – in streets, shopping centres, markets, stores and bus queues – are important elements in cityscapes.

Start by observing them in groups, stopping to talk, walking, standing, even running. See how they relate to their surroundings and form lines and blocks of colour, creating patterns and movement against the hard, static, linear elements of the city. Decide whether they are major or minor parts of the picture.

People move constantly, so a sketchbook is a necessity. Studies must be made rapidly; draw and redraw the shapes and masses as they move. Create an impression of the figures and try to capture essentials.

Seen from a low eye-level, heads in a group of people tend to form a continuous line, and the feet are at an acute angle. Viewed from a high level, figures tend to separate and become individual shapes; the intervals between them are more apparent.

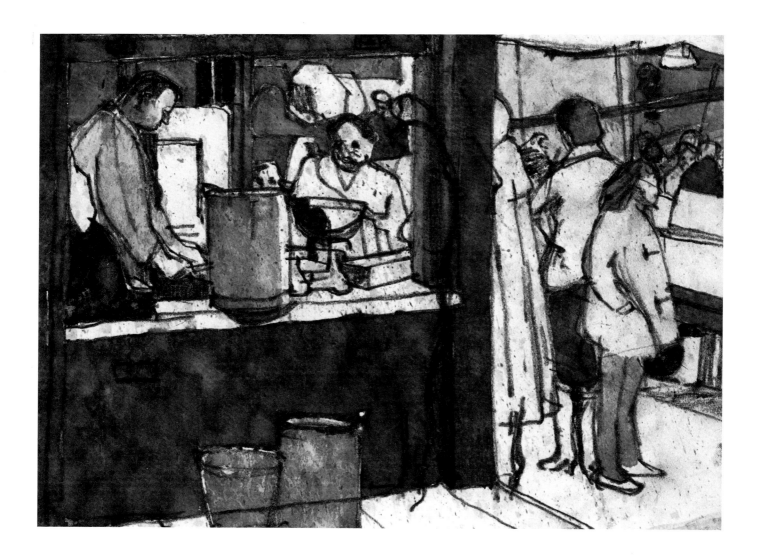

Below you see a sketch and an oil of people in an urban environment.

On the left, the corner of a market stall is glimpsed through a serving counter, with the opening making a strong frame for the stallholder and some of those waiting to be served. The heavy left-hand side of the sketch is emphasized by the lighter figures on the right, a teenager in jeans and a duffle coat waiting next to her mother.

The charcoal has been used strongly and with a sure hand, but the greatest areas of black are filled with an ink wash. There are no faces as such, and none are needed.

The oil painting is an exercise in exploring the difference between inside light and outside darkness. Remember that in Lesson Six you examined the reverse effect, looking from a room into the darkness outside. Here we have just the opposite, with the figures silhouetted against the bright shop-front, and all the piles of fruit taking on a marvellous glowing quality in the sharp fluorescent lamps.

Paint the same scene again in the morning, and then during the afternoon. Pin the results up and compare the effect. You will be startled by the total change that can come over the most ordinary street when the lights come on.

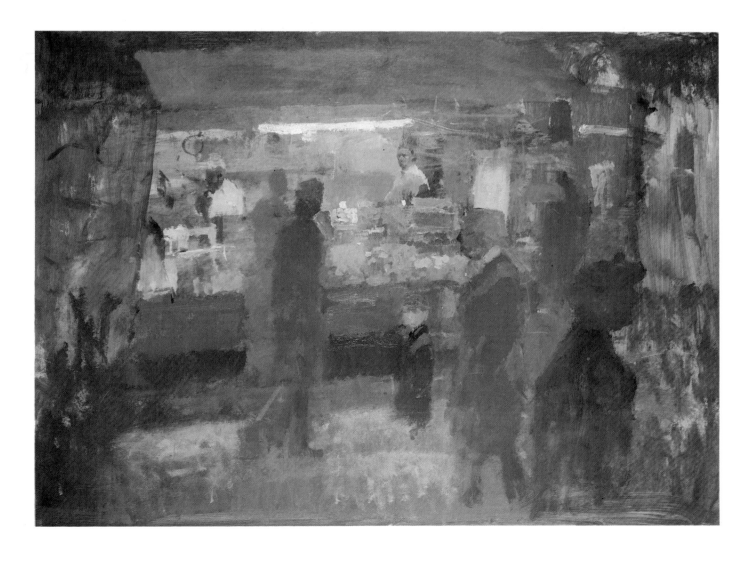

Street Scene in Watercolour

The speed of watercolour painting makes it ideal for capturing quick shifts in movement. Over a few hours you can produce a wide and varied series of responses to what you see. Normally you should paint in your main washes, allow them to dry, then work over them systematically. If there is no time to do this, use the prepared washes or tints described in Lesson Seven, or the direct painting method.

If your first attempts are disappointing, it will simply be because you have not as yet come to terms with the fact that working at speed means either working wet, or using just a single coat of colour.

Step 1. Decide on the main composition, and draw the shapes lightly in pencil as a guide when laying the first washes. Mix enough colour to cover the main areas: blue for the sky, ochre for the walls.

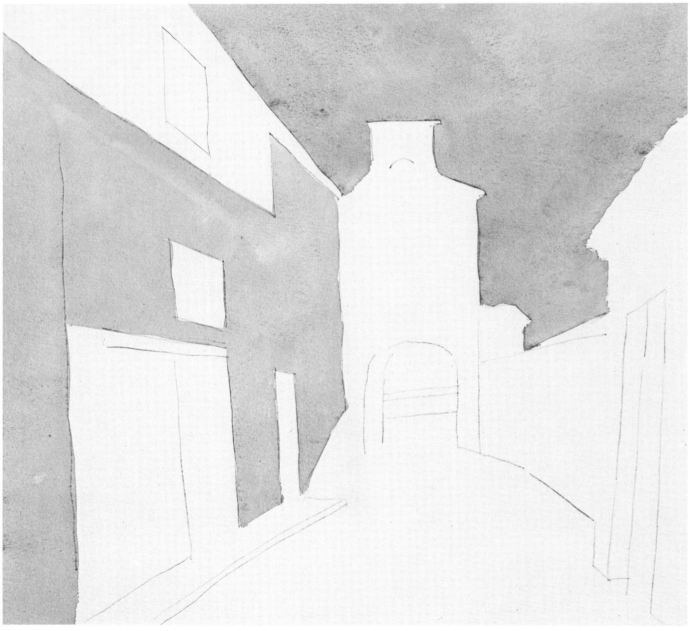

Step 1.

Step 2. Study the view and determine which areas are the darkest and which the brightest. To indicate the shaded area on the right of the picture, a dark wash was mixed from light red and burnt umber. This is one of the darkest of the large washed areas – darker than the wall on the left, and also darker in tone than the blue sky; it will dominate the right side of the composition.

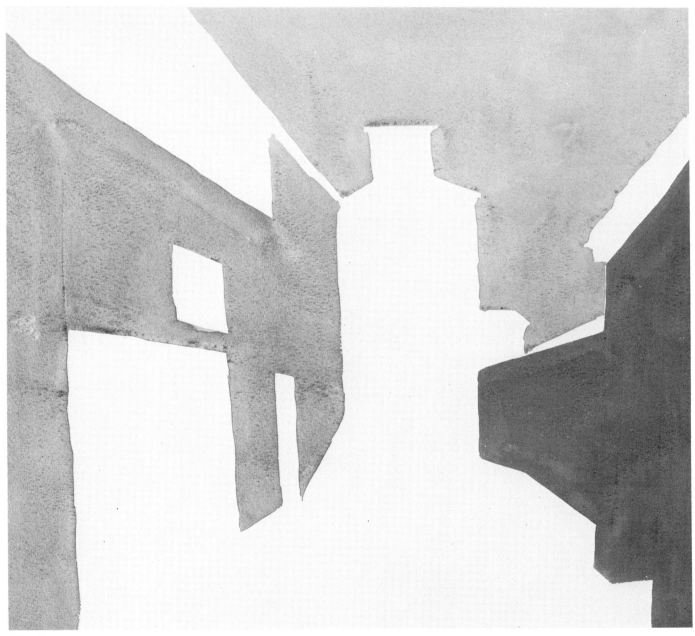

Step 2.

Step 3. In this scene most of the pavement was in shade, so I mixed a violet-blue and added it as a wash to the street. In tone it was almost as dark as the right-hand wall. At this stage I began to add some detail and small areas of dark shadow, such as those which are seen around the windows and the doors.

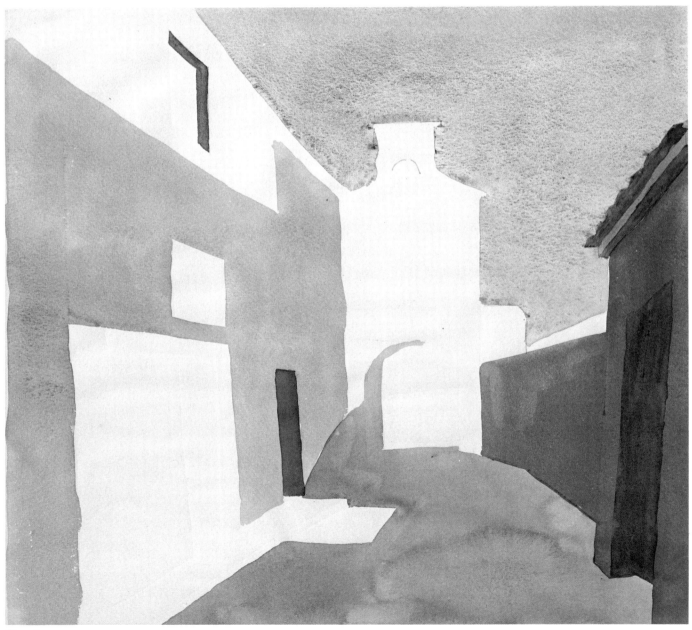

Step 3.

Fluent and competent drawing and painting can only come with practice, and the gradual building up of experience. By this time you will be able to make a good attempt at putting down what you see. By copying this project (or any other painting) from a book or a photograph you will unfortunately throw away what you have learned.

Learning how to translate three-dimensional forms in real space into two-dimensional drawings is an important skill. It is better to paint from memory – perhaps the recollection of a pleasant holiday site – than to try to reproduce a photograph.

Later you can try to learn from copying great artists for a particular reason.

Step 4. To finish off the picture, a very light ochre wash was added to the large white areas of the buildings. This can be put on with a dry brush or else in small areas of wash. I used a pointed sable to add the final touches which suggest brickwork, window and doorway details. Some darker violet wash was added to the street to strengthen the shadows. The top of the tower and the archway were drawn in with a small brush and a dark, violet-and-black wash.

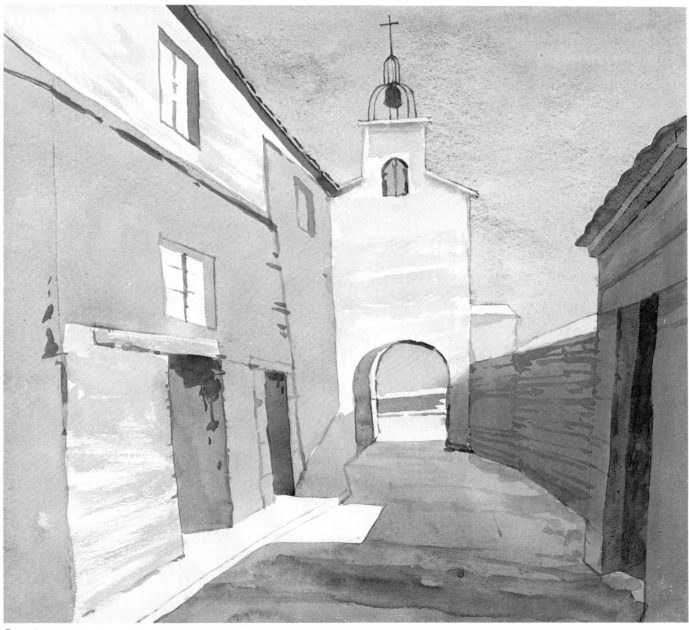

Step 4.

Working in Scale

In theory, cityscapes are no different from still-life subjects – a series of shapes, at different angles, which catch and trap the light, breaking it into highlights and shadows, warm and cold colours.

However, scale – and therefore the space which helps to establish it – is more important. It is essential to indicate the size of human figures – including the viewer – in relation to buildings. To artists working in the street the traditional methods of using receding tones and colour strengths are very useful to suggest space.

In many paintings a slightly misty atmosphere is created by an exaggerated tonal recession that moves from strong, dark, well-defined buildings in the foreground, through successively paler tones, to distant buildings. This recession happens even on a bright sunny day, but the effect is exaggerated in dull or foggy weather.

Similarly, in a busy street the colours and tones of clothes worn by people near you are stronger than those seen from a distance. The same effect is seen in the recession of trees in a landscape, and in the misty look of distant hills.

This use of colour and tone, combined with the receding size of buildings and objects in the urban environment, will produce an illusion of space and depth.

Streets are exciting pictorial material and, in the evening, street lighting is particularly important. Its regular pattern contrasts with surrounding dark masses, and it can transfigure even ordinary scenes. Shopping centres or corner stores, for example, take on marvellous colour combinations. Look at the people inside a shop as well as on the street.

A small notebook will be invaluable. Make drawings of the predominant masses of a composition, with colour notes of the main areas.

Experiment with a composition. Divide your sketch into sections, and try to relate the details within these areas to the main theme as the image develops.

A viewing-frame, easily carried in a sketchbook or paintbox, is useful for selecting a composition, and will also enable you to see angles and perspective in relation to the rectangle of the frame.

Although a camera is helpful, it is all too easy to copy the ready-made image; and the end result always tends to look frozen. In addition, working only from photographs limits your imagination

Townscape from the country; Simpson

360

and choice. Photographs are best used in conjunction with drawings, as a visual aid and additional source of information. Although a scrapbook of photographs and newspaper cuttings can sometimes be useful, drawings, however fragmentary, are essential. They are the result of individual observation and selection and, unlike photographs, can be easily manipulated to suit the desired image.

It is difficult to set up even a small easel in a city street – to say nothing of the other extra equipment required for oil painting. Few beginners have the nerve to paint in full view of a curious public, although if you can pluck up the courage you will soon become accustomed to an audience. To discourage an especially persistent artist-watcher, ask him or her to pose, preferably on the other side of the road.

It is much more comfortable to finish a painting in the studio, working from small oil sketches. However, if you prefer to paint directly from the subject, find a corner in an unused doorway or window.

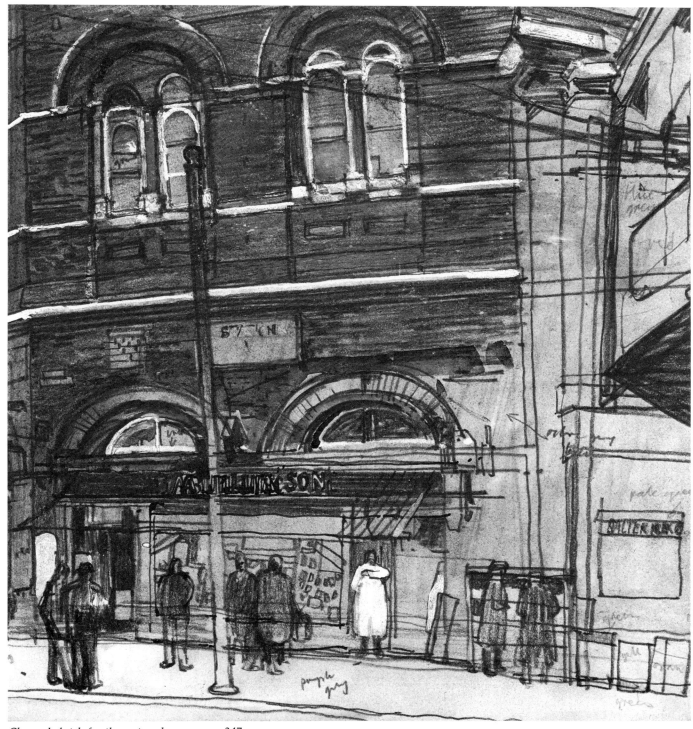

Charcoal sketch for the watercolour on page 347

Building Blocks

The temptation to embody the complete experience of a city street in one picture can be overwhelming. It will almost always result in a feeling of failure.

Although attempts have been made in Cubism and Expressionism to use multiple views and images to represent movement, it isn't easy to make more than one visual comment on a scene. Instead, do more than one painting of a subject.

Brickwork, windows and other building details are a problem. The task of painting every brick and every window can seem overwhelming, while the compromise of including some detail in parts of a work and ignoring it completely in others produces a very uneven picture. Details

can in fact be indicated without painting every stone – a paradox that you encountered with leaves on trees in Lesson Eight.

Oils and acrylics are particularly suitable for immense quantities of tiny detail. Learn to pick out the prominent lines, and let others blend into the building itself.

There is a vast difference in the character of individual streets and an expanse of city architecture. Your scale must be adapted to the atmosphere of the street itself.

Make a composition of a group of buildings. Pay particular attention to the proportion and weight

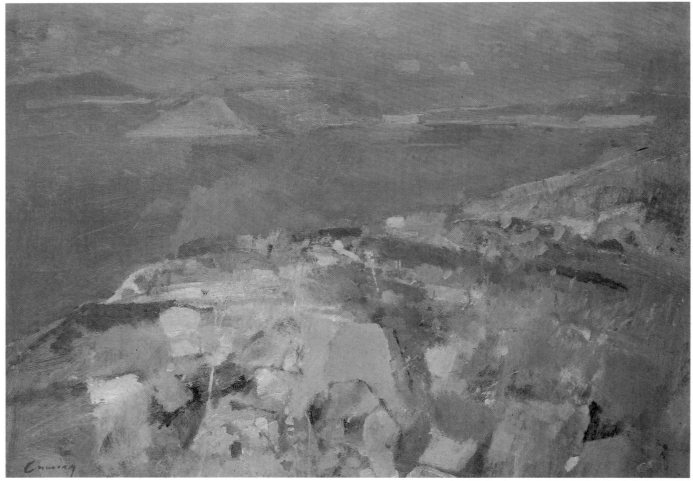

Buildings as shapes, colours and tones

of shapes. Analyse the effect of the light to see if it is strongly directional, or whether it has a particular quality that changes the tone of the buildings. Remember, the time of day will affect the colours in a scene. Look at the variety of shapes and colours, but don't paint all of them. Be selective and use details like the differences between windows, or between a row of buildings built to the same plan, as an integral part of your painting; don't include them just because they are there. Try to capture the atmosphere of the scene, and build up a colour scheme.

Try a single building, isolated in a landscape of its own. The painting below of a pier jutting out into the sea has both qualities – a splendid architectural complexity on a deserted sea front. Many seaside towns have such lonely buildings, while inland cities usually contain at least one area of deserted warehouses and factories.

Work broadly at first and apply thin washes and layers of paint. Establish the main tonal values and the relative weights of masses and shapes. Study the relationship between colours and tones.

A surface, or an area of colour, may need repeated working. Two or three coats may sometimes be necessary to achieve the fullest possible strength. Experiment in the studio. Work wet into wet. Lay passages of base colour, and when that is dry, scumble on broken passages of paint to allow the base colour to come through – surfaces can be built up over a period, creating a rich pattern of texture and colour.

A single building in isolation, layered colours and shades of blue

Suburban Street Scene in Oil

Although this looks like a complicated project, if you break it down into its component parts you will see that you are using all the techniques and skills you have already acquired. You will already have practised perspective and details of buildings in other media, as well as learnt to see precisely and carefully (as we suggested in the Introduction to Art). Here is a chance to put it all together in an interesting and challenging composition.

Begin with a drawing, trying out different views and compositions. I chose this particular street scene because it had a strong geometric format, with the central road narrowing dramatically towards the central axis. The houses, too, are fairly straight, with only a jutting porch or two to break their line. The dividing fences enforce the geometric pattern, and even the pollarded elm-trees fit by growing tall and slim – I enhanced the effect by ignoring the few bolls and curves on their lower stems.

Look back at the geometric drawings and compositions on pages 302 and 303. The drawing opposite is also simple and pleasing; the quality of excellence in the finished work will reside in the handling of paint, and the creation of more detail than you have been accustomed to working with in the broader studies we have suggested previously.

When you have made your first drawing, move away from your big easel for a few hours and make some small 'patch' studies of elements in the picture.

Now might be a good time to go back to experimenting with pigments, grinding a few colours with oil and mixing up different batches of related tones. Although the subtle use of related tones is very important to the overall effect, they must none the less have clear outlines and give a sense of morning light. Try grinding a little ochre with safflower oil instead of linseed oil and compare the different effects by laying the two mixtures side by side on a piece of board and holding them to the light.

Add a little green, and 'draw' a tree with squares of colour, using a small, flexible palette-knife instead of a brush.

Lay four or five patches of slightly different ochres side by side to give the sort of haphazard, flaking impression you see in a row of older houses faced in brick or stucco.

Now look at a small section of a front garden and repeat the process, breaking down the scene into rectangles of related colours. Experiment again with different kinds of oils rather than changing the colours, and see if you can take advantage of the varying textures that will appear. These will not be obvious at first, but you may be able to feel them as you spread the paint.

Look back at page 128 and 129. Re-read the advice about keeping your wrist loose and your arm flexible, then try to draw a whole forest of straight trees without using a ruler. In the drawing opposite the charcoal lines have been drawn freehand. Do the same with paint on a scrap of canvas, until you can feel the shapes of the trees grow and branch out naturally.

Many artists feel that your hand should move with the natural growth of plants. A tree should 'grow' under your brush from the ground upwards, as it does in nature, so that as you lift your hand slightly towards the top, your brush-stroke becomes lighter and more feathery.

This is usually true, and makes the form easy to follow, but in this project the trees seem to 'grow out' of the painting and are still firmly trunks rather than thin branches. It was easier to draw them in from the top with a light brush, pressing a little harder as my hand moved downwards so that the trunks became heavier and more opaque.

Experiment on paper or board, keeping your wrist relaxed, and working with different thicknesses of paint as well as different colours.

Once you are happy with your little sketches, go back to your easel and begin to lay in the ground, and the first areas of colour. If your window does not look out on an urban scene, take your sketchbook into town instead of simply copying this picture. Look for the comforting simplicity and regularity of traditional architecture rather than the exciting jumble of rooftops, dockyards, or modern buildings. If you cannot see a row of houses like the ones in this painting, it would be better to find a single large building with a classical façade so that you can learn to create softness and light within a given framework.

The whole philosophy behind this particular study is the transformation of geometry into a subtle array of colours and forms.

Once the framework is established you can go on to fill in the negative spaces around the major shapes, remembering to increase the vertical effect by keeping most of your brush-strokes working in an upright direction.

The colour is quiet and yet not murky or dark, giving the impression of a bright spring morning even though there is very little evidence of strong sunlight. This effect is achieved in part by the yellow and white highlights on the house fronts at the right-hand side of the painting. The sky is hazy, but the blue is quite vibrant and helps to set the mood.

When you apply the colours, try using the odd stroke of a toning colour to heighten the overall effect – in this case the turquoise detail on the house front at the far right does just that.

The colour of the milk cart shown in the detail below is a reddish-orange – the complementary colour of green and blue – and adds intensity to the surrounding colours in a quite remarkable way. If you cannot see this effect take a small piece of grey-blue or green paper and put it over the milk cart: the tone drops. Try the same with other colours, for example purple, which would enhance any yellow in the picture.

The finishing touch was given to the trees, which were shaped with browns and umbers; their pollarded branches fade away into the sky with tiny brush-strokes, and their trunks act as a framework for the painting.

This picture was painted entirely from a window, over a period of many weeks in the spring; patience is one of the keys to successful oil painting.

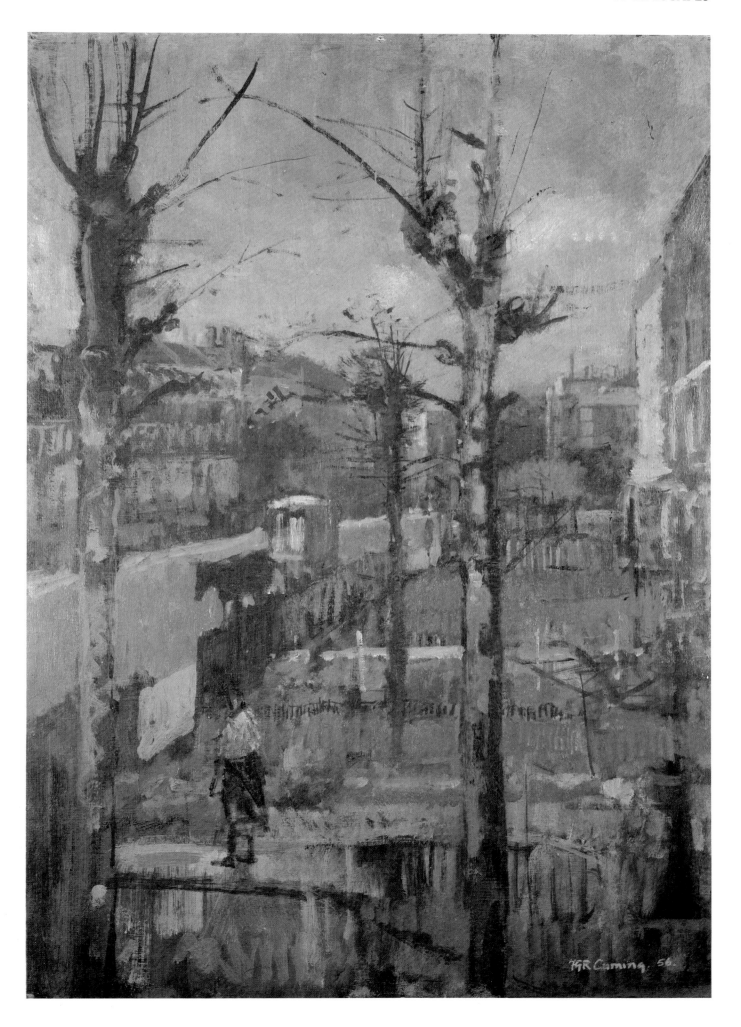

The Travelling Artist

The towns and cities of every country are remarkably individual; many of the most anonymous streets are, in fact, somehow imbued with their own atmosphere, so that we know immediately that it is Paris, or New York, or a Cotswold village, or a Midwestern farming community. For the painter this is a real challenge – to make every building tell its own story and the people reflect their family background and national history.

Once more it is a question of attention to detail, and worth every moment of the time spent looking and observing the tiny changes in the proportions of the street, the materials of the lamp-post, the pattern of the pavement. When you first turn your attention to the busy streets of your own town, it may be difficult to 'switch off'

the habitual recognition which blinds the artist's eye, so try to go somewhere new, even a bus-ride away, to a strange square or unusual town centre.

Take a sketchbook with you and sit down somewhere convenient, on a park bench or a window sill, and draw whatever you see. Concentrate on small things first – they are easy to pick out from the jumble of buildings and street activity. Look at the way windows are set into the walls, their fastenings and shutters, the double glazing of the north, the beaded curtains of warmer climates. Copy the pattern of door-sills, the join of pavement stones or the lines of bricks. Observe what sort of decoration is most common – moulded cornices, vertical tiling, strip boarding, or plain brick or stone. Cast-iron brackets can be

Dutch street scene

beautifully simple or convoluted; either way they give character and charm to any kind of building. Try to carry some sort of impression with you throughout your sketches; make colour and tone notes copiously, and see if there is some quiet spot that you would be able to use to paint, with a small easel or even a prepared sketchbook and a few tubes of paint.

Finding a Subject

Towns and villages drenched in sunlight with brilliant ultramarine skies; city streets busy with people and dogs, shops and traffic; night scenes with lamps receding into the distance – these are all ideal subjects and easier to paint than you might think, mainly because of the strong colours. Although sunlight is important in cityscapes – the strength of light and colour can give

rewarding pictures – street scenes can be painted in any kind of weather. Overcast skies with heavy grey clouds, stormy days, snow, evening sunsets and night scenes are all worth waiting for. Take advantage of all these different conditions.

London Regency house

City Gardens and Parks

Parks, recreation grounds, squares and ornamental gardens provide the opportunity to work in reasonable peace, and also offer refreshing contrasts of colour and shape, with rapid changes of pattern. Trees are outlined against the city skyline; lawns are a perfect foil for flowerbeds; and these green areas create bright passages of colour against weathered buildings coated by industrial soot, and grimy old brickwork containing a variety of ochres, umbers, reds, off-reds, browns and dirty greens.

Family groups, football or cricket matches and children flying kites or sailing boats on a pond add interest to the scene and are excellent material from which to draw and paint.

Look at the shapes made by people in action, and by spectators, and see them against the surrounding parkland, city, town or village. Decide how to organize the painting, and compose the groups against their setting. There are many ways of using such a subject.

A park viewed from surrounding buildings can be interpreted as a colourful cameo against geometric shapes. Seen from close up, against the city, its contrasting shapes and areas of colour can be treated experimentally to lively effect, with ex-travagant use of paint and unusual ways of applying it.

Control is not reflected only in handling detail, or in the ability to draw a straight line. A good painter exercises some kind of control even when using the largest brushes in the most energetic manner. A broad, free approach often helps to express an idea or emotion. Titian, Rubens, Rembrandt, Turner, Constable, van Gogh and Manet all used swirling paint to contribute to the energy of their compositions.

The illustration below shows sections of drawings of a park, made from inside a building. I used pencil and ink, with acrylic colours for the colour notes – the green lawn, the pelmet at the top of the window-frame and the trees; the geraniums on the window sill are sketched in.

Interesting contrasts were provided by the indoor objects and the landscape and barely visible buildings beyond, the geraniums and the winter snow-scene. The basic shapes were drawn in pencil but the colour areas were quickly introduced, and the drawings were developed by alternating the paint (used thinly) and pencil. In the winter scene some sharper statements have been made in ink.

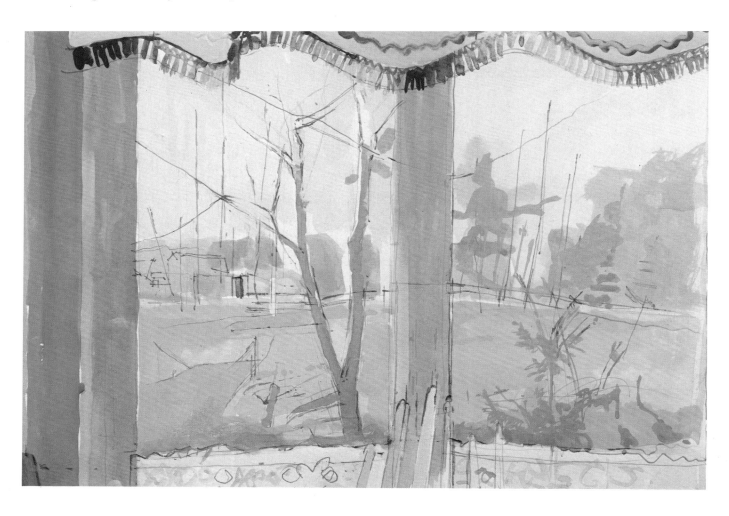

Seasons and Light

Changing circumstances – the light at different times of day, weather conditions, artificial lighting – will transfigure a dull subject. After a snowfall, roofs are outlined against dark buildings, car tracks are suddenly visible, and colour and tone relationships alter completely.

Even an ordinary building, insignificant in the daylight, can look magnificent when night falls.

With this kind of overwhelming colour in the sky, keep the shapes as simple as possible. You cannot compete with natural phenomena, and it is the mark of a perceptive eye not to try to do so.

Street scenes can be as empty as landscapes, especially with this sort of moody subject, and the sense of loneliness is emphasized by the tiny pinpoints of light in the distance. Although the lamps may actually be yellowish when seen nearby, far-off lights at dusk are usually pure white. Make sure your brush is absolutely clear – that touch of white should glitter against the darkening sky.

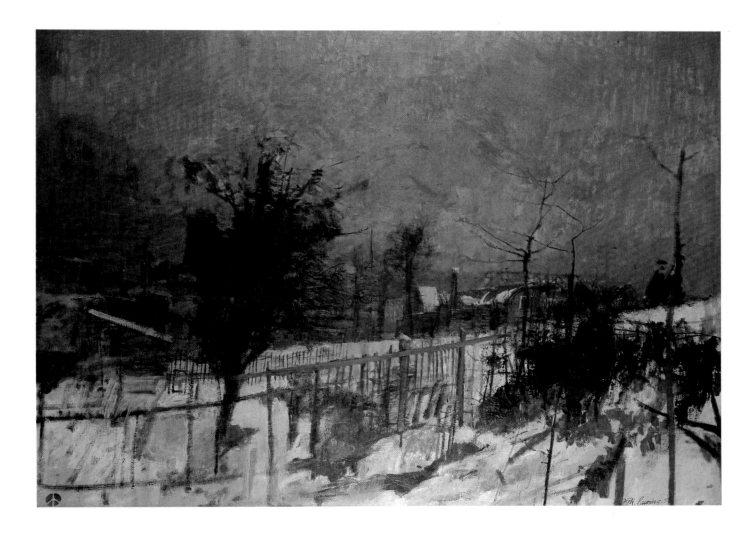

Extra Projects

Typical City Views

Skylines in towns and cities often provide interesting compositions, outlined against the ever-changing sky, in rain, snow, brilliant sunlight and other conditions. Look at the perspective of strip-lighting in large office blocks, and at the patterns it makes during the day and, especially, at night. Modern glass buildings reflect wonderful broken skyscapes and town scenes; cloud formations are particularly spectacular.

Shop windows combine images from inside the building with reflections of the street outside. Walls are decorated with torn posters and graffiti; look at their texture and the pattern of brickwork.

Roads, railway stations and road junctions provide sharp, angular perspectives. Two roads seen from the same position may give high- and low-level views. Paint the same street-market by day and by night, or the interior and exterior of a supermarket. Other scenes can be recorded from modern high-rise car parks, with their hard, angular architecture setting off views of the surrounding town. Analyse the outlines of trees against architectural shapes.

Below is an example of imaginative viewing; a plan for a new town development, as seen from a nearby tall building.

One thing to note is the unnatural regularity of this visualization compared to the real towns and village streets you will see.

The houses are built with individual courtyards providing an exciting exercise in geometry and perspective.

The slanted roofs have to be suggested by carefully diminishing tiles, while the flat roofs have a single textured wash.

The children's playground is another challenge with paving on some places, terraced grass on others, and with parents, as well as the natural inhabitants of playgrounds, children of all ages.

Learn to look everywhere for ideas. An architectural magazine is useful for you as an artist; you can find new ideas and new approaches for your own work.

Don't copy this plan, or any other plan, but use the angles and grids to practise just with shapes. Then find a local building higher than its surroundings, and draw what you can see from your own viewpoint.

'Newtown'; Lofthouse

Water

Reflections can be seen in rivers, canals, rain-puddles. In still water they are slightly wobbly mirror images. If the surface is disturbed, the image becomes broken and fragmentary, with patches of colour picked up from buildings and the sky. Puddles tend to reflect small cameos and details of the scene beyond.

Make a study of a cityscape reflected in a puddle. Exaggerate the foreground, and take the buildings to the top of your work surface. Exclude the sky. Use this unusual imagery to make the reflections the most important part of the painting.

Rooftops

Rooftops hold a perennial fascination for artists of every city; the geometry of the angular, disconnected lines is attractive because of its chaos and feeling of growth and decay over the years. Compare the delightful study below with the perfect plan on the left. Perhaps that is one reason why old towns attract the best artists!

Everyone responds in different ways. Some people, stimulated and excited by the confusion of shapes and colour, enjoy manipulating paint freely and energetically over the canvas. Others prefer to record a subject in controlled and tightly observed detail.

As details develop, try to link them to these main areas. Individual objects, such as the spire, should not seem out of context, unless you want to emphasize particular features.

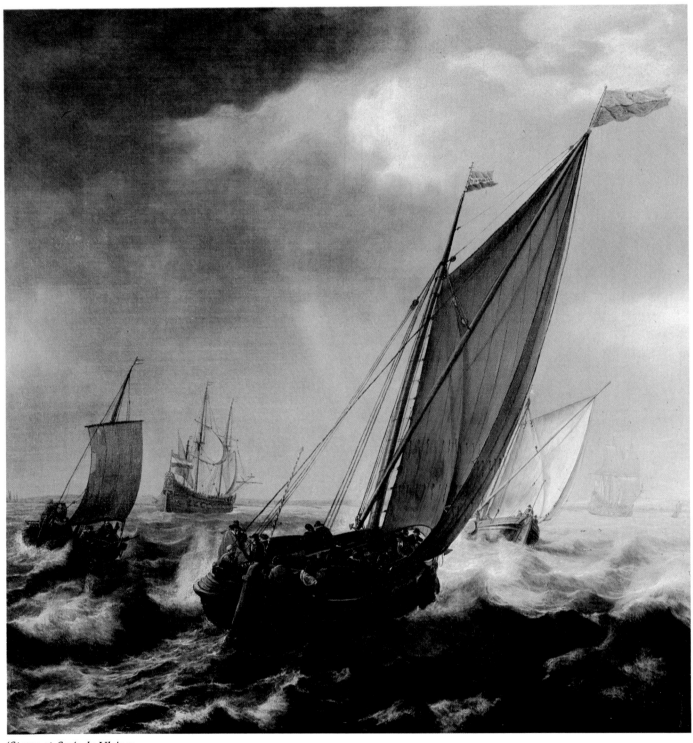

'Storm at Sea'; de Vleiger

Lesson Ten
Waterscapes

Considering that geologists tell us the earth was once covered by water, the natural home of man's ancestors, paintings of water in any form are a surprisingly recent addition to fine art.

This was not true in the East. Chinese and Japanese artists were acknowledged masters of the genre before Western medieval illuminators began sketchily painting a few waves beneath the Ark; and the pattern of movement and power in the sea was to become one of the major subjects for many Japanese wood-block carvers, culminating in the work of Hokusai (1760–1849).

Western art in medieval times was much more land-locked, concentrating on religious themes which generally included scenes of deserts, rocks and hills; these were seldom refreshed with any form of water except for springs.

During this time there was nothing comparable to earlier images such as those found in Egyptian tomb paintings: hunting parties among the reeds by the river, or royal barges on the Nile.

The manuscript illuminators who were responsible for so many later, secular, artistic traditions were not overly concerned with water except in some favourite boat scenes. The best known, the curious 'hill' of wavy lines which was used to imitate the sea, was usually painted with a cockle-boat cresting the hillock. This traditionally carried St Patrick to Ireland, as well as associated figures from early Christianity. St Peter, of course, was a fisherman, and was often depicted with water, though this was suggested rather than painted in detail.

There were less peaceful images in northern Europe; the outlying settlements were far more conscious of the dangers from the sea than their more settled compatriots in the south. Viking carvings represent ships and sea battles in considerable detail. A handbook for defending garrisons indicated the use of forts and castles along the coast, on an island completely surrounded by continuous blue waves.

To some Mediterranean peoples the sea was productive rather than dangerous. A graceful beaker of the thirteenth century is gilded and enamelled with fish swimming all over the blue-toned glass. However water was seldom so imaginatively treated in paintings, where it served basically as a 'floor' for ships and boats.

Waves and sea-creatures were depicted in some embroidery and book-cover patterns. The cockle-boat was a favourite motif and decorative borders of shells and sea-horses glittered in gold thread and very appropriate pearl drops. Many such themes were also used on illuminated maps

which encouraged the belief that monsters and sea-dragons waited amidst tumultuous waves for unwary sailors foolish enough to brave the unknown deep.

These were all paintings which used water as an adjunct rather than a subject. It was the Dutch who took the first step in the direction of true waterscapes, and it was their native land with its canals and long seashores which inspired them rather than the Middle-Eastern landscapes of the past. Rembrandt van Rijn (1606–69) was primarily a portrait painter, but he also took great delight in painting vignettes of the land- and seascapes around him, as did many of his colleagues and pupils. Aelbert Cuyp (1620–91) and Jan Vermeer (1632–75) were among the greatest exponents of shore-line views and towns by the sea, as was Caravaggio (1571?–1610) in Venice.

However, these were still primarily land based even though the occasional sketch of a boat or a ship under sail might be the focal point. *Shipwreck of the 'Hope'* by Caspar David Friedrich (1794–1840) was different, one of the highlights of the Romantic era in Germany, a perfect example of the new approach to painting the sea, where the water was the true hero, the centre of attention and the *raison d'être* for the artist's conception.

It was, of course, Friedrich's contemporary and inspiration, Joseph Mallord Turner (1775–1851), who created an entirely unique way of looking at water, mist and light, so that waterscapes became truly a genre of their own.

Turner's pre-eminence is perhaps too well known to describe, but he brought to his work an obsessive fascination with the technical and emotional problems of painting water, and his influence was so strong that it revolutionized almost all of English landscape art. John Sell Cotman (1782–1842), one of his pupils, eventually became president of the Norwich Society, to which most of the East Anglian painters, known collectively as the Norwich School, belonged.

In America the Hudson River School was a later development. Perhaps its members were influenced by their own Dutch background; in any case they found a ready following in a part of the country which was as dependent on its lakes, rivers and sea-coast as the Dutch had been centuries before. Thomas Doughty (1793–1856) was one of the earliest of its members and one of the most successful although not necessarily one of its finest craftsmen.

Meanwhile in Japan the woodblock artists of the eighteenth and nineteenth centuries used water as a decorative element, either quiet and calm as in the anonymous example (right), or in huge waves that rivalled Turner in power and intensity. Most European painters of the period were greatly influenced by Oriental art.

Eugène Boudin (1824–98), a direct precursor of the Impressionists, was a painter of delightful seaside scenes, and his pupil and life-long friend Claude Monet (1840–1926) went on to plant a garden full of the flowers he wished to paint, and

'Shipwreck of the Hope'; Friedrich

'Two Junks on the Sea'; woodblock

to build his own pond, complete with Japanese bridge and overhanging willows, from which he drew the inspiration for his unique series of waterlily paintings; the reflections of flowers, leaves, bridge and clouds shimmer in the light that dances across the pond's surface.

An exponent of American waterscapes was Winslow Homer (1836–1910). He had established himself as a well-known painter even before 1881–82 when he came to England, where he developed a love for watercolours and waterscapes that marked his work for the rest of his life. His early oil paintings of peaceful rural scenes gave way to immense and dramatic portrayals of the fiercest aspects of the sea.

Since the 1900 s, waterscapes have generally been favoured by the Neo-Romantic artists, whatever their official category. Some, following Raoul Dufy (1877–1953), delight in the clear primary colours of the southern harbours, the boats and the people set off by a brilliant blue sky; other artists, more sombre in their depiction of the harbour-side, paint cranes and cargo ships that are as fascinating, if not as beautiful, as vistas of sea and horizon.

Water is still a popular element in contemporary art, but the style is very different; major artists such as David Hockney (b. 1937) seem fascinated with the blue tones of the sea and swimming-pools, painted in marvellously limpid tones and sometimes in abstract shapes.

There are still many painters who love the effect of the swelling sea and the image of a ship in full sail, although today it is more likely to be a racing yacht than a tea-clipper, or a modern warship instead of a Viking galley.

The traditional harbour scenes are a continual focus for amateur and professional painters; there are few picturesque quaysides without an easel or two by the edge of the jetty.

For all of these artists, the sea, the river, the lake and the canal will never lose their fascination.

A View of the Water

You may already have drawn or painted landscapes which included areas of water. However, this lesson concentrates on some of the problems involved in waterscapes, and introduces the wealth of subjects available.

Outdoors, the visual world is never static. This is even more obvious when it contains moving water. The movement may be slight, as with a gently flowing stream; but it can also be rapid and dramatic – a waterfall, or a river in flood.

Water can be either a physical support for the main object (a boat or a fish), or a subject in itself. Water also reflects the sky, which is also moving. There are, therefore, a number of separate, but related and very specific, problems.

1. Water as a reflecting surface can be very still, as in lakes, quiet rivers and rain puddles, mirroring a scene and the sky. This can also be seen in the painting at the bottom of the opposite page.

1.

2. More restless water – a rippling pond, harbour or flowing river – also reflects its surroundings, but the image is broken up by light or movement. Then there is water in a rough sea or lake, or in a rushing brook with rocks and weirs, which reflects only the colour of the sky. Finally, there is 'white' water in violent upheaval: stormy lake- and sea-scenes, waterfalls, the surface of a fast-flowing river – the most exciting aspect of the subject, and one of the most difficult to capture.

2.

An obvious point, often overlooked, is that perspective is as important in drawing and painting waterscapes as it is for houses, fields, or other clearly defined objects. Receding lines, and the relative scale of objects at different places in space, follow the same rules. Too often, however, beginners concentrate exclusively on trying to paint the shapes formed by constantly moving water, and don't relate the size of their lines to other objects in the composition.

Water surprises constantly. On occasions it reflects the light from behind and above the spectator, rather than the sky itself, and looks light and luminous against dark clouds. The sea can look as solid as a wall, or like molten metal.

There are days when the horizon is as sharp as a knife-edge, and others when sea and sky merge imperceptibly. The serration of waves is sometimes visible on the horizon, and there are times when a cloud formation seems almost printed on the sea's surface.

Colours also change dramatically, from a variety of blues to mauves and violets, silver, slate, black, and greens. Occasionally the sea looks as brown as a ploughed field, umber ochre in colour.

Even at night, water has a magical quality, reflecting the light from buildings and streets, the stars and the moon. The scene is filled with a wonderful feeling of quiet excitement.

'Purple Noon'; Streeton

Starting to Work

When making studies from direct observation, a basic problem is how to pin down the elusive movement of the water, either to show the character of this movement, or to feature one fixed moment of it.

Water moves and also reflects a moving sky. For your first drawings, concentrate on only one of these aspects and work at an indoor swimming-pool where you won't have to worry about the sky. Many pools have seating for spectators.

Use either wash, charcoal, conté, or a combination of these media.

Swimming-pools often have lines on the bottom, dividing them into lanes for competitions. The effect of the water over these lines gives a vivid idea of its movement. The lines also provide references to help you to assess the shapes created by moving water.

Any drawing medium can be used to make tone as well as lines, and the tonal areas made by different media have their own particular qualities. Paint or diluted ink is especially suitable for producing a wide range of subtly blended tones, from a tint that can hardly be seen on paper to full black.

Tone exists in colour as well as in monochrome, and it is more easily recorded with a brush and wash than in line alone.

Use a medium brush – a No. 4 or No. 6 sable is a convenient size – and a small amount of diluted drawing ink or black watercolour for the wash to explore the shapes and forms of water and experiment with tonal patterns.

Water in movement; waves are made by the swimmers

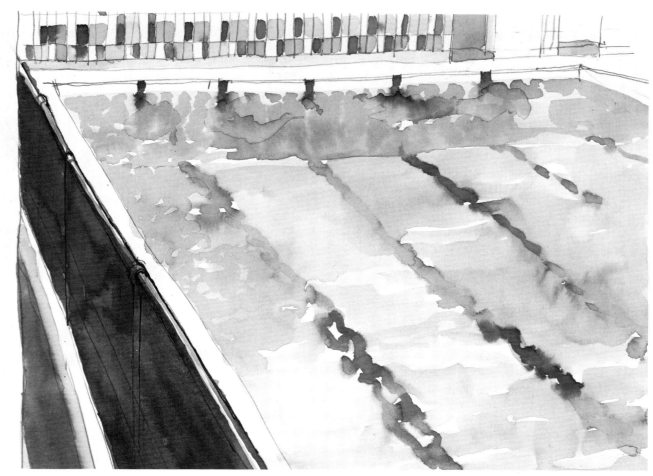

Lines under still water

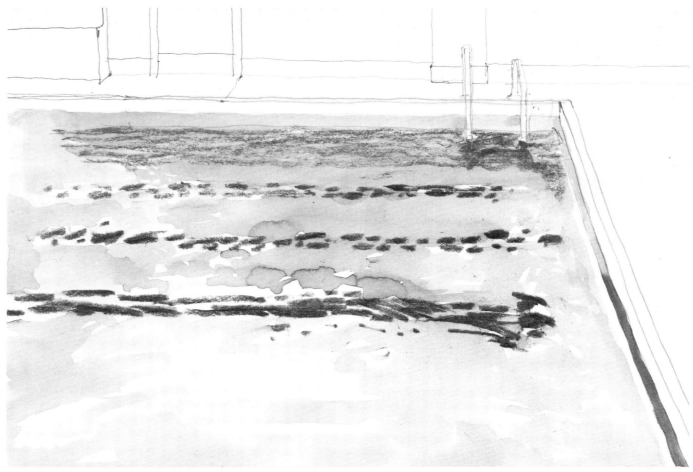

Lines blurred by moving water

Drawing Boats

Many artists, when looking for a suitable waterscape, will for reasons of easy access and relative comfort, choose a harbour or marina. Boats are likely to be within the view, so it is useful to have a basic understanding of how they may be drawn.

Boats can cause some difficult drawing problems: their shapes are often hard to determine because they are being viewed from an oblique angle, and these shapes are further complicated by the changing curves from the top to the bottom of the hull, and from front to back. Add cabins, funnels, masts, etc., and you have a mass of lines and forms that can seem impossible to decipher.

The easiest way to tackle the problem is to try to construct the boat in your mind's eye. Divide the boat in half, lengthwise, and use this imaginary centre line to aid you when deciding the position of masts, funnels and cabins, and to help you to see angles in the vertical plane.

Keep your notebook handy and make quick sketches of sailing-boats when they are in use. Study the curve of the sails when they are full of wind or hanging slack. Look at the tilt of the boat's hull as it crests a wave. All this information will come in useful when you want to do a drawing like the one shown on this page. You can certainly never get a sailing-boat to 'pose' for you, so you must be able to benefit from past observations.

In these pastel drawings below I first sketched in the shape of the sailing-boat with grey pastel on dark blue paper. Particular attention was given to the angles created by the outline of the hull and the deck-well, and also to the shape of the hull where it met the water. Using the imaginary centre line as a reference, I placed the main mast, checking its size against the scale of the boat. Next I drew in the sail, carefully relating its size to the scale of mast and hull.

Detail came last, with the addition of the sky drawn in grey pastel; the far shore was roughly indicated in brown, and some figures wearing bright orange life-jackets were added. By allowing the dark blue paper to show through the white pastel of the sea, an impression of a sunlit surface was given.

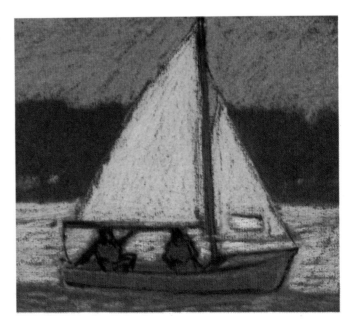

The trawlers on this page were drawn while they were in port being unloaded, and thus there was enough time to study their structure carefully and make a fairly detailed drawing. I began as for the sailing-boat but used two colours of pastel to help differentiate between the two hulls. Also, the fish-boxes, cabins and funnels were roughly indicated.

Finally, more detail was added to finish the drawing, but as there was so much going on, so many shapes and curves, the detail was kept very much to areas of colour rather than fine line.

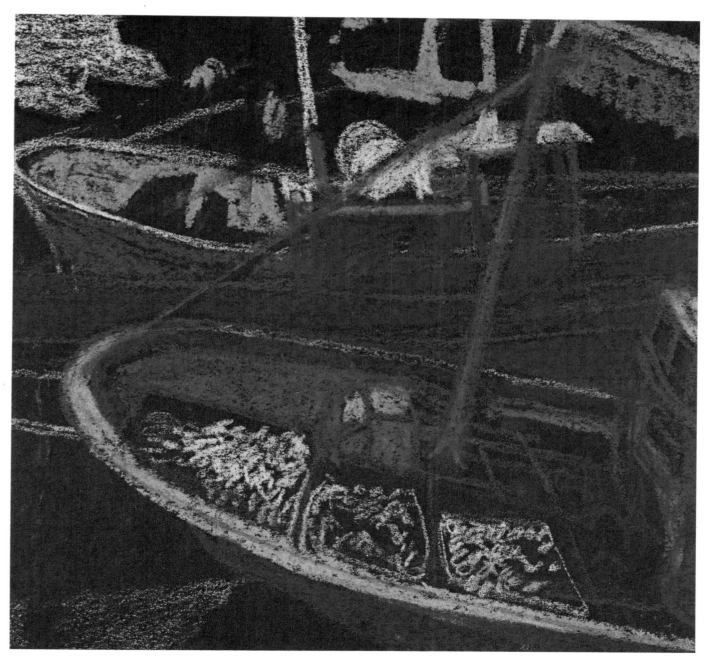

Drawing Shores and Reflections

When drawing reflections in water (no matter how still its surface may appear), you will have to train your eye to look for the most significant reflections and then quickly put them down on the paper.

A popular subject for this type of drawing is the reflection of trees in water. But here you will find a compound problem, for not only is the surface of the water always changing, but the trees sway and the leaves rustle, catching the light differently with each gust of wind. If you look carefully, you will see that the trees sway rhythmically but produce an irregular pattern, while the ripple pattern of the water is quite regular.

Pastels, pen and ink, and charcoal are well suited to this kind of quickly worked drawing.

When you are doing these first sketches, don't concentrate too much on the trees – you will find plenty of models and ideas in your early landscape studies of overhanging trees. For variety and interest, however, you could try making sketches of different kinds of trees. Willows are particularly attractive and usually grow to a handsome size when they are near water.

Make sure you visit an appropriate spot in different kinds of weather. On a windy day trees and bushes will blur into dark patches on the water's surface; if the light is dim they may not even reflect that much.

Step 1. Begin any drawing of this type by sketching in the main shapes, such as large trees, the bank of the pond and the path around it. Do this in a fairly pale colour so that it will not interfere with later drawing.

Where there is a clear top and bottom to the picture, it is important that you take care not to divide the drawing straight across the middle. Although symmetrical compositions are possible, it is usually only the most experienced artists who can carry them off successfully. If you are not careful, drawing a subject with reflections can easily lead to a symmetrical result that is dull.

Step 2. Using a charcoal pencil – it makes a firm strong line – begin to draw in the directions of the tree branches, and indicate the reflections and patterns on the surface of the water. Work quickly and keep referring back to the view in front of you. Don't be afraid to alter the composition; the view will be changing, so take account of this.

Step 3. Complete the drawing, placing the darkest areas of the background and of the reflections. Mix a middle-tone wash from diluted ink (test it on a scrap of paper to be sure it is not too dark), and use this to fill out the background and to emphasize the strong ripple pattern of the water.

Step 1.

Step 2.

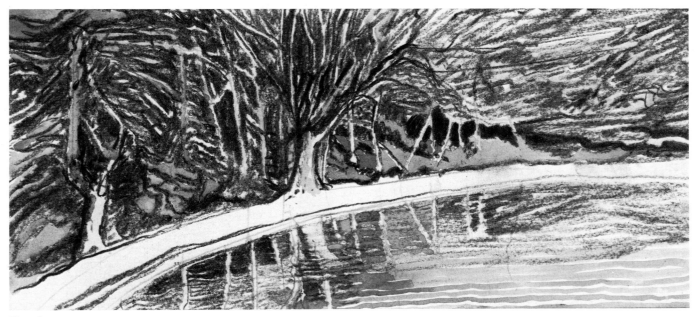

Step 3.

Falling Water Project

To get another kind of experience of water movement, draw it descending vertically. You may not have a convenient water fountain or live near a waterfall, but don't worry. Simply make a series of drawings of water falling from a tap into a sink, bath or bucket. Ensure that the water falls quickly enough to make an interesting pattern when it hits the basin before flowing away.

Step 1. Study the waterfall for a few moments and then outline its shape in white pastel. You should also take care to establish the scale of the waterfall within the landscape and in relation to the size of your drawing. Use the pastel sticks lightly – the flakes caught in the paper will give an impression of splashing water.

The glimmering surface of a waterfall makes a brilliant pattern of light and shade which is emphasized when seen against a dark background. For this reason I decided to use a rough black paper, and to incorporate this darkness in the finished painting. Dark green or brown would be equally dramatic, and even more naturalistic.

An indoor waterfall

Step 1.

Step 2. With green and yellow pastel, indicate the foliage in the foreground. Return to the waterfall and, using long loose lines, develop the 'sweep' of the water as it spills into the pond below. Pastel used in this way is not concerned with detail: the strokes should follow the line of the water without attempting to fill in every drop of spray.

Step 3. To give the waterfall three-dimensional form, introduce a mid-blue into the white pastel areas. This will heighten the sparkle of the white as seen against the dark background. The drawing is completed by using solid grey to separate the sky from the heavy mass of the mountains in the middle distance. The river bank in the foreground is the lightest area, and pale tints of yellow and green are used to indicate this.

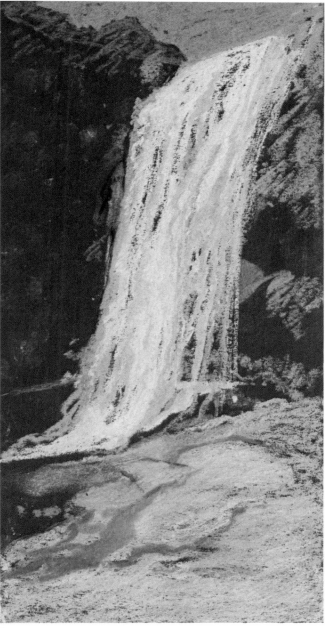

Step 2.

Step 3.

Watercolour Waves in the Studio

It is not difficult to sit in a studio with paper and watercolours, and produce effects that look like waves (just as it is easy to paint clouds). However, capturing the sun on water, with its movement, changing colours and reflected light, is a formidable task.

The difference between making a picture which is something like the subject, and one that achieves exactly what you want, is very great. Practice and application are necessary to produce successful paintings of water.

Waves, and patterns on water, are a never-ending subject for study. Patterns are caused by movement in the water itself, by boats moving over it, by wind, and by the action of the tide. These differing pressures on its surface all cause moving, intermingling effects that can be caught for a moment and recorded with brush and paints.

The examples on these pages are in black and white. However, because of reflections and the influence of nearby objects, every colour on your palette can be used to paint water – a clear substance with no body colour of its own.

Seascapes in Pastel

Pastels, either the soft powdery kind or oil pastels, are a most useful medium for outdoor work. They can be used in preliminary studies for a large painting in some other medium, or in their own right. The example here is a seascape which is conveniently divided into broad bands of colour – the sky, which is light blue, the sea, which is a much darker blue, and the foreground and middle-distance headland, which are a bright orange-ochre. Where it meets the sand the sea is basically white.

Step 1. Draw in the blue of the sea. You may find that you need only one stick of pastel to get the right colour. If it is not quite the correct shade, then add an additional colour and blend them together. Add the orange foreground now as it will help you to match the colours correctly, and balance the background colours. Seascapes often look simple in outline, but they can become quite complex once work has begun.

Step 2. Add the blue of the sky. At his stage you do not have to blend the colour into the paper: just draw it on, indicating the shapes you require. Leave some areas of paper blank, as you would in a watercolour painting, to give cloud shapes.

Step 3. Begin blending the colours together, and into the paper, by gently rubbing with your finger until the desired effect is achieved. Notice that colour has been added to the headland on the left of the picture, and also some blue added under the clouds.

Step 4. Put in the final details – a very dark blue-purple added to the sea will suggest waves, and some grey on the edges of the clouds gives them a three-dimensional appearance. You may want a little more colour in the foreground, with some green added to the white waves. Blend the pastels together where necessary to soften the change from one colour to another.

Step 1.

Step 2.

Step 3.

Step 4.

Beach Scene Project

Coastal scenes with rocks, beach and sea are popular and usually well represented in any art gallery or exhibition. However, the subject is anything but hackneyed – coasts provide a variety of moods and scenes. Not only is the sea itself fascinating and worth a lifetime's study but small villages and holiday resorts, rocks, pools and wide stretches of sand are also marvellous subjects.

Beach scenes provide the artist with the perfect opportunity to work with large areas of wash and a minimum of detail.

When you have chosen the view you wish to paint, study it carefully and try to see it in as few tones and colours as possible, ignoring all details. This should be easy as the view will consist mainly of sky, sea and beach. Mix some washes, trying to match the tones. The use of tone, combined with the warmth or coolness of the colours, will determine the mood of the picture.

Step 1. Having mixed the correct washes, begin by filling in the largest areas, establishing the horizon with the first wash of blue sky. It is important to do this thoughtfully as its position will establish the main divisions of composition: sky, beach and sea.

In this example the sky was painted a light blue, mixed from ultramarine to which a small amount of burnt umber had been added to give the blue a warm cast; the beach colour was yellow ochre, and sufficiently warm not to need any mixing. A tonal sketch will help to establish balance.

Step 1.

392

Step 2. The sea may prove to be the most difficult area to paint because of the changing colours and patterns produced by waves and the reflection of light from the sky. The colour will also alter between foreground and background. Lay a wash of blue based on ultramarine, and into this work the additional washes to render patterns of light and waves, etc.

Alternatively, you can mix the colours and apply them directly, beginning at the horizon and moving down the sheet of paper. Small areas of white should be left to represent the waves.

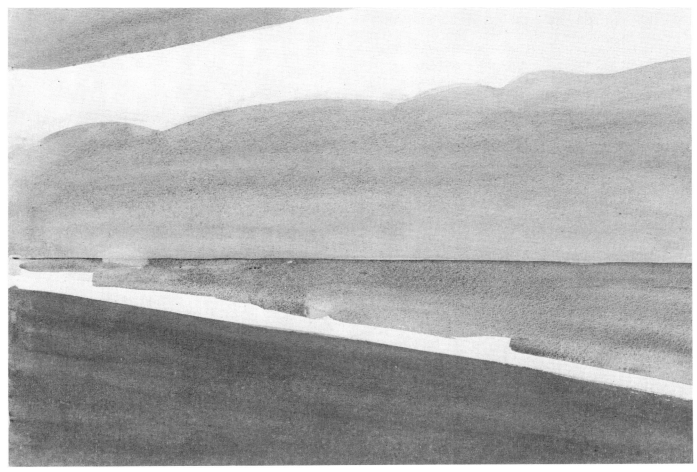

Step 2.

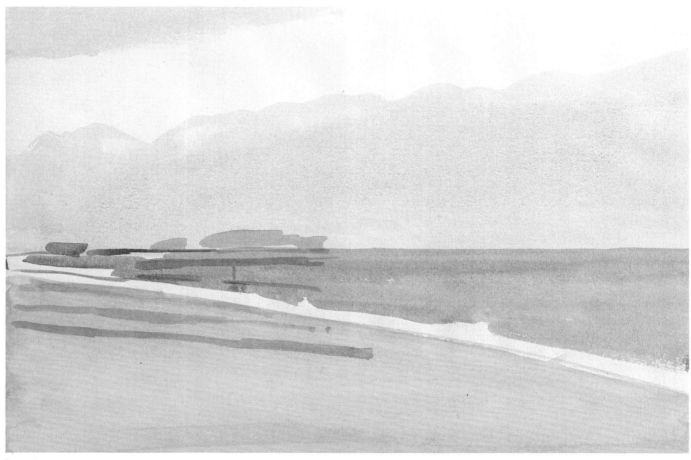

Step 3.

Step 3. When the main areas of wash are completely dry, begin to add detail: there may be people walking about or sitting in the sun, there may be boats drawn up on the beach, children playing by the water's edge, buildings along the waterfront or ships on the far horizon. Try to place these in a way that helps to compose the picture and captures the mood of the scene. But at the same time don't let the details spoil the simplicity of the scene.

Step 4. The boats on the beach are first sketched in with dark washes. Details are added only when these are dry, using a small pointed brush. Work quickly so that you do not pick up any of the original wash.

Step 5. To complete the picture, draw in details with a small pointed brush and unthinned, or lightly thinned, paint. Use any of the watercolour techniques to achieve the results you desire: wash out areas of colour to give highlights by dampening the areas of wash and then lightly mopping or lifting them with a damp sponge; you can either scratch in white lines or paint them in, to indicate the crests of the waves.

Additional colour and texture may be added by using pastels, charcoal, pencil or ink. But remember, the main characteristic of this type of scene is the large areas of uninterrupted colour.

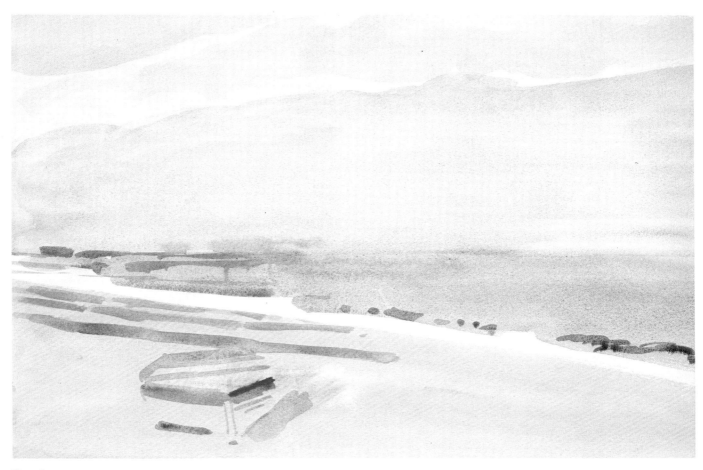

Step 4.

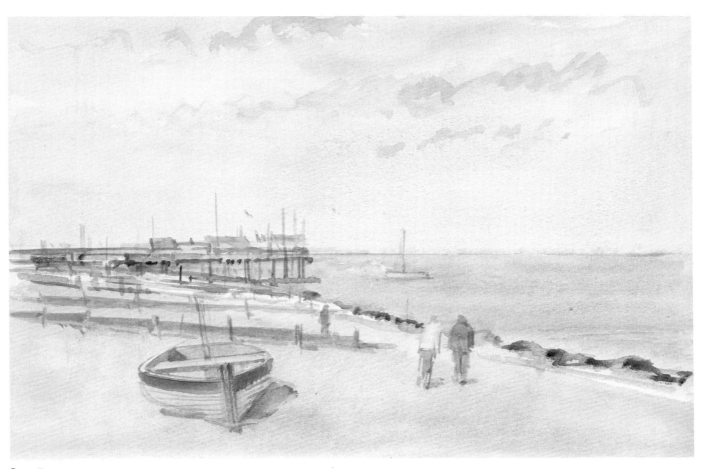

Step 5.

More Boats

Now that you have some experience of the simpler waterscapes, begin to look around at the more complex shapes of hulls and sails belonging to working boats of all kinds. These offer the artist considerably more scope in design and arrangement than the traditional single sailing-boat cleaving the waves. There is the cargo piled up on the decks, the winches and masts, cranes and slings, fog-horns and funnels – all the paraphernalia of a busy port.

Begin with simpler boats (such as small tugs and barges), outlining them in pencil or charcoal. A group of three tied together, such as those in the sketch on the right, will give you suitable practice in basic shapes and superstructure details.

Three barges in charcoal

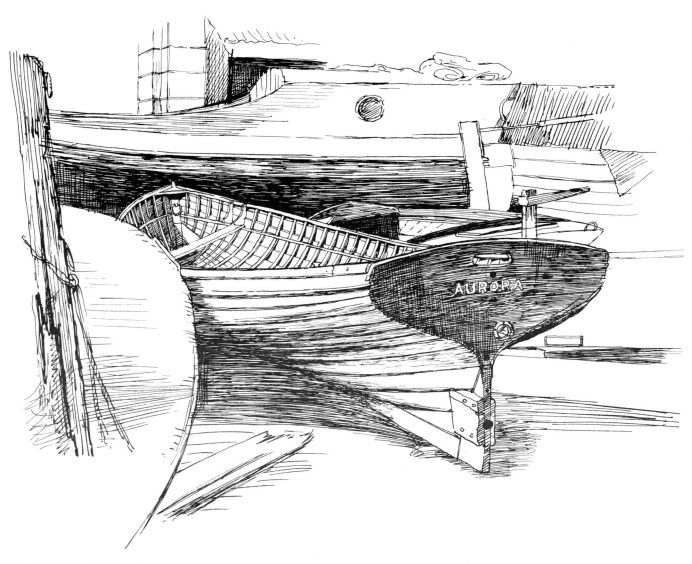

'Study at Yachting Club'; Simpson

Next find a small rowing-boat like the one below left, the kind that is often pulled up on the beach to overwinter or dry out after a storm; the ribs and thwarts make a marvellous geometric pattern, and they will help your perspective enormously, creating a feeling of depth and shape.

Finally, draw on your experience to make a larger pen-and-ink drawing, similar to the one on this page, to include the simple shapes of the dock-yard structures, the cranes, and the reflections in the water recorded with the simplest squiggles.

When you are interpreting a great many geometric forms you can use one of two methods. A first sketch in pencil will establish the outlines. Or you may prefer to use a ruler to make the first three or four basic structure lines, and then fill in the areas with freehand hatching or shadowing. Although this is a very complex subject the drawing is actually quite simple, and easy to do once you have your proportions correctly marked on the paper.

Again, it is important not to copy the picture on this page. Look at it carefully, try out details if you like, but then go out and see for yourself what sort of subjects attract your eye. If there is no harbour, then a river building or even an old pavilion by a pond or a dilapidated bridge can form the basis of an interesting group.

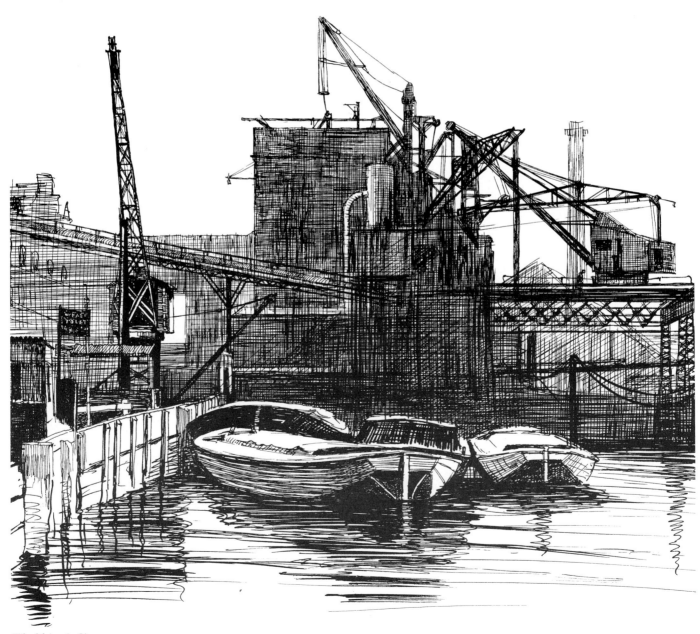

'Blackfriars'; Simpson

Summer and Autumn in Watercolour

Step 1. Below, the main wash will create the mood, so be careful to find the right colour. In this example, an overall wash of yellow ochre is laid leaving areas of white for clouds and reflections.

Step 2. For most atmospheric effects, you will want to work quickly. While the first wash is still wet, add raw sienna to the Horizon, suggesting mist, low clouds, a distant shore. A few horizontal strokes of grey mark the edge of the land nearer the foreground. Add grey to the clouds, and a little to the surface of the water, creating ripples. Darker grey and a fine brush sketches in the bare trees, dramatically outlined against the sky.

Step 1. A sandy beach in summer can be quite difficult to paint because the sunlight bounces off the surface. Start with a few main outlines, and a dune on the left.

Step 2. Complete the simple seascape by using tones of yellow, blue and pale grey washes. Keep the washes light and clear – they will create their own "sunshine" effect.

Step 3. A few strokes of green create sprays of dune grass, and a little white gouache picks up the froth on the waves.

Step 1.

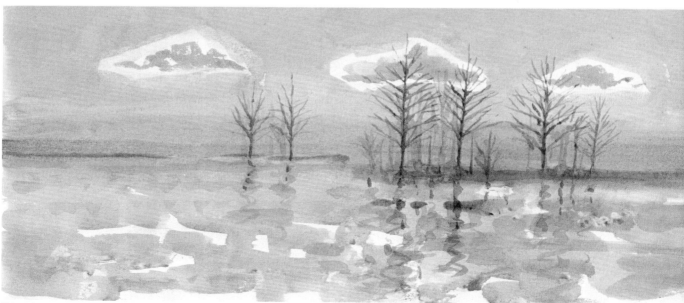

Step 2.

Step 1.

Step 2.

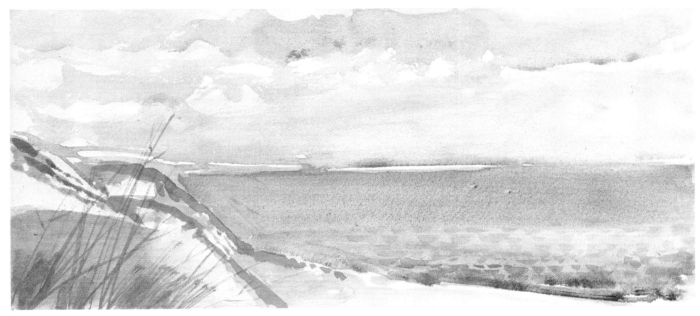

Step 3.

Waterside Sketchbook

All through this book we have encouraged you to carry a sketchbook with you as often as you can, and to jot down notes and ideas whenever you see something which attracts your eye.

With waterscapes, pencil sketching becomes a little more difficult if you choose to confine yourself only to the water as the main subject. The surface of water is not really all that attractive to look at and is not identifiable as water if not shown in its surroundings.

So when you take your sketchbook, think of the sea or the river as part of a larger scene. Beaches, pools, people, lighthouses and bridges all make frames and settings for your treatment of the water; they provide a balance, and a context in which to set your picture.

You will see drawings and paintings of boats all through this lesson, but here are some working sketches of waterside views which should help you to establish a good reference library – one you can consult whenever you begin to paint.

Seaside buildings

Rough water in a swimming pool

Canal sketch in oils; tonal values are clear

Waterscapes in Oils

Oil paint is an especially vivid medium for waterscapes, a subject that itself has many aspects, all full of colour, atmosphere, and rhythm.

Try to emulate the enthusiasm of young children, who love painting the sea and do so with an uninhibited use of colour. Frequently they arrive at marvellous interpretations of water that defy description but have more feeling than those achieved by more realistic approaches.

The ideal solution is to combine such a childlike reaction with the more sophisticated techniques that this book describes.

The paintings on these pages show examples of water in three totally different moods: violently storm-ridden in the first, with deep waves and whitecaps everywhere; calm and golden in the second, though the water itself is falling into marvellously atmospheric sprays; and finally, calm and scarcely moving at all in the third, with the hot afternoon sun drying out the riverside vegetation.

Look at each picture carefully to see how the artist has conveyed the powerful impression of a particular mood.

'Fighting Frigates'

402

'The Falls on the Wannon'; Buvelot

Harbour Scene

Where there is water there is activity – and material from which you can work. Fishermen, boats, moorings and jetties, ropes, bollards and capstans are exciting subjects. Sailing-boats make crisp triangles in bright colours. This project will take quite a while. You may prefer to work on the painting itself in the studio, from the drawings and studies you make on the spot. Try to do this as soon as possible after your visit – the memory plays surprising tricks.

Start by making small studies, in oil, in your sketchbook. Draw the infinite variety of shapes and patterns. Pinpoint changes in scale and formation. See the ways in which water reflects and picks up light, and how the surroundings affect the surface. Use a grid to establish relationships between the foreground, middle distance and far distance; note the changes within these divisions.

These studies provide an opportunity to experiment with different brushes: large and small, sable and nylon, flats, rounds and long-hairs.

The two sketches shown here are based on shapes, tones and details. Below is a broad-brushed oil sketch rendered in simple strokes, with bands of bright colour to show the hull and the superstructure. The water is equally flat in blending tones of blue, grey and mauve.

The tonal sketch opposite is a detail from the painting on page 407, and shows how the hulls, deckhouse shapes and buildings in the background contrast with the flat treatment of the foreground. The two areas are linked by the figures in the centre of the picture.

Tugs in a harbour; first oil sketch

Select an aspect of the scene and concentrate mainly on this. Try to achieve a specific effect; don't be distracted by superfluous problems. All the steps in the development of the painting, from drawings and sketches to the final stages, are aimed at creating a particular image.

Sketch the figures as silhouettes, marking in the large passages of colour, areas of water, and the horizon. Decide how to divide your working surface into foreground and the horizon line.

Make small, rough drawings of the tonal masses, the way to use shapes, and the contrast between linear movement and static geometric forms. Decide whether the painting will have realistic depth, or a flat decorative quality. Combine different surfaces – textured areas against simple shapes and blocks of colour. Build up the areas of the painting and make them descriptive and varied, with washes and glazes against impasto.

Water can be a light or dark mass, flat or full of depth and colour. If you stand by the side of the dock and look into the water you should be able to see stones, plants and fish under the surface.

The colours from this angle will be browns and greens. However, as you look slowly upwards and towards the horizon, the reflective surface becomes more apparent. The colour of the sky will begin to change the browns and greens to violets, mauves and blues. As you look into the distance the angle will become more acute, and the mirror quality of the water's surface will increase.

Make a careful study of these observations. Paint bands of changing colour to create the sense of an expanse of water.

Distance is as important in waterscapes as it is in landscapes. Look at, and think about, the structure of your composition. Lay stress on creating an illusion of space from foreground to horizon, with a front and back to your painting, as you did with previous subjects.

Tonal sketch of a detail from the painting on page 407

The early sunlight makes the water dazzling – use short strokes of pure white dry-brushed over your first blue layer. The base should be as dry as possible so that the texture of the oil surface is light and glittering like the sun on the water.

Finally, the first sketches were pinned up together, and after I had studied them, I went out the next day to paint the last of the Regatta, coming home to the harbour basin.

The tug reappears, the sailing-boats are placed here and there in the background, and the figures are heavily shadowed by the late afternoon sun.

Whenever an interesting event is taking place, use the opportunity to see something exciting and different, and capture it in your work.

If you are still unsure of yourself, or worried about people watching you, find a quiet spot sheltered by a building, or an old building near the harbour, and try to convey the atmosphere of what you see.

Lakeside Scene in Oil

A scene by a lake in late November; the leaves have gone from the trees, but the evergreen bushes and some of the plants are tinged with autumn colour. The surface of the lake is quiet and reflective, with that still, almost heavy feeling of very cold weather. This project is done on the spot, rather than from colour sketches.

Step 1. The first task is to lay down a ground and the first drawn outlines. Because of the general feeling of autumn the ground is burnt umber, with touches of cobalt blue and burnt sienna.

Step 2. Begin to block in the sky and the water very roughly, using titanium white, with the occasional touch of raw umber again, and with some cobalt blue in the mixture for the sky.

Step 1.

Step 2.

Step 3. Add a touch of yellow ochre to your sienna and cobalt mixture for the trees in the middle distance, with a little bit of white for the soft green foliage across the lake. Work in wide, easy strokes, following the general shape of the trees without trying to put in much detail. Move down the shore-line on the left with different shades of yellow ochre, more green, and a bit more sienna for the bushes on the left edge.

Add the reflections in the water with simple strokes, reversing the shapes so that the taller trees begin to reflect well below the surface line of the water, while the close, ground-hugging bushes are immediately reflected in the water.

Work all over the painting to bring it nearly to completion but keeping it balanced all the time. If you concentrate too much on one part of the scene, you will find it over-detailed and over-worked while the rest of the painting becomes rough and out of place.

For this kind of painting I prefer to work as quickly as possible, before the paint dries, so that the effect is more like working 'wet on wet' in watercolour. This will give a soft, rounded and slightly blurry look which suits the scene and the mood. If the atmosphere was crisp and sunny, let your technique match it with crisp, clear outlines.

If you add linseed oil at this stage it would make the paint too thin. You can see from the strokes of white on the surface that the brush should move easily, but cover the underpainting completely.

Mark in the first strong strokes on the trees which dominate the painting, letting their shapes run across the sky out of the frame.

Step 3.

Step 4. The tree has already been blocked in with the original strokes of raw umber and sienna. Now it is time to define it by adding detail with a darker burnt umber, to give roundness and shape to the branches and twigs.

Mix a new batch of pigment with plenty of sap green and raw umber, for the darker parts of the reed clumps. They need to be drawn in sure, firm strokes from the base upwards with your arm moving freely.

Using the same basic colours, add more of the outlines of the trees and the spit of land on the right, with the curve of the shore clearly marked.

A bit of sap green gives depth and a feeling of underwater plants growing just below the surface. Use a slightly larger brush and pure turpentine to help the pigment spread easily.

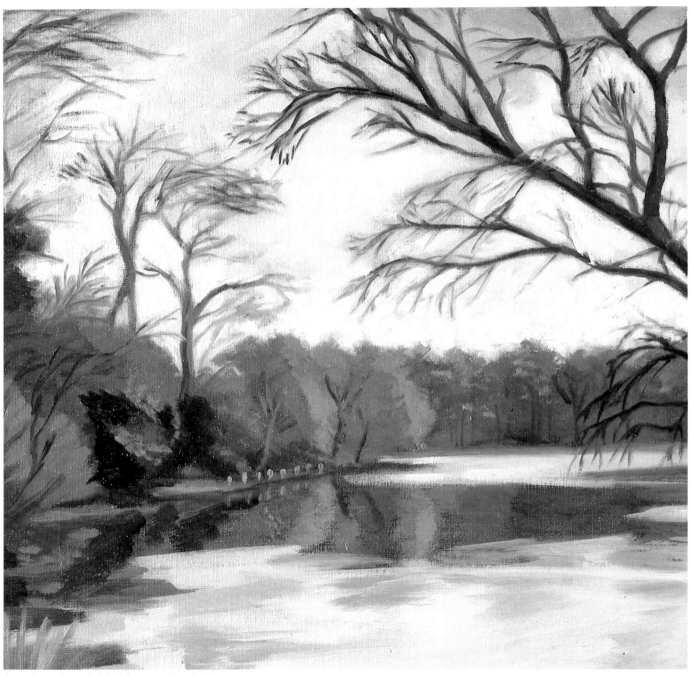

Step 4. *Enlarged detail from centre of picture*

Step 5. For the last session, sit down for a few minutes to look at the view again quietly, and pick out the details. A few strokes of white and umber will lift the edge of the shore all along the lake. Poles under the trees on the left give a sense of scale, and are repeated very lightly in the water underneath.

Lighten the sky a bit in the distance just over the horizon, and step back to look at the view again.

All of the earthy colours are appropriate to the season, the view, and the rather quiet, dull sky.

Look at the view again, and at your painting; the important focal point of the leaning tree will be quite dramatic, and the reeds nearby on the ground add colour and a strong vertical line.

Make a note to come back to the same spot at another season and see how the colours and the light have changed.

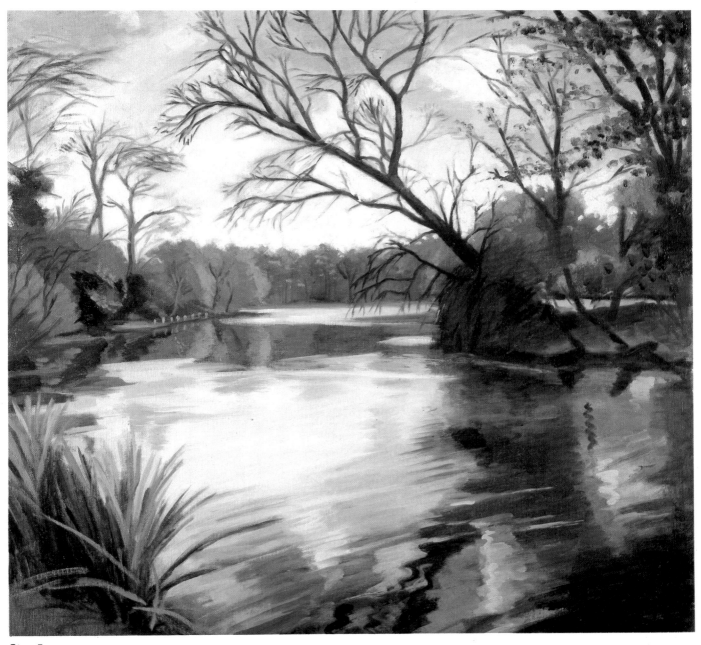

Step 5.

Extra Projects

It is not easy to capture moving water in a static image. Photographs taken at a fast speed of 1/500th of a second make it look like ice or solid glass. If a very slow speed is used, it looks like cotton wool or soft snow. To give an appropriate impression, water must be photographed at exactly the right speed.

Photography is immensely helpful in enabling artists to see the sequences in a movement, and it can be used as a basis for waterscapes. Keen photographers may wish to take a series of shots at intervals of a few moments. However, as with other subjects, photographs should be used for reference only; finished drawings and paintings should always be made from direct observation.

Rough water

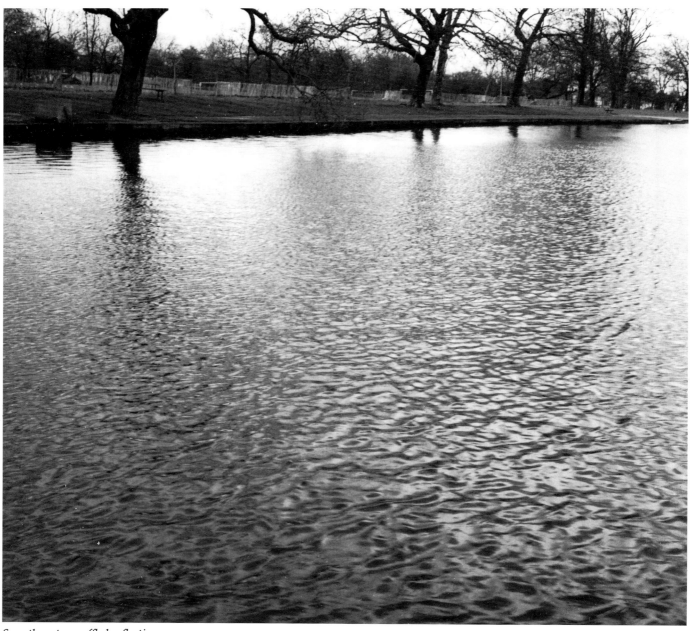

Smooth water, ruffled reflections

Water plays all kinds of visual tricks, and creates a variety of optical and colour mixes. It is seldom a true reflecting surface. Even under the calmest conditions there is some movement to distort the image. Every wave provides a series of mirror surfaces that reflect a scene or object above, to the side of, or in front of, the spectator – or combine to create a multiple reflection. An image is not necessarily reflected below an object: the sun's reflection can move considerably to the right or left as a result of the waves' diagonal angle. In hazy conditions the line of the horizon can seem to have a hump. Flurries of wind, the depth of the water, and so on, all affect the reflected image.

To give an impression of movement in water, try blurring the image slightly, using wispy brush-strokes to suggest moving waves.

Try to find places where there is water to paint as often as possible; if you live in the country there are sure to be ponds, and even drainage ditches which are full after the rain. In cities, look for small fountains, and there may be canals winding through warehouse districts.

Use your time well: on a calm day sketch the surface of the water with easy horizontal strokes, or with ruffled touches if there is a brisk wind that stirs the reflections and makes the surface opaque and frothy. Add a little white gouache to your watercolour sketches for the spray, and try spattering it over some areas of the surface to give the effect of sparkling drops of water.

Experiment with different levels; sit on the ground (remember to bring a cushion) and make crayon, pastel or other colour media sketches; climb a little way up the bank and repeat the exercise, then compare the two. The surface, the colour, the whole appearance of your subject will have changed.

Collect rocks and pebbles small enough to carry easily, and keep a bucketful in the studio. They will be useful as part of a still life, and fascinating if you lay them in a basin, or even in the bath, and slowly fill the container with water. Look at how they change colour and texture, growing sleek and shiny. Use what you have learnt from this the next time you visit the beach, painting rock pools as well as the sea.

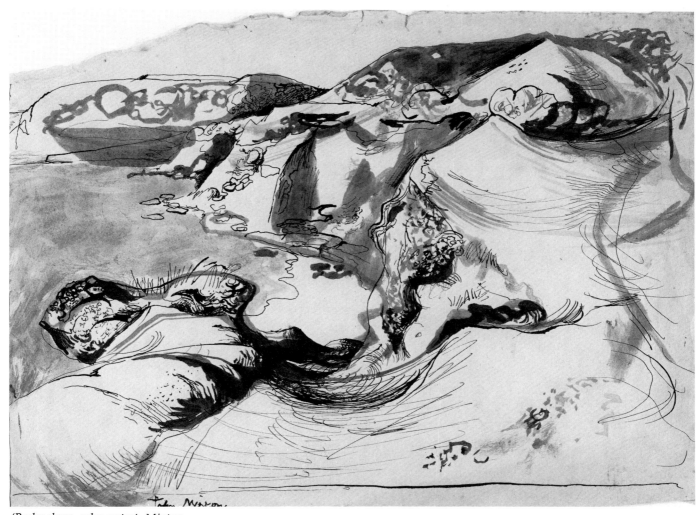

'Rocky shore, calm water'; Minton

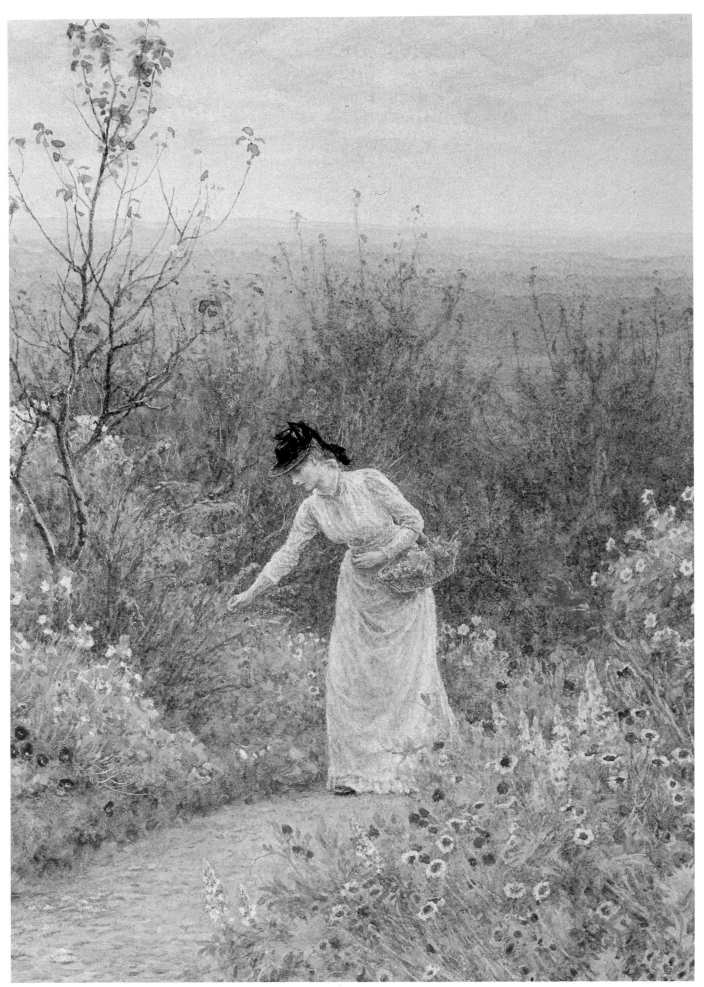

'A Garden in October'; Allingham

Lesson Eleven
Figures

In each of this book's introductions to special subjects we have attempted to condense 2,000 years into a few words – not an easy task! With this introduction, it becomes almost impossible: the human body has been a source of inspiration throughout every known period of our history, except among those few cultures which forbid the depiction of mankind. Stick figures or simple outlines occur in the artefacts of almost all cultures, no matter how primitive.

There is about 200,000 years between the early scratchings of cave-dwellers and the figurative stone carvings of the most ancient civilizations of Assyria and Mesopotamia, which were relatively sophisticated and complex in shape and pattern. By the time that Egypt was a great power her artists were capable of executing paintings and sculpture of great subtlety and imagination, and if the tradition of depicting figures in rigid poses seems strange to us, it did not prevent artists from creating an entire nation at play, at work, at worship, and on ceremonial occasions.

Both Greek and Roman artists took the human body and created ideals which are valid for many people today. Figures were often shown in silhouette and intertwined in scenes of ritual and celebration.

When Alexander the Great reached the Indian sub-continent, the culture he encountered was already at its height; sculpture, carvings and paintings showed the intricate formation of the body in almost every conceivable position. The erotic symbolism of these works is expressed in the preoccupation with figures of all kinds – gods and goddesses in human and animal form, animals real and imaginary, tangled in an inextricable pattern which none the less retained its figurative origins.

With the Moslem influence on illustrated manuscripts, human and human-like gods achieved an even greater prominence, in small paintings of exquisite delicacy and in every imaginable situation. These drawings and paintings from epic stories and love poems are exemplified in the Rajput, Jaipur and Moghul schools of the fifteenth and sixteenth centuries.

Western art, meanwhile, had changed completely from that of the earlier Greek and Roman schools. In the Orthodox Church the Christian ideal was symbolized by highly stylized figures and throughout the early medieval period artists were influenced by the rather stiff, two-dimensional Byzantine mosaics. The approach of the Renaissance and a return to classical ideals encouraged more fluid lines and a more realistic approach to the figure, seen in the cross by Cimabue (c. 1240–

1302?) for Santa Croce in Florence. The fervent passion for anatomy and movement which Leonardo da Vinci (1452–1519) shared with many other Italian artists changed their entire artistic perception and working methods. For the first time in Europe, the body was seen and painted as a living object rather than a stylized symbol, even if it was completely covered by robes or tunics.

It was also during the Renaissance that classical sculptures in particular encouraged artists to try paintings of naked figures. At this time they were 'idealized' into the classical mould, and the subjects were usually shown as historical or mythological characters.

This compromise of portraying real people – but in the robes and costumes of another time – was to continue for centuries, even though the sitters were often known and easily recognized. The portraits by Rembrandt van Rijn (1606–69) are more like pictures of figures in fancy dress than actual people; conversely, Peter Paul Rubens (1577–1640) often painted people dressed as scantily as possible; an almost transparent wisp of scarf covers the triumphantly naked men and women in the few places he thought it necessary to conceal. His wonderfully voluptuous figures bear little resemblance to the austere and elongated figures of El Greco (1541–1614). The so-called 'Rokeby Venus' by Diego Rodriguez de Silva Velazquez (1599–1660) is in a class by itself; if it is possible to say that an artist is exceptional amongst other exceptional painters, Velazquez surely merits the description. In every way his work was the product of an acutely observant eye which saw the complex possibilities in even a simple classical pose.

In eighteenth-century France, Jacques Louis David (1748–1825) spearheaded the Neo-Classical movement, returning to academic subjects – and shrouding his figures in a plethora of drapery. His knowledge and mastery of figure drawing enabled him to produce immensely powerful compositions which captured the fevered emotions of Revolutionary France.

Jean Auguste Dominique Ingres (1780–1867) was David's pupil, his classical training at odds with his desire to render realistically that which his eye saw. This artistic struggle resulted in pictures of considerable tension, but with a quality of sensuality which may have been almost unconscious, conveyed through his use of line. His three major paintings are of the female nude and, although they are classical in pose, the smooth porcelain-like texture of the painted surface conveys an ethereal and curiously remote sexuality.

In the mid-nineteenth century, the Pre-Raphaelite Brotherhood was an influential group of British artists who, with John Ruskin as critic and spokesman, sought to turn the aesthetics of art away from the dehumanizing effects of the indus-

trial age to the more sincere and sensitive ideals which they thought were embodied in the art forms of the medieval world, and more precisely the Age of Chivalry. Revering the styles of painting which preceded Raphael, the high moral ideals of the Pre-Raphaelites were reflected in their choice of subject-matter – scenes from the mythology of King Arthur and portrayals of events in the life of medieval heroes and heroines were favourites – painted in a realistic but highly romanticized manner. Dante Gabriel Rossetti (1828–82) and Edward Burne-Jones (1833–98) are the most noted exponents of the style, which had enormous influence on most of the applied arts as well as painting.

Meanwhile, other painters were beginning to place the figure in domestic settings, in works that are notable for their sentimental charm, and the sympathetic manner in which figures of all ages and from all walks of life are shown.

The Impressionists adapted the domestic setting to their own use, and many of the most popular and famous paintings of their period are scenes of ordinary people doing mundane things.

The twentieth century has seen the greatest number of changes in style and personal vision in the history of art. The early periods were full of experimentation and 'isms' – Cubism, Dadaism, and so on. Nevertheless, artists continued to draw and sketch the figure in more traditional ways – the drawing below by Joan Miró (b. 1893) was made in 1919 – even when their formal paintings followed a different form.

Nude; Miró

Many American artists were greatly influenced by European ideas. Childe Hassam (1859–1953) was an important Impressionist painter, and his interest in urban life helped to encourage the Ashcan School whose members, realistic portrayers of city life, included Rockwell Kent (1882–1971) and Edward Hopper (1882–1967).

The last century has seen the development of innumerable styles of figure painting and drawing, from the images of soft femininity by Pierre Bonnard (1867–1947) and Edgar Degas (1834–1917) to the angularity of *Nude Descending a Staircase* by Marcel Duchamp (1887–1968), the tortured sexuality of the human form by Egon Schiele (1890–1918) and the almost Byzantine stylizations of Amadeo Modigliani (1884–1920).

The surreal abstraction by Janos Koch (*b.* 1923) and the sombre atmospheric realism of Joseph Herman (*b.* 1911) reflect the concern with social tension, embodied in anonymous figures, while other contemporary painters use well-known pop stars as symbols rather than as individuals.

No matter what his usual style or subject, almost every artist today will have drawings and sketches of the figure in his portfolio – indisputable proof that the human body is a never-ending source of inspiration.

'Players in a Game'; Koch

'Miners'; Herman

The Human Body

The human body has always been a popular subject with artists. In sculpture as well as painting, recording the figure, either clothed or nude, has proved to be both demanding and aesthetically rewarding.

It is impossible to make studies of the human form which are entirely unaffected by concepts of ideal proportions and shapes, or by social attitudes to nakedness and morality.

The Victorians perpetrated a dreadful vendetta against the body to the extent that fig-leaves were even added to Greek and Roman sculptures in museums. Nevertheless, the study of the male and female nude continued even during this puritanical period.

The nude figure is still a popular subject today, and forms an important part of art education. Without a working knowledge of the human body – how it moves, what it looks like – artists would find it difficult to make sensible and intelligible drawings and paintings of clothed figures. Both kinds of studies of the body, clothed and unclothed, are important aspects of learning to see as an artist.

Students sometimes say they can't cope with studies of people; this is understandable. You can pretend that the tree you have drawn is something like the actual tree, or at least similar to it. But it is much more difficult to overlook the defects when comparing a figure drawing to the real body – inadequate results are all too obvious. In addition, there is no doubt that the problems of understanding what you see and then trying to draw it accurately are greater with the human figure than with any other subject.

As always, it is all too easy to refuse to believe your eyes; or to see what you think might, or ought, to be there. Expectations are often based on admired drawings and paintings, and can be affected, to some extent, by social evaluations.

Then too, the figure, especially the nude, has always been associated with half-realized dreams of perfection. For centuries the classical model of the perfectly proportioned body made some people ashamed of their own appearance. Today's ideal figure is more likely to be an unattainable sex symbol that hovers at the back of the viewer's mind, affecting his or her concept of beauty in a quite extraordinary way. If a model is good-looking you may well minimize his or her faults – another instance of recording what you expect to be there rather than what you actually see.

Drawing and painting the human figure is the supreme challenge. The following projects will enable you to approach the most complex problems gradually.

Preliminary Exercise

Draw the torso, as shown on the right, down to the line of the buttocks. Interpret it as a triangle pivoting on the rectangle of the hips. Most women have wider pelvic rectangles than men.

Add cylinders of arms and legs. Concentrate on simple proportions without any detail. Make sure that the limbs are related to the length of the torso.

Drawing of an unclothed figure

Starting to Work

Before you begin to think about anatomy and proportion, start with a simple project and draw directly from observation. This will help you to see how accurate your eye has become, and to what extent you will have to refresh your memory by returning to earlier lessons on perspective and undefined geometric shapes.

Remember that perspective is a tool, not a substitute for a careful and trained eye.

Start not just by considering the drawing of basic geometric planes and forms but, perhaps surprisingly, by reminding yourself of the interior views you worked on in Lesson Five. For your first figure drawing, get someone to pose in a room, if possible the same room that you used for the earlier interiors. Ask the person to sit (standing for any length of time is difficult for any but experienced models), and position him or her some distance from you. Your model should be far enough away so that you are not concerned with details of features, but can consider the whole figure as a number of interrelated forms.

Step 1. Find a chair that won't hide the model too much, or use a stool. Refuse to be lured into drawing detail! Look at each part of the figure and use the simplest possible form to describe it. Try to forget that a human body has separate arms and legs; where possible, see these merely as elements making up a much larger mass.

Use charcoal. This medium makes it easy to build up very simple masses quickly.

Step 1.

Step 2. The aim of this project is to identify forms (circles, rectangles, triangles); simplify them as much as possible, and draw them accurately in relation to each other.

Fill in the background but keep it simple. Remember to use anything that is a reference for the shapes – the vertical lines of the chair frame, the horizontal of the floor or a table.

When you have finished this project, keep the sketch for reference.

Sketchbook Notes

If at first you don't have the confidence to work from a model, start by drawing yourself in the mirror, with or without clothes. Carry a sketchbook on the train and bus, and try to make quick studies of the people you see – how they sit and stand, their shapes and proportions. Don't try to draw faces, except for a few lines to mark the features. See heads as tilted ovoids, arms as cylinders, and so on.

These sketches will help you to establish a quick way of seeing the underlying forms of the human shape.

Anatomy

A knowledge of anatomy is not in itself a guarantee that you will be able to make good figure drawings. Like perspective, it can be of assistance, but it is no substitute for the ability to see the subject as a complete whole, and then to subdivide this whole into the forms that will reveal the model's essential character.

None the less, basic anatomy can be useful in showing how our bodies work – for example, the main points of articulation in the skeleton. Muscle drawings give some idea of the connections within the figure – but it is only an idea, and not an absolute formula, because the external appearance of every human figure is very different.

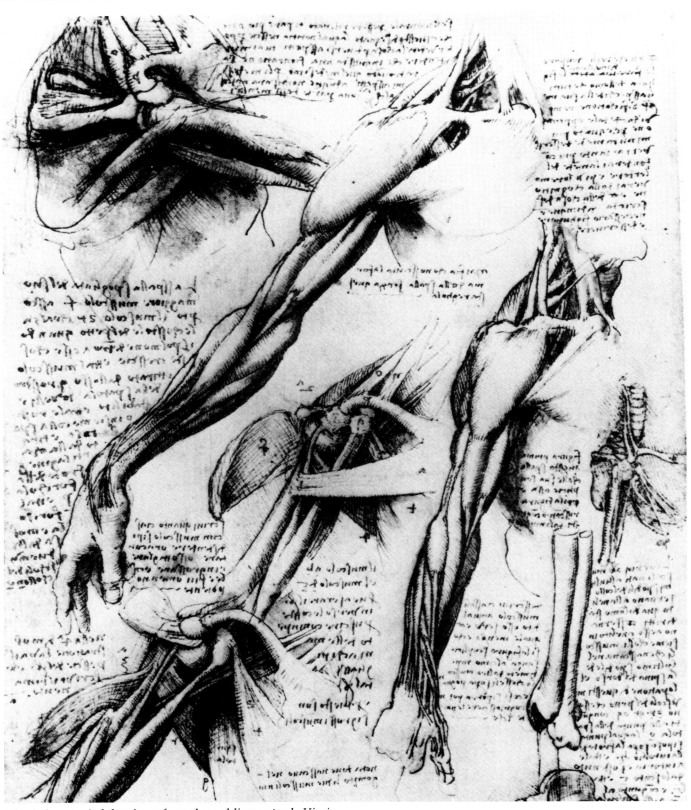

Classical anatomical drawings of muscles and ligaments; da Vinci

Anatomical drawings can only depict an impersonal machine; although this is perfectly adequate for medical students, it is dangerous for an artist to look for the ideal when his or her subject is a particular human being.

For the only time in this book, you will be asked to draw from illustrations. Make copies of the anatomical drawings on these pages. Draw each three or four times until you feel you have a good understanding of the figure's underlying construction. Vary the drawings by slightly altering the position of the limbs, and estimating the effect this would have on the anatomical details.

Finally, see if you can draw the figures from memory.

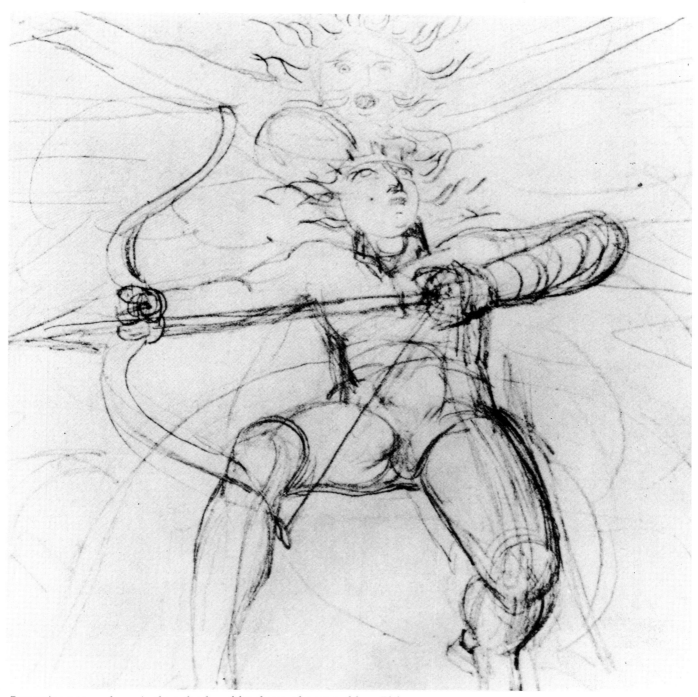

Romantic anatomy shown in these sketches of foreshortened arms and legs; Blake

Drawing a Standing Figure

When drawing and painting the figure it is important to remember that the session is more likely to proceed favourably if the model is relaxed and co-operative. Try to allow him or her to relax into a comfortable position that can be held for a fairly long time. If the pose alters slightly after you have started to work, accept the change. The model is more likely to be able to keep a position if he or she has settled comfortably.

Most amateurs need to move after ten minutes or so. In addition, encourage your model to move a little even while posing; anyone who stays rigidly in a particular position will quickly tire and become bored.

An experienced model knows how to relax and

move slightly, but has the ability to return each time to the essential pose. However, a friend or a member of your family will need more guidance. Use chalk to mark the position of key parts of the figure – the feet of a standing figure – on the floor. And do the same for any object that is important to the pose and might be easily moved by mistake, such as a chair on which the model may be leaning.

Getting the balance of a particular pose right is one of the most difficult aspects of drawing or painting the figure.

If the model is resting against a chair or table, balance may well be contained both in the figure and in the supporting object.

Step 1.

Step 2.

When the figure is standing and therefore completely self-supporting, it is essential to observe where its weight is distributed before you start work. Is it on both legs, or more heavily on one?

Use any available verticals, and/or a plumb line, as a reference to decide on the position of the feet. This applies especially to the load-bearing foot if the weight is mostly on one leg.

It is also important not to be close to the model. Set up your easel so that you can see the whole figure without moving your head; a distance of 6ft to 8ft (about 2m to 2.5m) usually will be satisfactory.

Problems with proportion and distortion are often caused by the fact that a student may be so close to the model that he actually makes two or three separate studies, each from a different viewpoint, which are joined in one drawing.

Step 1. Sketch in the main shapes of the figure, being especially careful to get the position of the head correct as seen in relation to that of the feet, so that the balance of the figure will be accurate.

Step 2. Develop the torso by indicating the parts which are turned to the light and those which are in shadow.

Step 3. Introduce facial features and other physical details and begin work on modelling the figure, putting in shading and highlights.

Step 4. To complete the drawing put in background details; check, and if necessary redraw, the angles made by shoulders, hips, knees and feet; and finish the modelling on the figure.

Step 3.

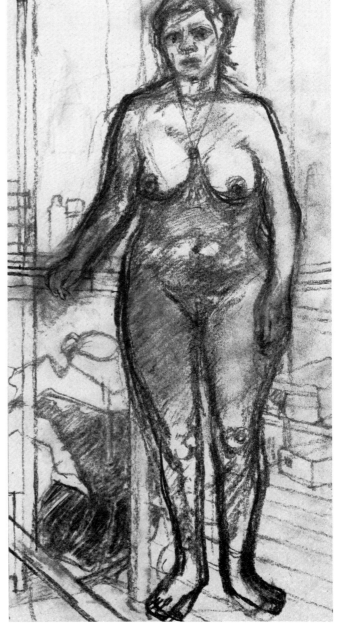

Step 4.

Drawing a Working Figure

It is easiest to do studies of moving figures when the action is restrained or repetitive, as in sweeping the floor, ironing, sawing a piece of wood or doing light exercises. Then the general shape of the figure can be seen in a certain set of movements, and it should be possible to fix a certain part of the action in your mind's eye and continue drawing even though the position will have altered.

Figures in action are interesting subjects to draw because they look more 'natural' than when posed formally. Apart from this, you will find it easier to convince family and friends to pose for you if they can be doing something, rather than sitting or standing still.

1. In this drawing of a woman cutting out a dress pattern I first established the position of her body and the tilt of her head, using the vertical lines of the window-frame as a point of reference. The main outlines were sketched quickly in charcoal, and then the main colours of the figure and the background were introduced in pastel.

By developing the background I was able more clearly to define the shape of the figure. The shape of the dress pattern and the fabric on the table were then drawn, and the hands holding the scissors sketched in to establish the area of activity.

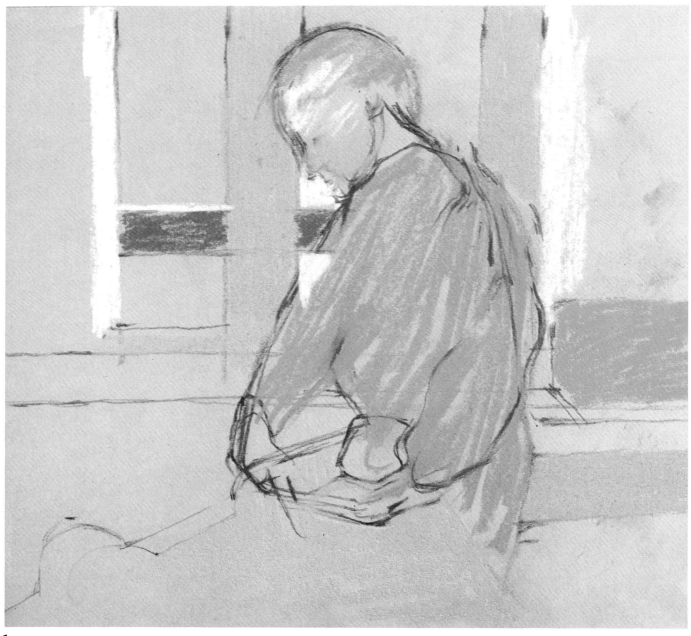

1.

2. As the drawing neared completion I began to put in the details which would give dimension to the figure. This was achieved in part by careful drawing of the profile and accurate positioning of the eye and ear, combined with modelling of the facial structure.

At this point I had the model hold her position for as long as a minute to make certain that the head, body and hands were correct. Such accuracy is important, for if the drawing of the parts shown in action was weak the emphasis would shift to other, better-drawn areas of the composition. For the same reason it is important to keep the background simple so that the viewer's attention will be directed to the moving figure.

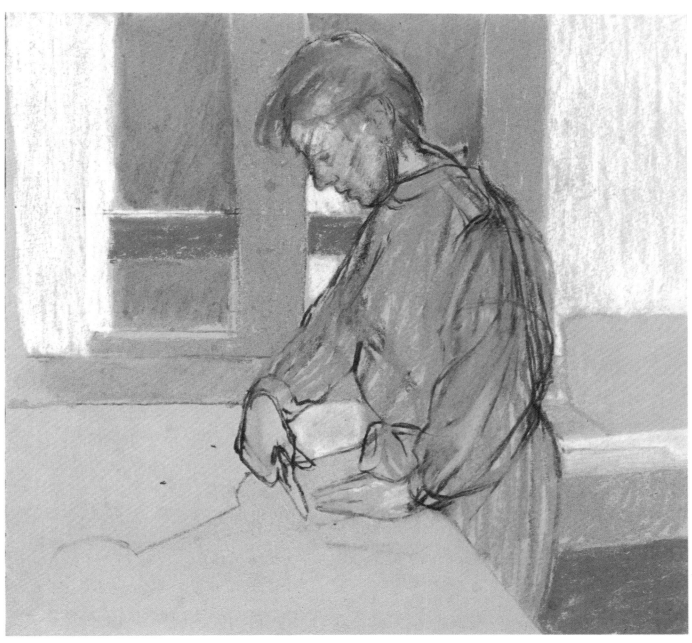

2.

The Golden Section

The illustration below shows how basic proportions are fractions of the whole – the 'golden section' of classical art. Again, this can only be used as the roughest of guides. Obviously, people's legs can be short or long in proportion to their bodies, and it is most important to record these characteristics. Models must not be given the average proportions of some idealized figure (see opposite). However, there are some general points that are of particular value, and that will help you guard against certain faults in recording the figure.

Beginners tend to make the top part of the figure too large in proportion to the bottom; for example, the head is generally much too big. In the classical proportions shown below, the head is one-seventh of the height of the complete figure, and the legs one-half. These give a guide – but only a guide – to what is usual; you should expect to find slight departures from these proportions. If your study is wildly different it could well be right. However, double-check that, in relating one part of the body to another, you have not neglected the correct proportions of another part.

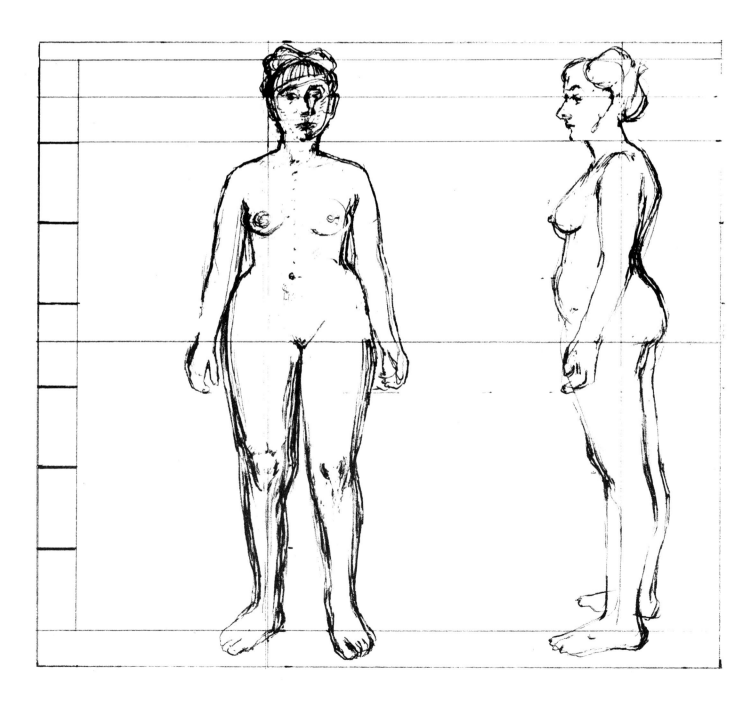

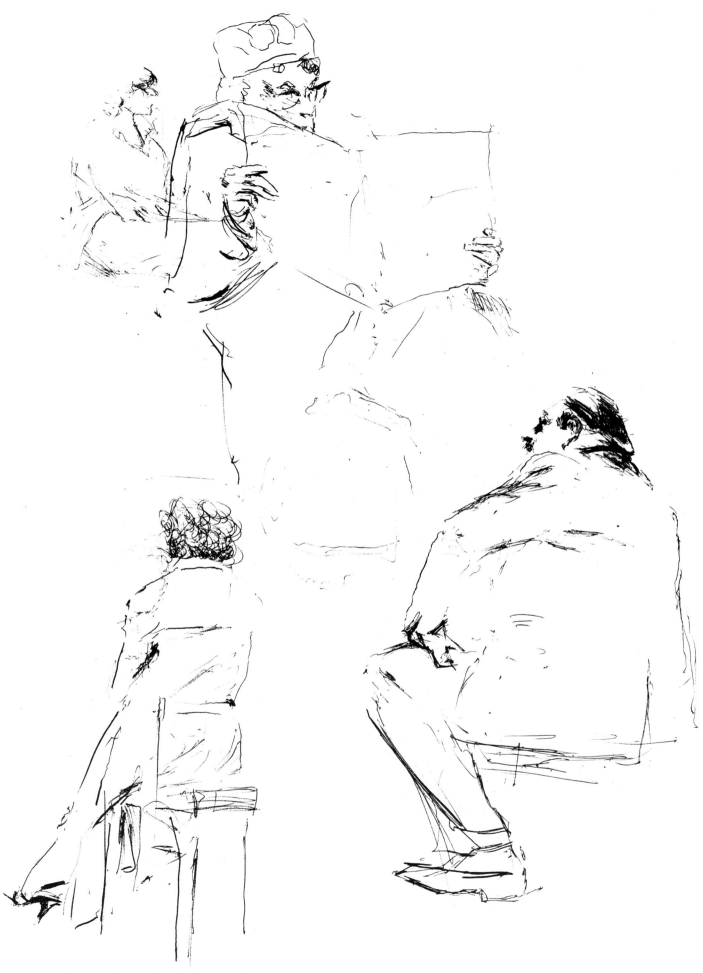

People's bodies are seldom in the 'ideal' proportion

Simple Figure Study in Watercolour

This study concentrates on the particular problems involved in painting a figure: how to use the medium to control form and space, and how to place the figure on the paper correctly, in relation to its position within the setting.

It is important to relate the figure to the ground plane in the painting in order to create a sense of the foreground, middle and background. It must also be related to other objects – the furniture and chairs in the room. Observe the shape made by the figure; it should stand out against the flat plane of the floor in the finished painting.

Try to contrast simple, flat masses of colour with complex areas. Don't worry about achieving a likeness. This project is concerned with the broad treatment of the human figure.

Step 1. If the floor plane is too low, you could lose the model's feet, and the position of the feet is one of the means of indicating depth.

Allow the floor to cover two-thirds of your work surface, and start the figure one-third from the bottom of the paper. This will create space between the spectator and the subject, and beyond. To anchor a seated figure, relate the position of the feet to the chair, and both to the floor.

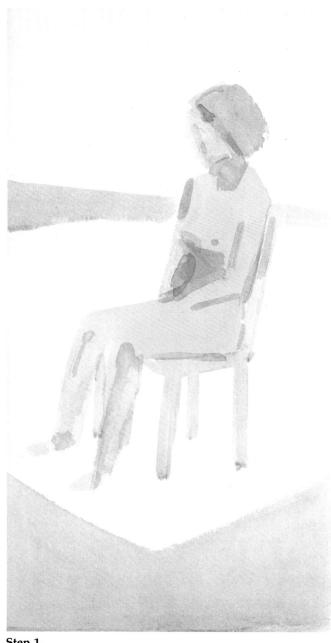

Step 1.

Step 2. The figure is a complex and difficult subject. It is best to use the simplest possible methods for the all-important task of establishing the main lines and movements of the pose. Look at the main directions of the limbs, and analyse any major directional changes. Watch for the relationship of the head to the position of the feet.

Beginners often attempt to draw the outline of the figure, and have trouble with proportions and the movement of the pose. This is because they concentrate on only one portion of the subject at a time. It is necessary to see the figure as a whole, and to establish points of reference – where a form changes direction and place – and to indicate the exact positions of the main areas of tone and colour.

Step 3. How paint is applied – the energy and speed of a line, the way in which surfaces, shapes and textures are laid – contributes much to the liveliness of a work.

Let your handling of the medium show in the finished study – with rapid strokes and washes of paint in a variety of shapes and textures. Experiment with the various marks and effects your brushes will produce. These should be an integral part of your final work. Concentrate on the main areas of tone and colour, and don't be tempted to add every detail as this can distract you from the important basic shapes.

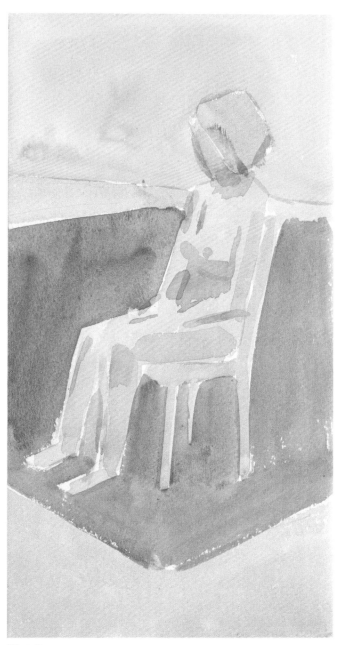

Step 2.

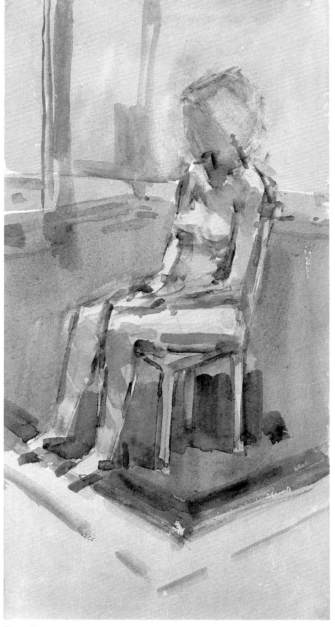

Step 3.

Balance and Movement

Matchstick Diagrams

Moving figures are important not just in figure painting, but in almost every aspect of art. They appear as part of a landscape, give life and reality to a street scene, and will be vital if you decide to work in sculpture or carving.

In movement the body balance is distorted and the human figure takes on new forms. Look at the shapes made by movement and balance; compare the figure to its surroundings, to the vertical and horizontal lines of furniture, walls and so on.

Base drawings and sketches on the simplest principles. Matchstick diagrams will show the main directions of limbs and torso. Analyse the position of the head in relation to the feet by drawing a vertical line through the figure.

See how the angles in relation to the line of head, shoulders, waist and hips change when the figure moves. The hips swing outside the vertical line in a standing figure; the position of the feet in relation to the head changes yet again.

These are simple exercises, but they do require practice. It is all too easy to be diverted from these basic procedures by the very complexity of the human figure. Try not to allow this to happen, and don't worry if the drawings don't look realistic. They are exercises in observation.

Making Matchsticks into Shapes

The figure has already been described as an assemblage of basic geometric shapes. Circles, spheres, cubes, cylinders and cones can all be seen in anatomy. Start by thinking along these lines in order to see limbs and other parts of the body as forms, and to perceive how the transition from one form leads to another. Once you have grasped the basic shapes you will see that, although the figure is cylindrical, the forms work artistically from the vertical and the horizontal. As you look round and over a sphere, the curves move in lateral and vertical directions.

The basic still-life exercises in Lesson Four dealt with describing form. However, the problems are far more complex in the human figure, and practice and constant observation are necessary in order to understand the many aspects involved.

Do some simple drawings, concentrating on movement and direction. Start by finding simple geometric shapes in the figure, then break them down into their component parts.

First Body Exercises

These first exercises will lead on to the more sophisticated problems of foreshortening limbs. If you stand a reasonably large mirror on a table you can act as your own model, and make studies of your own arms and legs. Look at the basic shapes and see how the form of your arm changes from elbow to wrist, from a cylinder or tube to a flattened, sharper oval as the wrist bones come nearer the surface. From the wrist the form broadens out and flattens, then develops into fingers.

Practise drawing variations of your hand on the table, with fingers extended or clenched, flat-on and foreshortened. Relate your hand to the surface of the table. Draw it from the left, the right, the centre. Do the same for your arm.

On the opposite page are sketches of feet and legs in various positions. Art students rarely bother with these parts of the body – we have all seen drawings of 'expressive' hands, but how many people think feet have character? – yet they are just as worthy of consideration as any other part of the anatomy.

But for anyone painting portraits or figures, legs and feet often pose the greatest problems. Try to understand how much your work will improve if your figures appear solid and comfortable on their feet. Look at drawings and paintings by the great masters, such as Murillo. He never hid hands and feet under drapery. Murillo's peasants have arms, legs and feet with real weight and force; the nails are curled and uneven, the calluses show clearly.

Quickly sketched hands in pastel

Carefully modelled hand in oil

Heads

Make a series of small studies of your head. Place the mirror in different positions to get different angles, and put it on a chair for a foreshortened view. Make sure the light is good so that the planes of your head are clearly defined. Record what you see in the mirror.

Aim for structure. Don't worry about a likeness – though one may be achieved, almost accidentally, if you use this method.

Work with a variety of media – pastels, water-colour, inks, charcoal, conté and oils; for the painted sketches, use a basic palette, thinnish paint and a medium brush.

Now begin to look at other people. Sketch constantly – on the way to work, in the train or bus – any time you have a few minutes to spare. Such quick studies of passing faces will help you to learn how to catch a momentary expression, or an instant likeness.

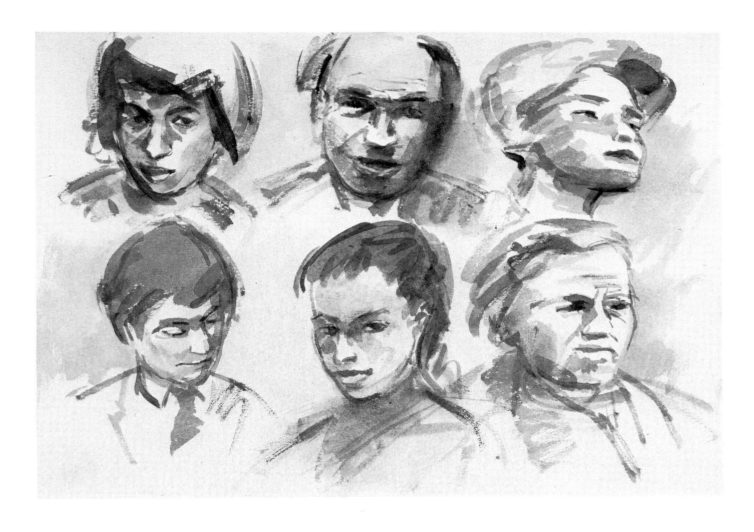

Flesh Tones in Watercolour

Flesh is basically one colour – its local colour. However, the body, like any object, reflects and takes on the colours of anything in its immediate surroundings. In addition, even if the figure's basic colour remains unchanged, it will nevertheless seem to alter in relation to the colours that surround it. A grey can become more red if placed next to a green, or take on a yellow hue when next to a strong blue. These changes affect what the artist sees and paints.

The effect of light and shadow adds a further complication. A strong light that is made up of a mixture of direct sunlight and indirect light gives a most interesting result.

Although you can mix colours while you work, it is helpful to prepare some combinations before starting to paint.

One of the most interesting ways to study the hues and tones that make up flesh colour is to observe the skin of the face. Shadows around eyes and nose, and tints of the lips and cheeks, all make for a challenging problem.

The following basic mixes give useful colours which should suffice for most figure paintings. However, it is important to combine the colours in the correct proportions and at the right strength.

Try a mixture of yellow ochre and cadmium red for the main, light, warm colour of the figure. It should be thinned out well with water, and used for a wash which will leave white areas as highlights.

For darker areas where the skin colour is in shade, or just a darker hue, mix yellow ochre with a little cadmium red and a small touch of ultramarine to add coolness.

Use a wash of burnt umber with some ultramarine where the figure is in shadow, and the colour warm.

Obviously these prescribed colour mixtures may not be suitable for every situation. Some light conditions require deep blue or pure red shadows; if the sun is strong, only lemon yellow may be needed to produce the correct colour.

Mixing the suggested combinations will help you to understand what is possible. You may even find .that only these three colour mixes are required to complete a figure painting in watercolour.

Step 1. Using yellow ochre on white paper, lay in the main overall colour of the face. Leave areas for the eyes and any highlights on the nose or other parts. Opaque white paint used on the face will always look odd, because the skin is translucent, but you can use it lightly to touch up the eyes after you have finished. When this first wash is dry, add a second, slightly darker wash of raw sienna. This introduces shadow and is the basis for further modelling of the face.

Step 1.

438

Step 2. Add a flat area of wash to establish the colour of the hair in relation to the face. This colour will also help you to decide the correct skin tones and colours for lips and eyes. Now begin to fill in facial details, using cadmium red for the mouth, and washes of burnt sienna to provide additional tone to the shadows around the eyes and to suggest eyebrows. Most people have varying tones on their faces; you will have to experiment.

Step 3. Finally, to achieve a gradation from light to dark, cold to warm, blend the colours together with a damp brush, using only clean water. The edges of the colours will no longer show, and you will eventually have a realistic modelling of the face. More colours can be added, such as ultramarine in cool areas of shadow created where the head is turned, and burnt umber in the warm dark areas at the nostril and corners of the eyes.

Add a white dot to the irises for sparkle.

Step 2.

Step 3.

Painting the Nude in Watercolour

A watercolour sketch is a good start to figure painting. It will test the extent to which you have absorbed the lessons on anatomy and balance, without being too detailed.

It will also introduce two basic problems posed by this aspect of art: skin tone, and composition around a single large subject.

Painting the nude can be a subject for amusement and humour, as well as a serious part of art school education. The least uncomfortable introduction to this aspect of art is to join a life class. However, as this is not always possible and generally limits the amount of time you can spend on your work, you should learn to use your family or yourself as models. A large mirror is essential if you plan to paint yourself, and can usually be bought cheaply in secondhand stores. Alternatively, buy plain sheet mirror.

Don't ask an amateur model to pose for more than about thirty minutes. He or she will fall asleep or get stiff. Standing poses are difficult, and cannot be held for a long time. Keep an eye on the clock, or your model may faint or collapse from boredom or lack of circulation. Professionals can work for around forty minutes. Then they need a ten-minute break.

If you are your own model make sure you can take up the pose again without moving your hands too much. You may prefer to paint yourself painting yourself and simply look up to the mirror from time to time.

It is extremely difficult to paint against the light – that is, with the main source coming from behind the model. To begin with, have light coming from behind you onto the model, or from a source above or to the left or right of you.

Although it is possible to work by artificial light – even normal domestic lighting – daylight is better as you will have less difficulty mixing and matching colours. Finally, for the sake of your model (or yourself), make sure the room is comfortably warm.

Step 1. Lightly sketch in pencil the main shapes of the figure and background, as a guide when laying in the main wash areas. Study the figure to determine the basic flesh colour of the model. Mix enough paint of this colour to lay in an overall wash. Be sure to leave areas of white where you see there are highlights on the figure. Look for the darkest area in the figure and indicate this with a blue-grey wash.

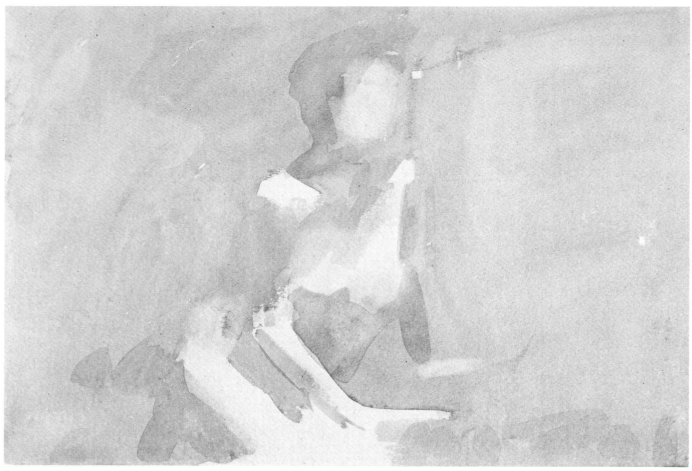

Step 1.

Step 2. Allow the first wash to dry thoroughly and then add a second. This should be a warmer, darker version of the original flesh tone. Apply this wash carefully, as it provides the shading which fills out the figure. At this stage the picture will already look as though it is almost finished. But do take the time to check the proportions, angles and spaces created by the way the model is posed. If these elements are correctly drawn, the figure will look believable and will be a good composition in itself.

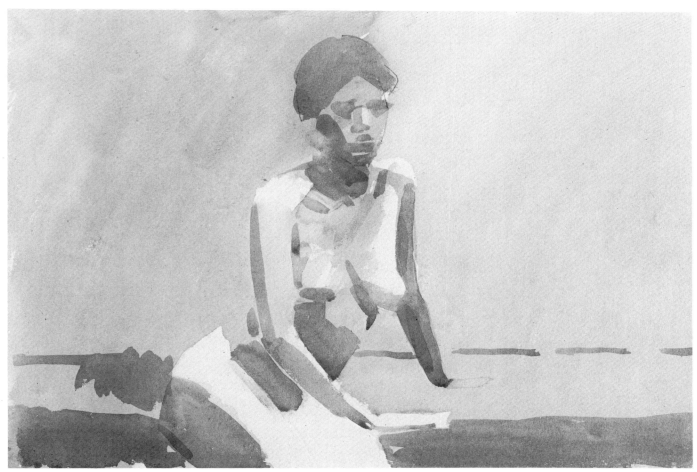

Step 2.

Step 3. Study the model and decide where darker areas of colour should go. There will not be many of these, so this third wash must be applied with discretion. Using the second wash colour as a guide, mix a small amount of a yet darker tone, and apply it where needed to model the figure.

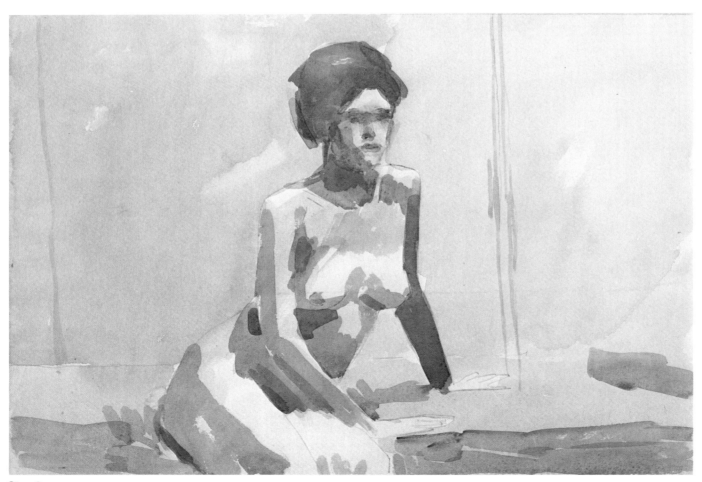

Step 3.

Step 4. To complete the study mix a dull blue, medium in tone, made up of ultramarine blue and a small amount of burnt umber. Use this wash to draw in the facial details and accentuate bone structure. Use it also to emphasize the darkest areas in the composition, such as the hair and the shadows cast by the figure on the background.

You can use a wide variety of techniques when painting a figure with watercolour, such as working wet on wet, or blending the colours together with a small sponge. But before you begin experimenting with different methods, first learn to paint according to the method described.

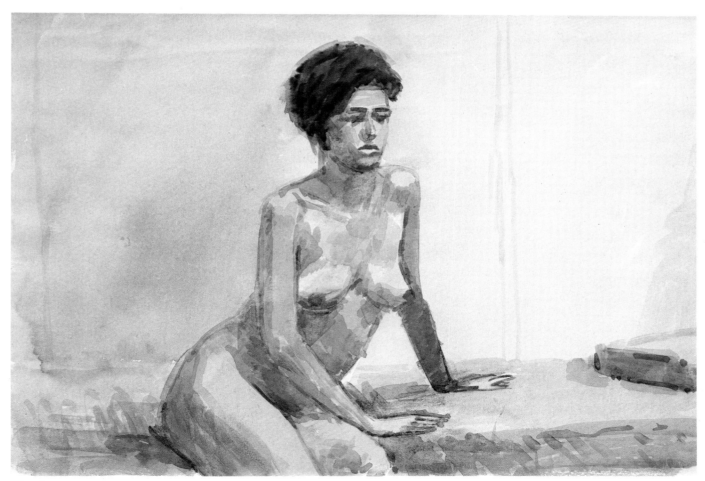

Step 4.

Figure Studies in Oil

Awareness of space and depth is important for recording the figure. Too often paintings are simply flat shapes and colours which, it is hoped, will somehow persuade the viewer that the original subject-matter was three-dimensional. This awareness is especially important when you use oil paints, which have texture and depth in themselves.

Oil paint is particularly appropriate for these spacious compositions, because the richness of deep tones and colours adds enormously to the sense of solidity and strength in the picture. For the student, the painting below works best in black and white. The single figure in the foreground is balanced by the three interconnected figures in the centre. The white tones on faces and gowns make them the focal point. At the back, a shadowy onlooker is a seemingly casual but very important factor; try blocking the figure out with a piece of black paper, and the picture changes – the central figures seem to move forward.

The classical artists of the Italian Renaissance and after described the human figure extremely accurately, not only as a flat shape filled in with the correct tones and colours, but also as an object in a three-dimensional world which they interpreted convincingly in two dimensions.

Look at oil paintings in galleries and museums, and study the concept and description of space used by the great masters.

Depicting movement and life in the body is one of the major accomplishments that an artist must learn. Even if you never paint a portrait or a figure study, some of your landscapes will be emptier than you would wish if they have no people; and awkward figures, moving stiffly and out of proportion, can destroy an otherwise good interior or garden scene.

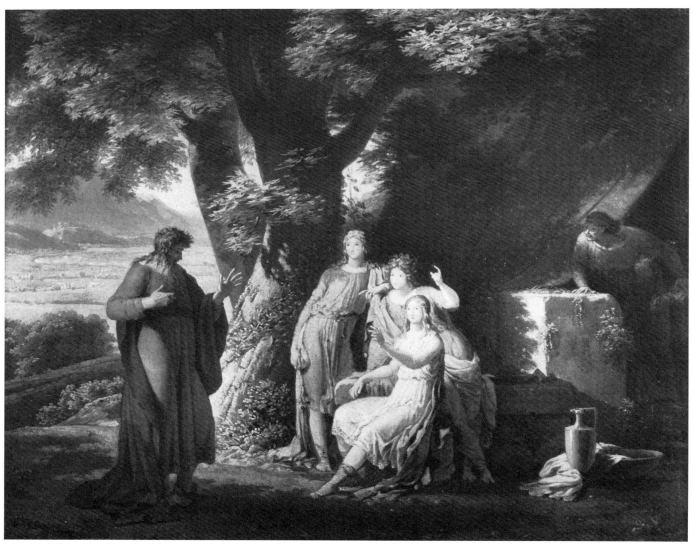

'An Arcadian scene'; Poussin

Skin Tones in Oil

There are a number of ways of using oils to interpret skin tones. Underpainting adds substance, while glazing and scumbling give a textured sheen. If you work alla prima, or with direct touches of colour, the figure will be full of lights and darks on the surface plane. Carefully built-up smooth layers of paint and glaze are also convincing, as are broad broken interpretations of form and mass. Suggestion can be as effective as an exact imitation, but in both cases the quality of observation is the key factor.

The problems of dealing with skin shades in individual features, such as nose, mouth, ears, hands, the area around the eyes, and so on, are all aspects of one problem: how they relate to the whole figure.

Individual features should be made subservient to the form of the head – a spherical form on which the nose and eyes are projections and indentations. Light, medium and dark tones can create advancing and receding forms within the basic sphere.

Composition in Oil

In figure painting, the main shape, placed against the square or rectangle of the canvas, will become the figure against its surroundings. A full-length figure must somehow be placed firmly on a support, and must be related both to the size of the working surface and to its surroundings. The way in which the main masses in the composition are used can create a sense of stillness or of movement.

Always make some preliminary sketches in pencil, tonal washes or colour, to help you decide on the final composition. Don't skip them – it is better to make mistakes at this stage than in your large finished pictures.

The sketches will help you make up your mind whether the figures should be placed at the top or bottom of your working surface, or on the left or right. Make small diagrammatic arrangements and choose the one that interests you most – an imaginative combination of figure and setting will produce an inspiring subject.

Matisse used backgrounds composed of wonderfully bright, patterned fabrics to enhance the colour and visual drama of his subjects. Bonnard preferred to paint models in everyday domestic situations – standing or sitting in a bath – and used the sparkling effects of the light and colour that surround the subject to the same effect.

For the sketches below of a simple nude sitting in a chair I set up a marvellously complex background not of patterns but of shapes. I pinned up squares of colours and canvases behind the model's head to increase the almost abstract effect, and the straight arm was echoed by the straight shadow of the window-frame.

From the first sketch you can see that I began with an undercoating of raw umber, then quickly blocked in the main forms with blues, purples, and yellow. In the second stage I added details and features, but there is no attempt to make this a portrait; the dynamics of the model's position and the curves of her body set against the deliberately flat background provide reason enough for this composition.

When you have been doing a number of carefully detailed paintings, it is always a sound idea to splash out in a free and decorative manner. It is good for your eyes, your hands and arms, and, above all, your perception.

Study in Shadows

We have talked about figure studies as part of the vocabulary of art, and it is important to regard them as an essential building block in the process of learning to paint.

Many of the studies we show are nudes, but you must not think that it will be difficult to find models; that would inhibit you from attempting to paint the human body as often as you can. Use yourself, members of your family or close friends and fellow artists as models.

With the human figure in any pose, the effect of shadows and light can change both your vision and the study that you make. Both these illustrations are of the same model, made before I began the painting overleaf. I was looking for a way of using the shadowed light from the window to blend the figure into its background, yet leave it distinctly apart. The first study was done in hard line, and although she looks relaxed and comfortable, the effect was too even. When she turned around and pinned up her hair, the light picked out a line along her back and arm, down one leg and across the stand, making a much more interesting study. These are the kind of considerations you should have in mind before you actually mix your paints.

You need not be explicit. Remember you are not supposed to be copying an erotic magazine or a film; in any case, highly detailed rendering is not necessary. Learn to see the body as these examples indicate: as a pattern of shadows, grace and line, in warm tones of flesh, integrated into the rest of the painting or drawing.

Woman by a Window in Oil

The sketches shown here are of the same model seen from two or three slightly different viewpoints. In every case I used a small enclosed corner setting to give the painting definition, and found a stool for her to stand on, adding a little height and interest to the composition. (You could try putting a few crates or wooden boxes together, covered with a piece of cloth for the same purpose.) Raising the figure slightly creates a new feeling, a much more formal impression, than a simple studio sketch.

1. The tiny study was done first, right in front of the window, with sunshine and clear white light coming from the north, with the result that the model is almost in silhouette.

2. In the sketch below, the open window creates a splash of bright white and yellow which lifts the entire painting into a new dimension, shadowing her body with pinkish tones.

1.

2.

3. The painting below was done as I worked on into the evening, so the light has faded to a rich mauve, with flecks of sharp contrast from the setting sun.

With all similar studies and paintings, try not to be too careful or too precise. For new painters, it is a constant temptation to attempt to put everything in the one work; if every bit of energy is expended on a tiny part of the whole, you will become discouraged before you get halfway through a simple exercise.

This is particularly true with full-length studies, as the complexities of shifting lights and shadows make it difficult to finish much at one sitting. Take courage, put your paint on broadly, and learn to see in masses, in shapes, and forms. As you develop more facility with brushes and paint, your strokes will become fluent and controlled, and then the tiny details of features, patterns, and so on, can be added, as they will be in the next lesson.

3.

Extra Project

Clothing the Figure

Drapes and folds in fabric pose a new set of problems. Start by observing the form which the material covers; try to ignore the nature of the folds themselves. Leonardo da Vinci, like other Renaissance artists, made excellent drawings of drapery over figures. If you look in a mirror you will see how your body affects your clothing, creating folds at the elbow of a jacket, for instance.

The fabric in a skirt worn by a seated woman falls away from her knees. The main tonal masses are created by the position of her legs, and the secondary shapes – folds and creases – follow, and are governed by, this main structure. The pattern and colour created by clothing can be used to reinforce the form or to heighten a painting's decorative qualities.

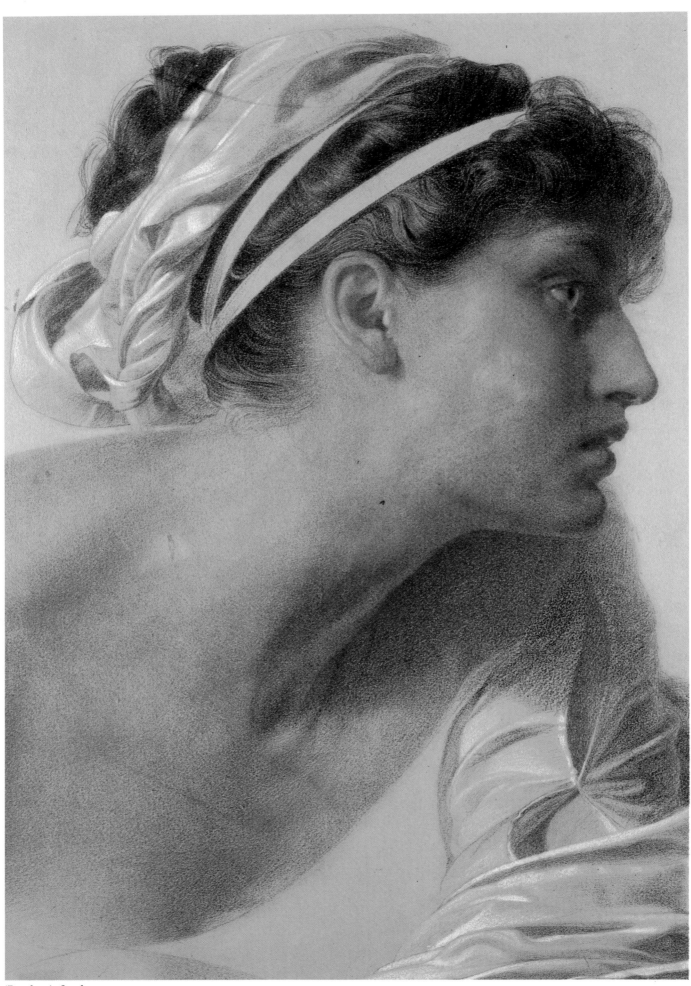

'Penelope'; Sandys

Lesson Twelve Portraits

The desire to picture a face so that it can be recognized as a particular individual is as old as the artist's curiosity. Primitive tribal masks often represented a particular god, spirit or revered ancestor, with a recognizable face, though for many people the idea of representing their own faces would have been frightening and possibly dangerous.

The stone carvings and wall-paintings of the early Middle and Near Eastern civilizations were sometimes so stylized that a particular person could not be identified, but this was not due to lack of technique; we know from paintings and sculptures of the period that craftsmen could be very precise and marvellously adept at creating a portrait when tradition allowed.

Ancient Greeks and Romans considered sculpture to be the finest art form, but there are striking painted portraits, fully modelled and very lifelike, on excavated coffins. Even during the Byzantine and early Christian era, when portraits in mosaic may have been stylized, many were nevertheless, clearly individualized.

As the Renaissance developed, interest in painting real people began to overcome old superstitions and traditional fears. Some of the most effective portraits of that or, indeed, any period were painted by Jan van Eyck (c. 1384–1441). His double portrait the *Arnolfini Marriage* is considered

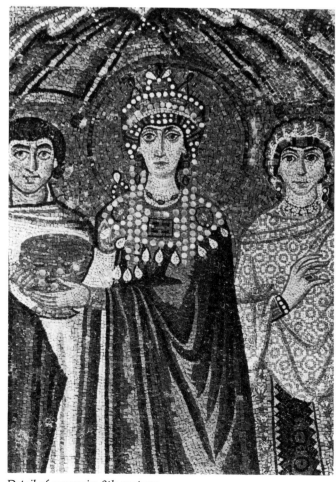

Detail of a mosaic; 8th century

revolutionary in technique; aside from its exceptional quality as a painting, the figures were shown full-length at a time when most portraits were head and shoulders only.

There are far too many fine examples of Renaissance portraiture to choose one or two outstanding examples. They include the colourful, brilliant head of *Doge Loredano* by Giovanni Bellini (*c.* 1430–1516); the *Camera degli Sposi* by Andrea Mantegna (1431–1506), decorated with episodes from the history of the Gonzaga family; the works of Titian (1487–1576) who with El Greco (1541–1614) was one of Philip II of Spain's favourites; and the eternally enticing portrait of an unknown woman, the Mona Lisa, although that was not the title Leonardo da Vinci (1452–1519) gave to it.

Hans Holbein's many portraits of Henry VIII, his family and courtiers, are both robust and psychologically compelling, as are the mysteriously delicate miniatures of Henry's daughter, Queen Elizabeth I, by Nicholas Hilliard (1547–1619).

By the end of the sixteenth century, private patronage had begun to replace that of the Church, and most of the greatest names in the history of art worked both to commission and for personal satisfaction; Diego Rodriguez de Silva Velazquez (1599–1660) might paint a genre scene of an old woman frying eggs, or a remarkable group portrait of the Infanta and her ladies, with the artist at work reflected in the mirror. Some artists were best known for their portraits. The paintings of Charles I and his family by Anthony van Dyck (1599–1641) still arouse compassion for that monarch, deposed and executed during the Civil War in England, and although Rembrandt van Rijn (1606–69) may have painted and etched historical scenes, as well as landscapes, it was his brooding and dramatic portraits which established his reputation.

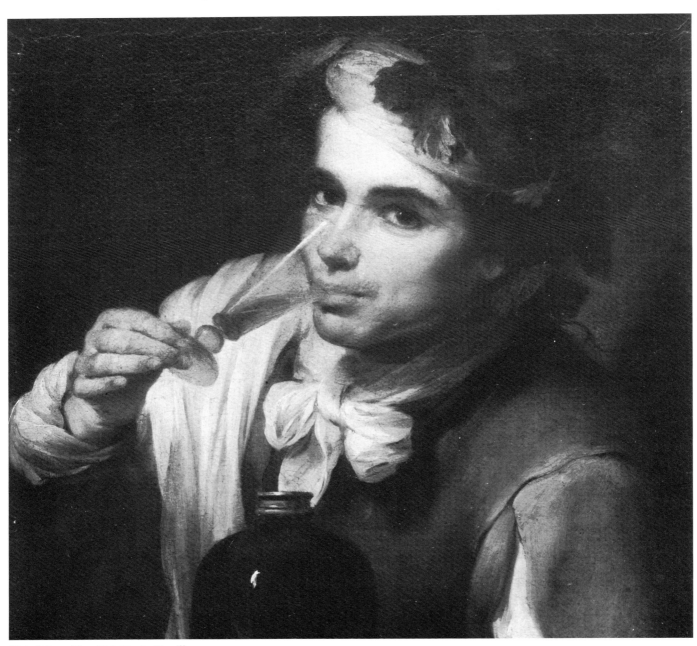

Detail from 'Boy Drinking'; Murillo

There were still many fine portraits by artists – Bartolemé Estabán Murillo (1617–82) is an example – whose work was mainly for the Church. Murillo's Holy Family paintings are remarkable for their human, individual quality, their faces expressive of tenderness and gentle love. Even his portraits of purely secular subjects are notable for their beauty and innocent sensuality.

As landscape and genre painting developed in Holland and France, historical and classical styles of painting fell from favour, and portrait painters also formed loosely into two schools: artists who also painted the occasional portrait, and those who painted very little else.

Sometimes it is hard to distinguish between the two. A painting called *The Swing* by Jean Honoré Fragonard (1732–1806) is actually a portrait of a French nobleman and his mistress. *Madame Recamier* by Jacques Louis David (1748–1825) is more concerned with expounding a style than portraying a human being, but a few extraordinary men like Francisco de Goya (1746–1828) were able to combine carefully observed portraiture and a profound sense of the importance of setting and composition.

Men, women and children painted by Thomas Gainsborough (1727–88) inhabit a genuine and lively world of well-heeled comfort, enjoying the English countryside, while Jean Auguste Dominique Ingres (1780–1867) is notable for the impassive grace of the women he painted, with their porcelain skin and all the finery of the French silkmakers carefully rendered with superb technique.

In America the early republic had some fine exponents of portraiture – John Singleton Copley (1738–1815) is known for his realistic but classical portrait of Paul Revere among many others, and Gilbert Stuart (1755–1828), one of the finest portrait painters of his time, could make his *Skater* into a Neo-Romantic masterpiece, but is best known for his portraits of George Washington. Thomas Eakins (1844–1916) was fascinated by the American scene, and his genre paintings and portraits show many aspects of Philadelphian life with remarkable skill and a sense of the dramatic.

Until the end of the nineteenth century, portraits were considered best left to private or corporate commissions, but with the beginning of the Impressionist period, the artist's interest in colour and light transformed everything, including techniques and poses.

Exact likenesses were not the prime consideration as artists began to play with techniques and visual experiences, looking for planes and shadows, and paint-susceptible qualities.

Over the past eighty years, every change in style has been mirrored in portraiture – the gentle

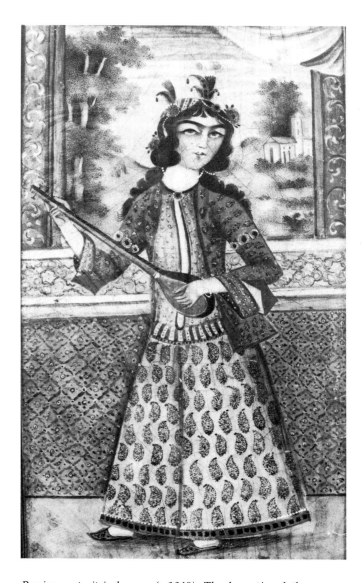

Persian portrait in lacquer (c.1840). The decorative clothes are as important as the model, but a different technique is used to depict them

tones of Edgar Degas (1834–1917) and Pierre Auguste Renoir (1841–1919), the wildly exciting lines and flat colours of posters by Toulouse Lautrec (1864–1901), the delicate drawings of Augustus John (1878–1961), and the modern neuroticism conveyed by Lucien Freud (*b.* 1922).

Looking at portraits today we have such a multiplicity of sources that the choice is overwhelming; the modern romanticists, the Pop movement, the revival of interest in Indian and Japanese simplicity, and so on.

Portraiture may usually be the province of specialized painters, but the effort to create the image of an individual human being on canvas will surely remain a fundamental impulse for every artist, and a source of deep pleasure and fascination for the viewer.

What Makes a Portrait

The previous lesson on figures introduced two of the main problems in portrait and figure painting: the difficulty of making a figure look lifelike, and of making it look like the model or sitter. Although they sound the same these are, in fact, quite different aspects of painting.

A 'lifelike' figure looks as if it could move. Some professional artists, including a number of famous painters, have never been able to suggest this quality and are careful not to include realistic figures or people in their studies. A picture that looks like the model must also incorporate the person's essential characteristics. This is another specialized talent that many artists lack.

Successful portrait painting demands the ability to create a picture that is both lifelike and recognizable. It involves not only accuracy of observation, but also an understanding of the sitter and how he or she responds. At their first sitting the best portrait artists spend almost as much time chatting or listening to music with the subject as they do painting, trying to see through the physical characteristics and evaluate the sitter's personality.

The basic difference between a figure study and a portrait, therefore, is that the latter has an extra dimension; it embodies the emotional interaction between the artist and the person being painted. This cannot be eliminated, and is possibly the essential ingredient which makes a good portrait into fine art.

Portraits by Rembrandt and van Gogh, for example, are marvellously strong re-creations of people on canvas, seen through the artists' eyes. The nature and character of the sitters come across with great vigour.

Different Approaches to Portraits

All drawing and painting involves choice. You decide what to select from the visual world. In portraits, as distinct from paintings that happen to have people in them, the complications of deciding what to paint are much greater than with any other subject. The essential aim is to create a likeness of feature and personality. This can be achieved in different ways.

The standard approach is to copy exactly the shapes and colours of the three-dimensional sitter, translating these carefully into a flat, two-dimensional painting. This slow, meticulous and methodical approach should theoretically produce a good likeness in tone, shape and colour. Photorealism is an extreme example, and can be successful in the photographic sense.

A second approach is more direct and emotional: recording how the artist's mind sees the sitter, starting with the main shapes of the face, details of the eyes, nose, lips, ears and hair, then filling in the light and the shade. The intention is to capture the person's character, accentuating his or her attitude, the special qualities in the face, the look in the eyes, the individual shape of the lips.

Obviously, many portraits fall between these two methods. You will find from experience which suits you best, and which is appropriate for an individual sitter – and the purpose of the painting. Almost all drawing and painting demands logical and methodical organization; yet you cannot work without emotion – the extra ingredient that makes a portrait an artistic experience.

When Matisse said 'L'exactitude n'est pas la vérité' (accuracy is not the truth), he was distinguishing between accurate copying and artistic translation. A portrait is, after all, a painting of the soul.

Many inexperienced artists feel compelled to use all the colours on their palette when starting a portrait. This can make the exercise unnecessarily difficult. Instead, intentionally limit your palette to one, two or three colours.

As mentioned earlier, skin may be rendered in its local colour, so a basic wash mixed to this hue would naturally be your main colour. Paint it on the paper to indicate the face, and leave areas of highlight as unpainted paper. When the wash is dry, put in the modelling of shadows with a darker tint of the same colour.

The examples on this page show three versions of a portrait, painted with a limited palette.

1. The boy's face is rendered in only two colours: yellow ochre and indian red. The highlights are shown with areas of white paper or thin wash, and the dark shadows with red and heavy washes of ochre.

1.

2. This example uses the same combination of colours, but ultramarine blue has been added to provide a little more definition to the modelling, and this gives the impression that many more colours have been used. In fact, of course, the combination of yellow, red and blue should, in theory, offer you a full colour range by mixing.

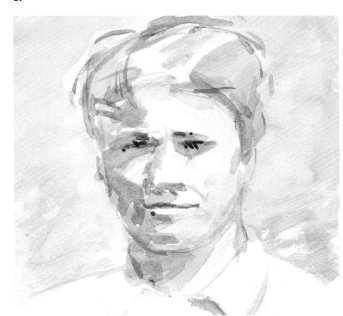

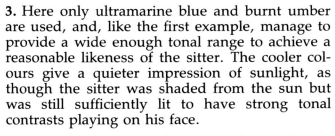

2.

3. Here only ultramarine blue and burnt umber are used, and, like the first example, manage to provide a wide enough tonal range to achieve a reasonable likeness of the sitter. The cooler colours give a quieter impression of sunlight, as though the sitter was shaded from the sun but was still sufficiently lit to have strong tonal contrasts playing on his face.

Any combination of colours may be used, and you should experiment until you have gained enough experience in the possibilities of a limited palette. In the end, exercises like this will help you to choose the correct colours for each situation and sitter.

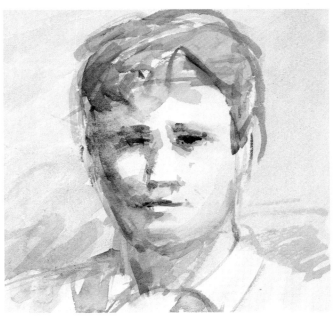

3.

Starting to Work

The earlier examples of facial sketches were basically anonymous.

In studies of the human head, facial details may be easy enough to position but can prove surprisingly difficult to draw. The set of the mouth and the shape of the nose and the eyes are all distinctive, and these must be accurately drawn to make the picture a portrait – for it is by such details that we are recognized. By exaggerating the shape of a distinctive nose, for example, cartoonists can render a personality instantly recognizable.

Needless to say, it is practice that will enable you to observe and draw the faces accurately. Draw heads on all possible occasions, aiming as far as possible to achieve a close likeness each time.

When you are not able to do a complete head – for example if you are sketching while on your way to work by train or bus – make studies of individual noses, mouths, chins, ears, pairs of eyes, and so on.

It is also extremely informative to look at the sketchbooks of Leonardo da Vinci. His quick drawings of expressions and features are marvels of observation.

Just as it is important to study all the various aspects of the face, it is also necessary to use a wide variety of media when doing portrait studies. Conté crayon, coloured inks, charcoal and pencil can offer all kinds of possibilities in line and tone.

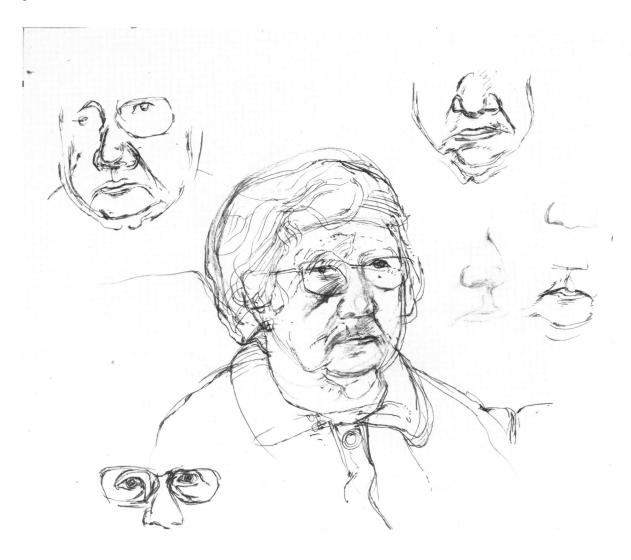

Pastel Studies

The contrast of hair colour with flesh tones may be an important aspect of the individual; or the way in which the forms and planes of the face fit together may be your particular concern. These may be more readily explored by means of conté or pastel than pencil or pen and ink. Try a few experimental sketches, focusing on the hair and attempting to capture the curl, wave and texture in both line and tone. This sort of sketching will provide invaluable experience and increase your artistic vocabulary, for you will know that a certain type of line perfectly describes a texture, or that a combination of line and tone implies a contour or expression.

Sitters often pose with their heads in their hands. Do some studies of this kind of position, noting how the facial muscles are altered by the weight of head on hand. The pose will also greatly increase the number of planes – and the amount of attention you must pay in order to get accurate proportions.

Self-portrait in Pastels

It can be difficult to find a model, and not everybody – even a long-suffering member of your family – is prepared to sit for long periods. Self-portraits solve the problem of having to use one, and you will be following the example of many artists, including Rembrandt, who quite often drew or painted themselves.

It is best to use a model for full-front views – it is all too easy to see yourself as very different from the face reflected in the mirror. Three-quarter views, however, are good subjects for self-portraits. Because you see yourself from an unusual angle, the personal element is subdued

and it is easy to work from mirror to paper without moving your head too much. Sit comfortably with a good light on one side and a mirror 4ft or 5ft (about 1.2m to 1.5m) away.

Use red pastels or coloured chalk on sepia or cream paper to add interest and reality to your work. Remember, flesh tones are pale brown with pinky hues, rather than pink. However, for this first portrait concentrate on tone and shadow.

The front of your head will probably be in the light with the side in shadow, although the reverse is possible. This contrast of light and shade can be used to make the head look solid.

Step 1. Using neutral colours, sketch in the main shapes of your head, upper body and background. Work very loosely and do not concern yourself with any detail. Simply indicate where your features fall and establish the correct shape for the head. Remember, when you use charcoal or pastels, to work with a relaxed wrist or the line will be too tight.

Step 1.

Step 2. Begin blocking in large areas of flesh tones so that the drawing of your head starts to take on a feeling of solidity. Decide which side of the head is highlighted and indicate this with small touches of white; shadows can be put in with cool blues and greens. Work up the background, keeping the tone subordinate to the overall tone of the head.

Step 2.

The two sides of the face are not identical and it is important to observe the differences and incorporate them in your drawing (see Asymmetry, page 472). Look constantly from one part of your head to another, and compare what you have drawn with what you can see. Most people have preconceived ideas, for example, about the size of their ears and exactly where they are positioned on the head. Use your knowledge of receding planes and perspective when placing features.

These drawings will need a great deal of concentration. Seeing is important in this study as in all art. If you are looking hard you will feel no need to talk to your model!

Step 3. Develop facial features by defining the contours with line. Use darker shades of the colours you have used so far; use pencil to give a really fine line. Pay close attention to the proportions of your face, adjusting the relationships between features if necessary.

The circle around the mouth on the first step has now become the area around the chin, and the effect of the highlight at the corner of the mouth is clearly marked. A few jagged lines mark the pattern on my shirt, to be blended into the mass below the neck.

Step 3.

Step 4. Blend the pastel colours with your finger-tips to give smooth areas of skin, and work more line drawing into hair, eyes and lips to give greater definition. The background should be completed now, but must be kept very simple so that it does not compete with the portrait; keep all detail for face and clothing. Take a close look at the colours within the areas of shadow as these should relate to your overall flesh tones. It is this kind of attention to detail that will create an accurate likeness.

Step 4.

Profile Study

Use any medium you are comfortable with, but remember that for this first sketch you will be better off with a soft pencil or sharp charcoal stick, rather than pen and ink or thick charcoal crayon.

Use a pad of paper about 8 × 10in. (20 × 25cm) and make the portrait a good size. Most beginners start with too small a picture, and try to draw tiny details in the middle of a large sheet of paper.

Ask your model to sit comfortably 4ft or 5ft (about 1½m) away from you, neither too far away nor too close – both will distort the image. It is best, and most comfortable, if you are both sitting. Your eye-level should be on a level with the head you are drawing.

Step 1. Sketch lightly the shape of the head. Don't use the circles and ovals of classic figure drawing; use your eyes instead. Look at the negative shape first – the shape of the space around the head.

In this case, the shelf support and the box behind the sitter make a right-angle intersected by the back of the head. The forehead is almost exactly in front of the edge of the photograph frame, and the nose comes halfway down the shelf itself.

Try to fit the outline of the features within the shape. Once again, use reference points for the end of the nose, the chin, the nape of the neck. You may find that the features don't quite fit, and that you have to change the shape of the head itself.

When you choose your temporary studio, look for vertical and horizontal references in the background.

The corner angle of a wall is useful, so is the edge of a picture or a shelf, a window-frame, a curtain, the straight top of a sideboard, etc.

There should also be a few smaller reference points. Books on a mantelpiece or, as here, a box on a shelf, are important extras. Add a vase or a tall glass if there is nothing there already.

Draw the largest forms first, and then gradually break these down into smaller and smaller units. Look through the earlier lessons if you have trouble drawing shapes.

Step 2. Carefully draw in the features, as if you were drawing a landscape. Try to forget that you are drawing a lip – treat it instead as a topographical feature. This objectivity is important. Most people subconsciously think of lips in a particular way, and there is a tendency to draw a symbol for a lip, rather than the lip you actually see.

All heads are different – all people are different. The most important priority in portrait painting is to stress that difference, not to produce a stereotype. Look for the very particular, not for the general.

Remember that your treatment of the head must vary or the drawing will look like a flat cut-out. The outline should be less than distinct in some places.

Begin to sketch in the shadows and some of the background.

Step 1.

Step 2.

468

Step 3. Now fill in the details. Make the strokes delineating the hair in the direction in which the hair grows.

Don't forget the soft, smudgy details like eyebrows and lashes – they add immense character and depth to the shape of the face. Put some identifiable objects in the background to give the viewer a feeling of reality.

The curve on the top of the picture-frame may not actually be there, but without it the frame and its vaguely sketched photograph could be almost anything. Block it out with your hand, and see the difference it makes to the setting.

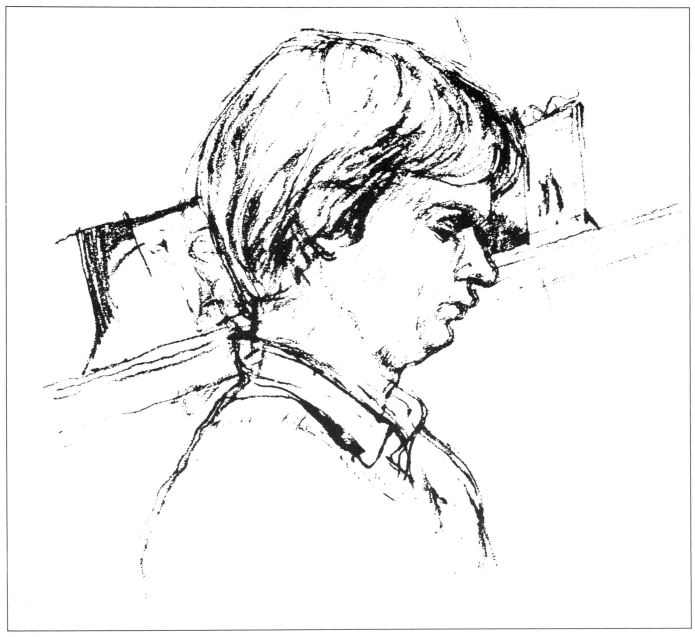

Step 3.

Using a Model

Portrait studies will enable you to discover how little you have actually seen before; and how interesting and beautiful any face can be. Each of the drawings below gives a different insight into the model – which is why artists can happily paint themselves, or a model, many times over a long period.

You can learn a great deal by looking very closely at works by good artists. A number are listed in the biography section, and you should be able to find reproductions in books on portraits or individual artists. Analyse the way in which negative shapes are used. As you make your version in a sketch or a study you will see that a slight difference between your work and the original artist's can alter the result completely.

An interesting exercise is to turn a few reproductions upside down before copying them. Many students get far better results working this way. It is easier to draw or paint what is there 'in the abstract' and there is less temptation to work from preconceptions. Use an illustration or an inexpensive reproduction as we have in the example below. Then you can draw over it, or even paint over it, without destroying a fine print.

One point – before you think we are now telling you to copy an illustration, when we have warned you not to do so in all our previous lessons, remember that this is for a particular reason. The techniques of portrait painting are more difficult than those of pure art, especially when you are striving to create a likeness of your sitter (see opposite page).

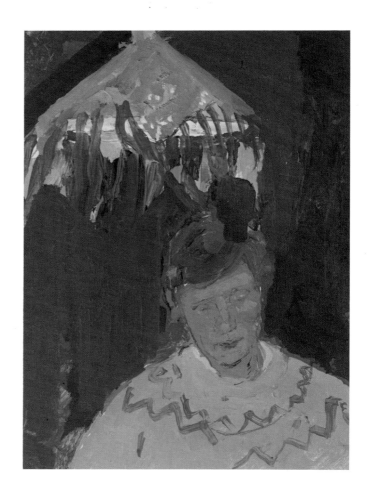

Catching a Likeness

One of the main points in obtaining a likeness has already been touched on: recognizing the particular proportions and features of a head, not just drawing what you think might be there.

However, there are bad portraits that look like the sitter, and well-painted portraits that are not instantly recognizable. To obtain a likeness you must be able to identify, and even exaggerate, the characteristics that make a model's face unique. These are almost always contained in the shape of the head, mouth and eyes – the parts of the face that, with very slight movement, can transmit a wide range of information.

Asymmetry

When working on full-face portraits you must guard more than ever against preconceived ideas of what people look like. Draw or paint what you actually see. Otherwise you will tend to put down symbols rather than actual features.

The front view of a head is the one which is most familiar. It is the first view a child draws, and it is what you see in the mirror. It is also the one that involves the greatest number of preconceptions. Most people think the face is symmetrical; it isn't. They think they know what the various parts of the face look like and, worse still, what drawings of these parts should look like. The photographs on this page show how asymmetrical even regular features really are.

'Portrait of Steiglitz'; Coburn

472

Poses

There are many conventions used in portrait painting. A three-quarter view is often used, and the sitter is usually on a slightly higher level than the artist. The work is normally an upright rectangle and the drawing or painting stops just below the shoulder. Larger studies show the upper half of the figure, with the hands displayed, or else the figure is shown full-length.

A man and his daily work

A girl and her daily exercise

Background and Props

Many portraits are made in a studio with only an appropriately coloured drape behind the head. Others include possessions grouped around the sitter or in the background to show his or her status.

Since the nineteenth century portraits have become less formal. An artist may show a subject at work or sitting informally, as though the decision to draw or paint someone in a particular place was made spontaneously.

Pattern and colour can be emphasized in particular kinds of portraits, and the normal effects of light and shade almost ignored. The result is a variety of patterned shapes, almost a collage of cut-out patterns, and makes a decorative picture.

You will have to find a subject that already has a strong element of pattern – a room with patterned hangings, wallpaper and carpets, for example.

Alternatively, set up your own arrangement. Persuade friends to model for you, and ask them to wear clothes with interesting prints or stripes. This is a most rewarding way of using figures, and a serious approach to studying painting including the decorative element. Many painters have found great inspiration in strong colours and patterns, both of which are fundamental to so many works of art, whatever their subject.

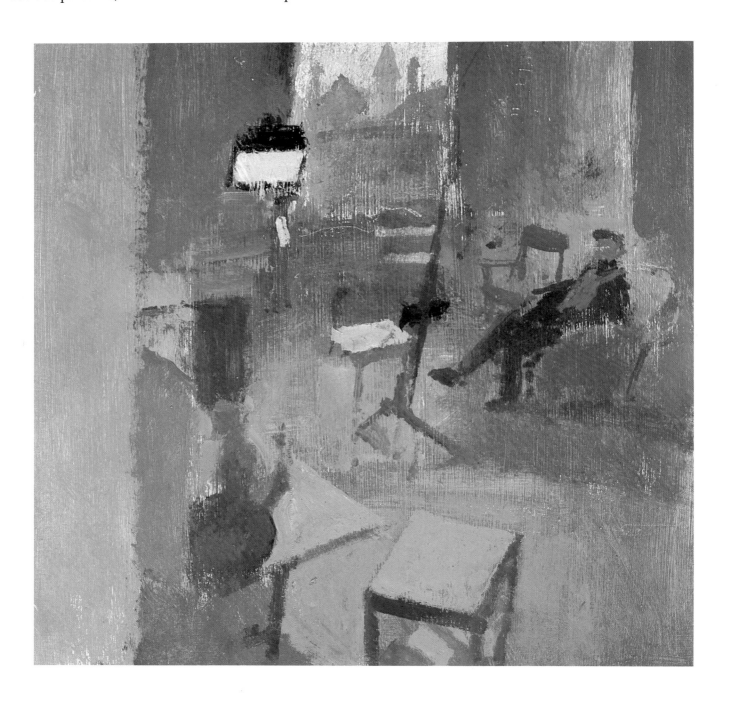

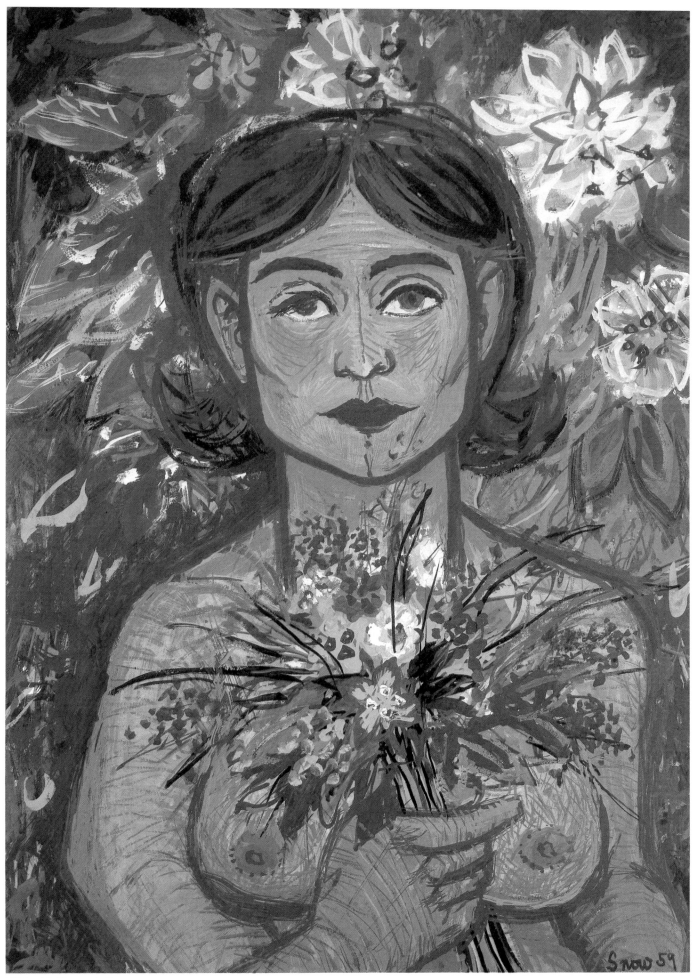

'Girl with Flowers'; Snow

Portrait in Watercolour

Painting a portrait in watercolour only is difficult for beginners. It should certainly be encouraged but the result is likely to be disappointing.

It is more rewarding to start by combining watercolour with some other medium. It can be used to add colour to a pencil drawing; or for the main colour areas, with line drawing and accents added in pastel.

Step 1. Usually the most difficult thing to resolve in a portrait is where to put the face in relation to the edges of the picture. As the hair is the main block of tone it is advisable to paint it in first. It is the most dominant feature of the composition and its position, once established, will dictate the placing of everything else. Use one flat wash and a large brush. Concentrate on the basic shape and avoid any detail.

Step 2. Having established the position of the head, begin to draw in the outline of the face and body. Again, avoid putting in any detail at this stage – you are merely setting out the elements of the composition.

Step 1.

Step 2.

Step 3. Begin thinking about tone by studying the face, trying to reduce the complexity of colour and tone to a very simple, single, mid-value tone. Mix a wash to correspond and use it to sketch in facial details. These may be augmented by a few dark touches to indicate shadow.

Step 4. The hair, which is still a basic tone, can be added to at this point. Paint in some indication of where the light and shade fall on the head. This will give the head a three-dimensional feel. Look again at the modelling of the face, and strengthen the shadows around the cheeks and eyes. Also, add some general tonal wash to the remainder of the figure so that the tones and colour of the hair, face and body are established.

Step 3.

Step 4.

Step 5. Adding detail to the face and body can be difficult, but look carefully at the sitter and draw in those colour accents which will make the portrait more closely resemble the person you are painting. This must be done without destroying the general tone which you have already established, so do not become too involved with detail.

Step 6. Fill in the background tone. This will help you to get the final colour and tone of the skin correct.

Using a clean brush and clean water, gently begin to blur some of the lines to create softer tones.

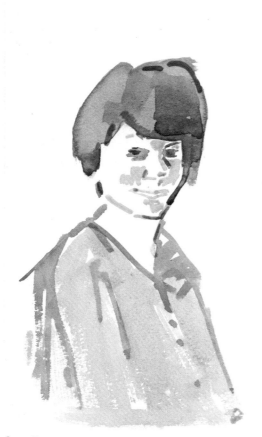

Step 5.

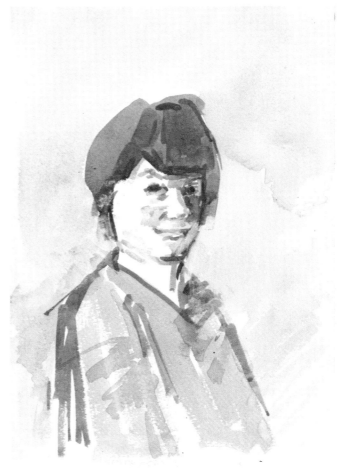

Step 6.

478

Step 7. Complete the portrait by finalizing the tonal values of flesh, hair and clothing, washing out any areas which have become too dark. Remember, achieving a colouring similar to that of your sitter is just as important as drawing the features accurately. In a blond-haired person the flesh tones will probably be peach or pinkish; a brown-haired person will most likely have olive tints while a black-skinned person may have either burnt umber- or sienna-tinted flesh tones.

Finally, with a small brush draw in the eyes, mouth and nostrils, using line to define the contours of the face. Elaborate the detail on clothing and body, defining shoulders, upper arm and neckline. Be careful not to overwork this detail as it would detract from the face.

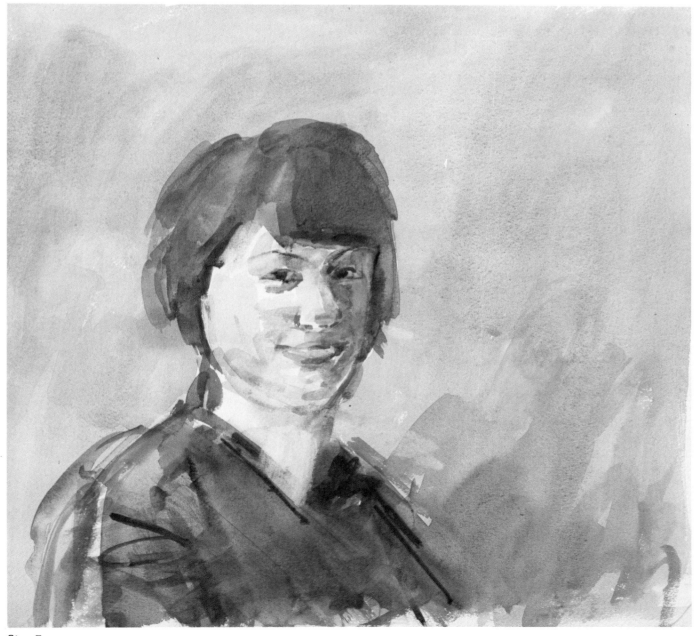

Step 7.

Portrait in Oil

Throughout this book, and in all the lessons in which you have been using oil paints, we have stressed the need for simplicity and directness in your approach to every subject.

This portrait is something of a summary, the result of twelve months of work and the culmination of all our hints and suggestions. And yet it is essentially a very simple painting: a young boy in an everyday sweater. There are no props or background patterns, no complicated poses – not even hands or lighting effects to detract from the face.

To begin with, choose your sitter very carefully, for this is not a project to sketch quickly and paint in an afternoon. A member of your family, or someone living nearby who can sit regularly, is the best arrangement. Although later you may be able to take short-cuts by working from photographs, don't do so now. You are working to develop your eye, your hand and the co-ordination between them, and perception of reality is more, not less, difficult from the two-dimensional evidence of a photograph.

Once you have decided on your model, find somewhere in your working space where you can set up an easel and a chair. Use electric lighting if you can – natural light would mean that you would be restricted to working every day at the same time, and for most students with other calls on their time that would be difficult to arrange.

Finally, provide a comfortable chair for the model, and a comfortable easel position for yourself. Ask for a normal quiet expression, or you will be chasing after the effect of a smile or grimace which changes every few minutes. Ask the model to wear something comfortable, but something which you find interesting.

Here, I wanted to explore the tonal relationship between all the blues and the browns, so the sweater with its blended bands of colour and the matching shirt were perfect. And although I was painting a portrait, I was not attempting to produce a photographic likeness. To spend a whole day on the subtle colour of the eyes might be too constricting at this stage in your progress; but a week on the interplay of colour between the flesh tones and the darker neck area shadowed by the collar might be time well spent.

Before your sitter arrives, prime and undercoat a canvas, choosing a shape which matches the idea of what you want to convey. If I had intended to try a full-length portrait I would have chosen a deeper canvas, while a head alone would have been more satisfactory in a square. This oblong was just right for my purpose. I used my favourite raw umber undercoat, and while it was drying I started a few sketches in order to look at the head in outline, and the shape of the features.

Step 1. The sketches were made from two angles, so that I could study the effect of the glasses on the shape of the face. Years ago most painters would have asked the sitter to remove their glasses, but today we know that if the model wears them all the time they are part of the personality, and so should be part of the portrait.

Note that I did not use formal perspective with its circles and ovals; I prefer to rely on direct observation for a specific model, because we are all so different and so varied that few of us fit the ideal of the 'Golden Section'.

Establish the shape of the hair and the outline of the face, and you almost have it. The nose is a dominant feature and sometimes difficult to draw in proportion. Look carefully; see how the distance between the eyes forms the top of the nose, and how the area above the upper lip marks its base.

Make your marks lightly but definitely, using a little charcoal pencil for the stronger areas while keeping the feeling light and flexible. Remember that these are working sketches, and if they are too laboured you will not be able to see how the final work will look.

You may transfer the outlines to canvas if you are unsure of your ability to repeat them correctly, but I would prefer you to try to make the underpainting in freehand work, with charcoal or thin umber paint. You can move the drawing around on the canvas before you start, to see how it looks in different places in relation to the rest of the picture. Remember that you'll need space for the shoulders and the sweater.

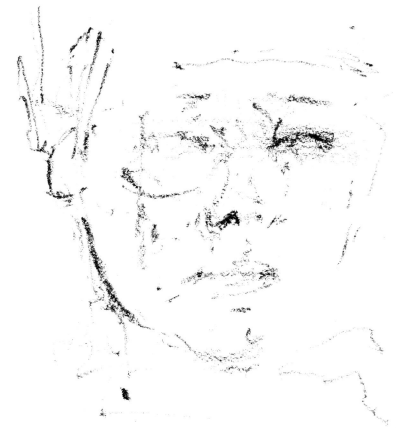

Step 1.

Step 2. Now that you are ready to start, go over the background quickly with a darker umber shadow, using a fairly wide brush and leaving the shape of the head very lightly covered. Paint the hair roughly and use the dark umber to outline the left side of the face. Find a pinky tone with some purple highlights, and rough in the side of the face with short horizontal strokes. Deepen the shadows under the eyebrows, point up the nose, and then with a small brush add a very few details: the line of the upper lip, the bright ochre point on the edge of the chin, the dark rim of the eyeballs. (The red splash was a mistake!) This step has been slightly enlarged so you can see the strokes clearly.

Step 2.

Step 3. Quickly layer all over the face with a neutral beige, and see how the pink and purple strokes add shape and shadow to the overpainting. Make a thin mix of yellow-beige, and sketch in the reflection of the glasses and frames – don't try to paint the actual glass.

Use a darker brown for the hair, working around and under the blond-beige you used in Step 1. Add blue to the mix, and paint in the neck, shadowed with more blue from the collar and the sweater. A richer blue for the sweater is highlighted by the bands of colour, and a final shadow of brown around the whole head adds mood and richness.

Step 3.

Double Portrait

It is sometimes very enjoyable to use the every-day scenes of family life as the subject for your painting. This is particularly true of children, though they need to be absorbed in their work before you can spend enough time watching and painting. It is best to find some sort of occupation for their eyes and hands, or else you will find them wandering around to end up watching you watching them!

Step 1. Make a preliminary drawing on the canvas using charcoal or conté.

At the first try the figures were too big for the canvas – I wanted to include something of the room as well, and to give a home-like sense with the upholstered chair and the old-fashioned fire-place.

Leave the lines and redraw the figures with a thin mixture of burnt umber and ultramarine thinned with turpentine. If you rub out the lines before you reshape the figures, you will find it harder to change your proportions; somehow your hand redraws the same shapes. When you are pleased with the general composition, rub out the old lines with a turpentine rag. Add definition to the background.

Step 1.

Step 2. If one of the sitters is home for an afternoon, take advantage of this and start with that particular figure. Even though you have the drawings and the sketches, the real person, even in a different position, helps to recall shape and movement.

Block in the main colours, using a mixture of red and white in various tones. Work quite roughly in broad strokes – you will add the detail later. Use sienna and white for the trousers, and pure sienna for a brief outline of the shoes.

Now block in the main features of the room: the fireplace, the mantelpiece, the outline of the chair, and the border of the rug.

In this kind of painting the room is as important as the figures, and almost more important than the features.

Add some thinly mixed black under the mantelpiece to give the cast-iron a crisp line. Wait until it is dry to add the cream. The whole grate should be tightly outlined, and you will have to wait for the layers to dry.

The rest of the painting is worked on much softer lines, adjusting your own techniques to the texture of the materials. Leave the metal of the fender, the kettle and the coal-scuttle until later – they all reflect the colours of the objects around them.

The chair has in fact come out rather flat, and although in this example you can give it some depth with shadows under the arms and front cushion, it may well remain oddly askew. Try to correct it but don't waste too much time; it is part of the background pattern.

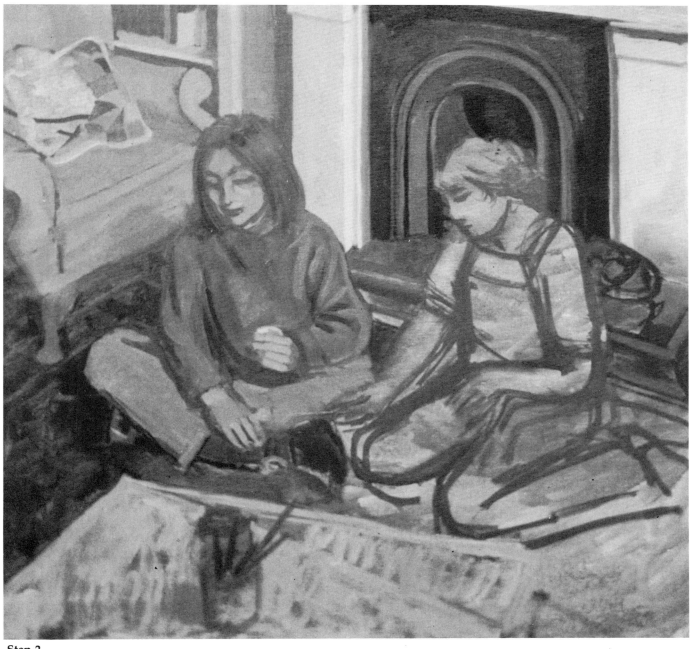

Step 2.

Step 3. Now begin to paint in the rest of the room. Alizarin crimson is obviously right for the carpet, and it will be picked up in the pattern on the wing-chair and in the patchwork. A wing-chair is a good shape to include in your 'set' if you can: it provides a pleasant shape and the contrast of a firm outline with the soft texture of upholstery. Of course, this can be difficult to portray the first time, so don't be discouraged if it doesn't quite work.

Work on the second figure now, again blocking in the clothes with broad strokes, and leaving the shadows until later. Next tackle the skin tones on both figures, painting in the faces, arms and hands. Watch the positioning of the fingers and hands carefully, but don't attempt too much detail.

The rest of the painting should be going well, with a darker red and burnt umber for the carpet pattern, and a mixture of yellow ochre and burnt sienna for the metal pieces.

The painting is almost finished, and it is time to stop for a while so that, when you look at it again, you will come to it with a fresh eye.

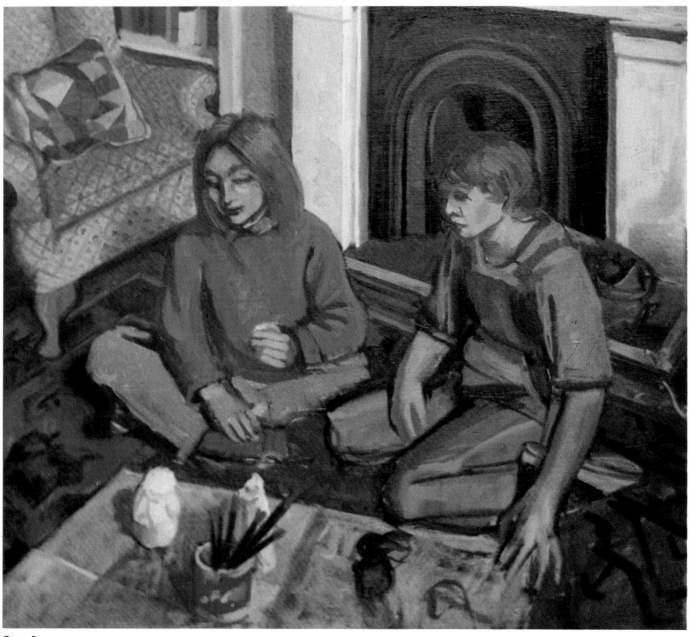

Step 3.

486

Step 4. After a break of at least a day or two, come back to the painting and try to pick out the details to be filled in to complete the spontaneous feeling of a moment in a child's day.

Add strength here and there to the shadows with some greyer tones on the mantelpiece, and a few brighter yellow-ochre touches to the yellow shirt.

Block in the books on the top left a little more clearly, using straight strokes of colour. Add a little more pink to the cheekbones, and a stronger pink to the socks. The leg with the canvas shoe is a little oddly placed but a strong shadow underneath helps to define it.

A few touches of colour to the shadows in the newspaper, and the band around the mug, all help to keep the colours warm and cheerful.

Never be discouraged from attempting unusual or complicated subjects, as long as you are prepared to be critical of your work, yet realistic about your expectations. These last projects are the summing up of only one year's instruction, and if you only attempt to do easy set pieces you will never progress.

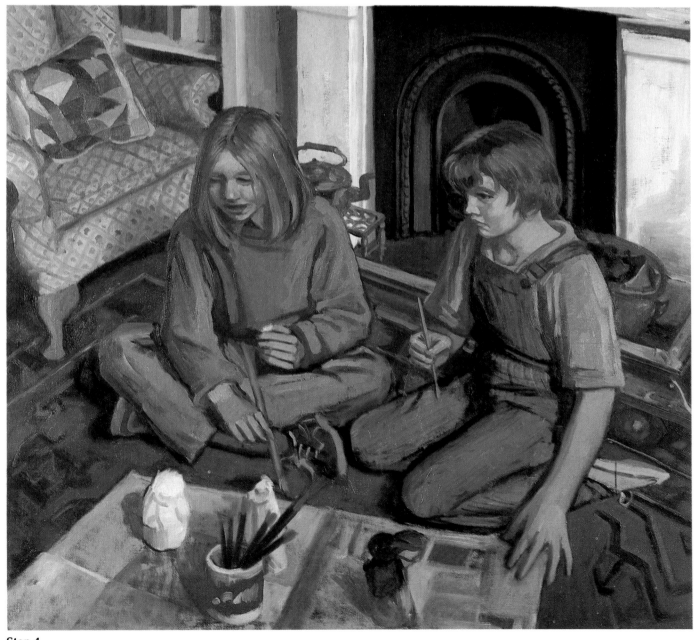

Step 4.

Combining Skills

Now you have almost completed Lesson Twelve, you will realize how closely connected all our projects are. We have made specific points on almost every page, but it is most important for you to realize how much of what you have learnt in one area can be usefully applied to other subjects.

This project is a perfect example of the exchange of techniques and approaches. In drawing **1.** the model was portrayed first in a tone study painted with simple black wash, and the background simply outlined and loosely brushed in.

Drawing **2.**, in pen and ink, is equally simple, yet it is obviously a portrait of an individual; the features are delineated and an impression of quiet

strength is conveyed with the minimum amount of line.

This variety of choice can be applied to every one of your painting sessions, and is one of the ways in which you learn to stretch your imagination.

Make use of everything you see, and of everything you do; think what you might achieve by adapting other projects and previous ideas.

Start from the beginning of Lesson One, and make several perspective outlines of your model's head similar to drawing **3.**, concentrating on cylinders, circles and blocks. Draw the first in charcoal, and then do another in conté – although close in appearance they will be far from identical in effect. Try out a pastel sketch as seen in draw-

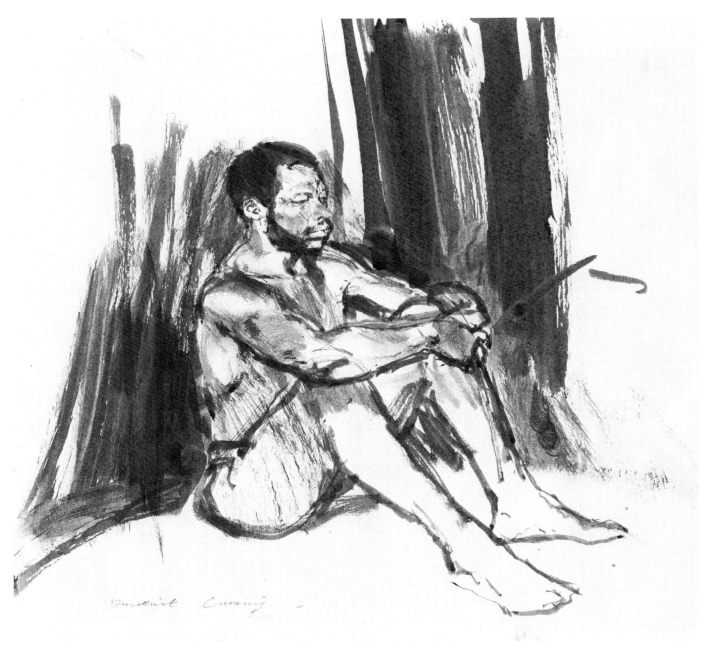

1.

ing **4.** on the next page, using really rough paper and a tinted background to bring out the texture.

Then, as I have done in the pictures on this page, use watercolour or ink wash for a tone drawing. Try another one in browns and sepia, and see how the change softens and deepens the impression.

Use oil next, for a study rich in colours and tiny details adding an elaborate background.

Stretch your imagination and go beyond experimenting with media; with the model settled comfortably in a chair, move the easel back to paint part of the room, and you have an interior with a figure, as seen in **5.** on page 491.

Seat your model beside an open window and as the light floods in to give you an entirely different colour spectrum, work in acrylic for a quiet, rainy-day study suggested by the painting **6.** also on page 491. Experiment with a garden setting and you have a new composition; if you walk to a beach or a swimming-pool you can have a waterscape with no trouble at all. The same figure can be shown leaning against the wall of a newspaper shop as the crowds go by. With one model and a wide variety of settings you can find a hundred different ways of using all the many artistic media and techniques.

2.

4.

5.

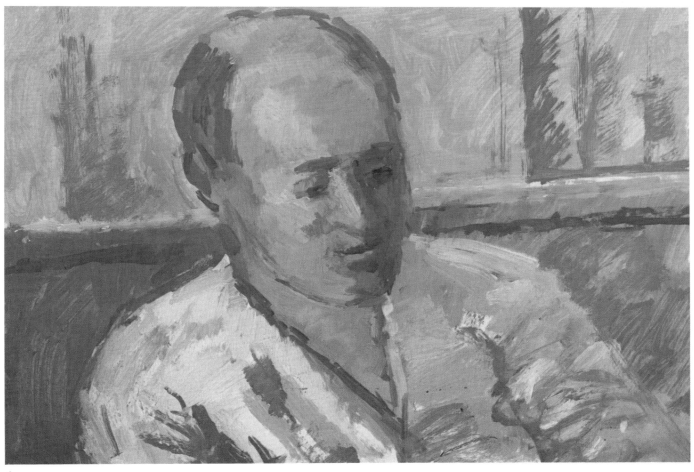

6.

Extra Project

Photorealism

Photorealism is an attempt to produce paintings which have the visual realism of photography, and photographs are generally used as a basis for the pictures.

Although this technique may not appeal to everyone it is extremely skilled, and it is useful and rewarding to make a careful study in the photo-realist manner. Any medium can be used – watercolour, pastel, oil or acrylic. Pastel is particularly useful and easy for beginners, as it can be gently smudged to blend and merge the colours. A slow-drying retarding oil is also convenient. When you have laid in the necessary colours in the grid matrix, it will still be wet enough to blend them into each other before they dry.

Step 2. Enlarge the image to fit your paper or canvas, and divide the picture into very small squares – the smaller they are, the more accurate your interpretation will be. Fill in the squares, constantly referring to, and copying, the areas in the relevant grid squares.

Step 1. Draw a grid over a photograph, and use this to break down the tones and colours.

Step 1.

Step 2.

492

Step 3. Carefully blend the edges, or dividing lines, between each square into the adjoining squares until the grid is no longer visible.

Step 4. Finally, add necessary detail and texture to complete the picture.

Step 3.

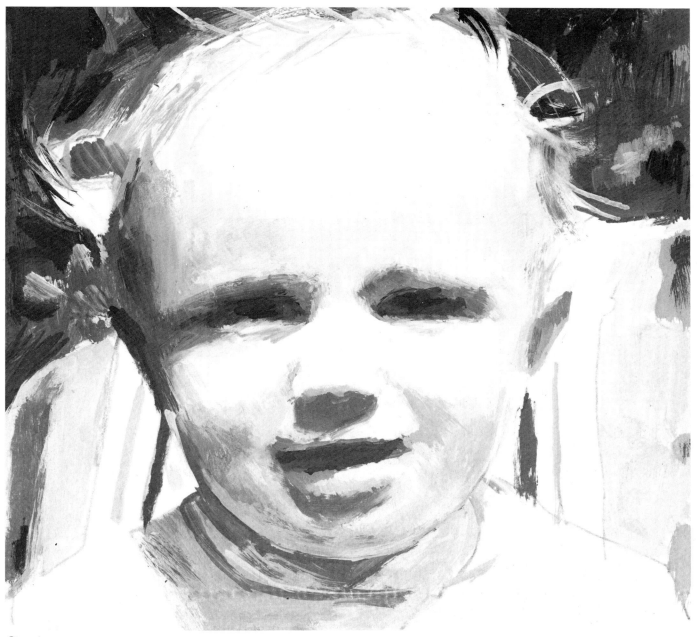

Step 4.

Appendix

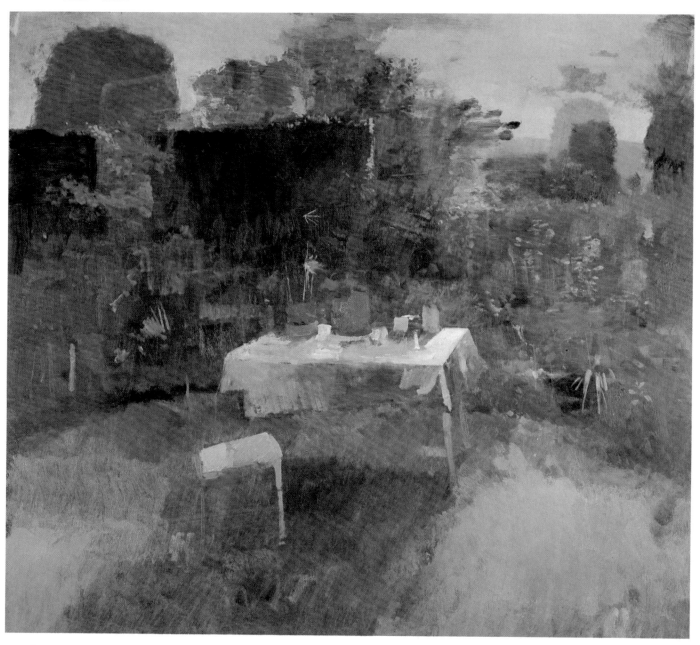

Selected Biographies

Angelico, Fra 1387?–1455. A Dominican monk from Florence, he is regarded as one of the foremost painters of the early Renaissance. The frescoes and altarpiece for the monastery at S. Marco in Florence are the best examples of his powerful style, which relied on a simple, direct use of colour and an accurate rendering of perspective.

Audubon, John James 1780?–1851. American naturalist and illustrator, famous for his volume *Birds of America*. He was an expert draughtsman; his subjects are scientifically accurate and set within refreshingly natural compositions.

Bacon, Francis *b.*1909. Irish-born British painter. His subject-matter has a nightmarish quality, conveyed more through the way in which the paint is used than the actual composition: violent slashes of colour smeared into one another give life to the agonized screams and contortions of the figures.

Beardsley, Aubrey 1872–98. English illustrator renowned for his erotic portrayals of the decadence and the veneer of evil adopted by *fin de siècle* society of the 1890s. His highly stylized use of pure black and white reflects the influence of Japanese woodblock prints, which were extremely popular during the Art Nouveau period.

Beckmann, Max 1884–1950. German painter and one of the leading Expressionist artists. Heavily influenced by his grisly experiences as an orderly at a field hospital during World War One, and stylistically by the work of Bosch, Beckmann attempted to expose the suffering and misery caused by any kind of aggression.

Bernard, Émile 1868–1941. French painter and art critic who was one of the creators of the style known as *Cloisonnisme* for its resemblance to the enamellers' technique; strong flat areas of brilliant colour contoured by heavy dark lines.

Blake, Peter *b.*1932. British painter and one of the originators of Pop Art. His work draws heavily on the images of graphic and advertising art (including comic books).

Blake, William 1757–1827. English painter and engraver whose poetry and accompanying illustrations revealed his preoccupation with spiritualism and religious symbolism. He also used his unique imaginative talents to illustrate the Book of Job and some of the works of Shakespeare, Milton and Dante.

Bonnard, Pierre 1867–1947. French painter and leading artist of the late Expressionist period. Stylistically he was influenced by Gauguin and Japanese woodblock prints, but his work after 1900 was more naturalistic, taking as subjects the intimate interior scenes of daily life. These he painted in bright clean colours, using a heavy impasto technique. *Nude in a Bath* (Petit Palais, Paris) is typical of this style, which became known as *Intimiste*.

Bosch, Hieronymus *c.*1450–1516. Netherlandish painter and probably the greatest of the fantastical artists. His exuberant use of colour, intricate composition and attention to minute detail are perfect stylistic partners to his vivid and sometimes horrific images based on folk tales and religious symbols. Most of his existing work is at the Prado, Madrid.

Botticelli, Sandro *c.*1445–1510. Florentine painter. His highly individual style relied on an archaic but graceful linear treatment of secular allegory and religious subjects, and made him one of the most influential artists of the Renaissance. *Primavera* and *The Birth of Venus* (Uffizi, Florence) are outstanding examples of his genius.

Boudin, Eugène 1824–98. French painter whose many small paintings of the beach and seascapes around Honfleur in his native Normandy were a major influence on the Impressionists, particularly Monet.

Braque, Georges 1882–1963. Most influential of the twentieth-century French painters; his early works were among the first to be called Cubist. His particular concern was to show how shapes and the spaces around them are integral. He introduced collage techniques and elements of typography into his work.

Breughel, Pieter (The Elder) *c.*1525–69. Netherlandish painter and engraver, considered by many to be the greatest landscape artist of the sixteenth century. He is renowned for his vivid portrayal of everyday peasant life, observed with great wit and affection. His mastery of composition and awesome technical ability are best seen in the famous series *The Months*, of which five paintings are extant (Kunsthistorisches, Vienna; Metropolitan, New York; and National Gallery, Prague).

Buffet, Bernard *b.*1928. One of the best-known contemporary French painters – his realistic subjects are painted in broad areas of colour outlined heavily in black.

Canaletto (Giovanni Antonio – real surname Canal) 1697–1768. Italian painter and engraver who virtually monopolized the sale of scenic views of Venice to travellers on the Grand Tour. His ability to instil a sense of intimacy is what sets his work apart from that of other topographical artists.

Caravaggio, Michelangelo Merisi da 1571?–1610. Italian painter esteemed for his rich colour and command of *chiaroscuro*, with strongly highlighted figures emerging from a dark background. His early work was secular, but with his first public commissions at the end of the fifteenth century he turned to religious subjects. He took great pride in working from life and this, combined with his dramatic techniques, emphasized his vision of the Holy Family, Christ and the Apostles as ordinary people from the lower social orders.

Cassatt, Mary 1844–1926. American painter whose early involvement with the French Impressionists, and admiration for Degas, directly influenced her style. Her favourite subject was mothers and their children.

Cézanne, Paul 1839–1906. French painter, held by many to be the father of modern art. His ideas about structure and the 'cylinders, spheres and cones' which appear in all nature were eagerly accepted by the Cubists. One of his greatest innovations was to replace black and white shading with a careful evaluation and use of colour to provide tone.

Chardin, Jean Baptiste Siméon 1699–1779. Eighteenth-century French painter unsurpassed in his delicate handling of oils and pastels. He manipulated the media to instil great depth of tone and feeling into still lifes and portraits.

Cimabue *c.*1240–1302? By association with his student, Giotto, he is considered to be one of the founders of modern painting, who helped to break the Byzantine stylistic mould and render subjects in a more realistic manner.

Claude Gellée (Claude Lorraine) 1600–82. French artist who is generally recognized to be the master of the poetic landscape, in which the view is rendered in terms of tonal value rather than line, and the colours are drenched in golden sunlight. Between his paintings there is little difference in composition: trees and buildings on either side counterbalance each other and guide the viewer's eye to the centre of the painting and into the far distant view.

Constable, John 1776–1837. English painter, who although he was little known during his lifetime is now considered to be one of the finest landscape artists of the nineteenth century. He worked only from nature and took his subjects exclusively from the English countryside. His handling of clouds and sky heralds the Impressionist technique in its bold brushwork and lively use of colour.

Corot, Jean Baptiste Camille 1796–1875. French painter best known for his landscapes, in which the luminous quality of light and blurred outline combine to present an idealized vision of nature.

Cotman, John Sell 1782–1842. English watercolourist. His major subject was landscape; he arranged large, flat areas of wash in controlled and harmonious patterns, in a way that foreshadows more modern techniques.

Courbet, Gustave 1819–77. French painter, described by Redon as 'the great realist who was simply a great painter'. His monumental oil paintings of everyday subjects, the paint thickly applied with a palette-knife, outraged the art world but revealed his socialistic views and revolutionary bent.

Cozens, John Robert 1752–97. British artist who specialized in highly romanticized watercolour views of the Swiss and Italian countryside, painted from sketches made during two tours of the regions in 1776–79 and 1782–83.

Crome, John 1768–1821. Known as 'Old Crome' to distinguish him from his son, who was also an artist, he was an English landscape painter and etcher. His style is similar to the work of seventeenth-century Dutch landscape painters.

Dali, Salvador *b.*1904. Spanish painter who is undoubtedly the best-known Surrealist artist. Through the hallucinatory images of his paintings Dali attempts to reveal the neurotic mind; his early paintings are based on his own paranoid delusions.

David, Jacques Louis 1748–1825. French painter. After working in both the Baroque and Rococo styles he finally turned to Neo-Classicism, although his handling of composition and colour is often more primitive than that school condoned. In his paintings, which are executed on a grand scale, the use of classical themes and dramatic *chiaroscuro* reflected the political fervour of the time. During the Revolution David became Director of the Arts, but later he developed into something of an establishment figure, and served as court painter to the Emperor Napoleon.

Davis, Stuart 1894–1964. American painter whose brightly painted, flat images recall the later works of Matisse and Léger and reflect the hectic, zany side of modern American life and attitudes.

Degas, Edgar 1834–1917. French painter and one of the first Impressionists. He took his subject-matter from contemporary Parisian life, and his best-known works include evocative studies of ballet-dancers and women going about their daily routine.

Delacroix, Ferdinand Victor Eugène 1798–1863. Leading painter of the Romantic school in France. He was a prolific artist whose subjects ranged from animal studies and portraits of great composers to historical and religious scenes, and scenes from the works of Byron, Dante and Shakespeare. He was one of the first painters to utilize colour theory, and his work influenced the Impressionists.

Dürer, Albrecht 1471–1528. German painter and engraver and most famous artist of the Northern Renaissance. He was the first in Germany to teach the rules of perspective and the proportions of human anatomy, and the first one to practise etching. He also invented the method of printing two-colour woodblocks.

Dyck, Sir Anthony van 1599–1641. With Rubens, he is the most important seventeenth-century Flemish painter. He was court painter to both James I and Charles I of England, greatly admired for the graceful treatment of his portrait subjects and his technical skill in painting the elaborate costumes and fabrics of the period.

Eakins, Thomas 1844–1916. The most important American painter of the nineteenth century. His portrait and landscape styles, while basically realist in approach, are quite distinct: the former is heavily influenced by Rembrandt but the latter is much more modern in its use of glowing colour.

Eyck, Jan van *c.*1384–1441. The most famous fifteenth-century Netherlandish painter, credited by early writers with being the inventor of oil painting. Although this is not true, his technical skill in the use of paints and glazes to make seemingly iridescent colour surfaces, his technique of rendering great detail, and his ability to juxtapose greatly varying scale within one composition, are unparalleled. His painting the *Arnolfini Marriage* (National Gallery, London) is the supreme testament to his skill.

Fragonard, Jean Honoré 1732–1806. Leading French painter of the Rococo period, he is best known for his amusing, slightly erotic treatments of allegorical subjects, and delicate use of colour.

Fry, Roger 1866–1934. British art critic and painter responsible for shifting the art world's focus from Renaissance painters to the contemporary artists of his day, such as van Gogh, Cézanne and Matisse. He coined the term Post-Impressionist, and as an artist worked with Duncan Grant and others of the Omega Workshop.

Gainsborough, Thomas 1727–88. British landscape and portrait painter, an original member of the Royal Academy. His work is marked by a subtle use of tone and colour, and a naturalistic rendering of subject-matter.

Gauguin, Paul 1848–1903. French painter, print-maker and sculptor, and leading Post-Impressionist. He is best known for his move to the South Pacific in search of a primitive, basic lifestyle, which he considered to be the purest source of artistic inspiration.

Giacometti, Alberto 1901–66. Swiss artist and one of the twentieth century's most original painters and sculptors. His work is almost entirely figurative, showing the human form as simple stick-figures caught in mid-movement, their shape shrunken by the play of light about them.

Giorgione *c.*1476/8–1510. Venetian painter who broke with the tradition of Church patronage and was one of the first Renaissance artists to execute small paintings for private patrons. His subject-matter was most often secular rather than religious; poetic in mood, it contained obscure messages rather than easily read narratives derived from Biblical themes. He is often placed with Leonardo da Vinci as a founder of modern painting. His small oil painting *Tempest* (Accademia, Venice) evocatively depicts a landscape threatened by an approaching storm.

Giotto *c.*1266–1337. Florentine painter who is generally accepted as being responsible for establishing modern painting. Following in the footsteps of his teacher, Cimabue, he broke away from the rigid stylizations of Byzantine painting and introduced natural settings and elements of realism to the figures within his compositions.

Girtin, Thomas 1775–1802. British landscape watercolourist. His use of broad areas of colour wash to render light and space was similar to Turner's, and together they freed the medium from its association with line drawing, thus establishing it as an independent art form.

Gogh, Vincent van 1853–90. Dutch painter and a major influence on nineteenth-century artists. Throughout his life he suffered from severe depressions and hallucinations, which were exacerbated by his poverty and lack of artistic recognition. His early influences were Seurat, Degas, Toulouse-Lautrec and Gauguin. He was particularly close to the last until a violent quarrel with Gauguin caused him to cut off part of his right ear (his *Self-portrait* at the Courtauld Institute, London, records this mutilation). He was obsessed with the effect of light on colour and his palette was one of vivid hues, their vibrancy heightened by dramatic brushwork which gave a strong feeling of movement and direction to all his compositions. This can be most clearly seen in the series of landscapes, especially *Cornfield with Cypresses* (National Gallery, London), painted while he was a patient at the St Remy asylum.

Goya y Lucientes, Francisco José de 1746–1828. Spanish painter and etcher. At the age of thirty he was producing cartoons for the Royal Tapestry Works, where his great talent was soon recognized. He rose steadily through a series of royal appointments until, in 1799, he was appointed First Painter to the King of Spain. His early work was influenced by the luxuriant use of colour and romantic imagery of the Rococo period. But his awareness of the frailty of human nature is none the less apparent; his portraits of the Spanish royal family show them as quite ordinary people in spite of their grand costumes and the stately settings. Later, severe illness, personal tragedy and the atrocities of the war between France and Spain turned his optimistic vision to one of pessimism; and he is probably best known for the startling images of paintings such as *The Executions of the Third of May* (Prado, Madrid), and a series of etchings, *The Horrors of War*.

Grant, Duncan 1885–1978. British painter and designer who was one of the first to accept the new French schools of painting, including Pointillism and, later, Abstract painting.

Greco, El 1541–1614. Born in Crete and trained as an artist in Italy, he is considered to be one of the finest painters of the Spanish school. His subjects were usually religious, painted in dark-toned hues of a bluish tint. His figures are unique for their degree of distortion: elongated wraith-like portraits of church dignitaries, Christ and the Virgin are his hallmark.

Hals, Frans 1581–1666. Dutch painter and one of the greatest portrait artists. His ability to capture the fleeting expressions and subtle gestures which give character to the sitter was his finest talent. *The Laughing Cavalier* (Wallace Collection, London) is his best-known work, and clearly demonstrates his talent.

Hobbema, Meindert 1638–1709. Dutch landscape painter whose work closely resembles that of his teacher, Jacob van Ruisdael. However, Hobbema's paintings eventually became more tranquil in their loving protrayal of sun-drenched woodland rides and rustic watermills beside placid ponds.

Hockney, David *b*.1937. British artist and printmaker. His early oils were unusual for the sketchy quality of the brushwork; but he soon switched to acrylic paint and hard-edged, broad areas of colour. He is perhaps best known for his paintings of swimming pools and his portraits in which the sitter is isolated within an open, expansive interior.

Hogarth, William 1697–1764. British painter and engraver. He began as a painter of genteel family group portraits, but found this too restrictive and turned to satirical morality sequences in which the characters are shown falling prey to vice, and progressing through a series of misadventures and calamities until they ultimately pay the price for their misdeeds. Most notable of these series is *The Rake's Progress* (Sloane Museum, London).

Holbein, Hans (The Younger) 1497/8–1543. German painter and engraver, considered to be the finest portrait artist of the Northern Renaissance. His studies of Sir Thomas More's family, and that of King Henry VIII, show his unerring ability to capture the sitter's personality with a deft use of line and tone.

Homer, Winslow 1836–1910. One of the finest nineteenth-century American painters. He began as a lithographer, providing illustrations for daily newspapers, but later turned to vividly painted seascapes. His watercolours retain much of his forceful oil-painting technique.

Hooch, Pieter de 1629–after 84. Dutch genre painter. His small paintings of Dutch interiors are noted for the careful rendering of light within a well-ordered composition.

Hopper, Edward 1882–1967. American figurative painter, famous for his paintings of people isolated within highly simplified interiors, deserted streets and starkly rendered buildings.

Ingres, Jean Auguste Dominique 1780–1867. French painter of historical subjects and portraits. His work was deeply imbued with a fervent admiration for classicism, reinforced by his belief that line was more important than colour.

John, Augustus 1878–1961. British painter whose lifestyle exemplified the unfettered spirit of the rebellious artist. His landscape paintings and portraits show an interest in Impressionism, but are much more strongly drawn.

Kandinsky, Wassily 1866–1944. Russian-born painter and one of the first and most important Abstract artists of the twentieth century. He believed that harmony of colour and form was the basis of non-objective art and so developed a highly formal, geometric style of abstraction.

Kelly, Ellsworth *b*.1923. American artist, famous for his hard-edged paintings done on shaped canvases. His early work was colourful, but later work tended to shades of grey. Most recently he has been experimenting with the colour and textures of steel created by rust, and he hangs huge sheets of the metal just as he would a finished canvas.

Klee, Paul 1879–1940. Swiss painter and graphic designer who began his artistic career as a teacher at the Bauhaus. His work is characterized by a child-like simplicity. Amusingly drawn people and animals dance across jewel-coloured backgrounds but are in fact symbolic abstractions of nature seen within a carefully constructed colour scheme.

Kokoschka, Oskar 1886–1980. Austrian painter noted for his energetic portraits, which were intended to reveal the sitter's psychological make-up. His ability to see and render a subject from an unusual viewpoint made him a clever magazine illustrator and landscape artist.

Léger, Fernand 1881–1955. French painter whose early figurative work, although curvilinear, was influenced by Cubism. Later works reveal his obsession with the geometrical shapes of machines.

Leonardo da Vinci 1452–1519. Florentine artist whose genius extended to mathematics, engineering, anatomy, music, philosophy, architecture and most realms of human activity. He is the epitome of Renaissance Man and his investigations and deductions anticipated many of mankind's later discoveries, including the circulation of the blood, mechanized flight, submarines and armoured tanks. But little of his monumental ouput reached a stage of completion; his artistic legacy is a few finished paintings, and notebooks crammed with detailed observations of, among other things, plants, animals, drapery, human expression, anatomy, and the action of water. The *Mona Lisa* (Louvre, Paris) and *The Last Supper* (Sta Maria delle Grazie, Milan) are his best-known works.

Lippi, Fra Filippo *c*.1406–69. Florentine painter. He is regarded as the only true student of Masaccio, the first painter of the early Renaissance to reject the ethereal quality of the Gothic style in favour of realism. Lippi's figure work takes realism a step further, as he used line instead of tone for modelling, and introduced the subtle effects of lighting which were so important to Renaissance artists.

Louis, Morris 1912–62. American painter noted for his colour-stain technique, which involved pouring thinned pigments directly onto unstretched, unprimed canvas.

Lowry, Lawrence Stephen 1887–1976. British painter whose work has a distinctly naïve quality, although he studied art for several years. Lowry took his subject-matter from the bleak urban settings of the industrial north of England.

Magritte, René 1898–1967. Belgian painter and one of the foremost Surrealist artists. The dream-like quality of his paintings is achieved by the detailed realism of objects and people, arranged to fool the eye and the mind of the viewer.

Manet, Édouard 1832–83. French painter regarded by many to be the father of modern art. His dictum that 'the principle person in a picture is the light' sums up his

contribution to the artistic revolution of Impressionism, a movement he greatly influenced but of which he firmly disapproved. His work is marked by sharp tonal contrasts of light and shade and the use of a few colours only – but always black. When painting he worked quickly and directly from the model, and did away with any unnecessary details which might clutter the flat planes and carefully considered composition of the picture.

Mantegna, Andrea *c.*1431–1506. Italian painter and engraver, greatly influenced by the art of classical antiquity. He was an expert draughtsman and a master of perspective and foreshortening.

Matisse, Henri 1869–1954. French painter and sculptor, and one of the twentieth century's most influential artists. In his paintings the subject-matter is subordinated to the pattern and design within the composition, and reduced to abstract shapes of brilliant colour. His final works were a series of collages made from large pieces of brightly coloured paper, torn into bold shapes.

McCubbin, Frederick 1855–1917. Australian painter and one of the founding members of the Box Hill Group, who left the cities to paint in the countryside.

Michelangelo Buonarroti 1475–1564. Florentine painter and sculptor and one of the greatest artists in history. He was a master of most forms of artistic endeavour and his work is remarkable for the range and intensity of the human emotions it evokes. He is responsible for the ceiling and altar frescoes in the Sistine Chapel of the Vatican, and the Pietà in St Peter's Basilica, Rome – a building which he redesigned.

Millais, John Everett 1829–96. English painter and a founder of the Pre-Raphaelite Brotherhood. A noted portrait, landscape and historical painter, he rendered his subjects in glowing colours and in a tender sentimental way, with great attention to detail.

Millet, Jean François 1814–75. French artist. He began as a painter of portraits and erotic nudes, but turned later to landscapes and scenes of peasant life rendered with an increasing realism and an empathy for the harshness of his subjects' lives; he himself was the son of a peasant, and lived and worked amongst them, sharing their poverty. *The Angelus* (Louvre, Paris) is one of his best-known works.

Miró, Joan *b.*1893. Spanish painter and one of the twentieth century's most innovative artists. His style was Surrealist, and in his paintings natural forms are abstracted into odd little shapes or symbols that are placed randomly on a background of solid colours.

Modigliani, Amedeo 1884–1920. Italian painter whose work consists almost entirely of portraits and female nudes rendered in simple but slightly elongated shapes and equally simple colour. His skill as a draughtsman reveals his early training, when he studied the great artists of the Italian Renaissance.

Mondrian, Piet 1872–1944. Dutch painter and one of the founders of De Stijl. In his work he banished all traces of representational art and aimed at creating artistic order through the use of geometric forms, always set at right angles to the vertical or horizontal plane, and painted in the three primary colours together with black, white or grey. Eventually he dispensed with the colours completely.

Monet, Claude 1840–1926. French Impressionist painter. He was much influenced by Manet and like that artist he preferred to work directly from life. He was also fascinated by the quality of light and its effect on the colours of the subject. He was determined to capture this, and in his final work, a series entitled *Waterlilies* (Orangerie, Paris) painted when he was nearly blind, Monet would seem to have realized his ambition: all form falls away and the viewer is left with the impression of glimmering light dancing on the surface of flowers and water.

Munch, Edvard 1863–1944. Norwegian painter and a forerunner of the Expressionist school, whose work was influenced by van Gogh and Gauguin, and who tried to portray intense emotion in visual terms. He was obsessed with morbid themes and neurotic behaviour and his paintings have a distinctly nightmarish quality. *The Scream* (National Gallery, Oslo) is one of his best-known works.

Nash, Paul 1889–1946. British painter and print-maker who, from 1917, worked as an official war artist of World War One. Later he came under the influence of Chirico and the Surrealists and adopted their style for landscapes and book illustrations. He was again appointed an official war artist in World War Two.

Nicholson, Ben 1894–1982. Probably the best-known British abstract painter. He took his inspiration from the simple geometric shapes of Cubism, and from artists like Mondrian.

Nolan, Sir Sidney *b.*1917. Best-known contemporary Australian painter. His early works were abstract, but he later began painting historical scenes based on Australian folklore. His use of broad washes of colour and superimposed images has a faintly Surrealist quality.

Noland, Kenneth *b.*1924. American painter whose early experiences with colour-staining led him to develop a hard-edged style in which flat colour and the shape of the canvas are the only compositional elements.

O'Keefe, Georgia *b.*1887. American painter whose work borders on abstraction. In her paintings, loosely drawn forms taken from nature are captured floating in open space. Her choice of subject-matter and style are obviously influenced by the arid expanses of the south-west American landscape.

Palmer, Samuel 1805–81. British painter, a follower of William Blake – his themes were usually Arcadian but alive with Christian symbolism. His talent was precocious – he first exhibited at the Royal Academy when 14 years old – and peaked during his 'Shoreham Period' (1826–35); his later landscapes lack emotional charge.

Parmigianino, Francesco 1503–40. One of the most refined of the Italian Mannerists. His paintings were most often of religious subjects, although he did do several remarkable portraits. He was also one of the first artists to make his own etchings as original works of art, rather than as copies of paintings.

Patenier, Joachim *c.*1485–1524. Netherlandish painter and pioneer of landscape painting as a distinct genre. His style was inspired by Hieronymus Bosch, and although there may have been figures in his composition the emphasis always fell on the surrounding landscape.

Perronneau, Jean Baptiste 1715–83. French portrait painter best known for his pastel drawings, although he also worked in oils.

Picasso, Pablo 1881–1973. A Spaniard and unarguably the most celebrated and prolific artist of the twentieth century. Over the span of his creative life he has influenced, and been influenced by, most of the progressive art movements this century. With Braque he evolved the Cubist style, and this influence can be seen in all his later work. Picasso also worked in collage, sculpture, ceramics and stage design, and made prints and illustrated books. His style shifted from pure Cubism through Surrealism to a sort of monumental classicism. His most famous painting is *Guernica* (Prado, Madrid), an enormous panel inspired by the desolation of the Spanish Civil War, and devastating for its rendering of the horror and folly of war in general.

Piero della Francesca 1410/20–92. Long-neglected Italian painter who is now recognized as one of the major artists of the early Renaissance. He worked primarily in fresco, and executed huge panels remarkable for the feeling of serene majesty with which they are imbued. His style was rather old-fashioned – figures were clearly profiled and usually

faced the viewer straight on – and the composition was carefully symmetrical.

Piper, John *b.*1903. British painter and designer whose early work was abstract, but later reflected the influence of English Romantic realists like Samuel Palmer. He developed his reputation as a painter of landscape and architecture.

Pissarro, Camille 1831–1903. One of the leading and, during his lifetime, most respected French Impressionists. He was an early associate of Monet's and was influenced by Seurat and the Pointillists. He later helped Cézanne and Gauguin to develop their distinctive styles. He was a most versatile artist. Although he painted chiefly in oils, he also used pastels and gouache, and worked in etching and lithography. Throughout his work there is an adherence to the Impressionist ideal of using colour to interpret the quality and effect of the light rather than simply to render the view.

Pollock, Jackson 1912–56. Leading American Abstract Expressionist renowned for his technique of pouring paint onto the canvas. Although the end-result may appear to be random, he controlled the flow of the dribbles and spatters by lifting and tilting the canvas to capture chance effects. This technique revolutionized modern American art.

Poussin, Nicolas 1594–1665. French painter and one of the artists responsible for creating the French Classical style. His early studies in Italy led him to emulate the rigidly formalized compositions of classical antiquity. At the height of his career he turned to painting idealized landscapes, though these were influenced by his classical temperament, in which colour was subordinate to the line and geometry of the composition.

Raphael 1483–1520. Italian painter and one of the leaders of the High Renaissance. His talent was precocious; while still a teenager he was considered the equal of Leonardo da Vinci and Michelangelo, and his style was much influenced by these men. When he was twenty-five the Pope called him to Rome, where he stayed for the rest of his life, creating frescoes for a suite of apartments within the Vatican, and many sensitive portraits of Roman nobility.

Redon, Odilon 1840–1916. French painter, draughtsman and print-maker. Most of his work, and that for which he is best known, was fantastical and often based on the poetry of Edgar Allan Poe, although near the end of his career he turned to pastels and oils of still lifes, landscapes and animals painted in an Impressionistic style.

Reinhardt, Ad 1913–67. American Abstract painter influenced by Mondrian and Stuart Davis. He gradually reduced the amount of colour in his work until his canvases were composed of nine squares of black, so subtly tinted with different colours as to be indistinguishable from one another.

Rembrandt van Rijn 1606–69. Dutch artist whose painterly skill in the manipulation of light and shade to create drama and movement within a composition has placed him among the greatest artists of history. He had the ability to capture the spiritual essence of his sitters, and this is best seen in the series of self-portraits made over the course of forty years. He was much sought after as a teacher, and taught some of the finest artists of his period.

Renoir, Pierre Auguste 1841–1919. One of the great French Impressionist painters. A painting companion of Monet, he quickly dropped his rather heavy-handed style in favour of the broken brushwork and light-filled techniques of the Impressionists, which he later modified after studying Renaissance painting in Italy. This meant that he concentrated more on the figure, which was rendered with a greater feeling of solidity. He did not share the Impressionist commitment to spontaneity, and would make several preliminary sketches before beginning a painting. *The Luncheon of the Boating Party* (Phillips Memorial Gallery, Washington DC) is an excellent example of his style.

Reynolds, Sir Joshua 1723–92. British painter, who from 1753 was the most sought-after portrait painter in London. His sitters included most of the wealthy, fashionable and famous people of his day, including Emma Hamilton and Dr. Johnson.

Rivers, Larry *b.*1923. American painter whose paintings show the influence of both Abstract Expressionism, in his choice of imagery, and Impressionism, particularly Pierre Bonnard, in the painterly quality of the brushwork and colour.

Roberts, Tom 1856–1931. Australian painter and member of the Box Hill Group, sharing their interest in the pastoral landscape. He was particularly concerned with showing the daily lives of the farmers, and his genre paintings include ship-board scenes, street scenes in the town, and vivid crowded scenes inside the sheep-shearing sheds of the local ranches.

Rossetti, Dante Gabriel 1828–82. English painter and one of the founders of the Pre-Raphaelite Brotherhood. Although not a technically skilled artist, he is best remembered for the sensuous portrayals of female characters set within scenes of an imaginary medieval world.

Rothko, Mark 1903–70. American painter famous for his large rectangular canvases in which adjacent rectangles of colours that are similar in value are set against a contrasting background. The feathery blurring of the edges causes the shapes to float above the background. This type of painting became known as Colour Field.

Rubens, Sir Peter Paul 1577–1640. Greatest Flemish painter of the seventeenth century and considered by many to be the finest artist of the Baroque period. He is unparalleled for the ease and skill of his execution and the prodigious amount of work he produced. This included book illustration, cartoons for tapestry, and paintings on almost any subject and setting. The panels done for the Banqueting House in London are still to be seen in their original place. His students included van Dyck, and he was so well respected that he acted as a diplomat to Spain and England, where he was knighted by Charles I. He worked mostly on a large scale, and combined a Flemish eye for realism and sense of colour with an understanding of design and composition based on a study of Italian Renaissance art.

Sandby, Paul 1725–1809. British watercolourist and etcher whose early training as a topographical draughtsman is reflected in the accuracy of his landscapes. He rarely worked from pencil-sketched outlines, preferring to lay direct colour washes or else to do a watercolour outline. His handling of gouache recalls the appearance of oil paintings and he was one of the first to portray the landscape as it truly appeared, rather than as an idealized vision of the artist. Sandby is also responsible for introducing aquatint engraving into England.

Sargent, John Singer 1856–1925. American painter and the most renowned portrait artist of his time. He settled in London and there painted many of the eminent Edwardians in a style much influenced by Manet, Hals and Velazquez.

Schiele, Egon 1890–1918. Austrian artist and leading Expressionist painter and draughtsman, who was inspired by images of Freudian psychology. The biting, angular lines of his nude studies portray a tortured eroticism. They were considered so outrageous that he was imprisoned on an indecency charge.

Seurat, Georges 1859–91. French painter and leading Neo-Impressionist, famous for his use of small dots of primary and complementary colours painted very close together so as to mix optically, producing secondary colours and areas of shadow. This style became known as Divisionism or Pointillism. *La Grande Jatte* (Chicago Art Institute) is one of the finest examples of his work.

Shahn, Ben 1898–1969. American artist whose paintings, prints and photographs during the 1920s and 1930s placed

him firmly among the Social Realist artists of the period. He often combined elements of calligraphy to enhance the visual image.

Sickert, Walter Richard 1860–1942. The most important British Impressionist painter and a founder of the Camden Town School. He was influenced by Degas and Whistler, but his palette was much more sombre than that of the French Impressionists. He concentrated on painting the drab, and sometimes sordid, side of city life, although perhaps his best-known works are of London music halls.

Signac, Paul 1863–1935. French Neo-Impressionist painter and a founder of the *Salon des Indépendants*, where Seurat first exhibited. Signac helped to develop the colour theories of Neo-Impressionism, and believed that good painting was based on scientific principles of colour and composition. His ideas had a profound influence on the developing style of Matisse.

Stäel, Nicholas de 1914–55. Russian-born French painter and leading Abstract artist. He was greatly influenced by Braque, and from 1940 he began to evolve his impasto style, using blocks of pure colour to render the light and form of the subject. From 1950 he began to return to representational work, and elements of landscape, still life and so on became more readily recognizable.

Stella, Frank b.1936. American painter who began as an Abstract Impressionist but turned to Post-Painterly Abstraction, using shaped canvases and geometrically organized bands of colour to create an image that was intended to be treated solely as an object, not as an emotional statement.

Streeton, Sir Arthur 1867–1943. Australian painter who was one of the leaders of what came to be known as Australian Impressionism. Largely self-taught, he joined Tom Roberts and Frederick McCubbin in the Box Hill Group, staying at camping places, and painting outdoors as much as possible. He visited England and Europe, was knighted, and lived on to reflect more modern idioms in his later work.

Sutherland, Graham 1903–80. British painter and one of the most important figurative artists of the twentieth century. He began as an engraver and etcher. From 1941 he began painting scenes of war-torn London as an official war artist. His portraits are noted for their unsympathetic honesty; Churchill so hated his that after his death Lady Churchill had it destroyed.

Tintoretto, Jacopo 1518–94. Venetian painter and heir to the greatness of Titian. The drama and grandeur of his work resides in his mastery of perspective, foreshortening, and construction of space, combined with theatrical effects of lighting and composition.

Titian c.1487/90–1576. The most important painter of the Venetian school. Because of his total mastery of oil-painting techniques he was more able than any other artist to give a feeling of life and tangible reality to his subject-matter. His sensuous use of opulent colour was unparalleled and can best be seen in *The Rape of Europa* (Gardner Museum, Boston).

Toulouse-Lautrec, Henri de 1864–1901. French painter and print maker whose physical deformity – his growth was stunted as a consequence of his breaking both legs in childhood – may have caused him to prefer to live and work among the *demi-monde* of Paris. Using thinned oil paint on unprimed card, he painted and sketched sad and sordid scenes of brothels, music-halls and seedy Parisian cafés. He was a superb draughtsman, and in one line could capture the essential gesture of his subject's emotion. His work as a lithographer was later to influence the design styles of graphic poster art.

Turner, Joseph Mallord William 1775–1851. British painter and one of the most original landscapists. He worked primarily in watercolour and in oils, beginning as a topographical artist and gradually evolving an almost Impression-ist approach, trying to show his subjects in terms of the colour values of the light. The results are masterpieces of shimmering colour, with hardly a trace of figurative work. *The Sun of Venice going to Sea* (Tate Gallery, London) exemplifies his technique.

Uccello, Paolo 1396/7–1475. Florentine painter credited in the past with being the inventor of perspective drawing. Although this is not true, he was certainly one of the early masters of foreshortening and perspective, and thus one of the artists who helped ease the translation of the arts from the Gothic period to the Renaissance. His painting *St George and the Dragon* (National Gallery, London) shows his technique at its best; the painting is also one of the first to use oils on canvas.

Utrillo, Maurice 1883–1955. French painter famous for his Parisian cityscapes. They are painted in soft, pallid tones enriched with touches of burnt sienna and ochre, and they display a sensitive handling of tone.

Vasarély, Victor b.1908. French painter born in Hungary. He is credited with being the originator of Op Art: his thoroughly abstract, geometric forms explore the visual tricks produced by certain colour relationships.

Velazquez, Diego Rodriguez de Silva 1599–1660. Born in Seville, he is recognized as one of Spain's greatest painters (although he was in fact of Portuguese origin). His great talent, which lay in his ability to capture the spiritual essence of his subject, was based on sensitive and detailed observations of life. *Las Meninas* (Prado, Madrid), a group portrait of the young Infanta Margareta Teresa with her companions and dwarfs, is a prime example both of his technical skill and his gift for portraying character.

Vermeer, Jan 1632–75. Dutch genre painter who only during the last quarter of the nineteenth century attained his rightful eminence alongside Rembrandt. Only forty paintings are recognized as being his work, and they are small intimate interior scenes of sublime tranquillity, showing people following gentle pursuits – sewing, reading, playing music.

Veronese, Paolo c.1528–88. Italian painter and one of the most extravagantly decorative artists of the Venetian school. Most of his works are huge, complicated scenes of sumptuous pageantry which allowed the artist much scope in working with elaborate perspectives and vivid colour.

Vlaminck, Maurice de 1876–1958. French painter and one of the most outrageous members of the Fauve movement. He was influenced by van Gogh and worked with Matisse and Derain, but his paintings have a greater intensity as he often used pigment straight from the tube, slashing it thickly onto the canvas with great energy.

Vuillard, Édouard 1868–1940. French painter who, with Bonnard, developed the style known as Intimisme – the depiction of everyday life as seen in the sheltered simplicity of domestic interiors. The colours he used and the composition of his paintings reflect the influences of Impressionism and Japanese woodblock prints.

Warhol, Andy b.1930. American painter and graphic artist and leading member of the Pop Art movement. He is best known for his multiple screen-printed images of Hollywood personalities and of packaged foodstuffs.

Watteau, Jean Antoine 1684–1721. French painter, and one of the major artists of the Rococo period. He began as a decorative painter, but, greatly influenced by Rubens, developed a more realistic and compassionate style which gave his works more substance than is typical of most painting during this frivolous period.

Wilson, Richard c.1713–82. The most important British landscape artist of the eighteenth century. He found his niche on a visit to Italy, when he turned from portraiture to landscape, taking the principles of classical composition and applying them in a most poetic manner to scenes of rural England and Wales.

Glossary

Abstract art. Art that does not try to represent recognizable objects, but uses form, colour and texture for their own aesthetic ends.

Abstract Expressionism. School of painting developed in New York in the 1940s, characterized by spontaneous expression through abstract forms. The most extreme type of Abstract Expressionism was Action painting, in which paint was splashed, thrown or dribbled over the canvas; Jackson Pollock was its most famous exponent.

Acrylic paint. Versatile, quick-drying synthetic paint, now a rival to oil paint in popularity. It is soluble in water, but can also be used with a special polymer medium.

Action painting. See Abstract Expressionism.

Aerial perspective. Effect caused by haze in the atmosphere whereby distant parts of a landscape appear bluish, their outlines blurred.

Alla prima. Technique in which the final surface of a picture is completed at one sitting, without underpainting. The term (Italian for 'at first') is used mostly of oil painting.

Aquatint. An etching process producing soft tonal gradations rather than firm lines.

Armory Show. Influential show of modern art held in New York in 1913. Its correct title is the International Exhibition of Modern Art; the popular name derives from the army building in which it was held.

Art Nouveau. Style that achieved popularity in all the visual arts from about 1890 to World War One. This 'new art' was characterized by flowing, plant-like forms.

Ashcan School. Group of late nineteenth-century and early twentieth-century American painters who depicted city life in a Realist way. They were most active in New York.

Barbizon School. Group of nineteenth-century French landscape painters who worked in and around the village of Barbizon in the forest of Fontainebleau. The naturalistic, uncontrived approach of the school presaged Impressionism.

Baroque. Term applied to the dominant style of European art from the early seventeenth to the early eighteenth century, characterized by panache and a sense of movement. Loosely, the term is sometimes used as a general label for the seventeenth century, as in the phrase 'the Age of Baroque'.

Bauhaus. School of design founded by the architect Gropius in Weimer in 1919, and later based in Dessau and Berlin until closed by the Nazis in 1933. The Bauhaus ideals of integrating art, craft and technology were enormously influential.

Bloom. Discoloured film that appears with age on varnished surfaces.

Body colour. Any paint that is opaque rather than transparent, but more particularly watercolour mixed with white. To all intents and purposes the term is a synonym for gouache.

Bole. Browny red clay sometimes used as a material for underpainting. It often shows through when the pigments on top of it fade or are abraded.

Cadmiums. Group of pigments made from cadmium sulphate and noted for their brilliance and permanence.

Calligraphy. Handwriting when considered as an art or craft.

Camden Town Group. Group of English painters active just before World War One, and living in the north London suburb of Camden Town. They are noted for works depicting unidealized urban scenes.

Camera Obscura. A room or a box in which an image of an outside scene can be projected by means of a lens onto a flat surface. It was sometimes used (for example by Canaletto) as an aid to accuracy in topographical painting.

Cartoon. A full-size drawing used to transfer a design to the painting surface, or to a tapestry. Today the word is more commonly used to mean a humorous drawing.

Charcoal. Sticks for drawing, processed from charred willow or vine-wood twigs.

Chiaroscuro. The effect of light and shade in a painting, a word derived from the Italian for 'bright-dark'. Usually it refers to paintings with strong tonal contrasts, most notably in the work of Caravaggio and his followers.

Chinese Ink. See Indian ink.

Cinquecento. See Quattrocento.

Classicism. Term describing the ordered harmony and restraint associated with the art of classical Greece and Rome. The word is used in various ways and may, for example, refer to direct imitation of classical models, or, much more loosely, to art that is more concerned with preserving traditional values than with personal expression.

Cloisonnisme. Style of painting, first developed by Émile Bernard, in which strong flat areas of colour are outlined with dark contours, in the manner of *cloisonné* enamels.

Collage. A picture or design made by sticking pieces of paper or other essentially flat objects onto a flat surface. From the French *'coller'*, to stick. See also *Papier collé*.

Colour field painting. Type of abstract painting characterized by broad expanses of unvariegated colour. Rothko was leading exponent.

Complementary colour. See Primary colours.

Conté. A type of hard crayon, named after its inventor, an eighteenth-century French scientist.

Copal. A resin derived from trees and used to make varnish and paint media.

Cubism. Style in painting and sculpture developed from 1907 by Picasso and Braque, and one of the most important turning points in European art. Cubist works broke down the forms of the objects they depicted into a multiplicity of facets, rather than showing them from a single viewpoint. The term Cubism was first applied derisively. The movement led the way to Abstract art.

Dada. Early twentieth-century international art movement, a forerunner of Surrealism. A product of the cynicism and bitterness engendered by World War One, the movement stressed irrationality and irreverence towards accepted standards. The word 'dada' (French for 'hobbyhorse') was chosen at random from a dictionary, reflecting this irrationality.

De Stijl. Dutch abstract art movement, at its height in the 1920s, that was inspired by ideas advocated in a magazine of the same name. The words are Dutch for 'the style'. The movement influenced the Bauhaus School. See also Neo-Plasticism.

Diptych. A work of art consisting of two linked (often hinged) panels or sections. A triptych has three panels, a polyptych four or more.

Distemper. A water-based paint used for large-scale paintings. It is not as permanent as fresco, and is used, for example, in theatrical scene-painting.

Donkey. Apparatus consisting of a low bench (astride which the artist sits) with a sloping board at one end to support a drawing or painting.

Dry brush. Technique in which a brush drags or skims undiluted paint over the surface of a painting so that the paint is left only on raised points, to create a broken effect.

Earth colour. Pigments derived from metal oxides, for example yellow ochre and terre-verte.

Easel. A stand on which the artist supports the picture when painting. Sketching easels are light and collapsible; the largest studio easels are virtually items of furniture.

Encaustic. Technique of wall-painting by means of applying colours mixed with hot wax – the term derives from the Greek for 'to burn in'. It was popular in the ancient world and sporadic attempts have been made to revive it.

Engraving. General term applied to various techniques of creating a picture or design by incising lines on metal, wood or other materials. The term applies also to the prints made by any of these processes.

Etching. An engraving technique in which the design is drawn in a thin layer of wax applied to a metal plate. The plate is immersed in acid, which eats away the metal only where the wax has been removed. When the wax has been melted off, the plate is inked and a print (also called an etching) can be made.

Expressionism. In its most general sense, a quality of emotional expressiveness in the arts gained through distortion and exaggeration. More specifically, the term is used in connection with north European, particularly German, painting in the early twentieth century.

Extender. Material added to paint to increase its bulk, known also as filler. It is generally used with cheaper quality paints.

Fat. Term applied to paint that is rich in oil. 'Lean' refers to paint thinned with a spirit such as turpentine.

Fauvism. Style practised by Matisse and a number of other French painters from 1905 to 1907. Their works, characterized by distorted shapes and very bright, unnaturalistic colours, outraged critics, one of whom dubbed them '*Les Fauves*' ('wild beasts').

Ferrule. The metal part of a brush that connects the bristles to the handle.

Figurative art. Art that represents recognizable objects, particularly the human figure, as distinct from Abstract art. Also known as Representational art.

Filbert. A brush whose bristles form a flat, tapering shape.

Fixative. Type of varnish sprayed onto drawings (particularly pastels) as a protective layer, to prevent their being smudged.

Foreshortening. The representation of an object so as to make it appear to project or recede. It may be thought of as perspective applied to an individual form.

Found object. Any object that an artist considers worthy of contemplation or exhibiting as a work of art without its being altered in any way. *Objet trouvé* is the French term.

Fresco. Technique of painting with water-based paints onto a wall covered with wet plaster. The pigment bonds chemically with the plaster, making the painting extremely durable. The term is often used incorrectly of any kind of mural painting. Leonardo da Vinci's famous *Last Supper*, for example, is often called a fresco, but in fact it is the product of a complex experimental technique which partly accounts for its poor state of preservation.

Fugitive. Term applied to pigments that fade away especially when exposed to sunlight.

Futurism. Italian artistic and literary movement flourishing from 1909 to about 1915. It expressed the dynamism of the new machine age.

Genre. In its most general sense, a distinctive type of work of art. Thus landscapes and portraits are two genres of painting, just as plays and novels are genres of literature. In a more restricted sense, the term is applied to scenes of everyday life. The latter sense is the more common in discussions of painting.

Gesso. A mixture of gypsum and glue used as a priming on panels and canvases in the Middle Ages and Renaissance to provide a smooth, brilliant white surface.

Gilding. The application of gold leaf to a surface.

Glaze. A translucent layer of paint that modifies the colour of the paint underneath. In oil painting it can produce very subtle luminous effects, as in the work of Jan van Eyck.

Gouache. Opaque watercolour paint.

Graphite. A form of carbon, used in making the 'lead' of pencils.

Grisaille. A painting executed exclusively in one colour, especially grey, sienna, or a similar neutral colour, from '*gris*', the French for 'grey'.

Gum arabic. Sap exuded by certain acacia trees, used as a binding medium in water-based paints.

Half-tones. Rather vague term applied to the tones in a picture between the lightest and darkest tones.

Hatching. Technique of creating tonal effects in drawing or engraving by means of closely spaced parallel lines.

History painting. Painting representing themes from history, mythology, the Bible or great literature. In conventional academic theory up to the nineteenth century it was considered the most important and elevated branch of painting.

Hudson River School. Group of nineteenth-century American landscape painters who depicted the Hudson River Valley and other spectacular scenery.

Hue. The title of a colour, the attribute that distinguishes, say, blue from yellow.

Icon. An image of a saint or other religious personage, especially in the Byzantine, Greek Orthodox and Russian Orthodox Churches.

Illusionism. The use of various techniques in art to create the effect of real space or form on a two-dimensional surface. One type is *trompe l'oeil* (French for 'deceive the eye') in which, for instance, a fly may be painted on a picture-frame in minute, naturalistic detail so that the spectator takes it for a real insect.

Impasto. Paint applied very thickly, to create a textured surface.

Impressionism. Movement in nineteenth-century painting, originating in France in the 1860s. Characterized by a desire to show an image of what the eye sees at a particular moment, it was the most important artistic movement of the nineteenth century, many later movements being either developments from it or reactions to it.

Indian ink. A dense black ink available either as a liquid or in solid cakes.

Key. The prevailing tone of a painting. A predominantly light painting is said to have a high key, a predominantly dark one a low key.

Lean. See Fat.

Lightfast. Term applied to pigments that resist fading when exposed to sunlight, the opposite of Fugitive.

Limner. An archaic term for a painter, in particular a painter of miniatures. Nicholas Hilliard, the greatest of all Elizabethan miniaturists, wrote a treatise called *The Art of Limning*.

Local colour. The 'objective' colour of an object or surface, independent of any modifications caused by, for example, reflections or atmospheric conditions. Thus the local colour of a distant hillside may be green, even though to the eye it looks blue. See Aerial perspective.

Mannerism. The dominant style in European art from about 1520 to 1600. It was characterized by self-consciousness and hyper-sophistication marking a reaction against the serene classicism of the High Renaissance.

Mastic. Resin obtained from trees, used to make varnishes and paint media.

Medium. The word has two distinct meanings: (1) The substance with which pigment is mixed to make it flow in such a way that it can be applied with a brush. For example, water is the medium in watercolour, egg yolk in tempera. (2) In a more general sense the term refers to the material of which any work of art is created – oils or acrylics, for instance, or, with reference to a statue, bronze or marble.

Minimal art. Type of abstract art that, in reaction to the emotionalism of Abstract Expressionism, used only very basic geometric shapes and flat colours.

Modelling. The suggestion of the three-dimensionality of objects in drawing and painting by such means as hatching and tonal variations.

Monochrome. A painting or drawing executed in any one colour.

Montage. A picture created by combining several ready-made images (such as photographs) or similar elements. The technique was used by the Cubists, and by many Pop artists.

Mural. A painting on a wall. See also Fresco.

Naïve painting. Painting done in a style that superficially looks childlike or untrained.

Naturalism. The representation of objects or scenes in an accurate, unidealized, objective way. The words 'naturalism' and 'realism' are often used interchangeably, but Realism (with a capital R) can refer also to a specific movement in nineteenth-century French painting, in which Courbet was the most important figure. Used in the latter sense, the term Realism implies a concern with low life or even squalid subjects, often with political overtones.

Neo-Classicism. The dominant style in European art in the late eighteenth and early nineteenth centuries. Characterized at its purest by severely classical forms and lofty moral ideals, the style marked a reaction against the frivolities of Rococo and was to some extent inspired by archaeological discoveries such as those at Pompeii.

Neo-Impressionism. A system of painting employing small touches of pure colour placed side by side so that they mix not on the canvas but in the viewer's eye. Neo-Impressionism, known also as Divisionism and Pointillism, was an offshoot of Impressionism and an attempt to make it more rational. Seurat was its main theorist and practitioner.

Neo-Plasticism. The name given by Mondrian to the style of abstract art that he and other members of De Stijl advocated and practised. It was a radically simple style, allowing little more than the primary colours and right-angled forms as means of expression.

Neue Sachlichkeit. German term meaning 'new objectivity' applied to a group of German painters active in the 1920s and 1930s whose works made strong social comments. Dix and Grosz were the two leading painters involved.

New Objectivity. See *Neue Sachlichkeit*.

Nocturne. A night scene. Whistler was the most celebrated practitioner and often used the word – originally a musical term – in the title of his paintings.

Novecento. See Quattrocento.

Objet trouvé. See Found Object.

Ochre. Name given to various pigments made from natural earths, also used generically for earth colours.

Oil paint. Paint in which the pigment is mixed with any of the various drying oils, the most common being linseed oil, which is made from flax. Oil paint is supremely versatile, allowing the creation of surfaces ranging from porcelain smoothness to violently expressive impasto; consequently it has been the dominant medium in European painting from the sixteenth century to the present day.

Op Art. Term applied to painting, especially that of the 1960s, that depended on dazzling optical effects to create visual illusions including, often, an impression of movement. Vasarély and the English painter Bridget Riley were leading exponents.

Ottocento. See Quattrocento.

Palette. The flat board, usually held in the hand by means of a thumb-hole, on which an artist lays out and mixes paint. The term can be applied also to the range of colours characteristic of a painter; thus Manet might be said to have a light palette and Caravaggio a sombre palette.

Papier collé. A picture created by cutting out pieces of paper and glueing them to a flat surface. It is a form of collage, and the technique was practised by the Cubists. The term is French for 'glued paper'. A similar technique is *découpage* (French for 'cutting out'), the decoration of a surface with paper cut-outs.

Pastel. Paint in the form of powdered colour bound with gum into sticks resembling wax crayons. Pastels are unique among paints in that they use no medium – the gum is simply there to hold the pigment together, and the paint is dry when applied (although it needs a fixative to hold it in place).

Perspective. Means of representing three-dimensional forms and spaces on a flat, i.e. two-dimensional, surface.

Picture plane. The plane on which the imaginary space of a picture begins: in effect the surface of the picture. In certain Illusionist pictures, forms may appear to project from the picture plane as well as to recede behind it.

Picturesque. Aesthetic attitude, common in the eighteenth century, that took delight in irregularity and curiousness of forms, as, for example, in ruined buildings. Nowadays the meaning of the term has changed and it is generally applied to any view that is conventionally pleasing to look at.

Pigment. The colouring-matter of paint. The medium with which the pigment is mixed determines the qualities of the paint. Pigments are now usually synthesized chemically, but they were originally derived from a variety of animal, vegetable and mineral products.

Plastic. Term describing something that has been modelled or moulded. It can be used also to describe forms in paintings that seem to convey a particularly strong feeling of three-dimensionality.

Plein air. French term meaning 'open air', applied to pictures executed out of doors.

Pointillism. See Neo-Impressionism.

Polyptych. See Diptych.

Pop Art. Movement in art originating in the 1950s and taking as its subject-matter products of the contemporary consumer society and mass media. Andy Warhol's famous paintings of soup-cans are among the most characteristic images of the movement.

Poster paint. A fairly inexpensive form of opaque watercolour used mainly for design work rather than paintings.

Post-Impressionism. General term applied to various trends in European painting in the period from about 1880 to about 1905. The term was first used in 1910 by the English art critic and painter Roger Fry as the title of an exhibition dominated by the work of Cézanne, Gauguin and van Gogh, the three giants of Post-Impressionism.

Post-Painterly Abstraction. Term applied to various styles of painting developed in America in the 1950s and 1960s. Reacting against the extreme subjectivity of Abstract Expressionism, the Post-Painterly Abstractionists created much more dispassionate paintings, often characterized by hard-edged areas of flat colour.

Pre-Raphaelite Brotherhood ('PRB'). Group of young British painters formed in 1848 with the aim of reviving what they considered the high moral tone of painting before Raphael. Although short-lived, the group was very influential. Millais and Rossetti were among the founder-members.

Primary colours. In painting, the colours that cannot be created by mixing other colours – that is, blue, red and yellow. Secondary colours are those created by mixing two primary colours; thus blue and yellow create green. A complementary colour is one having the maximum contrast with another colour; thus orange (a mixture of red and yellow) is the complementary of blue.

Priming. A layer or layers of material applied to a canvas, panel or other painting support to make it more suitable to receive paint by, for example, rendering it smoother or less absorbent. Gesso is historically the best-known priming material.

Quattrocento. Italian term, meaning literally 'four hundred', used as a period label for the fifteenth century (the 1400s). It can be used as an adjective as well as a noun, as in the expression 'a Quattrocento painting'. Corresponding Italian terms are used in a similar way: Trecento for the fourteenth century, Cinquecento for the sixteenth century, Seicento for the seventeenth century, Settecento for the eighteenth century, Ottocento for the nineteenth century, and Novecento for the twentieth century.

Realism. See Naturalism.

Renaissance. Term (French for 'rebirth') applied to an intellectual and artistic movement originating in Italy and founded on a revival and re-interpretation of classical culture. The chronological boundaries of the Renaissance are ill-defined, its origins in art being sometimes placed as early as Giotto. The brief period in the first two decades of the sixteenth century, when the movement reached a peak of balance and harmony in the work of artists such as Raphael, is known as the High Renaissance. The Renaissance gradually spread throughout Europe, and the term Northern Renaissance is applied to its dissemination outside Italy.

Representational art. Another term for Figurative art.

Rococo. Frothy, elegant style developed out of Baroque at the beginning of the eighteenth century. Boucher is a quintessentially Rococo artist.

Romanticism. Intellectual and artistic movement flourishing from about 1780 to about 1840. In contrast to the contemporary Neo-Classical style, Romanticism involved the subjective expression of emotion, often through dynamic forms and vibrant colours.

Salon des Refusés. Exhibition held in 1863 to show paintings, among them Manet's *Olympia*, rejected by the official Salon. It is regarded as a momentous event in the development of modern art.

Sanguine. Red chalk, one of the most common drawing materials.

Scumble. Opaque paint dragged over another layer of paint so that the underlying colour shows through in parts.

Secondary colour. See Primary colour.

Seicento. See Quattrocento.

Settecento. See Quattrocento.

Sfumato. Tones blended with imperceptibly subtle transitions (the word is Italian for 'evaporated'). Leonardo da Vinci was the most famous exponent of the technique.

Silverpoint. Drawing technique using a silver-tipped instrument and specially prepared paper. It was popular during the Renaissance and could produce exquisitely delicate effects, but later fell into disuse, probably because the lines cannot easily be erased.

Size. A form of glue used to prime canvases or panels.

Social Realism. Realist painting in which the subject has overtly social or political content. It is not to be confused with Socialist Realism, which is a name given to the official (and usually very dull) art promoted by the state in countries such as the Soviet Union.

Stippling. Technique of shading in drawing and painting, using closely spaced dots rather than lines.

Support. The surface to which paint is applied. Canvas, wooden panels and walls (in mural painting) are all supports. Most supports need to be coated with priming before they can be painted on.

Surrealism. Literary and artistic movement of the 1920s and 1930s. It was characterized by the use of bizarre, incongruous and irrational elements.

Tempera. Paint using egg as the medium. It was overtaken in popularity by oil paint during the Renaissance.

Tenebrism. A quality of overall darkness of tone in a painting. Derived from an Italian word for 'obscure' ('*tenebroso*'), the term is associated particularly with Caravaggio and his followers.

Tone. Term describing the degree of darkness or lightness of a colour.

Tooth. The degree of roughness of a canvas or other support.

Trecento. See Quattrocento.

Triptych. See Diptych.

Trompe l'oeil. See Illusionism.

Ultramarine. See Pigment.

Value. The lightness or darkness of a colour, essentially a synonym for tone, although the term is sometimes used in rather unclear ways.

Vanishing point. A point on the horizon at which receding parallel lines appear to meet, a term commonly used in connection with perspective.

Wash. A thin, usually broadly applied, layer of transparent pigment such as watercolour or ink.

Watercolour. Pigment bound with gum arabic and diluted with water in use. Watercolour is traditionally used to create translucent effects, white highlights being produced by leaving the paper blank.

Museums and Galleries

United States of America

The following is a selective list of American art galleries and museums, arranged alphabetically by city.

Baltimore
The Baltimore Museum of Art, Art Museum Drive, Baltimore, MD 21218-3898. Tel.: 410-396-6323. European paintings and sculpture from the Renaissance; 18th- to 20th-century American paintings; modern art.

Walters Art Gallery, 600 North Charles Street, Baltimore, MD 21201. Tel.: 410-547-9000. Arts from ancient times through the 19th century; decorative arts; paintings and sculpture; arms and armor; manuscripts; jewelry.

Boston
Museum of Fine Arts, 465 Huntingdon Avenue, Boston, MA 02115. Tel.: 617-267-9300. Wide-ranging collection from antiquity to modern times.

Chicago
The Art Institute of Chicago, 111 South Michigan Avenue, Chicago, IL 60603-6110. Tel.: 312-443-3600. Large collection, including all periods of European and American painting. Also, Chinese, Indian, Japanese, and Middle Eastern Art.

Cincinnati
Cincinnati Art Museum, Eden Park, Cincinnati, OH 45202-1596. Tel.: 513-721-5204. Ancient art; 16th- to 20th-century European paintings and sculpture; 18th- to 20th-century American paintings; African and Native American art.

Detroit
The Detroit Institute of Arts, 5200 Woodward Avenue, Detroit, MI 48202. Tel.: 313-833-7963. European, 20th century, ancient, American, African, Asian, Islamic, Oceanic, and Native American art; graphic arts and photography.

Houston
The Museum of Fine Arts, Houston, 1001 Bissonnet, Houston, TX 77005. Tel.: 713-639-7300. European and American paintings; pre-Columbian art and archaeology; Native American art; African and Oceanic art; Far Eastern art.

Los Angeles
Los Angeles County Museum of Art, 5905 Wilshire Boulevard, Los Angeles, CA 90036. Tel.: 213-857-6111/6010. Egyptian and Greco-Roman sculptures and antiquities; Chinese and Japanese art; European and American art; Asian art; Islamic art.

Huntingdon Library, Art Collections and Botanical Gardens, 1151 Oxford Road, San Marino, CA 91108. Tel.: 818-405-2100. 18th-century British and European art; French 18th-century paintings; Renaissance paintings and bronzes; c. 1730-1930 American paintings.

The J. Paul Getty Museum, 17985 Pacific Coast Highway, Malibu, CA 90265. Tel.: 310-459-7611. Greek and Roman antiquities; pre-20th century Western European paintings and drawings; illuminated manuscripts; sculpture; photography.

Norton Simon Museum, 411 West Colorado Boulevard, Pasadena, CA 91105. Tel.: 818-449-6840. European paintings and sculpture from the early Renaissance; 20th-century American art; old master paintings.

Manchester, NH
The Currier Gallery of Art, 192 Orange Street, Manchester, NH 03104. Tel.: 603-669-6144. European and American painting and sculpture; American furniture, glass, pewter, silver, and textiles.

New Orleans
New Orleans Museum of Art, One Collins Diboll Circle, New Orleans, LA 70124. Tel.: 504-488-2631. Wide-ranging collection, including old master paintings; Italian Renaissance and Baroque painting; pre-Columbian art.

New York
The Frick Collection, 1 East 70th Street, New York, NY 10021. Tel.: 212-288-0700. Paintings; sculpture; prints and drawings; decorative arts; furniture.

The Metropolitan Museum of Art, 5th Avenue at 82nd Street, New York, NY 10028. Tel.: 212-879-5500. Ancient and modern art of Egypt, Greece, Rome, the Near and Far East, Africa, America, pre-Columbian, Europe, and Oceania.

The Museum of Modern Art, 11 West 53rd Street, New York, NY 10019. Tel.: 212-708-9480. Modern art from 1880; painting; sculpture; drawings; prints; photography; film; video; posters; illustrated books; manuscripts; architecture and design.

Solomon R. Guggenheim Museum, 1071 Fifth Avenue at 88th Street, New York, NY 10128. Tel.: 212-423-3600. Works on paper of the last 100 years; wide range of post-World War II American and European painting and sculpture.

Whitney Museum of American Art, 945 Madison Avenue, New York, NY 10021. Tel.: 212-570-3600. Paintings; sculpture; drawings; prints and photography.

Philadelphia
Philadelphia Museum of Art, 26th Street and Benjamin Franklin Parkway, Philadelphia, PA 19130. Tel.: 215-763-8100. Wide-ranging collection, including European, American, Native American, Far Eastern and Near Eastern art.

Richmond, VA
Virginia Museum of Fine Arts, Boulevard and Grove, Richmond, VA 23221-2466. Tel.: 804-367-0844. Wide range of ancient art; Impressionist and Post-Impressionist art; British sporting art; Russian Imperial jewels; contemporary art.

San Diego
San Diego Museum of Art, Balboa Park, 1450 El Prado, San Diego, CA 92101. Tel.: 619-232-7931. 14th- to 20th-century European paintings, sculpture, and decorative arts; Asian arts; contemporary painting and sculpture; contemporary Californian art; Native American paintings.

San Francisco
San Francisco Museum of Modern Art, 151 Third Street, San Francisco, CA 94103. Tel.: 415-357-4000. Early 20th-century to present international paintings, sculpture, architecture, photography, design and media arts.

Washington, DC
Freer Gallery of Art, Jefferson Drive at 12th Street S.W., MRC 707, Washington, DC 20560. Tel.: 202-357-4880. 19th- and early 20th-century American artists; wide range of art objects from the Far and Near East, South and Southeast Asia.

National Gallery of Art, 4th Street and Constitution Avenue, N.W., Washington, DC 20565. Tel.: 202-737-4215. European and American painting, sculpture, graphic and decorative arts; European old master paintings; Renaissance bronzes.

National Museum of American Art, 8th and G Streets, N.W., Washington, DC 20560. Tel.: 202-357-2247. Painting; sculpture; graphics; photography; folk art; contemporary crafts.

United Kingdom

The following is a selective list of British art galleries and museums, arranged alphabetically by city.

ENGLAND
Cambridge
Fitzwilliam Museum, Trumpington Street, Cambridge, Cambridgeshire, CB2 1RB. Tel.: 01223-332900. Very wide international collection includes Titian, Veronese, Hogarth, and Impressionists.

Leeds
Leeds City Art Gallery, The Headrow, Leeds, West Yorkshire, LS1 3AA. Tel.: 0113-247-8248. Large collection includes Victorian oils, English watercolours (Cotman), and 20th-century works.

Liverpool
Walker Art Gallery, William Brown Street, Liverpool, Merseyside, L3 8EL. Tel.: 0151-478-4178. 14th- to 16th-century Italian, Netherlandish, and German paintings; 17th- to 20th-century English paintings; 17th-century old masters; 19th-century French paintings.

London
Courtauld Gallery, Somerset House, Strand, London, WC2R 0RN. Tel.: 0171-848-2526. Old masters; French Impressionists; Post-Impressionists; Roger Fry Collection; extensive prints and drawings; regular exhibitions.

Hayward Gallery, South Bank Centre, Belvedere Road, London, SE1 8XZ. Tel.: 0171-928-3144. Wide variety of exhibitions by the Arts Council of Great Britain.

National Gallery, Trafalgar Square, London, WC2N 5DN. Tel.: 0171-839-3321. A vast collection of Western European art from the 14th to 20th century, including Leonardo, Titian, Turner, Picasso.

National Portrait Gallery, 2 St Martin's Place, London, WC2H 0HE. Tel.: 0171-306-0055. British portraits, medieval times to the present day.

The Royal Academy of Arts, Burlington House, Piccadilly, London, W1V 0DS. Tel.: 0171-300-8000. Old master collection; annual Summer Exhibition; other temporary exhibitions.

The Tate Gallery, Millbank, London, SW1P 4RG. Tel.: 0171-887-8000. Major collection of British paintings of all periods; modern foreign paintings.

Victoria and Albert Museum, Cromwell Road, South Kensington, London, SW7 2RL. Tel.: 0171-938-8500. International collection of all periods; Raphael cartoons; Constable paintings.

Wallace Collection, Hertford House, Manchester Square, London, W1M 6BN. Tel.: 0171-935-0687. Fine old master collection, including Poussin, Boucher, Hals, Murillo, and Velazquez.

Manchester
City Art Gallery, Mosley Street, Manchester, M2 3JL. Tel.: 0161-236-5244. Old masters, Gainsborough, Turner, Pre-Raphaelites.

Whitworth Art Gallery, The University of Manchester, Oxford Road, Manchester, M15 6ER. Tel.: 0161-275-7450. Large permanent collection from all periods: Blake, Pre-Raphaelites, Cézanne, van Gogh, Hockney.

Oxford
Ashmolean Museum, Beaumont Street, Oxford, Oxfordshire, OX1 2PH. Tel.: 01865-278000. Wide-ranging collection of European art includes 16th- and 17th-century Italian paintings; Dutch and Flemish still lifes; French Impressionists (Pissarro); English School; drawings by Raphael, Michelangelo.

Christ Church Picture Gallery, Canterbury Quadrangle, Christ Church, Oxford, Oxfordshire, OX1 1DP. Tel.: 01865-276172. Old master paintings (Tintoretto, Veronese, Hals, van Dyck) and drawings (Leonardo, Michelangelo, Raphael).

Sheffield
City Museum and Mappin Art Gallery, Weston Park, Sheffield, South Yorkshire, S10 2TP. Tel.: 0114-276-8588. 18th- to 20th-century British art, with large Victorian collection; contemporary art with local links.

Graves Art Gallery, Surrey Street, Sheffield, South Yorkshire, S1 1XZ. Tel.: 0114-273-5158. 16th- to 20th-century British art, including Camden Town Group; European old masters.

NORTHERN IRELAND
Belfast
Ulster Museum, Botanic Gardens, Stranmillis Road, Belfast, Northern Ireland, BT9 5AB. Tel.: 01232-383000. Irish art from 17th century to present day; old masters; 18th- and 19th-century watercolours; international contemporary works.

SCOTLAND
Edinburgh
National Gallery of Scotland, The Mound, Edinburgh, EH2 2EL. Tel.: 0131-624-6200. Major collection of European painting up to 1900, including Titian, Raphael, Rembrandt, Constable, Turner, Impressionists; also, collection of drawings.

Royal Scottish Academy, National Galleries of Scotland, The Mound, Edinburgh, EH2 2EL. Tel.: 0131-225-6671. International exhibitions and annual RSA exhibition; RSA Diploma collection.

Scottish National Gallery of Modern Art, 75 Belford Road, Edinburgh, EH4 3DR. Tel.: 0131-624-6200. 20th-century art, including Braque, Picasso, Moore, and Hockney.

Scottish National Portrait Gallery, 1 Queen Street, Edinburgh, EH2 1JD. Tel.: 0131-624-6200. Scottish portraits in all media, from 16th century to the present day.

Glasgow
The Art Gallery and Museum, Helvingrave, Argyle Street, Glasgow, G3 8AG. Tel.: 0141-221-2600. Major international works, including Impressionist collection.

Hunterian Art Gallery, 82 Hillhead Street, Glasgow, G12 8QQ. Tel.: 0141-330-5434. International collection includes works by Rembrandt, Stubbs, Pissarro, Whistler, and Scottish artists from the 18th century to the present.

WALES
Cardiff
The National Museum & Gallery Cardiff, Cathays Park, Cardiff, CF1 3NP. Tel.: 01222-397951. Art from the Renaissance to the present day, including old masters, Rubens cartoons, and 19th-century French Realists and Impressionists.

Newport
Newport Museum and Art Gallery, John Frost Square, Newport, NP9 1PA. Tel.: 01633-840064. Early English watercolours; 20th-century British oils, with the emphasis on Welsh artists.

International Galleries

The following is a selective list of international art galleries and museums, arranged alphabetically by country and city.

ARGENTINA
Buenos Aires
Museo de Arte Moderno

Museo Nacional de Bellas Artes

AUSTRALIA
Adelaide
Art Gallery of South Australia

Brisbane
Queensland Art Gallery

Melbourne
National Gallery of Victoria

Perth
Art Gallery of Western Australia

Sydney
Art Gallery of New South Wales

AUSTRIA
Salzburg
Residenz Galerie

Vienna
Gemäldegalerie der Akademie der Bildenden Kunste

Kunsthistorisches Museum

Museum Moderner Kunst

BELGIUM
Antwerp
Koninklijk Museum voor Schone Kunsten

Brussels
Musées Royaux des Beaux-Arts de Belgique

Liège
Musée d'Art Moderne

BRAZIL
Rio de Janeiro
Museu Nacional de Belas Artes

Sao Paolo
Museu de Arte

Museu de Arte Contemporanea

CANADA
Montreal
Musée des Beaux-Arts

Ottawa
National Gallery of Canada

Toronto
Art Gallery of Ontario

Vancouver
Vancouver Art Gallery

CZECH REPUBLIC
Prague
Narodni Galerie

DENMARK
Copenhagen
Statens Museum for Kunst

EGYPT
Cairo
Museum of Islamic Art

FRANCE
Antibes
Musée Picasso

Aix-en-Provence
Musée Granet

Besançon
Musée des Beaux-Arts

Lyons
Musée des Beaux-Arts

Montpellier
Musée Fabre

Nice
Musée Matisse

Orléans
Musée des Beaux-Arts

Paris
Musée National d'Art Moderne

Musée de l'Orangerie

Musée des Arts Décoratifs

Musée d'Orsay

Musée du Louvre

Tours
Musée des Beaux-Arts

GERMANY
Berlin
Nationalgalerie

Bonn
Rheinisches Landesmuseum

Städtisches Kunstmuseum

Munich
Alte Pinakothek

Neue Pinakothek

Staatsgalerie Moderner Kunst

Nuremburg
Albrecht Dürer Haus

GREECE
Athens
Benaki Museum

HUNGARY
Budapest
Hungarian National Gallery

Museum of Fine Arts

INDIA
New Delhi
National Museum of India

Rabindra Bhavan Art Gallery

Trivandrum
Sri Chitra Art Gallery and Gallery of Asian Paintings

IRELAND
Dublin
Hugh Lane Municipal Gallery of Modern Art

National Gallery of Ireland

ISRAEL
Haifa
Museum of Modern Art

Tel Aviv
Tel Aviv Museum

ITALY
Bologna
Pinacoteca Nazionale

Florence
Galleria degli Uffizi

Galleria dell'Accademia

Palazzo Pitti

Milan
Galleria d'Arte Moderna

Museo d'Arte Antica

Pinacoteca Ambrosiana

Pinacoteca di Brera

Modena
Galleria, Museo e Medagliere Estense

Parma
Galleria Nazionale

Rome
Galleria Borghese

Galleria Nazionale d'Arte Moderna

Galleria Nazionale di Roma

Vatican Museums

Turin
Galleria Sabauda

Venice
Galleria dell'Accademia

Palazzo Ducale

Peggy Guggenheim Collection

JAPAN
Kurashiki
Ohara Art Gallery

Kyoto
Municipal Museum of Art

National Museum

Tokyo
National Museum

National Museum of Western Arts

MEXICO
Mexico City

Museo de Arte Moderno

Museo de San Carlos

NETHERLANDS
Amsterdam
Rembrandt-Huis Museum

Rijksmuseum

Rijksmuseum Vincent van Gogh

Groningen
Groningen Museum

Haarlem
Frans Halsmuseum

Rotterdam
Museum Boymans van Beuningen

The Hague
Gemeentemuseum

Mauritshuis

NEW ZEALAND
Auckland
City Art Gallery

Wanganui
Sarjeant Gallery

Wellington
National Art Gallery

NORWAY
Oslo
Munch-museet

Nasjonalgalleriet

PERU
Lima
Museo de Arte

POLAND
Poznan
National Museum

Warsaw
National Museum

PORTUGAL
Lisbon
Museu Calouste Gulbenkian

RUSSIAN FEDERATION
Moscow
Kremlin Museum

State Pushkin Museum of Fine Arts

State Tretyakov Gallery

St Petersburg
State Hermitage Museum

State Russian Museum

SLOVENIA
Ljubljana
Narodna Galerija

SOUTH AFRICA
Cape Town
Michaelis Collection

South African National Gallery

Durban
Museum and Art Gallery

Johannesburg
Africana Museum

Municipal Art Gallery

Port Elizabeth
King George VI Art Gallery

SPAIN
Barcelona
Museo de Arte de Cataluñs

Museo Picasso

Bilbao
Museo de Bellas Artes

Madrid
Museo del Prado

Museo Lázaro Galdiano

SWITZERLAND
Basel
Kunstmuseum Basel

Bern
Kunstmuseum

Geneva
Musée d'Art et d'Histoire

Winterthur
Kunstmuseum

Zurich
Kunsthaus

TURKEY
Istanbul
Topkapi Palace Museum

UKRAINE
Kiev
State Museum of Ukrainian Art

State Museum of Western and Oriental Art

ZAMBIA
Livingstone
Livingstone Museum

ZIMBABWE
Harare
National Gallery of Zimbabwe

Reading List

General Reference

ART: A HISTORY OF PAINTING, SCULPTURE & ARCHITECTURE, vols 1 & 2, F. Hartt, Thames & Hudson, 1976
CIVILIZATION, Sir Kenneth Clark, Penguin, 1982
DICTIONARY OF ART & ARTISTS, Peter and Linda Murray, Penguin, 1969
ENCYCLOPEDIA OF PAINTING, 4th revised edition, edited by Bernard S. Myers, Crown, New York, 1979
HISTORY OF ART SERIES, Thames & Hudson
TECHNIQUES OF THE WORLD'S GREAT PAINTERS, W. Januszczak, Phaidon, 1981
THE COMPLETE GUIDE TO PAINTING & DRAWING, TECHNIQUES & MATERIALS, C. Hayes, Phaidon, 1978
THE MACMILLAN ENCYCLOPEDIA OF ART, edited by Bernard L. Myers and Trewin Copplestone, Trewin Copplestone Publishing, 1977
THE STORY OF ART, E. Gombrich, Phaidon, 1950

Special Reference

BAIGELL, Matthew, *A History of American Painting*, Thames & Hudson, 1971
BARR, Alfred, *Cubism & Abstract Art*, Secker & Warburg, 1975
BARR, Alfred, *Fantastic Art, Dada & Surrealism*, Arno, New York, 1968
BECKWITH, John, *Early Medieval Art*, Thames & Hudson, 1964
BLUNT, Anthony, *Art & Architecture in France 1500–1700*, Penguin, 1980
BOWNESS, Alan, *Modern European Art*, Thames & Hudson, 1972
CAHILL, James, *Chinese Painting*, Macmillan, 1982
DODWELL, C.R., *Painting in Europe 800–1200*, Penguin, 1971
FREEDBERG, S.J., *Painting in Italy 1500–1600*, Penguin, 1971
HAY, D., *Age of the Renaissance*, Thames & Hudson, 1967
HONOUR, Hugh, *Neo-Classicism*, Penguin, 1968
HUGHES, Robert, *The Shock of the New*, BBC Publications, 1980
LEVEY, M., *High Renaissance*, Penguin, 1975
LUCIE-SMITH, E., *A Concise History of French Painting*, Thames & Hudson, 1971
MURRAY, Linda, *The Late Renaissance & Mannerism*, Thames & Hudson, 1967
NOVOTNY, F., *Painting & Sculpture in Europe 1780–1880*, Penguin, 1972
POOL, Phoebe, *Impressionism*, Thames & Hudson, 1967
REWALD, J., *The History of Impressionism*, Secker & Warburg, 1980
REWALD, J., *Post Impressionism*, Secker & Warburg, 1979
RICE, David Talbot, *The Art of Byzantium*, Thames & Hudson, 1959
ROSE, Barbara, *American Art Since 1900: A Critical History*, Thames & Hudson, 1975
SANDLER, Irving, *The Triumph of American Painting: Abstract Expressionism*, Harper & Row, New York, 1977
SCHUCHARDT, W.H., *Greek Art*, Weidenfeld & Nicholson, 1972

Index

Page numbers in *italic* refer to the illustrations. Entries for equipment and materials are confined to specific projects and detailed descriptions.

Acknowledgements

In addition to the galleries and organizations listed below, we would like to thank all the many private collectors who allowed us to reproduce their paintings in this book.

ADAGP 285; Cecil Higgins Art Gallery 216; 334; 376; Gallery of New South Wales, Australia 211b; Marlborough Gallery 416; Melbourne Gallery, Australia 324; 329; 379; Museum of Decorative Art, Budapest 417l; National Gallery, London 21t; 136; 138l; 175; 422; 456; National Gallery, Victoria, Australia 294; 351tl; 351tr; 456; Prospect Gallery 417b; SPADEM 56; 97; 133; 217; 254; 337t; 414. (b = bottom; l = left; r = right; t = top)